GF Watts Portraits

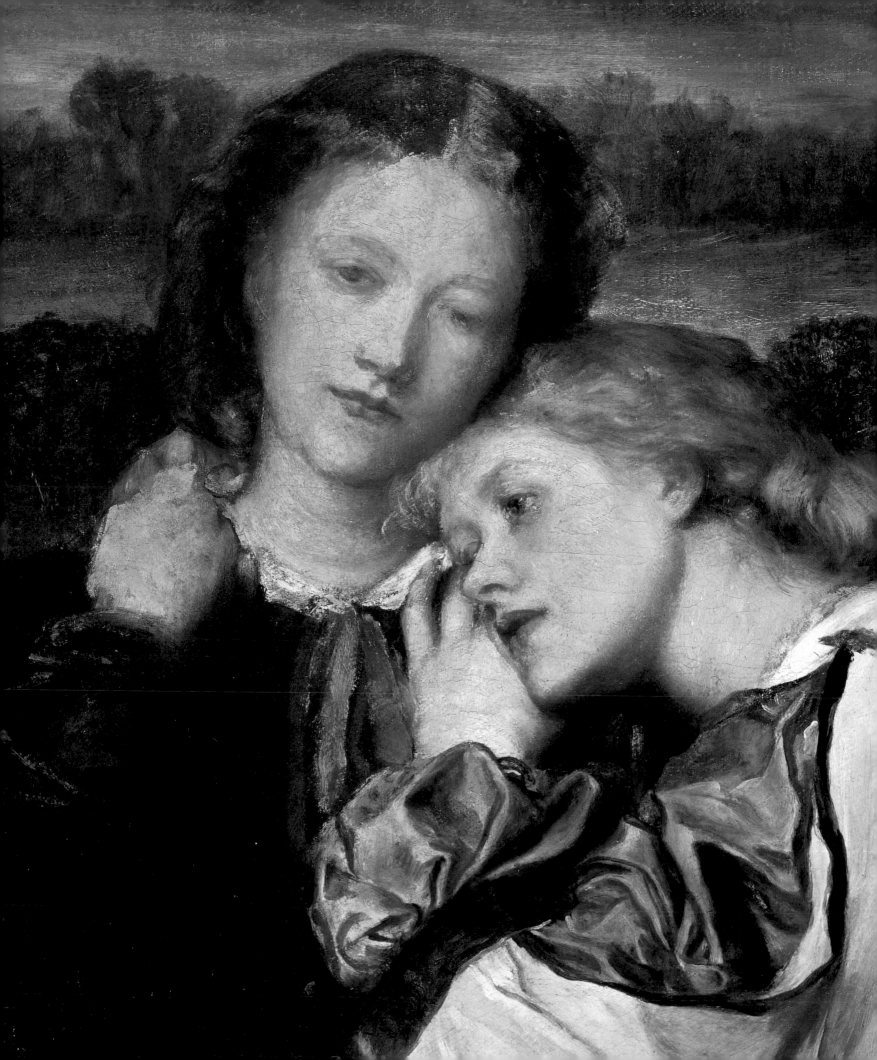

GF Watts Portraits
Fame & Beauty in Victorian Society

Barbara Bryant

Foreword by Andrew Motion

NATIONAL PORTRAIT GALLERY, LONDON

Published in Great Britain by National Portrait
Gallery Publications, National Portrait Gallery,
St Martin's Place, London WC2H 0HE

For a complete catalogue of current publications,
please write to the National Portrait Gallery
at the address above, or visit our website at
www.npg.org.uk/publications

Publishing Manager: Celia Joicey
Project Editor: Colin Grant
Editors: Caroline Brooke Johnson and Anjali Bulley
Picture Research: Chiara Issa
Production Manager: Ruth Müller-Wirth
Design: Rose-Innes Associates
Printed in Italy

GF Watts Portraits is supported by the Patrons of
the National Portrait Gallery.

ISBN hb 1 85514 354 2
ISBN pb 1 85514 347 X

A catalogue record for this book is available
from the British Library.

The publisher would like to thank the copyright
holders for granting permission to reproduce
works illustrated in this book. Every effort has
been made to contact the holders of copyright
material, and any omissions will be corrected
in future editions if the publisher is notified
in writing.

Abbreviations for London Museums and Galleries

BM	British Museum
GG	Grosvenor Gallery
RA	Royal Academy of Arts
NG	National Gallery
NPG	National Portrait Gallery
V&A	Victoria and Albert Museum

Frontispiece: *The Sisters (Kate and Ellen Terry)*, 1862–3
(detail; no. 43)

CONTENTS

Watts was an artist of great ambition. He channelled his energies into sculpting and drawing as well as painting, and his interests included music and poetry. He was determined to create art that would be understood not just in symbolic terms but as part of a moral and sometimes social agenda. The outstanding achievements of others fascinated Watts, whether they were historical or contemporary. In the context of a loggia he helped design for the churchyard of St Botolph, Aldersgate Street, London EC1, to commemorate civilian lives lost during acts of heroism, he wrote to *The Times* in 1887: 'the national prosperity of a nation is not an abiding possession, the deeds of the people are.'

His interest in those who had helped make the nation had earlier fuelled his ambitious submission to the Palace of Westminster competition of 1843. And it linked him to the writings of Thomas Carlyle, which developed the theme of heroism and were influential in the creation of the National Portrait Gallery in 1856. It is therefore no surprise that Watts devoted considerable energy not only to reinventing the art of portrait painting but also to developing a programme for painting portraits of his contemporaries that he could assemble within his own 'Hall of Fame'.

When he gifted his portrait collection to the National Portrait Gallery in 1896, just as the Gallery was moving into newly built premises in St Martin's Place, he was completing the link between portraiture and an admiration for the greatest men of his time. (He admired women, too, and was a supporter of the early phases of the feminist movement prior to the formation of the suffrage campaign.) Since the rules for admission of subjects to the National Portrait Gallery were that sitters had to have been dead for ten years, a device was established so that works in the Watts collection were transferred over a period of time. A group remains on permanent display in London while others can be seen at one of the Gallery's partner venues, Bodelwyddan Castle in North Wales. In many ways Watts created the idea we now take for granted of admiring the portraits of outstanding contemporary achievers.

Choosing, Watts's study of his first wife Ellen Terry, remains one of the most famous works in the Gallery, making it additionally appropriate that this exhibition devoted to his portraiture should take place in the Gallery. The exhibition is part of a centenary season, starting with *The Vision of Watts* at the Watts Gallery, Compton – a very special institution for which this signals a revival of interest and support – and including a collection display at Tate Britain. The exhibition at the National Portrait Gallery follows on from the very successful one in 2003 of Julia Margaret Cameron's photographs, selected by Colin Ford, which shed new light on the work of another great Victorian.

This exhibition has been created through the hard work of Barbara Bryant. She has devoted herself to the quest of locating Watts's portraits and then the harder task of distilling them down to a number that could be displayed. I am most grateful to her for her outstanding work and for her illuminating essays in this catalogue. I would also like to thank Peter Funnell, Curator of Nineteenth-Century Portraits, who has overseen the project, and Andrew Motion who has written a delightful foreword. Many others deserve thanks, including Calum Storrie and Crispin and Grita Rose-Innes for design work; all in the Publications Department for the catalogue; Andrea Gall, Helen White and Richard Hallas for conservation work; and Sophie Clark for managing the exhibition with the support of Rosie Wilson. Many other colleagues in the Gallery have contributed to this exhibition, including Kelly Bagley, Pim Baxter, Paul Cox, Sarah Crompton, John Haywood, Beatrice Hosegood, Ruth Kenny, Jacob Simon, Kathleen Soriano, Hazel Sutherland and the staff of the Archive and Library. Finally, I am grateful to the many lenders who have made the exhibition possible; in many cases portraits have been lent that have not left their locations for more than one hundred years. This support will be widely appreciated by a public that will now have a chance to understand Watts's extraordinary brilliance.

Sandy Nairne
Director, National Portrait Gallery

CURATOR'S PREFACE

In 1877 the writer and cultural commentator Henry James declared G.F. Watts to be 'the first portrait painter in England'. He had just seen the inaugural exhibition of the Grosvenor Gallery that ushered in a new phase in the appreciation of the artist's work. Today, in the centenary of Watts's death, it is hoped that this book and the exhibition that it accompanies will provide a similar reassessment.

The National Portrait Gallery's exhibition opens a door onto Watts's portraiture, providing a sense of the society in which he moved as well as insight into the thinking of one of the nineteenth century's most innovative practitioners of this genre. With his portrait output comprising over 300 oils and countless drawings from the 1830s to the very end of his life in 1904, no exhibition on a modest scale could hope to provide a detailed view of his entire career. Nor would an enormous exhibition be particularly desirable since some of Watts's output is, frankly, routine, even if it is never boringly conventional.

My aim from the outset has been to take this broad subject and select the most interesting phases of the artist's career as a portrait painter. This exhibition provides an avenue into some of the questions raised by his portraits, but it is not a fully comprehensive survey. The early years are unrepresented here, as are the portraits in sculptural tomb monuments. A well-chosen selection was the best way forward and what you now see here in the catalogue and the exhibition is based on more than twenty years of art-historical research on Watts's life and career, viewing as many original works as possible and using primary sources whenever feasible. I have sought out key unpublished works as well as some iconic paintings like *Choosing* to provide a more nuanced interpretation of the portraits and to identify the particular strand in his *oeuvre* where poetic meaning blurs the definition of the portrait.

The literature on Watts has its own curiosities. Assessing his work has often fallen to the amateur, first and foremost his second wife, whom he married in 1886. Her hold on his reputation has done more harm than good, even up to today. Her flawed manuscript catalogue is a starting point for any work on the artist, but it needs to be used with care, not least in the area of the portraits. We need to excavate the people and their personalities with greater accuracy. This exhibition introduces a new cast of characters, friends, associates, muses of the artist, while adding much more to our knowledge of those individuals close to Watts.

Since so many portraits in this exhibition remain with the descendants of the sitters, I have depended entirely on their good will. I am grateful to all those owners named in the catalogue and to those who wish to remain anonymous. Without them the exhibition would not have happened. I would like to offer my heartfelt thanks to all of them, especially those who opened the doors of their homes to me.

At the National Portrait Gallery I would like to thank Peter Funnell, who supported my original proposal and has overseen the progress of the show; former Director, Charles Saumarez Smith; and current Director, Sandy Nairne. Sophie Clark deserves special praise for her exceptional work as Exhibition Manager. Caroline Brooke Johnson greatly facilitated the progress of the book in its later stages. Calum Storrie's sustained work on the project produced an exhibition design and installation that solved every problem and enhanced every aspect of the show. Colin Grant edited the catalogue with patience and good humour. The elegant design of the exhibition graphics and the catalogue are owed to Crispin and Grita Rose-Innes.

I would like to thank those who have helped or offered information and assistance in my studies on Watts over the years, but this list would be very long indeed. I do wish to acknowledge the following individuals who aided the progress of this exhibition in diverse ways. At an early stage Sir Oliver Millar and Christopher Lloyd lent their vital support. Others who offered essential help are Katy Barron, Frances Bellis, David Bindman, Susan Breen, Judith Bronkhurst, Margarita Cappock, Frances Carey, Jacky Carver, Bill Drummond, Simon Edsor, Susan Elliot, Katherine Eustace, Rupert Featherstone, Kate Fielden, Emma Floyd, Grant Ford, Estelle Gittins, Pam Gomer, Kate Harris, Colin Harrison, Malcolm Hay, Nicola Helyer, James Holloway, Richard Jefferies, Tim Knox, Alastair Laing, Martin Levy, Rupert Maas, James Miller, David Moore-Gwyn, William Mostyn-Owen, Virginia Murray, Lady Rupert Nevill, Charles O'Brien, Leonée and Richard Ormond, Jacqueline Ridge, Daniel Robbins, Francis Russell, Peregrine Sabin, Joanna Selborne, Isobel Siddons, Peyton Skipwith, Yvonne Steward, Hans and Louise van Tartwijk, Grace Timmins, Simon Toll, Helen Valentine, Malcolm Warner, Giles Waterfield, Dawn Webster, Catherine Willson and Andrew Wilton. To Philip Mould I am most grateful for his keen interest in the progress of this exhibition.

Research carried out while holding fellowships at the Huntington Library and Art Gallery and at the Yale Center for British Art has fed into this project. For my training as an art historian at Columbia University in New York, I must thank Allen Staley, with whom my research on Watts first began, as well as Richard Brilliant, Theodore Reff and the late Kirk Varnedoe. They valued original thinking backed by rigorous methods; their high standards have proved an inspiring model.

Last and most of all, I am grateful to Julius for invaluable support since Watts brought us together and for his reading of the essays and commenting on endless points of vital interest. Thanks, too, go to Max who put up with many detours to visit Watts's paintings and who recently let me use his sofa. I hope one day he reads this book.

Barbara Bryant

I first visited the Watts Gallery, at Compton near Guildford, twenty-odd years ago. As a susceptible teenager, I'd stuck a postcard of his 'Self Portrait, aged 17' on the wall of my room, impressed by the early confidence of his gift and the Romantic beauty of the image: tousle-haired, with a Keatsian mixture of intensity and relaxation. In my twenties I'd seen a handful of other portraits I liked, all of which suggested that Watts's reputation (then at a low ebb) was less than it deserved to be. By my early thirties I'd heard about the gallery's studio collection. I went in the spirit of pilgrimage, not just out of curiosity.

Nothing had prepared me for what I found. After I turned aside from the roar of the A3 into the sudden hush of the village, then into the deeper silence of the side-road leading to the gallery, the weight of the twentieth century lightened. Big dripping hedges crowded the lane; light thickened into a veneer; well-to-do houses – including Watts's own Limnerslease, built for him and his second wife Mary in 1890–91 – crouched behind their laurels. Then from the rumpled car-park a track led round an unpromising out-house onto a lawn – and there it was: an Arts and Crafts dream turned into reality. Shaggy bushes concealing much of the façade. A row of pert little dormer windows. The entrance more like the opening of a bower than the way into a building.

It was the special talent of the gallery to make every visitor feel they had discovered something that no one else knew about – something all the more precious for being poised, apparently, on the verge of collapse. The air of the rooms felt woody with damp; bramble-fingers had pushed through some of the window-edges; pigeons coo-cooed on the roof as though they had claimed the place for themselves. The pictures, too, felt more nearly out of time than timeless: large allegorical canvases that seemed nervously to overstate their interest in the Aesthetic and Symbolist movements; precocious early drawings (including a splendidly gloomy lion, done when Watts was ten) that owed no particular allegiance except to skill and watchfulness; portraits of long-forgotten or dimly remembered Victorian names. The poet Henry Taylor, for instance, with his eyes left unfinished by Watts (who often left the eyes until last, believing they were the key to much of his sitter's character).

But the Taylor portrait wasn't just magnetic in its incompleteness, staring blindly over the still rooms of the gallery. It was also strikingly powerful in its expression of personality – as were a number of others round abouts. John Stuart Mill, revealing exactly the blend of steeliness and kindliness that he shows in his writing. Tennyson, sunk into his melancholy but never letting his attention swerve from the world. These things alone were confirmation that Watts merited a much wider audience, and had cultivated ambitions ('The Utmost for the Highest') that were not the hubristic inflations of a self-aggrandiser, but the proper ideals of a committed and courageous spirit.

All the same, it was difficult to leave without feeling that Watts had sunk irretrievably far from public esteem. The gallery wasn't just quaint, it was seriously decayed: it suggested that while certain big Victorian names were suitable for rehabilitation (Tennyson himself), others were simply too much a part of their period to find a place in our own time. There was pathos in the thought – especially when the nearby Watts Chapel, opened in 1904, the year of his death, beckoned to me from its mound on the way back to the main road. This extraordinary monument may have been driven to completion by the enthusiasm of Mary, whose designs cohere into a tremendous swirling celebration of her husband. But it also reflected a general sense of his significance, and was done with real confidence that his achievement would last. In such a haunted place as the gallery the ghosts of Watts and Mary seemed to be bemoaning their fate, shaking their heads over the unimagined changes brought by the First World War, by Modernism, by the twentieth century's long retreat from figurative painting.

Enough time has passed, and a sufficient momentum of interest in the Victorians has accumulated to allow us to look at Watts afresh. And not just to look at him for what he did, but to look at him in the best possible place. Watts's enthusiasms and emphases cannot easily be separated from the National Portrait Gallery. His bequest to the Gallery helped to build the foundation of its nineteenth-century holdings, and his overall contribution to portraiture of the period was crucial to the promotion and re-definition of the genre. As a painter himself he widened its catchment to include literary and artistic types (Tennyson several times, Browning, Swinburne) as well as society and aristo-cratic names – thereby reinforcing the National Portrait Gallery's own burgeoning practice. As a technician, he fought to preserve Renaissance principles while at the same time making his canvases more than just superior kinds of mug-shots – by painting several large pictures in which background mattered, and by searching for what was veiled in a person-ality as well as for what was on display. As an advocate he was vitally involved in the influential National Portrait exhibitions of the 1860s. As an argufyer he identified the necessary modesty of the portraitist's role, yet extolled the values of the final result. (He wanted, he said, to produce 'portraits of individuals whose names will be connected with the future history of the age … the principle I have adopted with a view to their future value as historical records is, that such portraits should be as inartificial & true as possible'.)

All these things make Watts sound like a man deeply of his time – and so he was. Learning from the existing collections and practice of the National Gallery and the British Institution, he was alert to the special opportunities of his moment to produce art that captured the spirit of the age. But if this makes him sound a conservative figure (someone

whose trajectory was almost bound to end in the brambles of Compton), it misrepresents him. Thanks partly to his foreign travels to Europe, partly to the Frenchifying influence of his connections with the Holland family, partly to the unorthodoxies of his domestic arrangements, partly to his open-minded response to Symbolism and the Aesthetic movement, and partly to an unusual depth of fascination with the inner workings of his fellow men and women, he kept his art active as well as reactive.

One of the keys to his success was his willingness to think of his painting in terms of the other arts. Very many of his remarks about painting invoke music (no doubt partly due to the influence of Walter Pater), while others refer to poetry. Painting, he said, 'is art that corresponds to the highest literature, both in intention and effect, which must be demanded of our artists, poems painted on canvas, judged and criticised as are the poems written on paper'. In practice this not only meant that he was alive to psychological subtleties, but interested in making character seem fluid – subject to moods and waywardness, rather than being fixed and unchanging.

This is what makes his portraits of the Victorian great and good so compelling: we see them as wounded, aspiring, hopeful, flawed individuals, not merely as figures in a pantheon. It is also what draws us into his pictures of those whose names we have forgotten: Virginia Pattle, Princess Lieven, Jeanie Nassau Senior. We see his subjects as people who are involved in their particular world, and who often enjoy a richness of setting that has become frankly strange, yet also as personalities brimming with feelings that we can recognise as our own. Compared to the predominantly aristocratic portraits by his well-known contemporary Francis Grant, these are pictures we can identify with, in the same way that we can identify with the differently remote worlds depicted by Gainsborough or Lawrence.

But is Watts as good as Gainsborough or Lawrence? Looking across the whole range of his work – there are some 800 surviving paintings, of which about 300 are portraits – his achievement appears much less consistent. It's possible that no amount of passing time will allow us to see the Symbolist works as anything other than curiosities. But the flexibility that made these experiments possible – the refusal to settle behind the carapace of Victorian Grand Old Man – is the very thing that gives his portraits their lasting energy. He was always willing to be surprised by what he found in his studious contemplation of character, and to capture that surprise for us to share.

Andrew Motion

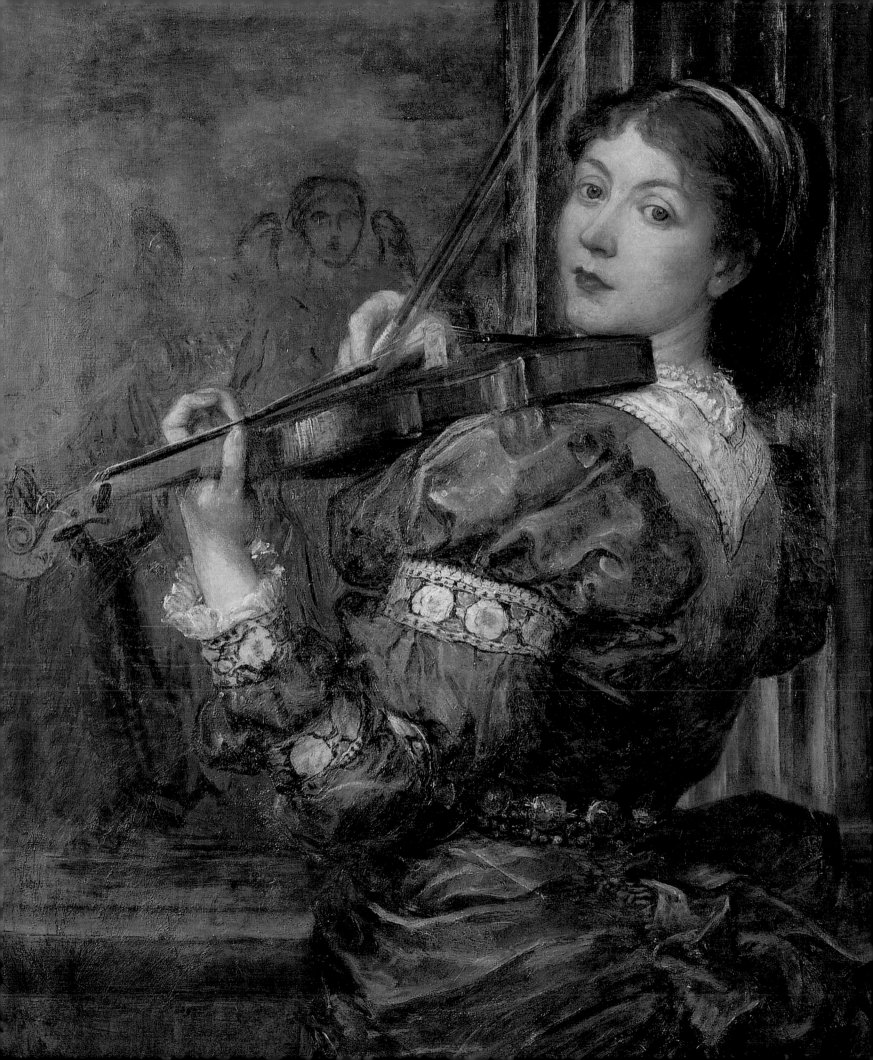

GF WATTS AND THE POTENTIAL OF PORTRAITURE

George Frederic Watts died in 1904 at the age of eighty-seven. His paintings and his portraiture had deep roots in both the art of the past and in the ideals of the late eighteenth century, encompassing many of the trends and movements of the nineteenth century and further venturing into the twentieth. The sheer number of works of art he produced provide an index of this output: some 800 oil paintings, including approximately 300 portraits, in addition to countless portrait drawings, both formal ones and informal sketches. Watts was twenty when he exhibited for the first time at the Royal Academy, displaying two portraits and one other work; he continued to show there to the last year of his life in 1904 when one final portrait appeared. Two-thirds of his total output of works exhibited at the Academy consisted of portraits, with still more appearing at other venues throughout his life.[1] Portraiture was part of his make-up as a person and an artist; indeed, his biography can be tracked in an extraordinary series of self-portraits he painted and drew, spanning his entire working career of seventy years (nos 8, 48, 59; see figs 6, 9, 18, 25).

The artist's bequest to the National Portrait Gallery, subsequently dubbed 'The Hall of Fame', now forms an integral part of the nineteenth-century collections there. Yet these works, representing a small fraction of Watts's whole portrait output, are only the public face of his art: much more remains to be discovered, and in many private commissions and other works he blurred the boundaries between subject painting and portraiture. This catalogue and the exhibition it accompanies consider these aspects of his *oeuvre*. This essay examines Watts's career through the mirror of his portraits.

Early years in London

Humble beginnings as the son of a pianoforte maker, living in the less prosperous districts of London, did not forecast success for Watts, but an early facility in drawing and the encouragement of his widowed father gave the boy a gentle start. A musical household formed the backdrop to his early life, though he was often ill as a youngster. Through family connections he entered the studio of William Behnes (1795–1863) in 1827 aged ten. Behnes was a talented sculptor, and Watts had the chance to observe and draw as an informal student, copying engravings such as studies in physiognomy. More importantly, casts of the Elgin Marbles led him to seek out the originals at the British Museum, newly installed from 1832. The painter Benjamin Robert Haydon (1786–1846) reputedly urged Watts to study these antique masterpieces,[2] but the more immediate example of Behnes's portrait work, in the form of both delicate pencil studies[3] and busts and statues in marble, provided a useful career choice for a young artist keen to make his own way.

By the late 1820s Behnes's practice in Dean Street, Soho, was booming, giving Watts the opportunity to observe eminent individuals who came to sit for him and to follow the progress of busts of John Nash (1831), Lord Eldon (1832) and Lord Brougham (1834).[4] Such exposure stimulated the young artist with the idea of portraying the great and the good. Behnes's younger brother Charles advised Watts, introduced him to wider literary horizons and also arranged for him to receive some instruction in oil painting.[5] Perhaps spurred on by the gathering of thirteen paintings by Anthony van Dyck (1599–1641) seen at the British Institution in 1834, Watts produced a convincing pastiche of this artist's work using his own face. When the oil passed as an 'Old Master', after being smoked in a chimney to give it an aged effect, he first experienced the power of the portraitist.[6]

Watts entered the Royal Academy Schools on 30 April 1835, aged eighteen, but found 'no teaching';[7] he had already progressed beyond the standard art-training routine of copying from engravings. His oil painting had advanced to a precocious fluency, as seen in the early *Self-Portrait* (c.1834; Watts Gallery) and the portrait of his father (c.1835; fig. 1), both sensitive studies of character. By this time Watts was already making his way as a portrait draughtsman with his own studio in Marylebone.[8] His first works to be exhibited at the Royal Academy, in 1837, the year of Queen Victoria's accession to the throne, included two unidentified portraits, and clients for his small-scale, neat oil portraits soon followed.[9] He attracted the patronage and friendship of Constantine Ionides (1775–1852), an émigré Greek shipping merchant for whom Watts became family portraitist, painting five generations over six decades; most of these paintings are now in the Victoria and Albert Museum.

After the death of the portrait painter Thomas Lawrence in 1830 it was widely acknowledged (certainly retrospectively) that the traditions of British portraiture fell to a low ebb, and any artist setting out to paint portraits had few models for guidance. As a young artist, Watts inevitably felt the impact of Lawrence, but he also learned from the study of older art. The British Institution presented exhibitions on Old Master painting and the earlier British school through the 1830s, with displays on Joshua Reynolds (1723–92) in 1833 and Van Dyck in 1834.[10] Still more immediate was the National Gallery, located adjacent to the Royal Academy. The opening of new premises in Trafalgar Square in April 1838 provided an encyclopaedia of portrait images at close quarters at just the time his own work began to mature. Attracted to the elegant individuals and sinuous compositions in Van Dyck's paintings, Watts executed a small watercolour copy of *George Gage with Two Attendants* and scrutinised the portrait of *Cornelis van der Geest*, known as 'Gevartius' (fig. 2), of c.1615–20, one of the most admired and copied paintings in the National Gallery in the 1830s and 1840s. This close-up

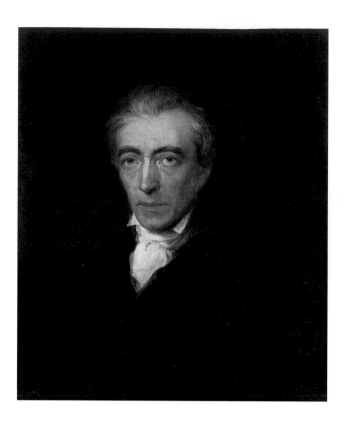

FIG. 1 *George Watts: Father of the Artist*, G.F. Watts, *c.*1835, oil on canvas, 584 x 483mm (23 x 19"). The Watts Gallery, Compton, Surrey

FIG. 2 *Cornelis van der Geest*, known as 'Gevartius', Anthony van Dyck, *c.*1615–20, oil on oak, 375 x 325mm (14¾ x 12¾"). The National Gallery, London (NG 52)

head study had considerable relevance for Watts's portraiture, as he later discussed in detail.[11]

When the Royal Fine Arts Commission announced a competition in April 1842 for the planned decoration of the new Palace of Westminster, Watts entered and won one of the top three prizes.[12] The premium of £300, the most money he had ever seen, impelled him to travel abroad, in particular to study fresco painting. In July 1843 he left England for Italy and would not return for four years.

Italy and the Hollands

Italy opened Watts's eyes to light and colour; away from London, he found personal happiness as a favoured member of the circle of Henry Fox, 4th Baron Holland, Secretary to the Embassy in Florence (1839–46), and his wife Lady Augusta. At the Hollands' Casa Feroni Watts was in the midst of a thriving continental circle of diplomats, aristocrats and writers of all ages. As a favour to his patrons, he painted and drew portraits of their friends, studying their faces as the way into their personalities (nos 9–12), producing more than ten oils and some forty drawings. Previously for Watts portraiture had served as a way to make money. Here friendship entered into the equation. In London, hearing news of the young artist, Haydon despaired, not comprehending why 'that boy Watts' painted portraits: 'he went out as the great student of the day,

though he came out for Art, for High art the first thing the English do is to employ him on Portrait!'[13]

The Uffizi presented many treasures in the Tribuna and in the celebrated gallery of artists' self-portraits (Watts later called it 'the most interesting gallery I know').[14] Self-portraits of English artists such as Lawrence and George Henry Harlow might well have awakened a sense of his own potential. He studied Old Master paintings in Florentine collections. He was aware of more recent developments through artists such as the Paris-based Ary Scheffer[15] visiting Florence and through travelling to Rome, then the base of the Nazarene school. With a new sense of authority based on a searching study of portraiture, Watts adopted a suave continental style for certain sitters. These little-known works, such as his portrait of Carlo Ludovico di Bordone, Grand Duke of Lucca, or indeed the more intimate view of the artist's friend Henry Cottrell (fig. 3; see also no. 14),[16] reveal the confident and fluent manner the young painter had developed by the mid 1840s.

In 1845 Watts travelled to Milan, Perugia, Rome, Pompeii and Naples, and briefly back to London with Lord Holland. With the departure of the Hollands in 1846, he stayed on at the Villa Medici at Careggi outside Florence. By this time he was actively pursuing history painting with several major compositions in hand, including his forthcoming entry to the next competition for the decoration of the

Houses of Parliament.[17] In 1846 a letter to his patron Ionides reveals his dilemma:

> If I had applied myself to portrait painting, I might carry all before me, but it had always been my ambition to tread in the steps of the Old Masters, and to endeavour as far as my poor talents will permit me to emulate their greatness nor has the sight of their great works diminished my ardour. This cannot be done by painting portraits, therefore I forego the present advantage in the hope of acquiring future fame.[18]

At this moment, as his Italian sojourn drew to an end, the artist was fully absorbed with the idea of Greece, Greek sculpture and Phidias. He planned to go back to London only briefly and then return to Italy, but instead he stayed in London.

London *c*.1850: the artist in crisis

By the time Watts returned to England in June 1847, he believed his path would be history painting in the grand style, but the suicide of its great exponent Haydon one year before had irreparably tarnished this ideal. Despite winning one of three first premiums and £500 for *Alfred Inciting the Saxons*, no actual commissions to paint frescoes at Westminster were immediately forthcoming.[19] Watts's absence from England during the mid 1840s lost him some professional ground as Academicians viewed him as an outsider who had strayed from their circle. He then had to rely chiefly on private patrons and on the annual exhibitions to further his career. The portraits he sent to the Royal Academy (fig. 4 and no. 18) in 1848 provoked outright disapproval: the *Athenaeum* reviewer complained that 'such works will not maintain the position or justify the notice assigned to the artist elsewhere'.[20] The *Art Union* went further:

> We naturally inquire why this, a portrait is the only contribution of one of the most famous artists of the age – whose capabilities are of the loftiest order, whose mind is highly accomplished, and in whose power it is to confer honour on the British School of Art? His works exhibited at Westminster all have established his reputation: Why has he made no worthier effort here?[21]

Such remarks placed the artist in an impossible position, adding guilt to his professional confusion. His personal life was not much better, with his low spirits finding artistic form in a group of social realist paintings depicting scenes of misery in modern times.[22]

A closer look at the photographic record of the portrait of *Mary Augusta, Lady Holland* will reveal Watts's attitude to portrait painting at this critical point in his career (fig. 4). Painted over the winter of 1847–8, soon after his arrival back in London, it marked the continuing patronage of the Hollands. In contrast to informal studies of Lady Augusta done in Italy, this work had a public impetus, aimed firstly

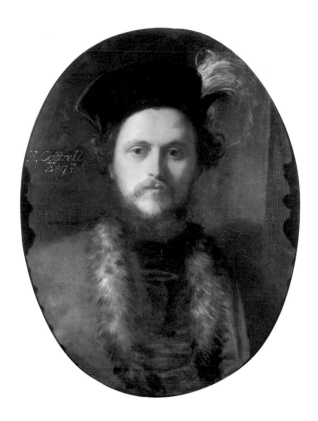

FIG. 3 *Henry Cottrell ('Count' Cottrell)*, G.F. Watts, *c*.1843–5, oil on canvas, 610 x 483mm (24 x 19"). Unlocated

at the Royal Academy and ultimately destined for the great house in Kensington. Fully in the grand manner tradition, the painting also set the artist the challenge of painting the reflection of the sitter in a mirror. Only his second (known) full-length, this work is a deliberate showpiece. It is also a distinctly un-English type of portrait, revealing a familiarity with French portraiture.

Watts was well aware of contemporary French art: in 1843 he briefly passed through Paris, staying with Edward Armitage, a fellow premium winner, who had joined Paul Delaroche's atelier. The example of J.A.D. Ingres (1780–1867) was more relevant since he was celebrated as a subject painter as well as a portraitist in oils and on paper.[23] Exhibited in 1846, Ingres's *Comtesse d'Haussonville* (fig. 5) shows a three-quarter-length figure seen before a grand mirror above the dressed chimney-piece, with an arrangement of *objets d'art* and other accessories.[24] The distinctive pose presents the young Comtesse in two views, frontally and from the back in an artfully rendered reflection in the mirror.

It is quite conceivable that Watts knew this painting, especially given the wide social contacts of the Hollands and their own travel.[25] Perhaps Lady Augusta, as a frequent visitor to Paris, cited it as a model for her own portrait. The cosmopolitan Hollands, like many of their diplomatic friends, had a strong affinity with French culture. Their long-standing ties with France dated back to the 3rd Lord Holland and his

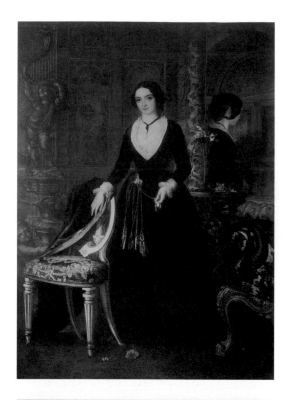

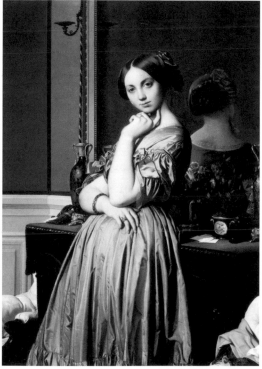

FIG. 4 *Mary Augusta, Lady Holland*, G.F. Watts, 1847–8, from a photograph at The Watts Gallery, Compton, Surrey. Original destroyed: oil on canvas, 2159 x 1550 mm (85 x 61")

FIG. 5 *Comtesse d'Haussonville*, Jean-Auguste-Dominique Ingres, 1845, oil on canvas, 1318 x 920mm (51⅞ x 36⅓"). The Frick Collection, New York

wife who had met and supported Napoleon even when he was in exile. The next generation maintained ties with the Bonapartes. Though in Italy for some years, Lord Holland and Lady Augusta travelled regularly to Paris where they occasionally resided and collected French decorative art and furniture. Watts's portrait alludes to these interests, as Lady Augusta stands in a grand ornate interior, identifiable as the Gilt Room at Holland House, where a taste for French furniture can be discerned. The mirrored reflection to the right opens out the portrait from the somewhat claustrophobic interior space giving an oblique, more indirect and personal representation of a sitter well known to the artist.

To its first audience, at the Royal Academy in 1848, this portrait seemed disturbingly Francophile. A comparably ambitious work, a double portrait of *Ladies Mary and Adeliza Howard* (Arundel Castle) by Francis Grant (1803–78) exhibited the same year,[26] fits comfortably within English portrait traditions by emphasising naturalness in the outdoor setting and the landscape rolling down to the sea. In portraiture English critics were suspicious of too much artifice, which they associated with French art in the Neoclassical tradition.[27] Watts had ventured out with a type of portrait alien to English sensibilities. In addition to his one Francophile portrait, he also showed a portrait of a Frenchman at the Academy (the portrait of Guizot, no. 18, which was apparently 'skied', i.e. hung very high), but no major subject paintings, despite being a recent winner for his history painting in the Houses of Parliament competitions.

After this career crossroads Watts dramatically revamped his style in a more classically restrained mode. He concentrated on simple forms set against a plain background, akin to murals and frescoes, seeing this as more purely 'Phidian' (i.e. like the Greek sculptor Phidias) in conception. While using Dorchester House as a studio for large paintings,[28] Watts became friends with John Ruskin, who wrote in 1849 that Watts was 'to my mind the only real painter of history or thought we have in England'.[29] He patronised Watts briefly, buying one work, borrowing another and commissioning a portrait drawing of his young wife Effie. Soon, however, Ruskin's interests turned to the Pre-Raphaelites, veering away from Watts, who could not acquire an enthusiasm for botany.[30]

Still dependent upon his close patrons, the Hollands, and their extended circle, along with the Ionides and Duff Gordons, Watts carried out work mainly in the form of portrait drawings, initially pencil studies, until he graduated to more impressive large works, executed in soft chalks. Through the constant exercise of portrait drawing, the artist developed his abilities to a high level. Such works were highly sought after, though only a small percentage made it to the exhibition rooms after 1850. His own self-portrait in this medium is like a window on his soul, revealing his uncertainty at this confusing stage in his life (fig. 6).

Life in the Hollands' circle gave the artist an entrée into the world of literary lions and politicians. In the early nineteenth century the wife of the 3rd Baron Holland (and mother of Watts's friend Henry Fox)

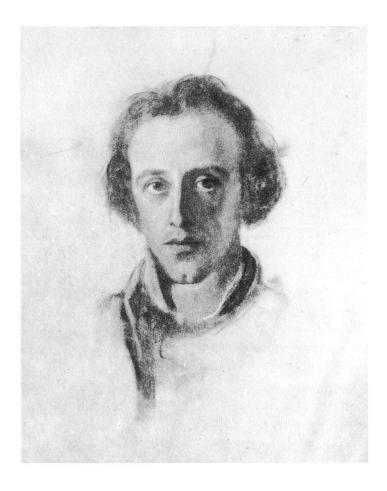

FIG. 6 *Self-Portrait*, G.F. Watts, *c*.1848–50, photograph of lost drawing. National Portrait Gallery, London (NPG RN857/9)

presided over a noted Whig salon. The formidable dowager Lady Holland died in 1845; her son then took over the great house in Kensington. In the renovations Holland House gained a ballroom, making it fit for entertaining royalty. Watts played the role of artist to the family, further contributing to the improvements by painting mural panels in the Gilt Room and executing one Italianate mural on a ceiling. Most importantly, here Watts rubbed shoulders with men such as Guizot and Lord John Russell, whom he painted in an intimate oil study (*c*.1851; NPG) at about this time. Such works prompted Watts to think in terms of documenting great men of the day. The roots of his so-called 'Hall of Fame' date from these years.

Watts had a rocky relationship with the Royal Academy, especially after 1850 with the poor hanging of *The Good Samaritan* (City Art Gallery, Manchester). When the hanging committee placed this much valued painting, commemorating the philanthropic work of Thomas Wright,[31] 'out of sight', Watts rejected the Academy as a destination for his important paintings. For a few years he sent only portrait drawings (and one oil); then after 1852 he withdrew completely for six years.

Arrival at Little Holland House

To the exhibition of 1850 Watts also sent a full-length portrait in his new classically inspired style: *Miss Virginia Pattle* (no. 21). As a depiction of his new-found friend, this painting summed up recent events in his life. In his studio on Charles Street off Berkeley Square in Mayfair the artist had encountered an unusual beauty. Virginia, one of seven sisters, recently arrived from India, had made a visual impression first, but the artist came to adore her as an ideal, and her family became his own by unofficial adoption. The artist had sought an introduction to Virginia, who lived with one of her elder sisters, Sara Prinsep, and her husband Thoby, a retired East India Company official and member of the Indian Council. In London the unconventional Pattles dressed in flowing robes, wore their hair in simple styles and adorned themselves with Indian jewellery; they often spoke Hindustani among themselves (indeed it has recently been shown that they were of Indian descent[32]). Watts also painted a double full-length of Sara and her sister Sophia Dalrymple in his radically simplified and fresco-like style (fig. 7), as well as a portrait of Julia Margaret Cameron (*c*.1850–52; NPG), yet another sister.

Watts grew infatuated with Virginia, but she entered society with a view to marriage. When she married Lord Eastnor (later Earl Somers) in October 1850, Watts sank into despondency, beset by headaches. A friend described him at this time as 'a remarkable man, and a very mournful one inwardly'.[33] But Sara Prinsep tended his health and spirits, and her sister Sophia dubbed him 'Signor', a name he adored for its romantic, Italianate, Renaissance associations and one that he decreed might only be used by his most intimate friends. He then aided the Prinseps by persuading the Hollands to grant them a twenty-one-year lease on a new home in Kensington. At the end of 1850 the Prinseps took possession of the dower house on the Holland estate; thereafter Little Holland House became Watts's home as well, providing an extended family and a cosseted existence at the centre of a female-dominated household.[34] Sara Prinsep's literary and artistic salon provided endless stimulation for the artist and a ready supply of models. Thanks to his personal involvement in this circle, portraiture became embedded in his art, rather than an exercise to fulfil a commission. His full-length portraits of the sisters (fig. 7, for example) were not exhibited at this time but were widely seen at Little Holland House,[35] presenting a contrast, in the words of the Pre-Raphaelite painter William Holman Hunt (1827–1910), to 'the existing age of vulgar portraiture'.[36]

Ambitions and friendships in the early 1850s

Much of Watts's future career as an artist who flourished outside the confines of the Royal Academy was established at this stage. Portraiture, particularly many portrait drawings, financed the time he devoted to more ambitious mural projects. He valued the public dimension and didactic possibilities of mural work, and this more serious approach to his art also had an impact on his portraits.

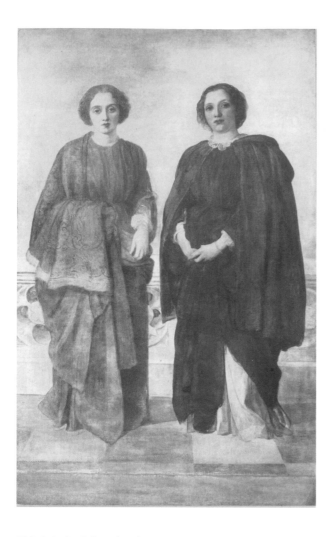

FIG. 7 *Sophia Dalrymple and Sara Prinsep*, G.F. Watts, *c*.1850–51, oil on canvas, 2362 x 1448mm (93 x 57"). From an early photograph, The Watts Gallery, Compton, Surrey

Watts maintained social contacts in London's intellectual, political, artistic and literary worlds as a member of the newly formed Cosmopolitan Club (discussed more fully in the following essay), which from 1852 met in his former studio in Charles Street. Here he forged lasting friendships with the artists Henry Wyndham Phillips (no. 25)[37] and Holman Hunt, archaeologist Austen Henry Layard (no. 23), architect P.C. Hardwick, Chichester Fortescue MP and, most important of all, Tom Taylor, a true Victorian polymath – ex-academic, ex-lawyer, civil servant by day, journalist, prolific playwright, art critic, art historian and friend of artists. Taylor proved to be an art-historical mentor to Watts, asking him to contribute to his life of Haydon, published in 1853, on the strength of Watts's already recognised position as an 'eloquent advocate of the claims of High Art'.[38] The two men visited collections containing Haydon's paintings, to assess them in the original. Later Taylor, along with C.R. Leslie, worked towards a definitive volume on the works of Sir Joshua Reynolds.[39] At this time, encouraged by the

activities of his friends, Watts himself rethought the uses of portraiture so that it began to enter into his work in unexpected ways.

In 1852 Watts's proposal to decorate a massive wall in the Great Hall at Lincoln's Inn with a fresco met with approval through the good offices of his friend Hardwick. Watts conceived the scheme of *Justice: A Hemicycle of Lawgivers*,[40] depicting legal figures through the ages in a personalised history of the subject from antiquity onwards. Historical research into what Solon or Alexander looked like was never his purpose; instead he gave *Justice* a distinctly modern slant by using his own friends,[41] many quite easily identified, as models for the historical characters.[42] This exercise (mostly dating from 1854, although the mural itself did not see completion until 1859) further expanded Watts's sense of the potential of portraiture.

Travels: Italy in 1853 and Paris in 1855–6

Two European trips in the mid 1850s had a direct influence on Watts's portraiture: the first, to Italy, brought about a reinvigorated interest in colour and the second, to Paris, stimulated a reassessment of his portrait activity. Although he never resided in Italy again, in 1853 Watts travelled there for a month-long autumn tour, which included his first visit to Venice.[43] In company with his young student, John Roddam Spencer Stanhope and Sara Prinsep's son, Henry, Watts travelled via Paris and Marseilles, briefly visiting Genoa, Leghorn, Pisa, Florence, Bologna, Padua and finally Venice. His fragmentary letter to Ruskin encapsulated the experience: 'I have been to Venice: you are right.' The 'glowing and gorgeous'[44] colour in original works by Titian and Giorgione made a powerful impact, as did the light-suffused colours and textures of the world beyond art. He closely studied earlier Italian art, a preoccupation of friends such as Coutts Lindsay and Robert Holford, when he examined works by Giotto in Padua and was 'attracted to Orcagna'.[45] Watts, now in his late thirties, had an entirely more informed and focused attitude to what he sought in the art of the past.

Something that has never come under discussion in relation to Watts's portraiture is his own acquisition of a late sixteenth-century full-length Florentine portrait then attributed to Pontormo, which he presented to the National Gallery in 1861 (fig. 8).[46] This impressive study of a black-robed figure appealed to Watts on several levels since it echoed his own recent efforts at full-length portraits. As a work on panel (like other Florentine portraits), it may have suggested to Watts that this wooden support would allow him to achieve the same kind of precise detail required for such an elaborate performance. In depicting an individual with links to the Medici, Watts was reminded of his own earlier experiences in Florence. But mainly this work was an example of a grand full-length, orchestrated with a rich panoply of scholarly accessories in the form of books, *objets d'art* and furniture. It portrayed an individual whose sensitively characterised face and restrained gesture convey a deeply felt dignity.

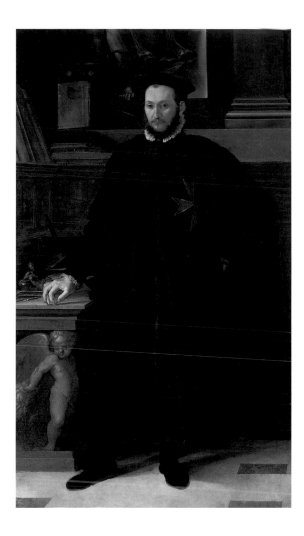

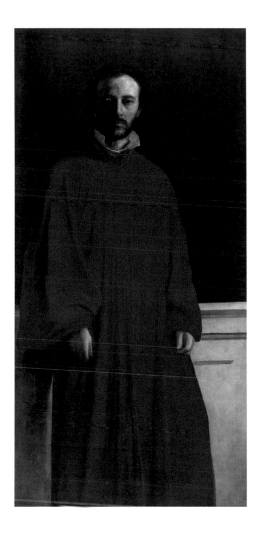

FIG. 8 *A Knight of St Stephen*, Florentine School, 16th century,
oil on wood, 2096 x 1213mm (82¼ x 47¾"). The National Gallery,
London (NG 670)

FIG. 9 *Self-Portrait ('the Venetian Senator')*, G.F. Watts,
c.1853, oil on canvas, 1549 x 749mm (61 x 29½").
Private collection, courtesy of Nevill Keating Pictures Ltd

Watts himself increasingly sought such qualities in his portraits, and this painting in his studio was an indication of his allegiances and capabilities: as a talisman and inspiration, it entered into Watts's domain. What better way to appeal to the connoisseurs and collectors in his social sphere? It seems very likely that he found the painting not while in Florence with the Hollands but during the trip of 1853 as a mature artist with established interests and the additional advice of knowledgeable friends such as Layard.[47] Indeed, Watts's own *Self-Portrait* of c.1853 (fig. 9), executed after the trip and dubbed 'the Venetian Senator', seems to convey in the quiet dignity of his bearing and in the bold use of red the combined lessons of his second trip to Italy.[48]

Watts travelled to Paris late in 1855 probably at the behest of the Hollands, for whom he painted Princess Lieven (no. 27), historian Adolphe Thiers and Prince Jérôme Bonaparte (no. 26). His visit may well have coincided with the final weeks of the Exposition Universelle, in which much British art featured. Here abundant opportunity existed to

investigate contemporary French art with the one-man displays accorded to Ingres and Delacroix and the unofficial Pavillon du Réalisme of Gustave Courbet. Although Watts did not appear in this mass exhibition, it was a landmark for the appreciation of British art abroad, especially of works by the Pre-Raphaelites, and a rare chance to see a summary of current trends. In sittings with Jérôme Bonaparte, whose son was president of the Exposition, Watts would have had access to unrivalled inside information about art in Paris.

Watts worked in a studio on the Rue des Saints Pères, said to be in the same building as that of Nathaniel Hone (1821–1917), the Irish artist who studied with Thomas Couture (1815–79) and lived partly at Barbizon, and with whom he discussed the contemporary art scene. Watts spent time with the Hollands on the Rue du Faubourg Saint Honoré; the portraits he produced reveal an advance on the simple classicising mode of *Virginia Pattle*. Instead, inspired by the paintings of Ingres and followers such as Flandrin, he revised his style in accordance

with the sitters and destination of his works for the Francophile Hollands. In *Princess Lieven* and *Prince Jérôme Bonaparte* the artist discovered the advantages of the three-quarter-length format, hitherto rarely used by him, but characteristic of Ingres, for its scope to elaborate the setting and produce careful detailing. The months Watts spent in Paris occurred at an important juncture. He sought further instruction by studying Old Masters in the Louvre and drawing small studies of a range of portraits, especially those by Van Dyck and Rembrandt (fig. 10). Although on his return he was preoccupied with various mural projects and further travel, in the late 1850s the artist re-evaluated his portrait output and with renewed confidence ventured into yet more complex works in this genre.

Watts's 'worthies'

In the early 1850s the formation of a new national portrait gallery came under discussion in the press and at large, and the idea finally came to fruition in 1856. For Watts the notion of painting great men of the

FIG. 10 Copies after paintings in the Louvre, G.F. Watts, *c.*1855–6, watercolour on paper, mounted on album sheet, 254 x 178mm (10 x 7"). © Sotheby's, London

past for his mural *Justice* dovetailed neatly with his growing plan to depict worthy individuals of his own day for his own collection, without being commissioned. His contact with increasingly wide circles of patrons helped the idea to germinate, as did some important examples in older art such as Renaissance collections of illustrious men. There were also contemporary precedents such as Robert Peel's well-known gallery at his home, Drayton Manor, Staffordshire, which included political, literary and scientific individuals.[49] As soon as Watts arrived back from Italy, Peel's collection was in the news, with part of it on view in London.[50] A more immediate example was the noteworthy group of oil portraits and busts of writers that adorned the library at Holland House, the residence of Watts's patrons, as seen in C.R. Leslie's *The Library at Holland House* (1838; private collection).

Watts's own collection of eminent individuals grew during the 1850s,[51] particularly with his portrayals of Lord Lawrence and Tennyson (from 1857). He certainly recognised it as having the shape of a collection by 1858 when he wrote to accept the commission from John Murray for the portrait of Gladstone. He emphasised that he intended to paint

> portraits of individuals whose names will be connected with the future history of the age. I have already begun a collection on my own account & really seize upon every opportunity of enlarging it, but, as the principle I have adopted with a view to their future value as historical records is, that such portraits should be as inartificial & true as possible.[52]

This self-conscious gesture towards aggrandising a professional branch of art is thoroughly characteristic of the artist's sense of high purpose and a way to make this kind of work more meaningful. By mid 1861 he had announced to his friends in the press that he intended to leave the collection to the nation at his death.[53] The painter J.M.W. Turner's recent bequest in 1856, following his own death in 1851, provided a powerful precedent.

For Watts this venture opened up a wide avenue of work. The standard portrait size meant an intense concentration on the head, keeping the portrait 'as true as possible'. The artist delved into the mind of each sitter, by giving a particular focus to the eyes. He sought lessons from older art, especially Van Dyck's head study of Gevartius (see fig. 2). Here in the intensely wrought face, he considered the eyes 'miracles of drawing and painting which no one could for a moment think of fitting into any other head'.[54] Watts's skills, honed from exercise in the large, chalk, portrait drawings, enabled him to produce a series of works that paralleled other aspects of his output. These portraits mostly conformed to a reduced format quite distinct from much of his privately commissioned portraits. In addition, of course, most of them portrayed men, whereas the other side of his output was predominantly of women. A natural division in his portrait work resulted, but he was no less ambitious in making his commissioned portraiture more worthy as art.

Decisions and exhibitions in the late 1850s

Watts had a public profile and reputation by the mid 1850s. The first account of him as an artist, which appeared in a biographical dictionary in 1856, commented on his portraits as 'displaying peculiar effects', adding that there was 'much indulgence in *experiment*' in his work.[55] The writer based his judgement on Academy submissions such as *Virginia Pattle* and the equally simplified full-length of the poet, Henry Taylor (RA 1852; unlocated). Yet the author also ventured a personal comment that 'failing health, failing self-confidence, and the still more serious lack of adequate stimulus to exertion … have almost withdrawn him from the healthy work-day arena of professional competition'.[56] Watts's continuing ill health prompted a trip to Asia Minor with his archaeologist friend Charles Newton from October 1856 to June 1857. Enjoying the mild climate, sailing the Mediterranean and participating in the adventure of an excavation that revealed major discoveries at Halicarnassus, he gained a fresh outlook as he turned forty.

Continuing his life at Little Holland House enabled Watts to concentrate his portrait activity on friends and members of the extended circle of the Prinseps. Sara Prinsep presided over an informal salon, embracing Tennyson, the Pre-Raphaelites, theatrical personalities such as Adelaide Ristori, and the more bohemian members of the aristocracy. During this time, as the people Watts met became more interesting, so too did the portraits he painted and drew. Most of these works he painted by choice, such as the first two portraits of Tennyson (see no. 34) and the members of the Nassau Senior family (nos 31, 32). While these portraits progressed, Watts made a career decision as a way to increase his income and also increase his satisfaction with portraiture. As he explained to his friend and patron Alexander Ionides in February 1858.

> I am going to devote a certain portion of each year to portrait painting, very carefully and honestly. I shall take enormous pains and endeavour to produce pictures that shall be valuable in all times both as faithful records and as works of art and as I intend them to be elaborate performances, I intend to ask and hope to get a large price.[57]

The portrait of Jeanie Nassau Senior, one of Watts's best-known works, glows with jewel-like colour and provides an intensely personal view of a close friend and confidante. Formal in its full-length format, yet informal in the casual view of the subject, this work is highly elaborated in a calculated way, using the lessons of contemporary French portraiture. The companion work of Mrs Nassau Senior's sister-in-law, Mary (Minnie) Senior, looks to a contrasting model, that of eighteenth-century English portraiture, with the full-length figure out of doors, as if the artist was demonstrating his range of approaches.

Watts seems to have considered these two portraits an informal pair. With them, he decided at the urging of his friends to re-enter the arena of the Royal Academy's annual exhibition, which he had forsaken since 1852. Renewed confidence and a sense of professional pride made the move essential, but he hesitated from a full disclosure and instead sent these two works and another to the Academy in 1858 under the name F.W. George. The ruse fooled no one (one critic noted 'assumed name, really the works of Mr. Watts'),[58] but it emphasised his suspicions towards the institution. The portraits made a splash with Watts's art-reviewing friends, who articulated what was distinctive about his work in the context of portraiture in the mid 1850s. Tom Taylor wrote in *The Times*:

> Some may complain that these are rather pictures than portraits, that the accessories in both are painted up to a point which threatens the supremacy of the heads; but we cannot say that we feel this … the three pictures together place Mr. Watts at once in the first rank among the women-painters of the day, besides indicating qualities which, if ever they find their full expression in portrait painting will permanently elevate and influence that branch of art in this country.[59]

Critics recognised immediately that Watts had made a break with traditional types as practised in the 1850s, presumably thinking of Francis Grant. William Michael Rossetti put it more simply, writing that in his portraits Watts 'sets plain life to music'.[60] This new type of portraiture opened up a range of possibilities and attracted a new clientele of individuals involved in the arts as well as youthful sitters whose beauty inspired yet more innovations. The following essay looks more closely at the circumstances in which Watts developed his new portraiture types and the clients for them.

When Watts painted the portraits of the Senior family, as they were part of the Little Holland House circle, informal arrangements prevailed. However with commissions he was very specific about his new aims. To his friend George Cavendish Bentinck, a connoisseur and member of the Cosmopolitan Club,[61] he wrote as an overture to accepting a commission (for no. 33):

> I do not like to begin the picture of your children without distinctly calling your attention to what I told you, viz, that I intend to ask a large price for my portraits. I shall not expect them to be taken unless approved of as likenesses & etc but I shall paint them with extreme care & endeavour to make them valuable as works of art & they must pay for those things that cannot pay & which I undertake in the interests of Art.[62]

The new approach to portraits was summed up in the phrase 'valuable as works of art'. He then remarked on his prices:

> I shall find out what Grant & other painters of reputation charge, & adopt their terms, at present, & if I succeed in making the improvement I hope to

make I shall raise my price as rapidly as prudence will permit, desiring rather to paint a few pictures well, than many carelessly.[63]

In the same spirit he wrote about a potential commission in 1859:

I suppose you know that I have raised my price for heads. Its now 100 guin. I intend to paint very few portraits taking immense pains & hoping to make them valuable pictures independent of likeness, but I shall paint very few & only subjects favourable to my object of making first rank pictures – I don't mean only beautiful people, they are not invariably best for pictures.[64]

As such 'valuable pictures' would be more ambitious, Watts cultivated commissions for full-lengths, which depended on a higher level of care; for such works he charged 300 guineas. He created more complex settings, included inventive details and indulged in colour, as had proven successful in the portraits of the Seniors. Further, this enhanced treatment justified his view that such works should aspire to the level of Old Master painting and be taken as seriously. Lastly, of course, his own professional integrity was at stake. As a 'painter of reputation' he could expect to charge a rate commensurate with Grant. At this stage in the late 1850s, thanks to the success of his recent paintings and the positive critical reaction to the exhibitions of 1858 and 1859, portraiture now occupied an enhanced position in his thinking as an artist.

The 1860s: professional standing for an unprofessional portraitist

With this renewed aim of creating portraits that were 'valuable as works of art', Watts produced a group of works that are at the heart of this study (nos 36–9). He was now a professional with an increased stature in the London art world; his success in the late 1850s resulted in new commissions for large-format portraits around 1860.[65] Despite an increased workload, he still often behaved in a distinctly non-professional manner. He carried on with an earlier habit, noted in letters, of allowing his clients to refuse finished works. Watts stipulated this on accepting a commission: 'remember whatever I do for you is upon condition that you take only what is perfectly satisfactory to you'.[66] To Cavendish Bentinck he noted 'if the picture is back & you do not like it, of course you will not take it at all'.[67] This meant that he was prepared to keep any returned work, which did not seem to bother him at all because such works had a value to him beyond portraiture. Indeed, as he painted increasingly elaborate portraits, they took on the virtues of subject paintings. Watts could easily add any rejected work to his own personal collection to hang in the studio or be sold separately.

Watts often dithered over prices. To John Murray he wrote in 1862 that his price for heads 'has been for a long time 100 guins but as I really cannot be sure it was so when I commenced the picture, & as I look upon you as a professional man, I will say 80 guins'.[68] To a close friend he was more forthcoming about prices, as when writing to Layard he

noted: 'My price for an oil head is 100 guins a long price I own, & indeed I am rather ashamed of asking so much but I have been in some degree influenced by the practice of my brother artists, & also by the necessity of paying my bills!'[69]

Despite often loose arrangements, Watts flourished as a portraitist and much of his reputation from the late 1850s onwards rested upon such work. In 1860 he did, however, decide to cease producing the beautiful highly finished chalk portrait heads that had formed such an outstanding feature of his private output during the previous decade (no. 23). Even to Layard he demurred:

I have lately given up making drawings, as I have become very fastidious & find that a drawing takes as long as a painting very often, & of course does not go so far though in reality it may be a better thing it has not much importance. So I would rather try how far I can carry a more perfect material.[70]

For portraits, the 'more perfect material' of oil painting allowed impressive, large-scale full-lengths, with abundant detailing, destined for the wider exhibition audiences of the Royal Academy. In addition, he responded to the demands of his grander clients, who required portraits befitting their position in society.

The public dimension to Watts's work increased with his representation at the International Exhibition of 1862 with four paintings including three portraits – Alfred Tennyson (National Gallery of Victoria, Melbourne) and Sir John Lawrence (NPG) from his own collection and another private work – underscoring his current reputation as a portrait painter first and foremost.[71] By this time he had announced that his collection of portraits of eminent men would go to the nation and was actively recruiting sitters, as in January 1861 when he wrote to Julia Margaret Cameron: 'I wonder whether you could induce Professor Owen to do the like and whether you know Faraday ... I desire greatly to paint some of my worthies.'[72]

The crucial recognition of Watts's public role regarding portraiture occurred by 1865 when he joined the Committee of Advice for the Special Exhibitions of National Portraits; these exhibitions were planned to take place between 1866 and 1868 at the South Kensington Museum. The committee, headed by the Earl of Derby, contained representatives from the political and artistic worlds, including the artists Charles Eastlake (President of the Royal Academy, who died shortly after), Francis Grant (soon to be elected successor to Eastlake), Richard Redgrave (Surveyor of the Queen's Pictures), George Richmond and Watts. The committee comprised far greater numbers of the connoisseurs and collectors whom Watts knew well, individuals such as Robert Holford, Layard, Henry Danby Seymour, as well as the ubiquitous Tom Taylor. These special exhibitions surveyed the complete history of portraiture in Britain from Tudor to modern times; the extremely full catalogues set a standard and

familiarised a wide public (including artists themselves) with their own portrait history.[73]

The sheer scale of these exhibitions was immense, with upwards of 900 items in each one. The first show in 1866 probably came as the greatest revelation with rare early British works seen in quantity for the first time. Great collectors, many of them Watts's personal friends, advanced their treasures (probably with his encouragement); Richard Cheney and Holford sent works by Van Dyck and his friend Lord Lothian lent rarely seen works by Hans Holbein and Antonio Mor. At the second exhibition, in 1867, the eighteenth century was particularly well represented with major works by Reynolds lent by Lady Holland and Lord Lansdowne from Bowood and Lansdowne House.[74] And in the final show, in 1868, the modern pictures included eight portraits by Watts, one drawing and seven oils,[75] including his great full-length of Lord Campbell (no. 36), establishing him as the 'painter of reputation' he had wished to be ten years before. These images all showed men, underlining that since 1861 he was known to be forming his own collection of portraits of eminent men, his 'worthies'. He himself must have wished to present this side of his output to attract suitable sitters to his scheme. This last exhibition further emphasised the continuities in British portrait painting; it provided a visual demonstration of the place of Watts and his colleagues within a great tradition. As noted in the Art Journal: 'There has never been so favourable an opportunity afforded for the study of portrait-painting, either as an art or as an accessory to history.'[76]

Through his role on the National Portrait Exhibitions committee of 1866, 1867 and 1868, an increasingly public profile, and election as a Royal Academician in 1867, Watts found he was almost too sought after as a painter of portraits. His successes of the late 1850s and early 1860s commanded attention, but he resisted many overtures, even from friends such as Lady Ashburton to whom he wrote in 1862:

I am shocked to find how much of my time has been spent in painting portraits. I must give my thoughts and time to certain subject pictures I have promised myself to paint. It is not as portrait painter I would be known. I know that without constant exercise in the more abstract branches of his profession an Artist will never produce truly great portraits.[77]

The mixed message here did underline the important idea that Watts brought to portrait painting the sensibilities of a much more ambitious artist, one whose subject paintings ranged from invented allegories, such as Time and Oblivion (c.1848; Eastnor Castle), through romantic poetic subjects, such as Paolo and Francesca (version of 1848; private collection), to major mural compositions. In much the same way as Old Master artists operated, Watts wanted to be seen not primarily as a portraitist. Later he commented: 'I have said that I am a portrait painter but incidentally, meaning that I never regarded the practice as other than a means of study.'[78] Nevertheless, his reputation centred on a class

of portraits well removed from those by professional portraitists.

By the later 1860s Watts turned down more portrait commissions than he accepted largely because by this time he had found more purchasers for his subject paintings, chief among them Charles Rickards, a manufacturer from Manchester.[79] By 1866 he insisted 'I have positively given up portraiture as a regular practice. The difficulty of satisfying myself at all & my anxiety to please my clients being a great deal too much for me'.[80] In 1869 he wrote to his good friend and collector Henry Bruce (later Lord Aberdare):

I lose money painting portraits; in the time it takes me to paint a portrait I could paint several subject pictures for each of which I could get more money. I am not a good painter [of portraits], I know you will point to a certain amount of success, but if you knew what toil, anxiety & positive pain that success represents you would feel it in no degree commensurable, & you would understand. For the last year I have been besieged with applications to paint portraits, & have declined all, and mean to decline all, for they make me miserable & keep me poor.[81]

By 1870 the general view was that 'he had given up painting any but those he invited to sit to him'.[82] From now on the emphasis shifted for Watts. Although he did continue to paint portraits, subject painting became his priority again. The immediate effect of such thinking was that he carried out few full-lengths after this point: Madeline Wyndham (no. 54), which he had already begun; The Ulster, depicting May Prinsep (1874; Manchester City Art Gallery); and a failed portrait of the Prince of Wales. Otherwise, he engaged in bouts of portrait work, sometimes quite routine, as in the early 1870s when he had to meet the extra expenses of building his house, The Briary, on the Isle of Wight. The best of these portraits still displayed the lessons of earlier studies; indeed, there is a new confidence about such works, in keeping with his increasing professional position.

Later reputation

The first exhibition at the Grosvenor Gallery in 1877 ushered in a new phase in the appreciation of Watts's works.[83] Thanks to the initiative of his friends Sir Coutts and Lady Lindsay, this new exhibition venue responded to the needs of artists like Watts and Edward Burne-Jones (1833–98), who had not found complete satisfaction at the Royal Academy. Both artists triumphed at the Grosvenor Gallery when Watts's first large-scale 'symbolical' painting, Love and Death (Whitworth Art Gallery, Manchester), was unveiled for the first time. Watts showed four paintings that year. The other three were portraits: Madeline Wyndham (no. 54), Blanche, Lady Lindsay (no. 55) and Edward Burne-Jones (Birmingham City Art Gallery). Such a showing emphasised the extent to which he himself and the Lindsays (who participated in selecting the exhibition) valued Watts's portraits as a demonstration of his

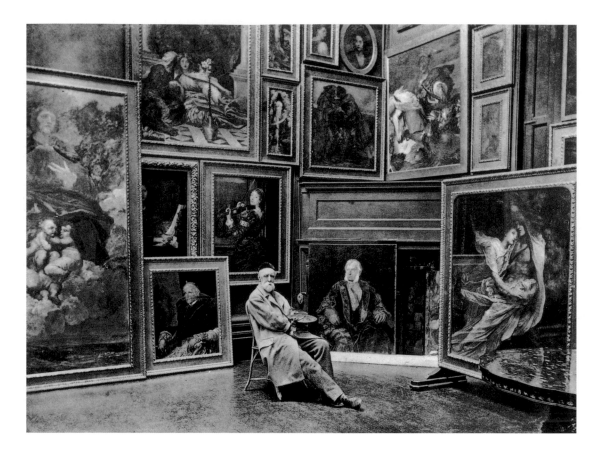

FIG. 11 *G.F. Watts in his Gallery*, photogravure by J.J.E. Mayall, 1884, from album 141 'Artists at Home', 1884, p. 49, 166 x 220mm (6½ x 8⅞"). National Portrait Gallery, London (NPG 27825)

best work. In addition, they were integral to the ethos of the Grosvenor, focused as it was on the primacy of the artist as the creator of beautiful works of art.[84] For almost every year that Watts exhibited there he sent one or two portraits, often more, to represent works from his own collection or new material.[85] He continued to do the same at the Royal Academy where he had been sending portraits almost exclusively since the early 1870s.

From 1877 onwards Watts's reputation had international reach. Now he had many more opportunities to paint the type of pictures he desired, and, more importantly, the audience for such works had expanded beyond the confines of a small circle of admirers. The paintings that he exhibited in Paris, beginning with the Exposition Universelle in 1878, opened the eyes of continental critics and artists to the Symbolist nature of his visual language and subject matter.[86] The portraits formed a key part of Watts's artistic persona, and he assiduously sent them to represent his best work, for example, in Paris in 1878 when he showed the magnificent *Madeline Wyndham* (no. 54), along with *General Lawrence*, *Philip Calderon, R.A.*, *Robert Browning* (all NPG), *The Duke of Cleveland* (location unknown) and *A Lamplight Study: Herr Joachim* (see fig. 19). Further continental exhibitions that included Watts's

portraits followed in Munich in 1879 and in Florence in 1881. In 1883 he saw the virtue of sending the portrait of the poet Algernon Swinburne to the Galerie Georges Petit along with other works, such as *Paolo and Francesca* (Watts Gallery), which were calculated to appeal to the interests of writers and artists in Symbolist circles in Paris. His representation in France culminated with two portraits at the Salon in 1889, *Constantine Ionides* (V&A) and *Frederic Leighton* (RA).

From 1880 onwards Watts's work enjoyed huge exposure. He enlarged his studio premises on Melbury Road to create an exhibition space, known as 'The Little Holland House Gallery'. His collection, comprising the portraits he had amassed since the early 1850s, went on view to the public on weekend afternoons (fig. 11). At the end of December 1881 a remarkable one-man retrospective exhibition, the first of its kind,[87] devoted to 'the greatest of our Royal Academicians',[88] opened at the Grosvenor Gallery. With this survey of his work up to the age of sixty-four, his entire career came into focus for the first time. *The Times*'s critic, Harry Quilter, astutely observed that one could walk through the galleries noticing 'the nineteenth-century atmosphere of unrest, questioning, and uncertainty'. Such qualities could also be discerned in many of the sixty portraits on show, as 'Mr. Watts has

given the look of a man more or less perplexed, if not saddened, by the enigmas of life'.[89] Quilter concluded that it would be the portraits 'upon which, according to the common criticism, Mr. Watts's future fame will chiefly rest'.[90]

In 1880 Watts published his own assessment of the climate in which he worked when his essay 'The Present Conditions of Art' appeared in the journal *Nineteenth Century*. Here he set out his belief that 'it is art that corresponds to the highest literature, both in intention and effect, which must be demanded of our artists, poems painted on canvas, judged and criticized as are the poems written on paper'.[91] Such a view of art extended even to his portraits, certainly as they were judged by contemporary critics. Marion Harry Spielmann, who produced a catalogue of Watts's work in 1886,[92] spent sustained periods of time talking to the artist and paid regular visits to his studio.[93] In 1886 he evaluated Watts's position:

> His first aim is rather, while obtaining absolute resemblance of feature and expression, to indicate the man's character, his habit of thought, his disposition, his very walk of life, as they showed themselves upon his face as he sat alone … by thus truly making the face the window of the mind, beyond what any other artist has attempted before, he has not only led to a reformation of portrait-painting in England, but he has rejuvenized what was in this country a sadly declining branch of pictorial art.[94]

Spielmann's broad assessment of Watts's position as a catalyst for the improved state of British portrait painting harks back to his work of the 1850s and 1860s which broke so emphatically with current trends. By the later 1880s his more restrained approach to portrait commissions meant that he did not hold the premier position enjoyed by John Everett Millais (who was able to charge £1000 for his larger format portraits[95]) and to a lesser degree Frank Holl or William Ouless. Watts was unusually selective in a way that professional portraitists were not.

Watts's reputation reached a high point in the 1880s both in England, when he refused the first offer of a baronetcy from his old friend Gladstone in 1885, and abroad, when a request came from the Uffizi to paint a self-portrait for their collections (no. 59). He had attained celebrity status in his own right. His public-spirited impulse to give works to national collections was already evident in 1883 when three portraits, *Lord Lyons*, *Lord Stratford de Redcliffe* and *Lord Lyndhurst*, entered the National Portrait Gallery. In 1887 another instalment of his gift to the nation appeared on the walls of the staircase leading to the Art Library at the South Kensington Museum (in the southwest corner of the South Court).[96] Consisting of nine 'symbolical' paintings, including *Love and Death* and *Hope*, this group (evocatively described by the French critic, Robert de la Sizeranne[97]) also contained *Cardinal Manning* and *Tennyson* (both NPG).[98] The sustained visibility of these two portraits in particular conferred on them the iconic status that they still retain today.

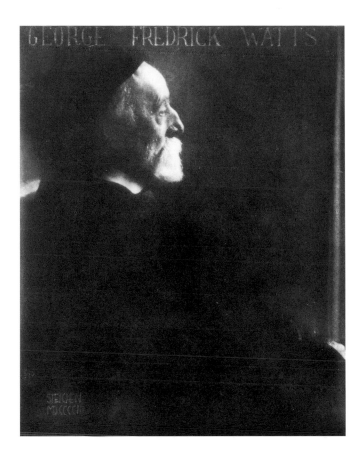

FIG. 12 *G.F. Watts*, Edward Steichen, 1903, photogravure, 210 x 165mm (8¼ x 6½"). National Portrait Gallery, London (NPG P168), Estate of Edward Steichen/Carousel Research Inc.

In December 1895 Watts presented fifteen further oil portraits and two drawings to the National Portrait Gallery in time for its opening in new premises the following year. After the retrospective exhibition of his work held at the New Gallery during the winter of 1896–7, when 155 paintings were shown, commentators could assess his position as an artist and portraitist in contemporary British art. By 1901, while the painter was still alive, G.K. Chesterton could write that Watts 'was destined to raise [portraiture] to a level never before attained in English art, so far as significance and humanity are concerned'.[99] This is a considerable claim but it is one with which many of Chesterton's contemporaries would have concurred. American photographer Edward Steichen sought out Watts to enhance his own collection of 'immortals' at just this time (fig. 12). Indeed, in 1902, when King Edward VII instituted the Order of Merit, Watts became its first artist recipient and the only one in the original group of twelve.[100] This unprecedented accolade, unlike more conventional honours, celebrated intellectual achievement and as such it chimed with Watts's own sense of his career's accomplishments, allowing him to savour the distinction it conferred at the opening of the new century.

NOTES

The discussions in the essays are based on my unpublished work on Watts's career in the context of developments in British art from 1830 to 1865, originally undertaken at Columbia University, New York, and continued since then.

1 Watts also exhibited portraits at the Dudley Gallery, the French Gallery, the Grosvenor Gallery, the Royal Society of Portrait Painters, the New Gallery, the Pastel Society, the Paris salon, the Galerie Georges Petit in Paris and at various international loan exhibitions, as well as retrospective by exhibitions.

2 Barrington 1905, p. 78.

3 These drawings were much admired by Watts, see Watts 1912, I, p. 22.

4 Behnes also sculpted the young Princess Victoria (1829; Windsor Castle); see Rupert Gunnis, *Dictionary of British Sculptors 1660–1851*, new rev. edn, London, 1968, p. 45.

5 Watts 1912, I, p. 21.

6 Ibid., pp. 21–2.

7 *Report of the Commissioners appointed to inquire into the present position of the Royal Academy in relation to the Fine Arts*, Fine Arts Commission Reports (13th), London, 1863, XVI, p. 329.

8 In 1835, through his connection with the radical MP John Roebuck, Watts obtained a curious commission to draw and paint a small-scale, seated full-length of the late Jeremy Bentham from a wax effigy known as the Auto-Icon, now at University College in London; see *The Old Radical: Representations of Jeremy Bentham*, ed. Catherine Fuller, Strang Print Room and Flaxman Gallery, University College, London, 1998, nos 32, 33.

9 Commissions came from both the middle classes, as with *Miss Brunton* (RA 1841; Tate Britain), and aristocratic circles, as with *The Children of the Earl of Gainsborough* (1840–42; private collection).

10 Paintings from the Grosvenor collection including Gainsborough's *Blue Boy*, and gatherings of Old Master paintings also appeared at the British Institution in 1835 and 1836; see Thomas Smith, *Recollections of the British Institution*, London, 1860, I, pp. 180–83.

11 Watts 1889, p. 254. This portrait by Van Dyck is now more closely framed, excluding an area of canvas that would have been visible to observers in the nineteenth century.

12 His prize-winning entry was *Caractacus Led in Triumph through the Streets of Rome* (fragments, Victoria and Albert Museum); see Staley 1978, no. 1.

13 Benjamin Robert Haydon, *Correspondence and Table-Talk*, ed. Frank W. Haydon, London, 1876, II, p. 207; see also Haydon's complaints about Watts's portrait painting in *The Diaries of Benjamin Robert Haydon*, ed. Willard Bissell Pope, Cambridge, 1960–63, V, p. 412, the entry of 25 January 1845.

14 Watts to Charles Rickards, 10 February 1869, Watts Papers; see Watts 1912, I, p. 245.

15 In 1844 Ary Scheffer painted Mathilde, Princesse Demidoff, daughter of Prince Jerome Bonaparte (Pitti Palace, Florence); Watts painted both sitters at the same time (Ilchester 1937, p. 325) and there are suggestive parallels between the portraits by Watts and Scheffer at this time. For Scheffer's portrait, see Francis Haskell, 'Anatole Demidoff and the Wallace Collection', in *Anatole Demidoff: Prince of San Donato (1812–70)*, Collectors of the Wallace Collection I, London, 1994, pp. 18–19, ill. p. 18.

16 My thanks to Dottoressa Lucia Fornari Schianchi for providing information about this portrait.

17 This large oil, *Alfred Inciting the Saxons to Prevent the Landing of the Danes by Encountering them at Sea* (ill. in David Cannadine et al., *The Houses of Parliament: History, Art, Architecture*, London, 2000, p. 235), is at the Palace of Westminster.

18 From a transcript of a letter from Watts to Ionides written from Florence, 15 June 1846, Watts Papers.

19 The government purchased *Alfred Inciting the Saxons* after the exhibition of the Houses of Parliament competition in 1847 and later, in 1853, commissioned a fresco for the Poets Hall in the House of Lords.

20 *Athenaeum*, 27 May 1848, p. 536.

21 *Art Union*, 1848, p. 171.

22 For a discussion of these works, see Staley 1978, no. 8, *Under a Dry Arch*.

23 His portrait drawings were well known as the most refined of a type of continental portraiture that the young Watts took up in Italy with the encouragement of his patrons.

24 See Munhall 1998, which gives details about the creation of the painting and the life of the sitter, Louise de Broglie, who married the Comte d'Haussonville in 1836.

25 The painting was exhibited in Paris in early 1846 (Munhall 1998, p. 104). Even if Watts did not see it himself, he had a number of friends who would have. For example, Lady Normanby, wife of the English ambassador in France, invited Watts to visit Paris in 1846. In addition, Guizot, an intimate of the Hollands, knew the de Broglie and d'Haussonville families (Munhall 1998, p. 25). Dowager Lady Holland was also a friend of the de Broglies.

26 For a recent discussion of Grant's portraiture, see Catherine Wills, *High Society: The Life and Art of Sir Francis Grant 1803–1878*, exh. cat., National Galleries of Scotland, Edinburgh, 2003; for an illustration of *Ladies Mary and Adeliza Howard*, see p. 51, pl. 32.

27 When Ary Scheffer showed a portrait of Charles Dickens in 1856, the critic for the *Art Journal* (1856, p. 163) considered that the 'colour of flesh is entirely false', citing the 'fifty' more natural portraits on the walls of the Academy including those by Grant, James Sant, William Boxall, Margaret Carpenter and Henry Pickersgill; he also commented that the French paintings were 'too highly glazed'.

28 Watts 1912, I, pp. 85–6. Robert Holford offered Watts the use of the space while Dorchester House on Park Lane was being completed.

29 Ruskin in a letter to Revd Edward Coleridge, c.1849/50, Cook and Wedderburn 1903–12, 11, p.30, n. I; and Watts 1912, I, p. 93.

30 Barrington 1905, p. 24.

31 For a discussion of this work, see Staley 1978, no. 7.

32 William Dalrymple, who is a descendant of Sophia, in *White Mughals: Love and Betrayal in Eighteenth century India*, London, 2002, p. XIV.

33 Aubrey de Vere, noted in Una Taylor, *Guests and Memories*, London, 1924, p. 210.

34 See Dakers 1999, pp. 18ff., for the chapter on Watts at Little Holland House.

35 By 1876, however, Watts had lent the double portrait of Sophia and Sara (fig. 7) at Little Holland House to the picture galleries of the South Kensington Museum.

36 Hunt 1913, I, p. 252. Hunt probably referred to artists such as Grant, James Sant, James Swinton and H. Pickersgill.

37 Phillips's portrait of Watts (NPG) dates from c.1850.

38 *The Life of Benjamin Robert Haydon, Historical Painter*, ed Tom Taylor, London, 1853, III, p. 361.

39 On the death of C.R. Leslie in 1859 Taylor continued his study of Reynolds, which was published under joint authorship as *The Life and Times of Sir Joshua Reynolds with some Notices of his Contemporaries*, London, 1865.

40 Sometimes called *The School of Legislation* in direct reference to Raphael's *School of Athens* at the Vatican.

41 The Pre-Raphaelites had also used their friends as models for characters in subject paintings, but Watts's usage is more in the tradition of allegorical portraiture where the individual did not serve merely as a convenient model but also as a personification of a historical individual.

42 Tennyson posed for King Minos; William Vernon Harcourt for Justinian; Sophia Dalrymple for Theodora; Charles Newton for Edward I; Emma Brandling (later Lady Lilford), one of the beauties who frequented Little Holland House, for Alfred the Great; and so on.

43 His visit may have been prompted by his friends Lord and Lady Somers, who, with Layard, went to Venice in September 1853.

44 Watts 1912, I, p. 144.

45 Barrington 1905, p. 199.

46 This painting, then considered a Knight of Malta due to the distinctive cross embossed on the robe, was thought possibly to be a portrait of one of the Medici. Shortly after, it gained the title *A Knight of St Stephen*, an order founded by Cosimo de' Medici in 1561. In Watts's day it was attributed to Pontormo, then Bronzino, more recently to Allori and now the Florentine School. The circumstances of this bequest to the National Gallery, and a later one by Watts, will be discussed in a forthcoming study.

47 For a discussion of Layard's role at the National Gallery, see Egerton 1998, pp. 426–30 (entry on the bust of Layard by John Warrington Wood); also the forthcoming study by Mariachiara Bianchi ('The Layard Collection', paper presented to the National Gallery Archive Group, October 2003).

48 Overall colour became a greater preoccupation from this point onward, as Layard specifically noted in his testimony to the Royal Academy Commission (see note 7), 29 May 1863, p. 354.

49 Peel commissioned Sydney Smirke to build a separate gallery for the display of portraits of 'distinguished contemporaries'. The collection was formed during the 1840s, but Peel's death in 1850 brought the scheme to a close. See H.G.C. Matthew in Funnell and Warner 1999, pp. 142–4 and ill. p. 143.

50 Peel opened his mansion in Whitehall for a reception of opinion formers at the end of April. Widely covered in the press, this event noted that the collection of 'political characters' was at Drayton

51 See R. Ormond 1975 for 'The Hall of Fame'.

52 Watts to John Murray III, 30 October 1858, Murray Archives. These unpublished letters will be discussed more fully in my forthcoming study.

53 As quoted in R. Ormond 1975, p. 6.

54 Watts 1889, p. 254.

55 David Bogue (ed.), *Men of the Time*, London, 1856, p. 775.

56 Ibid.

57 Transcript of a letter from Watts to Ionides, 3 February 1858, Watts Papers.

58 *Athenaeum*, 15 May 1858, p. 629.

59 *The Times*, 13 May 1858, p. 9.

60 *The Spectator*, 5 June 1858, p. 590.

61 Watts had already painted a portrait of his mother, Lady Frederick Cavendish Bentinck (Northampton Museum and Art Gallery). The Cosmopolitan Club and Fine Arts Club are discussed more fully in the following essay.

62 Watts to George Frederick Cavendish Bentinck, 22 June 1857, University of Nottingham Library. Watts's writing of the year is not entirely clear, but considering all the internal and external evidence, it is most likely to be 1857.

63 Ibid.

64 Watts to Mrs Prescott regarding another portrait of her daughter, 1 December 1859, Watts Papers.

65 In three-quarter length, he painted *Hon. Isabella Dundas Ramsden* and *Sir John William Ramsden* (Muncaster Castle) in 1859.

66 Watts to John Murray III, undated [c.1853] (Murray Archives).

67 Watts to George Frederick Cavendish Bentinck, 27 March 1860 (University of Nottingham Library).

68 Watts to John Murray III, 8 January 1862 (Murray Archives).

69 Watts to Layard, 14 March 1860, BM Add. Mss. 38986.

70 Ibid.

71 These works were probably chosen in conjunction with Layard who organised the Fine Art Section of the International Exhibition.

72 Watts to Cameron, 3 January 1861, Watts Papers, partly quoted in Ormond 1975, p. 6.

73 These publications were themselves a landmark in the history of art, with photographs making them among the earliest illustrated exhibition catalogues.

74 The importance of the second of these exhibitions for Whistler is discussed by Dorment (Dorment and MacDonald 1995, p. 25).

75 These included Jeremy Bentham (see note 8), General Sir Thomas Troubridge (private collection), Lord Lyndhurst (NPG), the Duke of Newcastle (unlocated), Sir Thomas Frankland Lewis, Bt. (unlocated), Sir Benjamin Brodie (unlocated) and the drawing of General William Napier (unlocated).

76 *Art Journal* 1868, p. 95.

77 Watts to Lady Ashburton, July 1862, sale catalogue, 1973 (NPG Archive).

78 Spielmann 1913, p. 119.

78 Watts's portrait of Rickards is at the Manchester City Art Gallery; see also MacLeod 1996, p. 466.

80 Watts to Dean Milman, 8 June 1866 (V&A Library).

81 Watts to Bruce, 7 February 1869, Watts Papers.

82 Henry Holiday, *Reminiscences of My Life*, London, 1914, pp. 171–2.

83 Bryant 1996, pp. 109ff.

84 Ibid., pp. 113–14.

85 He did not send to the two final exhibitions in 1886 and 1887. His portrait appearances were not quite as regular when he switched his allegiance to the New Gallery in 1888, but this was largely because at the age of over seventy he had far less portrait work in hand and his own studio gallery at New Little Holland House, his residence on Melbury Road, served to show the older work.

86 Bryant 1997, pp. 76–7.

87 Bryant 1996, pp. 126–8.

88 *The Times*, 6 January 1882, p. 6.

89 Ibid. Watts had corresponded with Quilter, so much of this important review results from direct contact with the artist.

90 Ibid., p. 8.

91 Bryant 1996, p. 109.

92 Spielmann 1886, p. 13.

93 Spielmann 1913, p. 123.

94 Spielmann 1886, p. 13.

95 Millais to an unknown correspondent, 17 November 1883, in which the artist added that he never painted the head and bust as 'the result is somehow not satisfactory' (Print and Drawing Department, Boston Museum of Fine Arts). It also meant that he did not encroach on a type of portraiture so much associated with Watts.

96 As reported by F.G. Stephens in *Portfolio*, 1887, p. 13.

97 For a discussion of this article, see Bryant 1997, pp. 76–7.

98 The paintings were still there in 1896, apart from *Cardinal Manning*, which had been transferred to the NPG by this date. *A Guide to the Collections of the South Kensington Museum*, London, 1896, p. 76.

99 Chesterton 1904, p. 46.

100 For the full list, see 'Royal Insight' magazine, on the Royal Collections website (www.royal.gov.uk). The original group was predominantly military, with additions of politicians and one scientist. Watts's inclusion as the only artist speaks for his considerable standing at this time; it also indicates King Edward VII's agreement with contemporary opinion. Although Queen Victoria never bought any oils by Watts, Edward VII owned the painting bequeathed to him in 1889 by Lady Holland (no. 1).

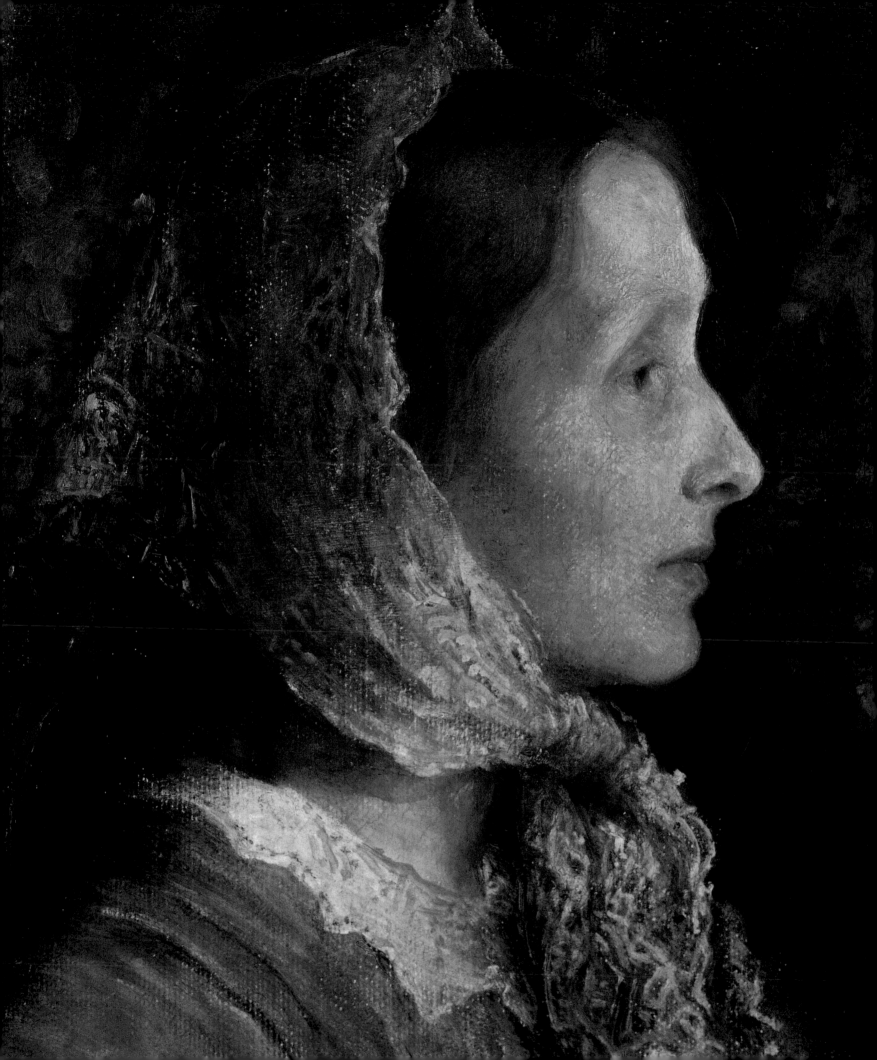

SUBTLE ALCHEMY: THE PORTRAIT PAINTER AS POET

In 1863 Emily Tennyson wrote, on seeing her portrait (no. 41) by G.F. Watts: 'I do not know how such a beautiful picture has come, but you are a subtle alchemist, a great magician.'[1] This revealing quotation epitomises the unique nature of Watts's art in the 1860s after he had created a new type of portraiture, one in which, in his own words, portraits would be 'valuable as works of art'. Watts's portraits moved away from traditional notions of the genre to more 'poetic' realms, rich in atmosphere and allusive meanings. Critics and commentators recognised at the time that the poetic meaning he invested in his portrait paintings marked a revitalisation of the genre in the mid nineteenth century. In so blurring the artistic boundaries of the portrait, Watts created unconventional and unforgettable images.

Each stage of Watts's career up to the mid 1850s contributed to this re-evaluation of the genre in his hands. From his interest in British and Old Master traditions to his fluency in delineating the face as a portrait draughtsman, he approached the genre afresh. Decisive in developing this new approach was his unusual access to Old Master works of art through eminent connoisseurs of the day and the new collecting policy at the National Gallery in the 1850s (see below). Furthermore, he had exceptional knowledge of advanced continental art, especially French portraiture. As discussed in the previous essay, he maintained some distance from the Royal Academy in these years, attracting patrons with non-establishment tastes. Watts also enjoyed unusual social circumstances, which enabled him to pursue an individual, seemingly uncommercial path. He did not run his own household at this stage; life at Little Holland House allowed him the freedom to pursue more personal work. Here he encountered some of the most interesting people in London including poets such as Tennyson and Browning, the young Pre-Rapahaelite artists, and a range of beautiful women and friends of his hosts the Prinseps. Watts occupied a unique position among artists who painted portraits.

Watts and the Old Masters
Events in the wider art world had a considerable impact on Watts. On returning from Italy in 1847, he reacquainted himself with the collections in London, revisiting favourite paintings such as Van Dyck's so-called Gevartius (see fig. 2), which he seems to have studied in great detail; he later wrote in an article in the *Magazine of Art*:

> How the eye swims in the somewhat viscous fluid! They are a little tired and overworked, and do not so much *see* anything as indicate the thoughtful brain behind. How wonderful is the flexible mouth! With the light shining through the sparse moustache. How tremulously yet firmly painted, no dextrous touch doing duty for manly explanation. The ear – how set on; it

could not be moved by a hair's breadth, or by any possibility transferred to any other painted head … there is no part of this wonderful portrait that might not be examined and enlarged upon … There is not a touch put in for what is understood by the word 'effect'.[2]

To Watts this painting became a touchstone for a kind of penetrating portraiture focused on the face, and as such was particularly relevant as he formulated his plans for painting the great men of the day. Yet his own acquisition in the mid 1850s of a grand sixteenth-century full-length (see fig. 8) indicated a parallel interest in a more richly Italianate style. His searching study of older art also enabled him to see portraiture as a kind of history painting. Of Raphael's *Pope Julius II* (c.1512; National Gallery), Watts wrote: 'I cannot help thinking [it] is the most truly historical picture, and this the most monumental and historical of portraits. The longer one looks at it the more it demands attention.'[3] His intense connection with the art of the past, expressed in vivid language, fed into his own work as he rethought his own portraiture.

Watts was on familiar terms with Charles Eastlake, President of the Royal Academy, who became Director of the National Gallery in 1855. Significant new acquisitions of portraits at the National Gallery throughout the 1850s[4] drew the attention of artists and connoisseurs.[5] These works provided immediate lessons for portraiture. Towards the end of the decade acquisitions of sixteenth-century Italian works introduced the notion of rich styling, sumptuous costumes, decorative backgrounds and colour derived from Venetian portraits. Much of this collecting policy was due to Eastlake who displaced the taste of the early nineteenth century to focus more on the masters of fifteenth- and sixteenth-century Italy.[6] To Watts this direction proved entirely sympathetic. His friendship with William Russell, one of the Trustees of the National Gallery from 1850 and a collector himself,[7] must have reinforced the study of older art. In 1861 Russell gave Watts a small portrait on panel attributed to the school of Clouet when the artist presented his Florentine full-length to the National Gallery (fig. 8), perhaps in recognition of the sacrifice he was making. The unusual profile format had several echoes in Watts's work of the 1860s (no. 41), underlining the link for him between the art of the past and his own practice. In addition, the artist himself played an active role in collecting and appreciating distinctive examples of portrait art of the past.

Collectors and connoisseurs
In other ways Watts had moved beyond the bohemians of Little Holland House, thanks to his mentors the Hollands with their own network of aristocratic and intellectual connections. From the early 1850s onwards the artist's membership of the Cosmopolitan Club provided him with

access to a meeting place for the cultivated elite of Victorian London; indeed, he himself was an integral part of it. In 1852, when he moved out of his studio on Charles Street in Mayfair, his close friend Henry Wyndham Phillips, who was secretary of the club, took it over. Phillips painted Watts's portrait at about the time when the club began to hold its evening meetings there.[8] Several members patronised Watts, including Henry Danby Seymour MP, who owned *Life's Illusions* (Tate). Seymour had befriended Gustav Waagen (1794–1868), a German art historian then preparing the supplement to his *Treasures of Art in Great Britain*, and was at just this time escorting Waagen around various collections. Austen Henry Layard, Coutts Lindsay and Charles Newton (all extremely close friends of Watts) performed the same task for Waagen, so talk of great art and great collections was in the forefront. Among the members whom Watts portrayed were Tennyson, James Spedding and Lord Goderich.[9] The group also included Tom Taylor; Chichester Fortescue; William Holman Hunt; Edward FitzGerald; William Vernon Harcourt; Lord Arthur Russell (brother to Lord John Russell); Henry Reeve, political writer for *The Times* and cousin of Lady Eastlake; Stewart Hodgson, the collector of modern art; and Richard Monckton Milnes.[10] Many of these individuals had serious scholarly interests in history or literature, in addition to their political careers. Indeed, this stellar membership prompted one writer to observe that there were 'rather too many plums in so small a pudding'.[11]

If the Cosmopolitan Club had a political and literary slant, then another venue provided a focus specifically on the arts. In the later 1850s Watts had connections with the Fine Arts Club, which held 'conversaziones' in the homes of enlightened collectors such as Henry Danby Seymour; for example, Watts borrowed from Seymour a particular painting, writing to him in August 1856: 'I am really charmed with your Old Master and think it a very fine specimen, as you were out of town I have kept it a few days on account of the great pleasure the sight of it gave me.'[12] The club also counted among its members Alexander Barker, Richard and Edward Cheney (no. 10), Robert Holford, Lord Lansdowne, as well as George Cavendish Bentinck MP, John Ruskin, the painter Richard Redgrave, and banker Louis Huth (see no. 30).[13] As Francis Haskell has pointed out, this group comprised 'hereditary peers to nouveaux-riches', and among this elite of rich and cultivated men and women, a new concept of taste evolved to include art from eras and cultures previously unappreciated by connoisseurs.[14]

Many of these collectors had an equal commitment to native British art, both past and present. The legacy of poet and connoisseur Samuel Rogers (1763–1855) was prominent. He had judged in the competition for decorations for the Houses of Parliament which Watts won; around 1850 the young artist also attended his famous literary breakfasts[15] and, like others, he knew the remarkable collection of Old Master paintings and British art on the walls of St James's Palace. In May 1856 the sale of Rogers's collection by his executors in London, along with

that of Lord Northwick in 1859, 'created romantic values for Reynolds and Gainsborough', because these men had been the last living contemporaries of those painters.[16] The portraits by Reynolds attracted much attention, fetching enormous prices. With their influx on the market there was an almost snobbish motive in acquiring them.[17] By 1858 Watts was working for another great collector, the 3rd Marquess of Lansdowne (a close friend of Lord and Lady Somers), whose treasures were spread between Bowood in Wiltshire and Lansdowne House in Berkeley Square, near the artist's studio in Charles Street. Until 1860 he was painting two murals for Lansdowne to decorate the entrance hall at Bowood.[18] Lansdowne had a notable collection of works by Reynolds, purchased directly from one of the descendant's sales in 1821, and Watts came to know it well.

Throughout his life Watts made a keen study of the face and the figure in British art. He referred more often to Reynolds in his writings than to any another British painter. Given that he matured as an artist during the 1830s when the ideals of history painting still prevailed, it is not surprising that of all artists of the British school Reynolds had the greatest relevance for him. While the young Pre-Raphaelites dismissed 'Sir Sloshua', Watts found much more. He clearly knew many of Reynolds's pictures at first hand; for example, *Giuseppe Baretti* (fig. 30, p. 70) directly inspired Watts's *Panizzi* (no. 17). The master featured in major collections in London, including the National Gallery (which then contained British art, augmented by the bequest of Robert Vernon of 1847 displayed at Marlborough House from 1850), the newly formed National Portrait Gallery, the Royal Academy and the collection originally established by Horace Walpole at Strawberry Hill (most notably *The Ladies Waldegrave*).[19] Later in the 1860s many works by Reynolds could be seen at the South Kensington Museum in the exhibition of National Portraits, which Watts played a role in organising. In 1856 William Cotton published *Sir Joshua Reynolds and his Works*, initiating a new era in studies on the artist which was then continued by Tom Taylor.[20] The opportunities to study Reynolds's work in the later 1850s came at a crucial juncture in Watts's thinking about portraiture.

Watts examined individual paintings by Reynolds with precision; he praised particular works for their 'dignity, colour, force of character, as in the portraits of *Dr. John Hunter* and *General Heathfield*'. The former work at the Royal College of Surgeons, portraying the renowned anatomist amid his collection of specimens, existed as a model for a kind of portrait that relied on accessories and details as much as on the characterisation. Watts admired *Heathfield* in the National Gallery for more painterly reasons, citing the rendering of the figure's hands as 'perfect in living suggestion – the insistence of knuckles not being required – and therefore complete'.[21] Praise also went to this painting for the eyes, a feature of the portrait rated most highly by Watts, and other elements of the handling that he found 'manly and rich', in contrast to a 'scratchy and thin' manner in Gainsborough.[22] Although Watts was

not uncritical, he did have the 'most profound admiration for Reynolds within his limits'.[23] Equally relevant for Watts's work was *Laurence Sterne* (1760; NPG), then in the collection at Lansdowne House, given by the dowager Lady Holland to Lord Lansdowne in 1840. This image of relaxed informality in the depiction of a well-known literary figure suggested a new range of possibilities to Watts for images of men. He always looked to Reynolds as a portraitist whose work 'indicates thought and reading', qualities Watts valued for his own practice.

In the late 1850s Watts sought out exemplars among great collections as he reformulated his own portrait work to create 'valuable pictures independent of likeness' and 'only subjects favourable to my object of making first rank pictures'.[24] What he did was calculated to appeal to the highly cultivated individuals with whom he now mixed. For Cavendish Bentinck he painted a family group so obviously derived from Reynolds's famous *Lady Cockburn and her Children* (fig. 35, p. 108) that it might be a pair (discussed in no. 33). At the Academy of 1860 a full appreciation of this work presumed art-historical awareness.[25]

Watts's more subtle approach to portraiture attracted Louis Huth, another member of the Fine Arts Club, who (like Cavendish Bentinck) was noted for his taste and collecting, as well as being an amateur artist. Watts painted his wife Helen Rose on more than one occasion. A relatively straightforward portrait of the young bride (formerly Ashmolean Museum), painted soon after their marriage in 1855, was followed by a full-length (no. 30). Watts responded to individuals with developed tastes, such as the Huths. Collecting ran in the family, and their banking interests in the City financed a move into cultivated society. Commissioning Watts to portray his wife resulted in a grand manner exercise that underlined the future aspirations of the wealthy young collector.

When Watts found sympathetic patrons, he often portrayed them along with their extended families. This had been a natural habit for him since his life at Little Holland House with the Prinseps and also harked back even earlier to his ongoing association with the Ionides. In 1856 MP Wentworth Blackett Beaumont, one of the sons of an art collector, married Lady Margaret de Burgh, daughter of the 1st Marquess of Clanricarde (1802–74). Beaumont moved in the same circles as artists, later buying the portrait of Henry Wyndham Phillips (no. 25). Watts began with Lady Margaret (no. 38) and her sister (fig. 36, p. 121) by 1859; by the mid 1860s he had also painted her husband, then her mother (no. 52) and father, and later she convinced him to paint her husband's brother-in-law. The first commissions may well have emanated from her father Lord Clanricarde who, if not a member of the Cosmopolitan Club, was certainly a friend of one of its founders, Henry Reeve. It may well have been this connection that led him to Watts.

These titled sitters owned ancestral collections of paintings, among which Watts's full-lengths were destined to hang. His portraits eminently suited the requirements of country house picture galleries, as Oliver Millar has observed.[26] Few artists served such a clientele. Pre-eminent

among them was Francis Grant who, since the 1830s, had cornered the market in aristocratic full-lengths thanks to his own almost unrivalled social connections. Watts certainly saw Grant as the artist to match, citing his prices as the market benchmark. Grant's clientele, however, was distinctly different. With his own links with the aristocracy and countryside pursuits, he attracted primarily members of the landed nobility. Critics characterised the style of his works as vigorous, easy and natural in attitude. Watts appealed to the collectors and connoisseurs of the metropolitan elite with portraits that often operated on a level beyond conventional portraiture.[27] Several key critics noted the distinctive qualities of Watts's portraits. When *Lady Margaret Beaumont* appeared at the Royal Academy in 1862, William Michael Rossetti declared, in reference to it, 'a portrait must be a work of *Art*'.[28]

Contemporaries of Watts in the 1850s and 1860s included James Sant (1820–1916) who produced attractive, if undemanding images, yet he had his following. The Countess of Waldegrave commissioned from Sant a set of portraits of the beauties of the day for Strawberry Hill in Twickenham, which were exhibited at the French Gallery in 1860.[29] Franz Xaver Winterhalter (1805–73), the favourite of Queen Victoria, catered for those aristocratic patrons close to royal circles. His works, which provided images of continental glamour, found favour in this realm. But there was a key feature of Watts's clientele. His patrons tended to be younger and distinguished by their additional interest in modern art. They were also well educated and their wider interests and academic pursuits informed their collecting habits.[30] When his sympathies were engaged, his response to such sitters was to provide their portraits with richer levels of meaning. In portraying beautiful women by commission or choice, he indulged his painterly talents and his vision of a poetically inspired portraiture.

The art of portraiture: 'a passion for beauty'

One of Watts's earliest decorative bust-length paintings of women to convey this new spirit was the portrait of Arabella Prescott from 1857 (fig. 13 and no. 29).[31] His only submission to the Royal Academy of 1859, it was sent not with the sitter's name, but with the title *Isabella*, in the manner of a fancy picture, suggesting a reference to the poetry of Keats or even Boccaccio. Surprisingly, it had a good position in the rooms; Ruskin mentioned it in *Academy Notes*, and other key critics dwelled on it as a 'refined piece of portraiture'.[32] Holman Hunt cited its stylistic similarities to the work of Eastlake, adding that *Isabella* was 'the only good idealised portrait in the exhibition'.[33] For Watts this painting acted as a kind of advertisement of how a portrait by him could depart from conventions.

As the portrait of a beautiful woman with a title evocative of Italy, *Isabella* is a key visualisation of the growing interest in images of decorative females in advanced English art circles. It shares certain features with the art of Dante Gabriel Rossetti (1828–82), particularly *Bocca*

Baciata (fig. 14), begun in the autumn of 1859 as a portrait of Fanny Cornforth and exhibited at the Hogarth Club in 1860 with its Italian title.[34] The significant differences between these two works are important; Rossetti's forthright depiction of sensuality, in a miniature-like, intensely coloured image, is a world away from Watts's pale, withdrawn Arabella Prescott, set against a blue sky and thinly painted with glaze-like oil colours as if in a fresco painting. But there is an important community of interests shared by both artists. Rossetti was impressed with Watts's art, and brought Burne-Jones into the Little Holland House fold by remarking that the older artist painted 'a queer sort of pictures, about God and Creation',[35] referring to his mural paintings. Watts greatly admired these two younger artists, describing their works in 1861 as 'products of undoubted genius and almost unknown'.[36] Rossetti also had ample opportunity to see other portraits of the female members of the Prinseps' household by Watts at Little Holland House, in works that began to go beyond the confines of portraiture with their decorative impetus and poetic mood.

Around 1860 Watts's portraits presented a hybrid. Cross-currents can be seen between his work and that of younger contemporaries, such as Frederic Leighton, whose three studies of the Italian model La Nanna[37] appeared at the same Academy exhibition in 1859. These works paid visual tribute to late Renaissance art; in addition, they were highly decorative studies of a specific person, much as *Isabella* was. Watts had regular contact with younger artists, such as John Roddam Spencer Stanhope (who was his student for a time before he drifted to the Pre-Raphaelite camp) and Valentine Prinsep, son of Sara Prinsep. But Watts was a more senior figure and he did not encourage, in the words of William Michael Rossetti, 'anything savouring of the free and easy'.[38]

Watts also admired Whistler, calling him 'a great painter' in reference to the works he showed in 1860, such as *At the Piano* (RA 1860; Taft Museum, Cincinnati). The suggestive possibilities of music making had also attracted Watts for its dramatic potential in *Prudence Cavendish Bentinck* (no. 28) and again in *Alice Prinsep* (no. 37), exhibited in 1861. Whistler's *White Girl* (fig. 17) adopts the format of grand-manner portraits. It could be seen as a response to Watts's full-lengths of women in pale dresses, such as *Virginia Pattle* (no. 21) or the much more recent *Helen Rose Huth* (no. 30) whom Whistler himself was later to portray. Indeed, the stark stare of *The White Girl* recalls that of Watts's *Alice Prinsep*, exhibited the previous year.

Watts's innovations emerged directly from a particular genre that critics called 'idealized portraiture'. In 1860 Taylor identified a failing in contemporary art when he considered 'what is the destiny of the art of portraiture in this country', though for him the distinctive qualities in Watts's portraits (nos 33, 35) provided an answer: 'Mr. Watts brings to this branch of his profession which we are glad to know that he has embraced, a mind and hand trained in epic and imaginative art of the

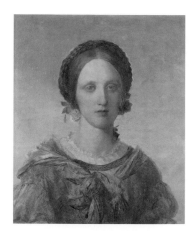 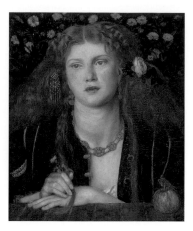

FIG. 13 *Isabella* (*Arabella Prescott*; also no. 29), G.F. Watts, 1857, oil on panel, 610 x 500mm (24 x 19¾"). Private collection

FIG. 14 *Bocca Baciata*, D.G. Rossetti, 1859, oil on panel, 321 x 270mm (12⅝ x 10⅝"). Museum of Fine Arts: Boston, Gift of James Lawrence, 1980.261

highest aims.'[39] In summing up the Academy of 1861 in which *Alice Prinsep* (no. 37) appeared, Taylor wrote: 'With the sole exception of Mr Watts we have not now a portrait painter who is at once a consummate draughtsman, a fine colourist, and an artist capable of imaginative creation.'[40] Indeed, this element of imagination is what set Watts's work on a new level as he imparted mood, atmosphere and suggestive meaning to his portraits.

Knowledgeable critics, like William Michael Rossetti in *Fraser's Magazine*, disseminated news of Watts, and in the process fostered the creation of his distinct persona. In 1862, writing of *Lady Margaret Beaumont and her Daughter*, this writer confirmed Watts's notion that a portrait must be a work of art.[41] At times the artist himself communicated with writers either formally or informally. Rossetti probably wrote *The Reader's* article 'About Portrait Painting – George Watts' in February 1863, where he noted that the artist 'contemplates presenting his historical portraits to the nation'. He further claimed that the portraits equalled even those of the greatest masters: 'the very latest portraits of Watts are distinguished by a Venetian quality of colour'.[42]

In this more Italianate phase, in one of his reputedly most gorgeous paintings, *Bianca* (fig. 15),[43] Watts painted Ellen Ford, one of Rossetti's models. Although this type of painting is more associated with Rossetti in modern studies, Watts's distinctive contribution can be reconstructed, with *Miss Eden* (RA 1858; unlocated), *Isabella* (fig. 13) and *Bianca*. In the last, one detects the older artist challenged the younger one at his own game in a work that is considerably more fluent and flamboyant. The languorous Ellen Ford as Bianca displays her beauty. The observer is invited to appreciate the painted surface, with the additional dramatic impact of the black velvet dress contrasting emphatically with white

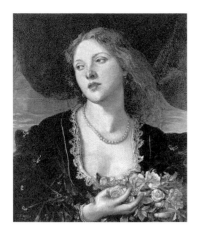
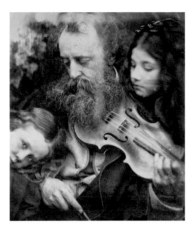

FIG. 15 *Bianca*, G.F. Watts, engraving after unlocated painting, published in *Magazine of Art*, 1886; original: *c.*1860–62, oil on canvas, 610 x 508mm (24 x 20")

FIG. 16 *Whisper of the Muse: G.F. Watts*, Julia Margaret Cameron, 1865, photograph, albumen print, 261 x 215mm (10¼ x 8⁷⁄₁₆"). Courtesy of The J. Paul Getty Museum, Los Angeles

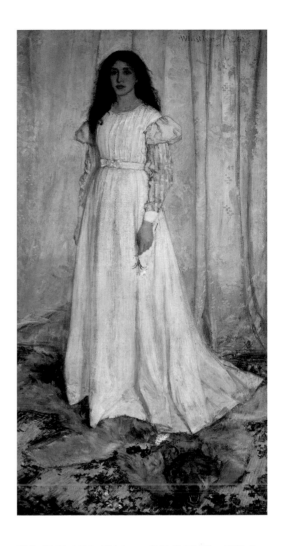

FIG. 17 *The White Girl*, James McNeill Whistler, 1861–2, oil on canvas, 2138 x 1079mm (83⅞ x 42½"). National Gallery of Art, Washington DC, Harris Whittemore Collection, 2004 © Board of Trustees

skin. In such works Watts strayed from the genre of portraiture into a more evocative mode that was primarily about the appreciation of beauty and colour, in line with the emergent spirit of Aestheticism.

Watts's meeting with Ellen Terry (see nos 43–5) in 1863 allowed him to transform his art still further in this direction. Tom Taylor introduced the two young actresses, Kate and Ellen, to Little Holland House from his theatrical circles. Taylor had earlier introduced the actress Ruth Herbert, Rossetti's 'stunner' and model, and Watts sketched and painted her, perhaps in rivalry with the younger artist. Taylor no doubt considered that Kate and Ellen, as actresses, would also suit his friend's current artistic direction. *Choosing* (no. 44) is the most exceptional result of the artist's short-lived union with Ellen (discussed in nos 43–6). Since the late 1850s Watts had painted a series of young beauties (nos 29, 37), first in portraits and then in works that became increasingly less restricted by that definition. Indeed, it now seems clear that in seeking out such sitters (nos 37, 40), he was in effect creating an informal gallery of modern beauties. This notion had its roots in earlier precedents of 'court beauties' of the seventeenth century and later. But Watts's passion for beauty took a highly personal form, and was recognised as such by his contemporaries. We can now see that such portraits exist in parallel to his depictions of eminent men, as he intuitively sought a balance to the high ideals embodied in that series.

The wider perception of Watts at this time is distilled in the photograph by his friend Julia Margaret Cameron, *Whisper of the Muse* (fig. 16). Here the artist dreamily seeks inspiration in an image replete with poetic suggestion, allied to music. This was the image Watts presented, of an artist removed from the prosaic realities of life, living with music, poetry and art. Another version entered a public collection,

the South Kensington Museum, in 1865, along with other images by the photographer,[44] and if it did not confirm Watts's unique position in the art world then at least it underlined his scrupulously constructed image as 'Signor'. He even typecast himself in *The Eve of Peace* (fig. 18), as a mature knight deep in thoughtful reverie – a work that underlines the crossover between portraiture and subject painting.

Critics emphasised Watts's singular status. Sidney Colvin's important article 'English Painters and Painting in 1867' focused on Watts's

passion for beauty … he has been forced by public apathy to devote himself chiefly to portrait painting. In this he shows an insight into character, a poetry of feeling and a masculine simplicity that no English painter can rival; and these qualities the public, to their credit be it said, have learned to appreciate.[45]

FIG. 18 *The Eve of Peace*, G.F. Watts, *c*.1863–76, oil on canvas, 1420 x 1015mm (56 x 40"). Collection of the Dunedin Public Art Gallery, New Zealand

Throughout the 1860s Watts actively sought out individuals such as Algernon Swinburne (exh. Dudley Gallery, 1866; NPG), William Morris (1870; NPG) and Dante Gabriel Rossetti (1870; NPG). These well-received and widely seen images contributed to the new imagery of poet-portraits. Such an approach also suited the portrayal of artists, as seen in Watts's depictions of Millais (RA 1871; NPG), and most successfully Burne-Jones (RA 1870; Birmingham Museums and Art Gallery), a shadowy, haunting image that crystallised that artist's singular vision.[47]

In line with the preoccupations of the 1860s, Watts also portrayed musicians in unusual images. *A Lamplight Study: Herr Joachim* (fig. 19) became one of his best-known works from the moment of its exhibition at the Royal Academy in 1867. Not reckoned a particularly good likeness,[48] the painting was valued more for intangible qualities, as an embodiment of Joachim's feeling for music, as Watts 'seized the genius of the sitter'. The critic for *Blackwood's Magazine* considered this a 'masterly achievement, grand and suggestive' and cited the 'cherished theory' regarding the essential oneness of colour and sound.[49] Ideas of the relation of music to art were very much a part of the early Aesthetic Movement, as later expressed in Walter Pater's dictum 'all art aspires to the condition of music'. Watts's deeply felt affection for music, a legacy from his family background and from his own musical experience as a violinist (see fig. 19), enabled him to recognise the parallels between the two arts, and he later wrote:

> I hope in all cases it will be seen that however I may fail all [my paintings] are distinct endeavours to convey a real feeling or mood, line & colour & form & surface … [are] employed rather as the musician employs melody & harmony, than with any intention of presenting actual truth.[50]

In several later works the idea of music and performance animated his portraits, perhaps most vividly in *Blanche, Lady Lindsay* (no. 55).

Watts's attraction to sisters (or sisters by marriage, as in the case of the Seniors) found further outlets beyond the grand-manner format (no. 43) in works that project mood and a sense of poetic meaning, as in his portrait of his friends, the daughters of the 18th Earl of Shrewsbury. Their father, a prominent Catholic nobleman, possessed a famous collection of Italian paintings. Some of these works had been dispersed in 1857 and 1861, but the extent of the Shrewsburys' collections was well documented. In 1857 the eldest daughter Constance married the 8th Marquess of Lothian, who inherited and actively collected Old Master paintings. Visits to their seat, Blickling, enabled the artist to portray for himself a group of the sisters together (further discussed in no. 42), but for his friend Lothian, he prepared individual portraits of Constance (see fig. 38, p. 128) and her sisters, including one of Lady Gertrude Talbot (fig. 20). These highly decorative studies brilliantly set out a distinctive alliance of portraiture with 'a passion for beauty'.

The portrait of Lothian himself, a close-up, restrained study on

A portrait by Watts was not the obvious choice for a client at the culmination of his career, seeking an honorific display. The artist was preferred by non-establishment patrons, often those connected with the world of the arts. In both style and content he set himself on a different level to other professionals. In an era when aesthetic currents flowed freely, Watts's work occupied centre stage.

Portraits and the 'poetry of feeling'

From the late 1850s onwards, in addition to his cultivated connoisseurs and collecting aristocrats, Watts specialised in the portrayal of poets, artists and actresses. The two first portraits of Tennyson (see no. 34) and that of Browning (exh. French Gallery, 1866) ventured a new depiction of poets by focusing on their faces as a way into their inner lives. In 1859 the artist wrote to Tennyson: 'I dare not think I have done more than suggest what your poetic imagination has completed for you.'[46]

panel, is painted with detailed touches and enlivened by a deep, intense green background (fig. 22). This young man in his early thirties suffered from a debilitating illness he was said to have contracted while in India.[51] In the last years, before his death in 1870, he was confined to a wheelchair, crippled by a wasting disease of a particularly distressing kind. Watts painted the portrait of his friend at this time and knowledge of his illness lends greater poignancy to the sitter's haunted look. Watts channelled his own feelings of loss and his deep sympathy with Lady Lothian's suffering at the slow decline of her husband into the conception of *Love and Death*,[52] in which a youthful figure of Love fails to restrain the inevitable progress of Death. The composition took form during the later 1860s with the first finished version exhibited at the Dudley Gallery in 1870, the year of Lothian's death, the painting acting as a memorial (fig. 21). In Watts's work this crossover between portraiture and subject painting lent new dimensions to each genre.

Throughout the 1860s Watts brought new thinking to the portrayal of men, using formats larger than the head size adopted for the images of distinguished contemporaries. He despaired of male clothing; to him the dress coat and 'chimney-pot' hat had no picturesque value. Later he commented:

> Portraiture, now its [art's] most real expression is deprived (speaking of masculine portraits) of nearly all that from an artistic point of view can render it valuable to posterity … A man's portrait can scarcely be made as a picture beautiful, or be cared for in the future as we now care for a Venetian or Vandyke portrait, without knowing anything about the original.[53]

The lessons of relaxed informality in the portraits of Reynolds had interested him from an early stage. The study of Old Masters at the National Gallery, such as Van Dyck's *George Gage with Two Attendants* (1622–3), which he had copied years before, or Moretto's *Portrait of a Young Man* (*c*.1542), a more recent acquisition in 1858, introduced casually posed figures animated by the flowing lines of the compositions. This approach lent a sinuous elegance to his larger portraits such as the seated three-quarter length of Arthur Stanley, Dean of Westminster (fig. 23). About the latter, a not very sympathetic critic found its emulation of Venetian art excessive, noting it was more like an old Italian picture than the living man.[54] Yet significantly, as for Reynolds, this searching of the Old Master canon provided Watts with a way of invigorating his male portraits. This research, often given fresh impetus by the continuing influx of acquisitions at the National Gallery, provided key examples for a fresh interpretation of portraiture, resulting in the introduction of movement into portraits, as in the emphatic twisting figure of William Bowman (no. 49), which might be compared to Andrea del Sarto's *A Sculptor* (*c*.1517), acquired by the National Gallery in 1862. Equally, this richer interpretation allowed for more layers of meaning. This kind of work bears witness to Watts's search for depth in portraits,

FIG. 19 *A Lamplight Study: Herr Joachim (Joseph Joachim)*, G.F. Watts, *c*.1866–7, oil on canvas, 915 x 686mm (36 x 27"). The Watts Gallery, Compton, Surrey (Photo: © Bridgeman Art Library)

FIG. 20 *Lady Gertrude Talbot*, G.F. Watts, *c*.1865, oil on canvas, 673 x 546mm (26½ x 21½"). Kiplin Hall, North Yorkshire

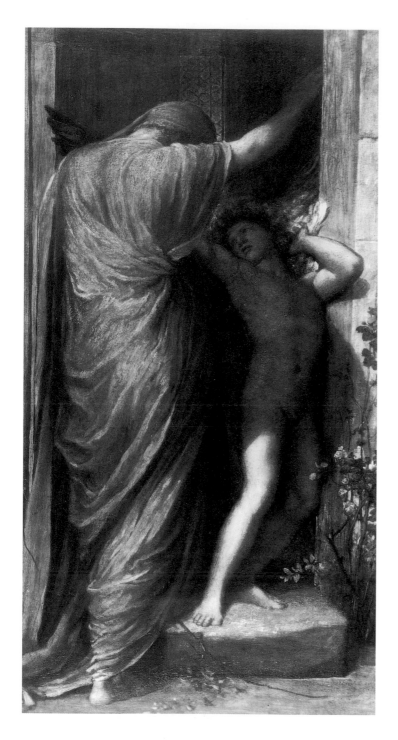

FIG. 21 *Love and Death*, G.F. Watts, *c.*1867–70, oil on canvas, 661 x 330mm (26 x 13"). Location unknown, art market, London, 1975

as he wrote: 'A superficial picture is like a superficial character – it may do for an acquaintance, but not for a friend.'[55]

The individuals Watts portrayed beyond 1870 continued to be among the most erudite and cultured of the mid Victorian era. Such sitters included bibliophiles, intellectuals, collectors of modern art, such

as Eustace Smith, and individuals with great art collections such as the Rothschilds, Earl Cowper, Lord Leconfield of Petworth, and members of the Thynne family. His one attempt at royal portraiture, a full-length of the Prince of Wales (1874; oil sketch, formerly Watts Gallery) failed dismally. The subject was not his personal choice, but he had agreed to the commission from the Middle Temple. Criticised on its exhibition in 1882, it was reclaimed by Watts, who returned the money and hid the picture away.[56]

The practice of portraiture

Watts's procedures departed from the normal working arrangements of a professional portrait painter. He negotiated a personal connection with his sitter, and even felt he could not carry on if he was not in sympathy with the individual; he 'would pride himself on the fact that nearly all his sitters became his friends'.[57] Central to much of his portrait work was the element of choice. He chose many of his sitters personally; refused many who came to him, even friends; kept many of the resulting portraits for his own collection; and sought out individuals who provided some original spark of interest for him, such as poets, writers, society beauties and even performers. He once painted Zazel (1885–6; unlocated),[58] an acrobatic dare-devil whose act consisted of falling from a great height after being shot from a cannon, simply because he admired her courage.[59] The freshness of a new acquaintance elicited the best from the artist.

In 1886 Watts summarised the method he adopted to gain the measure of his sitters:

> In my imaginative work I consider myself perfectly free as to detail so long as I do not violate any law; but not so, of course, in portrait-painting, when while giving my mental faculties full play so as to seize my sitter's intellectual characteristics, I observe equally the physical minutiae. To assist myself, I converse with him, note his turn of thought, his disposition, and I try to find out, by inquiry or otherwise (if he is not a public man, or is otherwise unknown to me), his character and so forth; and having made myself master of these details, I set myself to place them on the canvas, and so reproduce not only his face, but his character and nature.[60]

When he found the right footing with a sitter, he empathised strongly with them. For example, in the course of painting Lord Rosebery (1892–4; unfinished, Watts Gallery), he noted that, once the politician left office, 'a careworn look had gone'.[61] At times this process took on an even deeper aspect. Emilie Barrington, who worked much with Watts in the early 1880s, noted that he proceeded as much 'from a mental vision created by the impression which the nature, career and character of the sitter has produced on his own mind, as from the personality before him'.[62] Thus an accumulation of the artist's prior knowledge of the sitter conspired in formulating the visual image. This is a rather

FIG. 22 *William, 8th Marquess of Lothian*, G.F. Watts, *c*.1865–70, oil on panel, 661 x 533mm (26 x 21"). Collection of the Earl of Ancram

FIG. 23 *Arthur Stanley, Dean of Westminster*, G.F. Watts, 1866–7, oil on canvas, 1219 x 889mm (48 x 35"). Oxford Examination Schools, Oxford University

modern notion of the processes behind the creation of a portrait.

No professional portrait painter would allow themselves the deeply felt connection Watts often sought, but this formed an important ingredient in his approach. He wrote that 'the mesmeric influence possessed by individuals must be possessed by artistic productions. Without this quality they will be cold, and not breathing, and will not live always.'[63] Although not writing specifically about portraiture, certainly the same remarks applied to his belief that individuals had some 'mesmeric influence' and this guided his thinking about portraiture, both public and private. He explained later that 'before I paint the portrait of any man who is known to the public, I get to know a good deal about him. And from what I know about him I also know that a certain expression *must* sometimes come into his eyes. And I put it there.'[64] In line with Watts's earlier observations about the eyes of Van Dyck's 'Gevartius' (see fig. 2), he himself, contrary to the usual practice of portrait painters, often painted in the eyes last, leaving the empty sockets until a late stage in the painting,[65] since depicting them was so essential to the matter of likeness and character. The resulting image possessed a strangely fascinating quality, as can be seen in the version of the portrait of the poet Henry Taylor, left unfinished, deliberately it would seem (fig. 24). The

empty sockets seem to wait in perpetuity for the 'certain expression' to come forth.

By the latter part of Watts's career his 'usual measure for a portrait' was five sessions of one or two hours each in length; his subjects generally stood.[66] In setting out the portrait, the placement of the head conveyed specific information. The art critic M.H. Spielmann recorded that 'when he painted a portrait less than whole-length he always tried to indicate the size of his sitter by placing the head either close to or distant from the top edge of the canvas'.[67] It also became clear that the artist made certain choices quite deliberately, as for example in his most commonly known format, in which he 'frequently conceals the hands, and this, not from any want of power, but the desire to concentrate attention on the face'.[68]

By the early 1890s Watts again raised his prices to 500 guineas: 'sometimes it paid me commercially & sometimes not for I always was most uncertain!' He admitted 'occasionally finishing a portrait right off in a short time & after a few sittings & sometimes labouring for months almost years'.[69] He painted in the large studio at new Little Holland House, as Emilie Barrington recorded: 'walking back and forth between his easel and the large looking glass which doubled the length

FIG. 24 *Henry Taylor*, G.F. Watts, *c.*1865–70, unfinished, oil on canvas, 661 x 508mm (26 x 20"). The Watts Gallery, Compton, Surrey

of his space … looking at his work from as great a distance as possible … a manner of working which Sir Joshua Reynolds pursued.'[70] This procedure provided an overall view of the painting, so he could obtain the quality of breadth. Such a method applied particularly in the later works where he avoided too much tight definition, instead seeking atmospheric effects, as can be observed in *Violet Lindsay* (no. 57) and later portraits of the 1880s and 1890s, or surface effects as in *Dorothy Dene* (*c.*1886; private collection) and *Lina Duff Gordon* (no. 62).

Extensive conversations went on while he painted, as several sitters recorded. One writer repeated Watts's own explanation of how 'he tries to find out and read and know all about a man and puts his character and history into the face and likes his sitters to move freely about and talk out their heart to him. To get at the *real* man.'[71] To another writer he mentioned that 'pleasant chat instinctively drew forth the character's lights and shades, so necessary to the successful portrait'.[72] Thomas Carlyle discussed Goethe with Watts at great length, yet still complained, asking constantly when the sitting would be over.[73] The procedures of being a professional portrait painter caused Watts distress, as he later told Emilie Barrington:

The moment when relatives and friends came to inspect the portrait was quite torture. You stand first on one foot, then on the other, with nothing to say – waiting for the verdict. When it comes it is generally the one thing that is least bad in the painting which is most criticised.[74]

Conclusion: 'the window of the mind'

Despite Watts's professed dislike of the genre, for which he regarded himself particularly unfit, his portraits often captured the likeness of each individual along with a vivid sense of their inner, intellectual life, and in his own self-portrait (fig. 25) as much as in others. Any dilemma he suffered was entirely self-imposed: 'because he never rested satisfied with reproducing what was generally apparent to the outer eye; that he always studied the character until he could work out the inner self as much as possible.'[75] As G.K. Chesterton eloquently expressed, 'he scarcely ever paints a man without making him about five times as magnificent as he really looks. The real men appear, if they present themselves afterwards, like mean and unsympathetic sketches from the Watts original.'[76] After the retrospective at the Grosvenor Gallery in 1881 the distinct character of his portraiture came into focus. Regarding the portraits, Cosmo Monkhouse, an astute critic, commented that 'the special aim of his art has been to make the face the window of the mind'. This writer further considered that Watts's

collective achievement is a most vivid and enduring record of the number and variety of noble minds which have been at work in England during the last quarter of a century. It is in the truest sense national; it demands not only the admiration of the critic, but the gratitude of the citizen.

To him it was also 'evident that a man who can paint such portraits is not only an artist but a poet',[77] an idea that is captured in Edward Steichen's later photograph of Watts (fig. 12).

Certainly critics of the time, voicing commonly held views, found Watts's portraiture very much an integral part of his wider reputation as a poet in art, manifested not only in his symbolical works.[78] In 1879 he wrote of 'making a poet of the spectator'. He believed that even 'the most hardened materialist has some latent instinct of poetry and beauty'.[79] With their wide visibility in the 1880s, the portraits attained a particular position uniting the two strands in his work, poetry in its broadest sense combined with the higher aims of art. When, probably in early 1881, Oscar Wilde wrote to Watts offering a gift of his latest poem, he called it 'a very poor mark of homage to one whose pictures are great poems'.[80] Wilde's remark reflects the experience of seeing the great retrospective at the Grosvenor Gallery where portraits played a major role and were recognised as no less deserving the status of great poems. This deep link with poetry struck Watts himself, who considered in retrospect that 'My life might have been an Epic – it is now only a series of Sonnets'.[81]

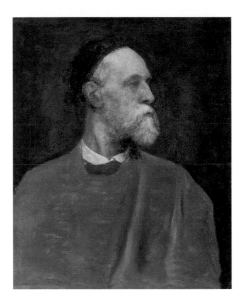

FIG. 25 *Self-Portrait*, G.F. Watts, *c*.1879,
oil on canvas, 635 x 508mm (25 x 20").
National Portrait Gallery, London (NPG 1406)

NOTES

1 Hoge 1974, p. 174.

2 Watts 1889, p. 254.

3 Ibid.

4 See Robertson 1978, pp. 295ff. for acquisitions during Eastlake's Keepership and when he was Trustee, with the collection doubling in size and the gallery acquiring works such as Rembrandt's *Self-Portrait* (NG 221; bought 1851) and Jan van Eyck's *Portrait of a Man* with a red turban (NG 222; bought 1851); and 298ff. for acquisitions once he became Director, including Palma Vecchio's *Portrait of a Lady* (NG 2146; bought 1856), Bassano's *Portrait of Man* (NG 2149; bought 1856), a Venetian school *Portrait of a Lady*, attributed to Tintoretto (NG 2161; bought 1855) and Bartollommeo Veneto's *Lodovico Martinegro* (NG 287; bought 1856).

5 For the impact of the collections of earlier Italian art on the Pre-Raphaelites in the late 1840s, see Malcolm Warner, 'The Pre-Raphaelites and the National Gallery', in *The Pre-Raphaelites in Context*, Henry E. Huntington Library and Art Gallery, San Marino, California, 1992, pp. 1–11.

6 For a discussion of the changes in the collecting patterns of the National Gallery during the 1850s, see Francis Haskell's review of *Sir Charles Eastlake and the Victorian Art World* by David Robertson in the *Times Literary Supplement*, 15 June 1978, p. 20.

7 My further study of Watts and the National Gallery, including his friendship with William Russell, will be published in due course.

8 Watts's *Story from Boccaccio* (Tate) and another work later entitled *Diana's Nymphs* (Watts Gallery) remained behind as decoration, keeping Watts's original link with the club alive until the last years of the century. On the club see Hunt 1913, I, pp. 344–5; Philip McEvansoyeva, 'The Cosmopolitan Club Exhibition of 1863: the British Salon des Refusés', in Ellen Harding, ed., *Reframing the Pre-Raphaelites: Historical and Theoretical Essays*, Aldershot, 1996, pp. 27–42.

9 Lord Goderich's father, the 1st Earl of Ripon, had been instrumental in the founding of the National Gallery. Watts's 1857 portrait of Lord Goderich (unrecorded by Mrs Watts) is unlocated; the artist later painted him when he was 2nd Earl of Ripon (NPG).

10 Later members included Leighton and Millais.

11 *Memoirs of the Life and Correspondence of Henry Reeve, C.B., D.C.L.*, ed. John Knox Laughton, London, 1898, I, p. 356.

12 Watts Papers, letter from Watts to Seymour, 12 August 1856.

13 Watts had worked in Dorchester House, Holford's great London palazzo in Park Lane, in about 1850, while Holford actively built up his collection. See Waagen 1854, III, pp. 193–222, and Laing 1995, p. 202 n.6.

14 Haskell 1976, p. 130. The group later evolved into the Burlington Fine Arts Club (officially founded in 1866–7).

15 Watts 1912, I, p. 176.

16 Gerald Reitlinger, *The Economics of Taste: The Rise and Fall of Picture Prices 1760–1960*, London, 1961, p. 182.

17 Ibid., p. 184.

18 Lansdowne belonged to the previous generation of high-born collector/connoisseurs; on the background to aristocratic wealth in the early decades of the nineteenth century, see David Cannadine, *Aspects of Aristocracy: Grandeur and Decline in Modern Britain*, New Haven and New York, 1994, ch. 1.

19 Watts mentions the colour and preservation of this painting at Strawberry Hill in Watts 1888, p. 90.

20 See previous essay, p. 16 and note 39. Henry Wyndham Phillips, the son of Thomas Phillips, RA, also provided a direct link with Reynolds. Thomas Phillips, who had died in 1845, was an active buyer at the sales of Reynolds's works in the 1820s; see William Cotton, *Sir Joshua Reynolds and his Works*, London, 1856, pp. 196, 199. These purchases of sketchbooks and oil sketches would certainly have been known to Watts through his friend Henry.

21 Watts 1888, p. 91; Spielmann 1905, p. 11.

22 Ibid. See also Watts 1889, pp. 253–4, where Watts admitted his knowledge of Gainsborough was not as complete since he had missed several opportunities to see his work. He did, however, comment on a portrait seen at the National Gallery of 'a very ordinary personage in a pink coat, which for naturalness and unaffectedness could not be better'. Nevertheless, his view was that Gainsborough 'was remarkable for bad drawing'. About Romney, Watts commented that he had 'no backbone' (Spielmann 1913, p. 123).

23 Watts 1889, p. 253.

24 See previous essay, pp. 19 and 20 and notes 62 and 64.

25 The critic for the *Art Journal* (1860, p. 63) noted that the painting was 'by no means Pre-Raffaelite, but reminds us rather of one of the Andrea del Sartos, in the Pitti, in Florence'.

26 Millar 1985, pp. 38–9.

27 It is also worth pointing out that there was yet another sphere of collectors in the 1850s, referred to by Eastlake as 'the Birmingham and Manchester manufactures', who paid extremely high prices ('beyond all limits') for modern pictures. Such buyers favoured the Pre-Raphaelites and genre painters such as William Powell Frith.

28 *Fraser's Magazine*, July 1862, p. 70.

29 Watts knew the Countess of Waldegrave through Chichester Fortescue, his friend from the Cosmopolitan Club; see Hewett 1958, pp. 29ff.

30 A number of these patrons published scholarly studies: Lord Lothian, for example, published (anonymously) a detailed study of Italian art in 1863 at the same time as he was buying Renaissance treasures in Italy. Even Thoby Prinsep was a noted Arabic and Persian scholar.

31 Equally relevant was the painting (now unlocated) of *Miss Eden*, finished in the autumn of 1857 but exhibited at the RA in 1858, the year before the portrait of Arabella. From descriptions and an old photograph, *Miss Eden* was evidently one of the first of the decorative studies of women, broadly inspired by some of the recent acquisitions of sixteenth-century Italian portraits at the National Gallery. There is also an interesting comparison to be made with Eastlake's *Ippolita Torelli* (RA 1851; formerly Tate Gallery, destroyed 1928; ill. Robertson 1978, p. 117) as a decorative female study modelled on Titian.

32 *The Times*, 10 May 1859, p. 9.

33 Hunt 1913, II, p. 140.

34 Bryant 1997, pp. 96–7, in entry on *Bocca Baciata*; for a fuller discussion of Rossetti at this time, see Allen Staley, 'Pre-Raphaelites in the 1860s: I Rossetti', *British Art Journal*, IV, no. 3 (autumn 2003), pp. 5–16.

35 Quoted in Georgiana Burne-Jones, *Memorials of Edward Burne-Jones*, London, 1904, I, p. 159.

36 Watts to Layard, BM Add MSS 38987, f. 196, 10 September 1861, regarding Layard's role in organising the British section of the International Exhibition of 1862.

37 Jones *et al.* 1996, nos 13–15 by Leonée Ormond.

38 William Michael Rossetti, *Some Reminiscences*, London, 1906, I, p. 204.

39 *The Times*, 19 June 1860, p. 5.

40 *The Times*, 4 May 1861, p. 12.

41 *Fraser's Magazine*, July 1862, p. 70.

42 *Reader*, I (28 February 1863), pp. 278–9. This richly coloured Italianate phase of work continued through the 1860s, as the *Art Journal* critic noted (1867, p. 144): 'no Venetian work was ever more transparent, liquid or glowing'.

43 *Bianca* was one of Watts's best-known paintings, much exhibited and discussed, until it was lost to public view after the 1930s.

44 The South Kensington Museum (now the Victoria and Albert Museum) bought eighty photographs by Cameron in 1865 and she donated a further thirty-four; see Sylvia Wolf, 'Mrs. Cameron, Photographer, Priced Catalogue: A Note on her Sales and Process', in *Julia Margaret Cameron's Women*, Hew Haven and London, 1998, p. 21.

45 *Fortnightly Review*, II (1 October 1867), p. 475.

46 Watts to Tennyson, 8 August 1859, Watts Papers.

47 Bryant 1996, pp. 114–15.

48 Barrington 1905, p. 36.

49 *Blackwood's Magazine*, July 1867, p. 91. At the same exhibition at the RA, another musically inspired portrait appeared, *The Hon. Mrs. Seymour Egerton* (unlocated), in which the sitter was shown singing.

50 Watts to Harry Quilter, 27 December 1881 (private collection). Barrington 1905, p. 114, noted that Watts did communicate with the critic of *The Times* (Quilter) about the exhibition at the Grosvenor Gallery.

51 *Blickling Hall, National Trust*, London, 1987, p. 43.

52 Bryant 1997, no. 51, for a discussion of a later major version of the subject exhibited at the Grosvenor Gallery in 1877.

53 Watts 1880, p. 242.

54 *Art Journal*, 1867, p. 144.

55 Watts 1888, p. 92.

56 Watts exhibited it at the annual Grosvenor Gallery exhibition in 1882. See also Watts 1912, I, pp. 280–81.

57 Barrington 1905, p. 33.

58 Recorded in Watts Catalogue, II, p. 175.

59 Lady Dorothy Nevill recalled Watts watching Zazel on more than one occasion at the Westminster Aquarium, 'observing this artiste with the greatest interest … as a more perfect example of graceful human motion' (see *Leaves from the Note-Books of Lady Dorothy Nevill*, ed. Ralph Nevill, London, 1907, pp. 250–51). Although Watts's painting was head-sized, the interest in such performers suggests comparison with Edgar Degas's *Miss La La at the Cirque Fernando* (1879; National Gallery, London).

60 Spielmann 1886, p. 13.

61 Noted by Watts to an interviewer in 1895, see Friedrichs 1895, p. 77.

62 Barrington 1905, p. 120.

63 Friederichs 1895, p. 77.

64 Ibid.

65 Spielmann 1913, p. 124.

66 *The Windsor Magazine*, XIV (1901), pp. 13–14.

67 Spielmann 1905, p. 24; see also note of 20 August 1935 by Henry Hake of the NPG after a conversation with M.H. Spielmann on 19 August 1935 (NPG Archive).

68 Monkhouse 1882, p. 178

69 Watts to Mr Clifford, 12 March 1891 (Getty Centre).

70 Barrington 1905, p. 85.

71 *A Bright Remembrance: The Diaries of Julia Cartwright 1851–1924*, ed. Angela Emmanuel, London, 1989, p. 168 (regarding her visit to Watts on 10 July 1891).

72 *The Windsor Magazine*, XIV (1901), pp. 13–14.

73 Barrington 1905, p. 33.

74 Barrington 1905, p. 16.

75 *The Letters of Emelia Russell Gurney*, ed. Ellen Mary Gurney, London, 1902, p. 34.

76 Chesterton 1904, pp. 143–5.

77 Monkhouse 1882, p. 178.

78 Bryant 1996, p. 116.

79 Watts 1880, p. 247

80 Wilde to Watts, *c.*1881, Watts Papers.

81 Quoted by Spielmann 1905, p. 57.

NOTE TO THE CATALOGUE

Portraits are titled by the names the sitters had when they sat to Watts. As the artist did not count himself a professional portraitist, no sitter books exist; some dating is therefore approximate, based on available evidence. For each entry, known provenance is given with gaps indicated. Contemporary exhibitions are cited along with relevant (though not exhaustive) later exhibitions. The literature is selected with very few citations from secondary sources, unless they present new material. There is an emphasis on primary and contemporary sources, including Watts's own comments, and unpublished material.

CATALOGUE

1 MARY AUGUSTA, LADY HOLLAND
1843

Oil on canvas
806 x 640mm (31⅛ x 25¼")
Inscribed (in another hand)
'Mary Augusta, Lady Holland by Watts'
Lent by Her Majesty the Queen
(Photo: The Royal Collection © 2004,
Her Majesty Queen Elizabeth II)

Provenance Painted for Lord and Lady Holland; displayed
at Holland House; given by the sitter to HRH Edward,
Prince of Wales, in 1889; at Sandringham, later
Buckingham Palace and then Kensington Palace
Exhibition Watts Grosvenor 1881, no. 1; *The Victorian
Exhibition*, New Gallery, 1891–2, no. 225; Watts New
Gallery 1896, no. 12; *The First Hundred Years of the Royal
Academy, 1769–1868*, Royal Academy of Arts, London,
1951–2, no. 332; Watts London 1954, no. 6; Watts
London 1974, no. 3
Literature Liechtenstein 1874, I, p. 237; Cartwright
1896, p. 20; Erskine 1903, p. 181; Macmillan 1903,
p. 24; Ilchester Catalogue 1904, p. 35, no. 479 (a copy
after the original given to Mary, Lady Ilchester, by Lord
Rosebery); Watts Catalogue, II, p. 69; Watts 1912, I,
pp. 52, 66; Ilchester 1937, pp. 320–22
Engraving C.H. Jeens, 1873

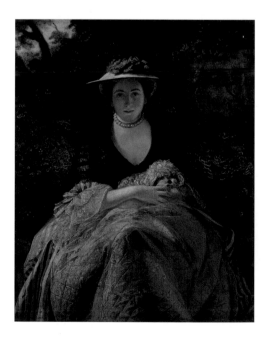

FIG. 26 *Nelly O'Brien*, Joshua Reynolds, c.1762–4,
oil on canvas, 1260 x 1100mm (50 x 43⅜"). Reproduced
by the kind permission of the Trustees of the Wallace
Collection, London

Of Watts's myriad depictions of Lady
Augusta Holland, this portrait, one of the
first of a long series, stands as the most
striking. Filled with southern light and
colour, the painting still seems to cast a
spell on the observer, much as the sitter
did on Watts when he arrived at the Casa
Feroni on the Via dei Serragli in Florence,
on 3 October 1843.

Mary Augusta (1812–89; usually
referred to as Augusta), daughter of the
10th Earl of Coventry,[1] had grown up mostly
in Italy, so that she possessed a certain
continental mode of behaviour often at odds
with English manners. In the 1820s she met
Henry Fox (1802–59), then beginning his
diplomatic career; their engagement and
marriage took place in 1833, followed by
postings in Vienna and Frankfurt. Ill health
dogged Augusta; she travelled to Italy, but
in 1838 suffered the stillbirth of a son. In
search of a warmer climate and more
congenial society, Henry sought a posting
in Italy. The Foxes established themselves
in Florence where he held the title of
Minister Plenipotentiary to the Court of the
Grand Duke of Tuscany from 1839 to 1846.[2]
In 1840 he succeeded to the title as 4th
Baron Holland.

Henry introduced Watts in a letter of
October 1843: 'Mr. Watts seems to me full
of genius and favourable ambition, without
any of the jealous, niggling, detracting vanity
of his brother artists. I have seen a good deal
of him, as he has made a beautiful sketch
of Augusta in oil.'[3] His general popularity
resulted in an invitation on 22 October to
stay at the Casa Feroni. By late October a
friend of the family wrote to say that Watts

> has done credit to their patronage by a great
> portrait of Ld. H. and two of Ly Augusta, one
> I thought of great merit, in the style of the
> *Chapeau de Paille*, from some lady having in
> a joke put one of the country hats on her
> head. Whatever may be its other merits,
> it is an extraordinary likeness.[4]

This painting is all about Italy, in its vibrant
explosion of colour, pale tonalities and blue
skies with the rolling hills of Tuscany in
the background. The indulgence in colour
is remarkable, with the figure in a pink
brocaded gown with matching pink bow
set against the blue sky. Watts himself
commented on the value of his new
environment when thinking of the dark,
bituminous paintings of Haydon: 'A visit to
sunny climates would have afforded Haydon
a valuable lesson … the rich colour of the
flesh that gives at once the key-note of the
picture, the out-of-door life so suggestive of
breadth and brilliancy.'[5] The recent cleaning
of Watts's portrait, which has revealed
these colours afresh, has also shown that a
surprisingly loose handling has enhanced the
informality of the image and that the artist
continued to apply paint, especially in the
area of the sky, even when the painting was
already in its frame.[6]

For all its informality, observers of the
time noted that the portrait also alluded
to traditions in older art, most notably
Rubens's *Le Chapeau de Paille*, the famous
seventeenth-century work (National Gallery)
then in the noted collection of Sir Robert
Peel. Casting the face into shadow by the
brim of a hat was a favourite device of
Reynolds, as seen in *Lady Chambers* (1752;
Iveagh Bequest, Kenwood), a work known
in engravings. Equally relevant is Reynolds's
Nelly O'Brien (fig. 26), well known, though
in the private collection of the Marquess of
Hertford at this time, which inspired the
overall conception of Watts's figure with its
frontal pose and large hat shading the eyes,
but most especially for the direct gaze of the
sitter. To Watts, who had recently seen a
large exhibition of Reynolds's portraits at
the British Institution,[7] such references were
natural and part of a visual confirmation of
his allegiance to a master whose portraits
exceeded the definitions of the genre.
The informality of Watts's work belies its
care and thoughtfulness as well as his

40

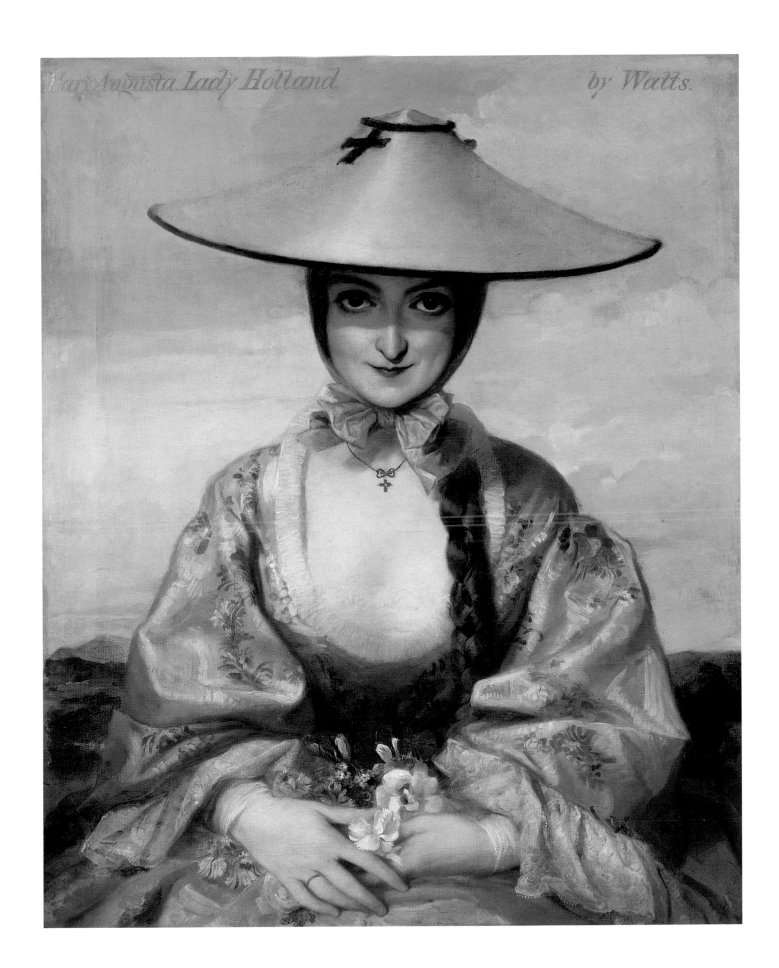

Mary Augusta Lady Holland by Watts.

aspiration to be seen as part of a great portrait tradition.

Casting Lady Augusta in the role of well-known portraits of the past flattered her intelligence. Watts's beautiful sitter appears in a fanciful dress, with a broad-brimmed 'capellina' straw hat, also known as a Riviera or Nice hat,[8] tied with a magnificent pink bow. One writer noted that such hats appeared on the peasantry of Nice,[9] and here it serves the same purpose to ward off the sun. But it also adds a distinctive and charming element, with the addition of a simple country hat confounding expectations of an aristocratic portrait.

The detail of the cross shape on the hat, repeated in Augusta's necklace, proclaims her sympathy with Roman Catholicism (to which she later converted). Her hands, which prominently display a ring (although not on the left hand), hold a cluster of country flowers as if she had just returned from walking. This vivid portrait of a new-found friend presents an individual whose impact on Watts changed his life forever.

The Hollands considered this portrait and others painted by Watts (for example no. 4) as part of a self-contained decorative group at the Casa Feroni since they ordered for each the same type of carved frame supplied by the firm of Carlo Conti on the Via Borgognissanti in Florence. When the paintings were moved to Holland House to be displayed there, this framing preserved their Italian associations.

1 Her father's great houses included Croome Court and Coventry House in Piccadilly; her mother, herself the daughter of the 6th Duke of St Albans, was the second wife of the earl, who had died in 1843.

2 *British Diplomatic Representatives 1789–1852*, ed. S.T. Bindoff, Royal Historical Society, London, 1934, p. 175.

3 Ilchester 1937, p. 320. Ilchester considered this sketch to be in his collection (ill. Dakers 1999, p. 11); it might equally be no. 2.

4 Ibid., p. 321 quoting a letter of General Robert Ellice to Dowager Lady Holland in London.

5 Quoted in Watts 1912, I, p. 68.

6 I am grateful to Rupert Featherstone, Senior Conservator, Royal Collection Conservation Studio, for discussing the technique of this work while restoration was in progress.

7 The exhibition opened by early June 1843 ('The Exhibition of Ancient Masters', *Athenaeum*, 10 June 1843, pp. 550–51; Watts left London in July. Another portrait by Reynolds that makes an interesting comparison was *Lady Caroline Fox* (from the Holland collection in London), who sits in a similar pose to Watts's Lady Augusta.

8 The term is still in use today, but Riviera hats (at least those sold now) take a different form with wide, turned-up brims. Also known as 'Leghorn' bonnets, from Tuscany, as seen in Gainsborough's *Mary, Countess Howe* (*c.*1764; Iveagh Bequest, Kenwood), a work that suggests comparison with Watts's portrait in its profusion of pink as well as in the detail of the hat; however, this painting was not widely known in the nineteenth century.

9 Cartwright 1896, p. 20. Watts might also have known of other portraits with these hats, such as John Jackson's portrait of his daughter (*c.*1810; Leeds City Art Gallery), which evokes associations with the established tradition of Italian genre scenes in British art.

2 MARY AUGUSTA, LADY HOLLAND

*c.*1843

Oil on canvas
480 x 380mm (18⅛ x 15")
Inscribed (in another hand)
'M, A, Lady Holland / by Watts.'
The Fenwick Charitable Trust

Provenance Painted for Lord and Lady Holland;
displayed at Holland House; passed to the Lilford
branch of the family, by descent to the Hon. Stephen
Powys in 1909; ... Sidney Sabin; Peregrine Sabin;
sold to the current owner, 2003
Exhibitions New Gallery, London, 1909, no. 165

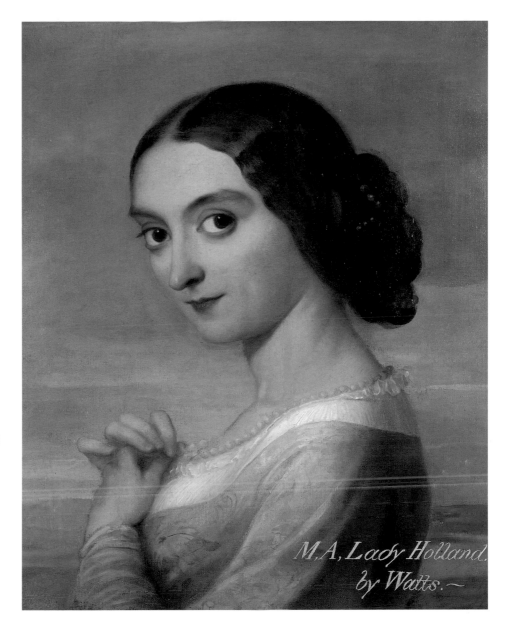

M.A, Lady Holland,
by Watts.—

When Lord Holland first commented on
Watts in October 1843, he mentioned that
he had 'made a beautiful sketch of Augusta
in oil'.[1] The oil sketch referred to is
traditionally thought to be the one still in
the family's collection (no. 3).[2] However,
it might just as easily be this more highly
finished portrait, which went into a different
branch of the family.[3] Either way, a second
letter of late October notes that Watts had
done two portraits of Lady Augusta, which
can be identified as the portrait in the Royal
Collection and probably this one; in both
the sitter wears what seems to be the same
floral patterned dress.

Augusta lived amid expatriate as well
as Italian society in Florence, but she had
no children. Watts's arrival provided much-
needed distraction; they were close in age,
she the older by four years. Noted for
her tiny stature and famously small feet
(sculpted in marble such were their fame),[4]
Augusta played to her strengths. Many of
her portraits are characterized by coquettish
looks and melting gazes. One wag thought
her 'under three feet in height – the very
nicest little doll or plaything I ever saw'.[5]

Augusta's doll-like qualities are in
evidence here. Watts painted her seated
in profile, but turning her head to look
outward. She sits before another landscape
view, a reminder that the artist had also

conceived a 'violent fancy for landscape'.
Her long hair is braided and wound into an
elaborate chignon, entwined with pearls.
Augusta raises her hands to toy with a loose
string of pearls, but all attention is on her
almost unnaturally prominent, expressive
eyes,[6] another notable element in her
arsenal of feminine charms. Watts was not
unique in his response to these charms, as at
least one other portrait of her, a miniature by
Robert Thorburn (1842; private collection),
shows her eyes as equally sultry and her

pose as equally self-conscious, with her tiny
hands dallying with the edges of her sleeves.[7]

1 Ilchester 1937, p. 320.
2 Watts Catalogue, II, p. 69. The two portraits are very
similar, but no. 2 is more fully worked, incorporating
the hands, and seems more highly finished.
3 Hence it was not in Mrs Watts's catalogue, nor was
it known to Ilchester.
4 Ilchester 1937, p. 318.
5 Quoted in Ilchester 1937, p. 167.
6 Ibid., pp. 158, 166.
7 Illustrated in Ilchester 1937, opp. p. 318.

3 **MARY AUGUSTA, LADY HOLLAND**
*c.*1843–4

Oil on canvas
622 x 470mm (24½ x 18½")
Inscribed (in another hand)
'Mary Augusta, Lady Holland'
Private collection

Provenance Painted for Lord and Lady Holland;
displayed at Holland House; by family descent
Literature Liechtenstein 1874, I, frontispiece; Erskine
1903, ill. p. 179, p. 181; Ilchester Catalogue 1904,
p. 231, no. 413; Watts Catalogue, II, p. 93

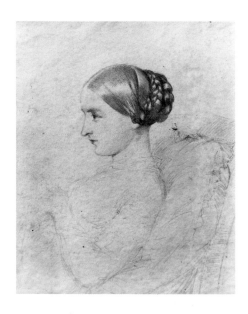

FIG. 27 *Mary Augusta, Lady Holland*, G.F. Watts,
print from a glass negative at The Watts Gallery,
Compton, Surrey. Original unlocated: 1843–6,
pencil on paper

This portrait of Augusta presents her in more
restrained mood in a more formal image,
less exuberant than the portrait from the
Royal Collection and less direct in its appeal
than the previous one. She sits contained
within an architectural framework, mostly
seen in a back view as her head turns,
leaving her face in profile. The open sky
leaves the view of her head clearly readable,
but the darker tone of the blue in the sky
and the shadow cast in the upper half of the
painting lend a subdued note to the image.

Augusta is again associated with
flowers, as she wears simple countryside
blossoms of jasmine and morning glories,
woven into a wreath. This natural 'crown'
and the more sober mood convey a dignity,
even stateliness, in a work that may have
been destined for the great galleries of
Holland House.

Watts probably conceived this portrait
as the pair to one of her husband. Henry Fox
seems to be conspicuous by his absence in
the portraiture of G.F. Watts. Partly this is
accidental, since the one oil portrait of him
was irreparably damaged in a fire at Holland
House in 1870. Yet it is abundantly clear
from the many painted and drawn images
of her (fig. 27) that Augusta attracted Watts
as an endlessly fascinating subject.

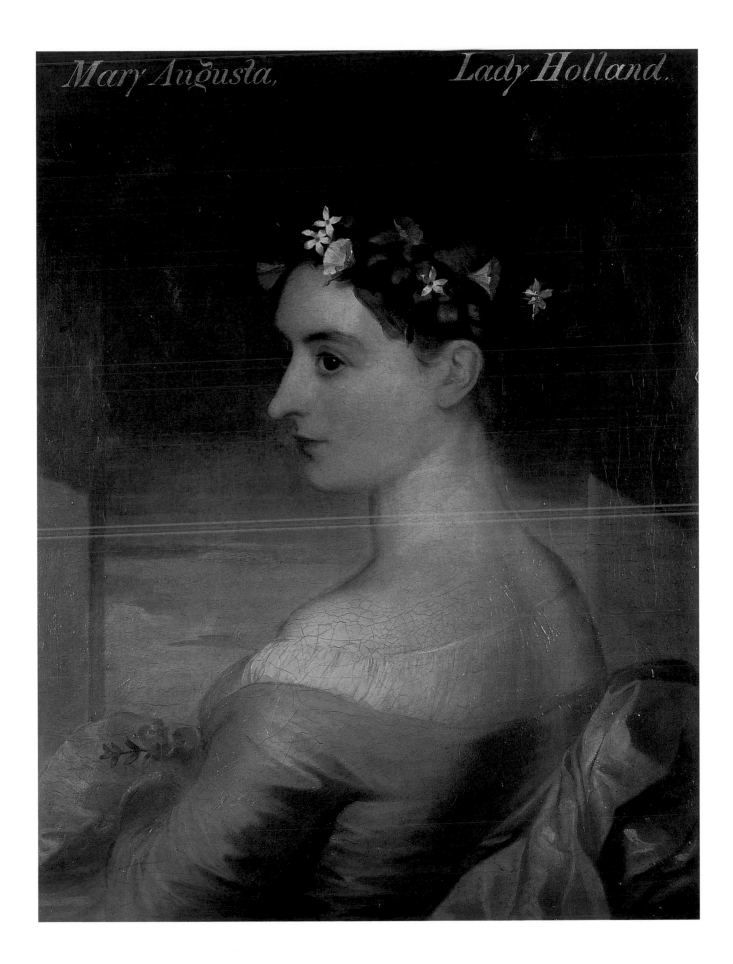

Mary Augusta, Lady Holland.

4 MARY AUGUSTA, LADY HOLLAND

*c.*1844

Oil on canvas
685 x 552mm (27 x 21¾")
Inscribed (in another hand)
'M. A. Lady Holland by Watts'
Trustees of the Watts Gallery

Provenance Painted for Lord and Lady Holland; displayed at Holland House; probably passed to the Lilford branch of the family; … Ffrench family of Monivea Castle, Co. Galway; bought by the Earl of Ilchester from a sale at Monivea Castle in 1939; Christie's, 3 May 1940, no. 103, bought Bell; returned to vendor (?) the Earl of Ilchester, by whom given to the Watts Gallery, 1940

Watts's myriad depictions of Lady Augusta Holland fall into two categories, those that were presentable to the public and those that are more private in their orientation. This work belongs emphatically to the latter category, as does no. 5.

Many private images of Lady Augusta by Watts do exist, such as the highly finished drawing of her sewing, feet propped up, with her little dog for company (private collection) or the oil sketch showing her reclining on her day bed (Watts Gallery). Some stayed with her; some Watts kept and some vanished only to turn up in the art market. Why this particular painting should have left the collections at Holland House is perhaps not difficult to deduce. A painting by a young artist showing the wife of a peer, herself a woman of a certain position, in *déshabillé*, loosening and combing through her hair with her fingers, was probably never going to be a suitable image for public display in the ancestral home.

The work, like others from the Hollands' collections, retains its Italian frame, a gloriously Baroque confection that suits the image it surrounds. These similarly framed images of Augusta seem intended to be seen as a series, depicting her many aspects. Here she appears before the same Italian sky seen in other portraits, and her loose pale grey dress is timelessly simple. The colouring is restrained, the paint thin. Focus is on the activity of her combing through her long tresses, usually seen bound up in elaborate braided coiffeurs. Watts was privy to her private realm and this visual evidence showed him to be very much part of it.

Yet it should be remembered that there were precedents for artists to enter the private realm of women, showing them in openly alluring poses, as in Venetian art of the late Renaissance. Depictions of Venus toying with her hair could also be adapted to the portrayal of courtesans. In English art of the seventeenth century Peter Lely essayed this type,[1] and in French art of the late eighteenth century François Boucher painted Madame de Pompadour at her toilette in typically Rococo manner, but it is rare to find such images in English art at this date in the 1840s.[2] Not until the Aesthetic era of the 1860s, a generation later, did artist and model conspire to produce portraits of women combing through their hair in such sensual and suggestive images, particularly in the works of Rossetti.[3] For Watts women's hair in both complicated styles (no. 15) and freely unbound (no. 40) continued to be a feature he went out of his way to exploit.

Watts and Lady Augusta enjoyed a friendship that went beyond the bounds of artist and patron. One senses that she was crucially involved in the creation of her portraits. Ironically, when she first married in 1833, her own husband told his mother that although Augusta's eyes were very beautiful, her figure was bad and 'having never been to Paris she had not learnt to make the best of it', adding (for good measure) 'poor little soul, her dress has hitherto been worse than Cinderella'.[4] But like Cinderella, ten years later, when Augusta met Watts, she found someone who could reinvent her as a confident beauty. He painted and drew her in many different guises, emphasizing her famously gorgeous auburn hair[5] and large expressive eyes. Their friendship revolved around the presentation of Augusta as a striking and stunning woman. Indeed, in her childless life, with a husband otherwise occupied, Watts performed an essential role.

1 See the portrait of Louise de Keroualle, Duchess of Portsmouth, in *Painted Ladies: Women at the Court of Charles II*, exh. cat. National Portrait Gallery, London, 2001, no. 49 (entry by Julia Marciari Alexander).
2 At around the same time Watts painted another fashionable woman in private repose in the stunning portrait of Madame Leroux (*c.*1845; unlocated, ill. in Gaja 1995, p. 45).
3 As, for example, Rossetti's *Lady Lilith* and *Woman Combing her Hair*; see Bryant 1997, nos 6, 33.
4 Ilchester 1937, p. 158.
5 Ibid., p. 373

M.A.Lady Hōw..
By Neille..

5 MARY AUGUSTA, LADY HOLLAND

*c.*1844–5

Pencil on paper
200 x 149mm (8 x 6"), drawing mounted
in fitted wooden case with silver hinges,
corners and lock
*Ashmolean Museum, Oxford. Purchased
(Hope Fund) with the assistance of the National
Art Collections Fund and the Friends of the
Ashmolean, 2003*

Provenance Drawn for the sitter; … J.G. Archer;
Maas Gallery, 2003; acquired by the Ashmolean Museum

This newly rediscovered work encapsulates the relationship between the artist and his patron in an unexpectedly intimate and undeniably fascinating manner. Unique in Watts's output, with its elaborate presentation within a velvet-lined case, it is an important rarity.

Of all the images of Lady Augusta by Watts, this one, hitherto unpublished, is the most suggestive, with the sitter gazing provocatively outwards. In style and format it can be compared to the series of drawings of the Hollands' close friends (nos 9–12) carried out during candlelit evenings at the Casa Feroni. Watts executed this group to present to his hosts as friendship offerings. Like those drawings, this one is precisely drawn with sharp pencil lines, particularly in the delineation of the face and hair, with looser treatment of the dress and outer areas. Subtle shading draws attention to the face. But in this work the artist shows more of the figure with its elegant nonchalant pose, and one detects a level of sophistication, akin to that of Ingres's portrait drawings, in the psychological assessment of the sitter through pose, gesture and the tilt of the head.

The sense of the enclosure of the boudoir lends an aura of secrecy to the depiction. Augusta's dress, open-necked and *décolleté*, is daringly revealing, suggesting a clandestine meeting. There is also a voyeuristic sense of being privy to a side of Augusta's life that was closed to all, even to her husband.

This drawing had no public dimension. We know it belonged to Augusta herself, thanks to the survival of the case, with her initials, A.M. (a reversal of her original given names, Mary Augusta, into her own preferred usage). Otherwise, there might indeed be a question about whether the drawing was for her husband or indeed a secret lover. But it was her own property, which she kept securely locked. When back in London, she arranged for the fine case in satinwood with ornamental silver mounts (marked '1846/7') to be made.[1] An intricate design allowed the drawing to be set into the case or removed, accentuating the complex role the work of art played as an object of contemplation.

Kept secret, this drawing served as a memento of how Augusta appeared during the heady days of her close friendship with the young artist in Italy who depicted her repeatedly over a period of three years. These paintings and drawings elevated her to a position of muse to an artist, recalling Romney's obsession with Emma Hamilton.[2] One of Watts's most perfect drawings, this portrayal of an intimate friendship is a rare survival.

1 Also marked 'Nock Williams, London', with the silver lock by Sampson, Mordaunt and Co.
2 Later Rossetti's relationships with Elizabeth Siddal and then Jane Morris operated on a similar level.

6 AUGUSTA WILSON-FITZPATRICK

1844

Oil on canvas

2083 x 1435mm (82 x 56½")

Tate. Bequeathed by Maj. W.R.D. Mackenzie 1952

Provenance Family of the sitter, including Hon. Mrs Lewis Wingfield in 1905, then by descent to Mrs Mackenzie, the granddaughter of the sitter; given by her husband, Major W.R.D. Mackenzie, to the Tate Gallery in 1952
Exhibitions Memorial Exhs, London 1905, no. 136 and Newcastle 1905, no. 149; Watts London 1954, no. 11; *The Swagger Portrait: Grand Manner Portraiture from Van Dyck to Augustus John, 1630–1930* (catalogue by Andrew Wilton), Tate Gallery, London, 1992, no. 58
Literature Watts Catalogue, II, p. 34; Ilchester 1937, p. 325; Gaja 1995, p. 27

FIG. 28 *Augusta Wilson-Fitzpatrick*, G.F. Watts, *c*.1844, pencil on paper, 470 x 330mm (18½ x 13"). By courtesy of Nicholas Bowlby

Born in Ireland, Augusta Fitzpatrick (1810–99), the daughter of Revd Archibald and Lady Susan Douglas, married John Wilson (1807–83) in 1830 in Dublin. Her husband was the illegitimate son of John Fitzpatrick, 2nd Earl of Upper Ossory. He took the family name Fitzpatrick in 1842 (on the death of his two legitimate half-sisters) and succeeded to the family estates; he had served as a Liberal MP. In Italy by 1844, the Fitzpatricks, who were related to the Hollands by marriage, were frequent visitors to the Casa Feroni and the Villa Medici at Careggi in the hills outside Florence.

This impressive painting, one of the earliest full-length portraits by Watts, was among the major works produced by the artist while under the wing of the Hollands in Italy. Lord Holland played a crucial role in encouraging Watts or, as he put it in a letter of March 1844, 'I have worried him into painting portraits.' He mentioned this particular painting as one of the products of that encouragement.

Watts readily adopted the grand manner format for this portrait in the knowledge that Augusta had married into a family who owned a notable collection of works by Joshua Reynolds. Indeed Reynolds had been a personal friend of John's father, the 2nd Earl. Augusta's husband had already come into possession of works such as Reynolds's portrait of his older half-sister, *Lady Gertrude Fitzpatrick as 'Collina'* (1780; Museum of Art, Columbus, Ohio).[1] For Watts the works of Reynolds were fresh in his mind on arriving in Italy since a major gathering of the master's paintings had taken place at the British Institution in 1843 shortly before his departure for Italy.

Watts first executed a precise pencil drawing of Augusta (fig. 28) turning away, with a focus on the extended neck and coiling tendrils of hair almost in the manner of Fuseli. Her long neck clearly fascinated the artist. As in his own self-portrait (no. 8), Watts included an extensive landscape background, here showing Florence, with the Duomo easily identifiable. The setting is richly characterized with Italian furniture, such as the vase and marble pedestal, and also includes an exotic bird, a detail occasionally used by Reynolds (fig. 35, p. 108) to animate the depiction. Partially wrapped in a paisley shawl contrasting with the pale dress, Augusta poses slightly awkwardly. Yet Watts managed to resolve the various elements of the composition in this decidedly approachable grand manner portrait. The specificity of Augusta's face, without an idealized gloss, prompted Lord Holland's assessment that the painting of her was 'extremely like, and yet will not hand her down to posterity as very beautiful!!!'

The Fitzpatricks settled in Ireland at Grantstown Manor, Queens County, with John resuming a parliamentary career in 1847. Augusta had one son in 1848. In 1869 her husband was created Baron Castletown of Upper Ossory; part of the great family collection of Reynolds's portraits came to them, with this work by Watts hanging alongside in its splendidly ornate Italian frame.

1 Some of the Upper Ossory paintings were in the collection of the Hollands, and when the 3rd Lord Holland died in 1840, these works went back to the family.

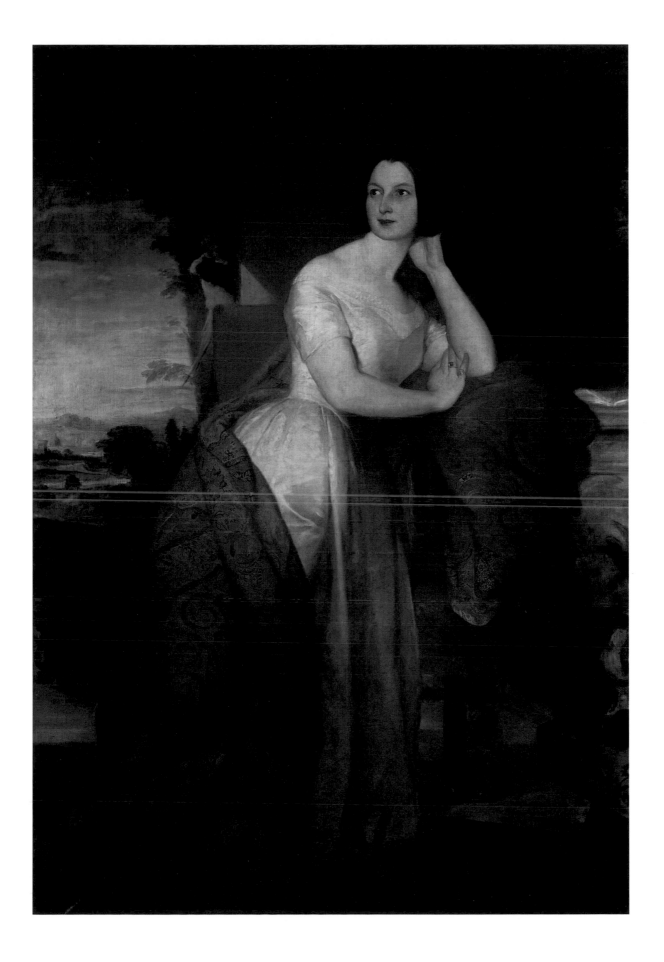

7 LADY DOROTHY WALPOLE
1844

Oil on canvas
724 x 572mm (28½ x 22½")
Inscribed (on hair ribbon)
'G F Watts Florence 1844'
Private collection

Provenance Collection of the sitter; by descent to
the present owner
Exhibitions Memorial Exhs, London 1905, no. 6;
Manchester 1905, no. 13; Newcastle 1905, no. 15
Literature Spielmann 1905, pp. 18, 19; *Leaves from
the Notebooks of Lady Dorothy Nevill*, ed. Ralph Nevill,
London, 1907; Watts Catalogue, II, p. 115; Edmund
Gosse, *Lady Dorothy Nevill: An Open Letter*, London,
1913, p. 5; Ilchester 1937, p. 339; Guy Nevill, *Exotic
Groves: A Portrait of Lady Dorothy Nevill*, Wilton, 1984,
p. 43 (referred to but not illustrated)

Lady Dorothy (1826–1913), the youngest
daughter of Horatio Walpole, 3rd Earl of
Orford (1783–1858), grew up at Wolterton
Hall, a Palladian house in Norfolk. She
was a descendant of the great collector,
Horace Walpole of Strawberry Hill. Watts
also portrayed her brother, Horatio William
(no. 12). While in Florence, the family lived
in grand style at the Palazzo San Clemente
and were on friendly terms with the
Hollands and with Watts.[1]

By her own account, both her parents
were 'artistic' in their tastes, with visits to
the studios of artists such as Overbeck and,
in Rome, the sculptors Lawrence Macdonald
and Pietro Tenerani as part of their itinerary.[2]
Along the way members of the family sat
for portraits in oil and in marble. Watts's
portrait shows Dorothy at the age of
eighteen. Her sense of style and unusual
manner were apparent from an early age.
Several years before, Lord Holland wrote of
Lady Dorothy that she 'dresses and conducts
herself in a way, if not to obtain admiration,
at least to attract attention and notoriety'.
Closer in time to the portrait, when she was
seventeen or eighteen, he wrote again, 'All
the ladies with daughters come or coming
out are frantic at the notice she attracts by
her horsemanship, her strange attire, and her
total absence of shyness.'[3] All her life she
possessed an unconventional manner and
outlook, once saying that 'the first principle
of society should be to extinguish bores'.[4]

Watts painted Dorothy in a manner
intended to refer to older art, an appropriate
choice considering her family's current
artistic interests and the famed ancestral
collections at Strawberry Hill, Mannington,
Wolterton and especially Houghton Hall in
Norfolk. With the near-profile pose and

quattrocento-style red velvet dress, the
portrait recalls Renaissance models. The
curious positioning of her hands, akin to
Watts's portrait of Lady Augusta (no. 2),
lends a sense of immediacy to the portrait.
The handling is fairly detailed, allowing
considerable delicacy of touch as seen in
the tiny white flowers that form part of
her hair decoration. Here Watts signed and
dated the work (suggesting the occasional
practice of Reynolds). There are parallels
with continental portraiture in the
Nazarene-like precision of the painting.

Dorothy married Reginald Nevill in
1847. She enjoyed a fascinating life as a
society hostess, horticulturalist (creating a
notable garden at Dangstein in Sussex) and
a connoisseur and collector of eighteenth-
century French decorative arts, as recorded
in her portrait by Henry Graves, exhibited
in the Royal Academy in 1856, in which
she sips tea from her Sèvres tea service.[5]
In 1894 she wrote a study of her family's
collections, *Mannington and the Walpoles*,
and in old age she produced volumes of
memoirs, carried on by her son, detailing
her long life. Perhaps surprisingly, she had
a huge fan in Edmund Gosse who wrote
an affectionate memoir of her, attempting,
as he noted, the insuperable task of
'presenting the evanescent charm and
petulant wit' of Lady Dorothy.

1 Lady Dorothy Nevill, *My Own Times*, London,
1912, p. 29.
2 Lady Dorothy Nevill, *Under Five Reigns*, London,
1910, p. 66.
3 Ilchester 1937, p. 339.
4 Edmund Gosse, *Lady Dorothy Nevill: An Open Letter*,
London, 1913, p. 16.
5 Ill. in Simon Houfe, 'Cult of the Curious, Lady Nevill's
Collections', *Country Life*, 20 April 1989, p. 224.

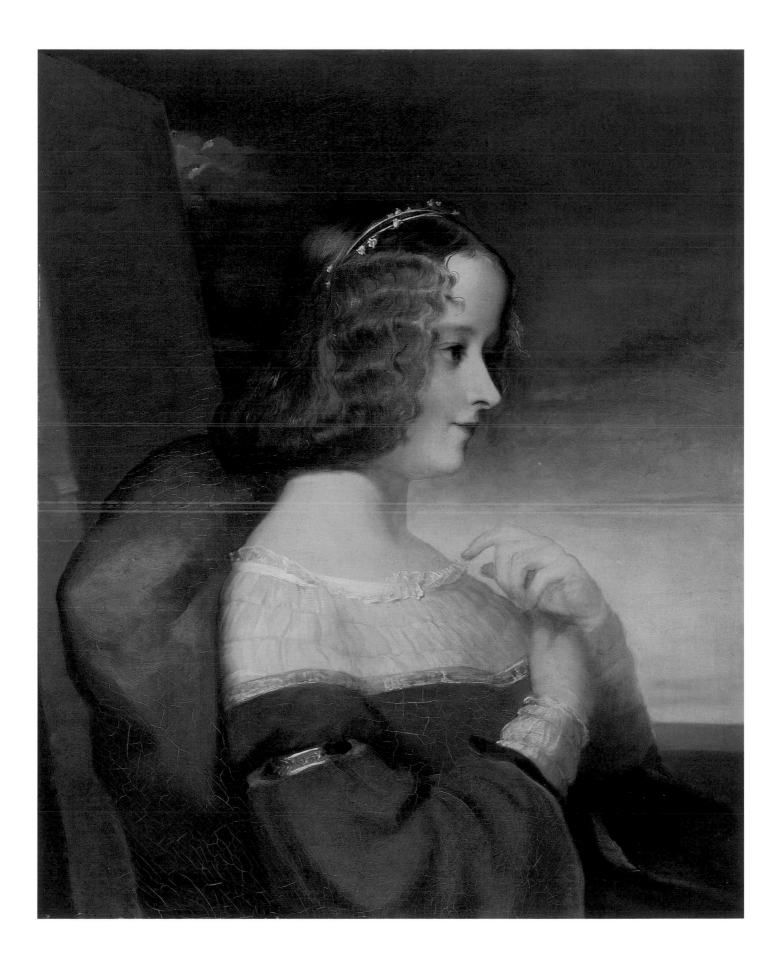

8 SELF-PORTRAIT

1845

Oil on canvas
864 x 660mm (34 x 26")
Inscribed (in another hand)
'George Frederick Watts by himself'
Private collection

Provenance Given by Watts to Lord and Lady Holland; displayed at Holland House; by family descent
Exhibitions *British Portraits*, Royal Academy of Arts, London, 1956–7, no. 459; *British Self Portraits, c.1580–1860*, The Arts Council of Great Britain, London, 1962, no. 81; *In the Public Eye: Treasures from the West of England*, organised by Sotheby's in association with the Historic Houses Association, Holborne Museum of Art, Bath, 2002, no. 45
Literature Liechtenstein 1874, I, p. 235; Erskine 1903, pp. 178, 183; Macmillan 1903, p. 82; Ilchester Catalogue 1904, pp. 49–50, cat. no. 59; Spielmann 1905, p. 19; Watts Catalogue, II, p. 167; Watts 1912, I, p. 53; Ilchester 1937, p. 337, ill. opp. p. 338; Staley 1978, pp. 59, 65; Millar 1985, p. 38; Gaja 1995, p. 31, 88; Dakers 1999, p. 12

Watts arrived in Florence in July 1843. *En route* to Italy he had met General Robert Ellice, who urged him to contact his friend Henry, 4th Lord Holland. Watts failed to do so and when he ran into Ellice, a more specific invitation was issued for 3 October 1843. Watts attended a dinner at the Florentine townhouse of the Hollands, the Casa Feroni; by 22 October he had moved into what was then the base for the English legation. As has been said, 'he came for a few days, and stayed for several years'.[1] He impressed Lord Holland initially as an artist 'full of genius and favourable ambition'. Watts attempted studies in the technique of fresco, with an eye to his eventual return to London and government patronage to participate in the decorations of the new Palace of Westminster. But he soon became sidetracked by portraiture, at the urging of his hosts, who probably wanted to see some tangible results of his labours.

In February 1845 the Hollands hosted a fancy dress ball at the Casa Feroni. One guest, tiring of his heavy armour, deposited it in a room used by Watts as a studio, where the artist tried it on and decided to paint this portrait. The idea of the figure in armour derives from prototypes in Renaissance art, as he might have seen in the public galleries of Florence. In this romantic image Watts cast himself as a character from the past, evoking associations with the Medici era. The same interest also sparked off a series of subject paintings of

historical and literary subjects from the Italian past.

Like the portrait of Augusta Wilson-Fitzpatrick, the landscape element provides an important dimension to its meaning. Watts had become enamoured with the Tuscan landscape, executing a number of independent views. By incorporating a landscape into the portrait, he paid further allegiance to his hosts, since the view shows the environs of the villa at Careggi.[2] The sunset view to a distant horizon also sets the mood of the portrait, with the sky shot through with autumnal colours. The reflective character of the image is further emphasized by Watts's own wary gaze.

According to the catalogue of the Ilchester collection, he gave the self-portrait as a token of his affection and gratitude to his hosts. (A study in watercolour remained in the artist's collection, later sold Sotheby's, Summers Place, 27 October 1999, no. 1101). It is the first completed self-portrait by Watts; earlier ones, such as the painting at the Watts Gallery showing the artist aged seventeen, are unfinished. This self-portrait from his Italian sojourn initiated a series of revealing self-images replete with associations of the past, which he produced throughout his life.

1 Ilchester 1937, pp. 320–1.
2 Gaja 1995, ill. 48, for a drawing of La Torre di Careggi, used for the view in the portrait.

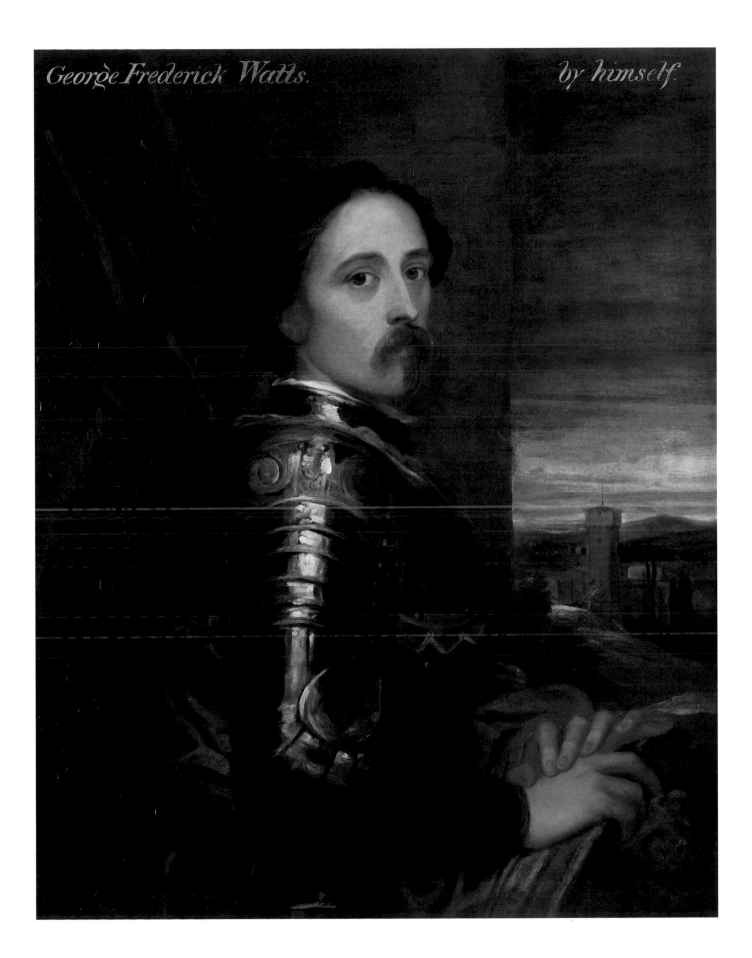

George Frederick Watts. by himself.

9 MARGARET, MADAME DE FLAHAULT

*c.*1843–6

Pencil on paper
254 x 210mm (10 x 8¼")
Private collection

Provenance Drawn for Lord and Lady Holland in
Florence; displayed at Holland House in Kensington;
by family descent
Literature Erskine 1903, pp. 181, 182 (ill.); Ilchester
Catalogue 1904, p. 200, no. 307; Ilchester 1937, p.359

Despite her name, Madame de Flahault
(1788–1867) was born a Scot, the Hon.
Margaret Mercer Elphinstone, daughter of
Admiral Lord Keith, and she later inherited
the title Baroness Keith in her own right.
In 1817 she married August Charles Joseph,
Comte de Flahault-de-la-Billarderie, son of
the Comtesse de Flahault and her lover
Prince de Talleyrand.[1] August had been an
aide to Napoleon and the family possessed a
collection of fine French furniture and works
of art, as well as Old Master paintings, which
are now part of the collections at Bowood.
In her youth Margaret knew Byron, who
gave her a Turkish costume in which she sat
for several portraits.

Madame de Flahault, who lived on the
continent and in London, was an intimate of
the circle of the 3rd Lord and Lady Holland.
Her gossipy correspondence with them is
much drawn upon in *The Chronicles of
Holland House* (1937). She also figured as a
visitor and friend of the younger Hollands,
Henry and Augusta, in Florence in the 1840s
and delivered tart opinions on their visitors.
She famously hated Count Pozzo di Borgo to
the point that Henry requested his mother
not to mention anything he reported back
to her, noting that she 'Is systematically
open-mouthed against her foes'.[2] In his
portrait drawing Watts presents the image
of a mature woman of the world, fixed in
her trenchant opinions.

This work formed one of the approxi-
mately forty portraits of the friends of Lord
and Lady Holland drawn by Watts during
the evenings at the Casa Feroni and the Villa
Medici at Careggi. Watts reputedly drew
these portraits by candlelight, with the
detailed rendering of the faces indicating
closer study accompanied by soft shading in
pencil. One writer singled this drawing out
for specific comment due to the delicacy

of treatment, particularly in the rendering
of the temples and deeply sunk eyes.[3] There
is usually a much looser sketching-in of
the upper part of the figure, sometimes
showing it in half-length, as in the drawing
of Madame de Flahault, and in others a
suggestion of the shoulders or even just
the neck. Even with these slight variations
in presentation, the drawings relate to
each other as a group in style and in format.
After being taken back to London, they
were displayed as a group at Holland
House, hanging at the top of the Great
Staircase in the ante-room leading to the
grand Gilt Room.

Watts certainly knew the traditions of
portrait drawing, both on the continent,
most notably in the work of Ingres, and in
England.[4] In his early career he had executed
small portrait drawings, but by this time
an increased sensitivity in the reading of
personality and character is evident. Indeed,
in meeting a wide range of European society
figures, including many diplomats and
members of the Italian nobility, Watts was
able to glean an awareness of the higher
echelons of society, learning about another
way of life by listening to and observing
its members. This understanding comes
through in these portrait drawings, not least
in this depiction of Madame de Flahault,
from whom Watts might have heard tales
of Byron at first hand.

1 Their daughter married the 4th Marquess of
Lansdowne; for the family's history and related portraits,
see James Miller, *The Catalogue of Paintings at Bowood
House*, London, 1982, especially pp. 8, 26–7.
2 Ilchester 1937, p. 204.
3 Erskine 1903, p. 181; for illustrations of others in this
group see Gaja 1995, pp. 50, 52.
4 Staley 1978, pp. 59–60, nos 4, 5.

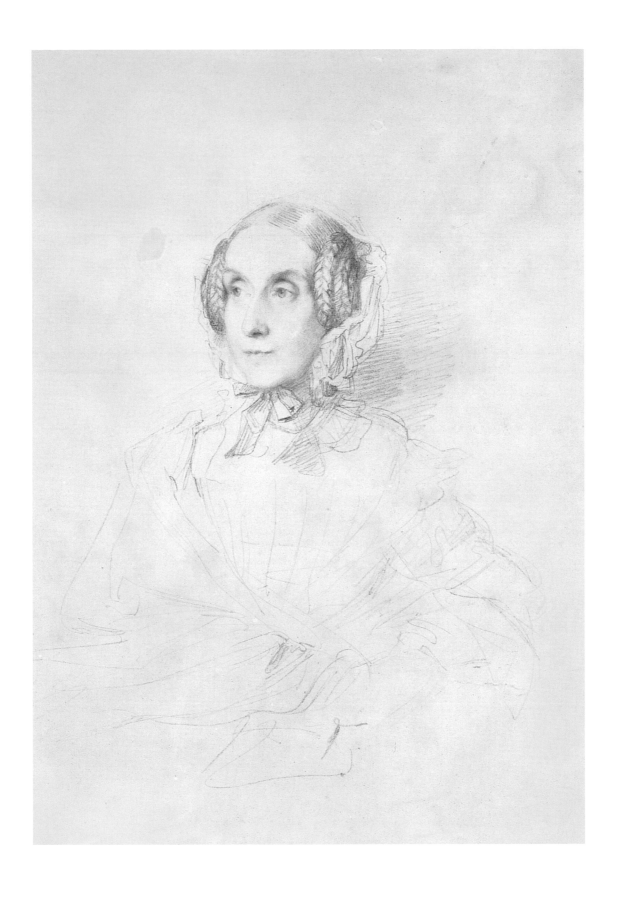

10 EDWARD CHENEY

*c.*1843–4

Pencil on paper
241 x 178mm (9½ x 7")
Private collection

Provenance Drawn for Lord and Lady Holland;
displayed at Holland House in Kensington;
by family descent
Literature Ilchester Catalogue 1904, p. 202, no. 330;
Ilchester 1937, p. 364

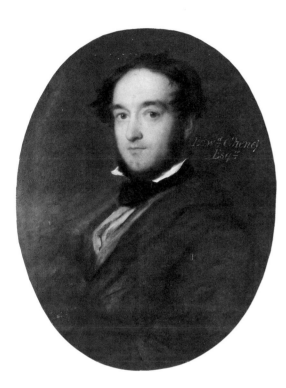

FIG. 29 *Edward Cheney*, G.F. Watts, *c.*1843–4,
oil on canvas, 610 x 483mm (24 x 19"). Original
unlocated

Watts's friendship with Edward Cheney (1803–84) endured beyond the years he spent in Italy. Cheney personified the type of connoisseur collector, and member of the Fine Arts and Cosmopolitan Clubs, with whom the artist found deep sympathies and a rich seam of common interests. Cheney is still renowned today for his innovative collecting in the area of eighteenth-century Venetian Italian art, notably that of Tiepolo,[1] and in his acquisition of a variety of works of sculpture.[2]

Cheney initially pursued a military career as had his father, but eventually he took up residence in Italy, publishing a Gothic novel, *Malvagna, or the Evil Eye*, in 1838. Like his elder brother, Robert Henry,[3] he dabbled in watercolour painting, but this was a mere sideline compared to his collecting interests. Richard Monckton Milnes described Cheney as belonging to that 'generation of Englishmen who regarded Italy as a museum created and preserved for their pleasure and edification'.[4] By 1842 he had already acquired many drawings by Tiepolo. By the time the German art historian Waagen visited him in London in the 1850s at his residence in Audley Square, it required six pages to cover the collection, which ranged from five works by Titian and another five by Tintoretto to Spanish masters and early Renaissance objets d'art.[5] He apparently owned the hat of the last Doge of Venice.

To Lord Holland Cheney was his 'dearest friend' from the 1820s onward. Holland overlooked Cheney's tendency to suffer from low spirits, which sometimes made him morose and difficult.[6] Watts's drawing shows Cheney holding a pencil, gazing sideways, seemingly in the act of drawing. The areas most fully worked are the face

and, significantly, the hand, showing subtle shading, while much looser, almost scribbled lines, delineate the jacket and tie. On the whole, the drawing is more fully considered than many of the others in the group, perhaps due to Watts's greater engagement with the portrayal of a friend. Watts's unlocated oil portrait (fig. 29) shows Cheney in much the same garb, but gazing directly outward.[7] Interestingly, many of Cheney's drawings by Tiepolo, which Watts probably knew, were head studies,[8] an indication that the full range of the possibilities of portraiture attracted both men.[9]

1 Haskell 1976 (1980 edn), pp. 138, 140, 183, 201–2, 212.
2 Tim Knox in his lecture, 'Edward Cheney's Collection of Sculpture at Badger Hall', at the conference, *Collectors in the Round: British Collectors of Sculpture from the 18th century to the 20th century,* Wallace Collection, May 2003, discussed Cheney's collecting of Italian Renaissance sculpture and small bronzes, as well as antique and neoclassical marbles.
3 Robert Henry, who inherited the family seat, Badger Hall, in Shropshire on the early death of his father, was a noted early photographer; see the discussion by Marjorie Munsterberg in Richard Pare, *Photography and Architecture 1839–1939*, Canadian Centre for Architecture, Montreal, 1982, p. 221.
4 Quoted in Haskell 1976 (1980), p. 138. Cheney was well connected, friendly with Rawdon Brown and Ruskin, who acknowledged his help in *The Stones of Venice* (1851–3).
5 Waagen 1857, pp. 170–75.
6 Ilchester 1937, p. 364.
7 Watts Catalogue, II, p. 36.
8 For example, *Study of an Oriental Head* (ill. in the Katrin Bellinger catalogue, summer 1994, no. 28), one of the drawings acquired in 1842, formerly in the collection of Canova.
9 In 1861 Cheney wrote a scholarly article on the portrait of a woman then considered to be Beatrice Cenci, by Guido Reni, in the journal of one his favourite clubs, The Philobiblon Society.

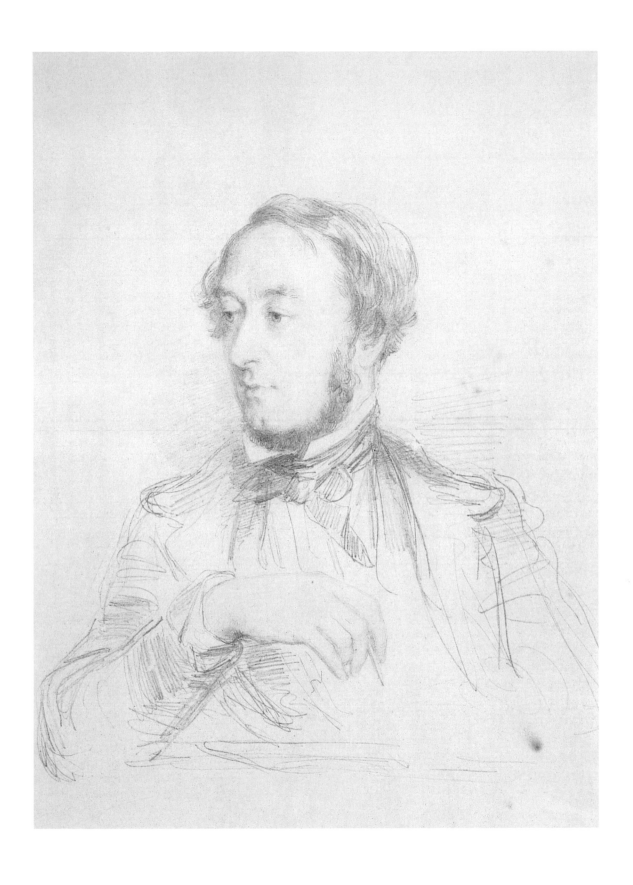

11 GEORGIANA, LADY DOVER

c.1843–6

Pencil on paper
254 x 216mm (10 x 8½")
Private collection

Provenance Drawn for Lord and Lady Holland in Florence; displayed at Holland House in Kensington; by family descent
Exhibitions Watts London 1954, no. 102
Literature Liechtenstein 1874, II, p. 13; Erskine 1903, p. 178; Macmillan 1903, p. 24; Ilchester Catalogue 1904, p. 200, no. 317; Ilchester 1937, p. 359

Staying with the Hollands in Florence gave Watts instant access to a glamorous and intellectual society of continental diplomats, as well as wealthy and well-connected English travellers. Lady Dover, seen here in her mid-forties, had long-standing connections with the art world dating back to the first years of her marriage. When Watts portrayed her, she possessed a major collection of Old Master and British art as well as the contemporary history painting, *The Trial of Queen Caroline in the House of Lords* (1820–23; NPG) by George Hayter,[1] all displayed at her London residence, Dover House, in Whitehall.

In 1822 Lady Georgiana Howard (*c.*1800–1860), daughter of the 6th Earl of Carlisle and niece of the Duke of Devonshire,[2] married the Hon. George Agar Ellis (1797–1833), later 1st Lord Dover.[3] Her husband, a young Oxford graduate noted for intellectual and political success, attained election to the Society of Antiquaries at the tender age of nineteen; he had served as a Whig member of Parliament by the time he was twenty-one. Agar Ellis supported advanced causes and strongly promoted the arts as a director of the British

Institution. In commissioning the young artist George Hayter to paint a group portrait (in which he himself appeared) in 1820, depicting the most notorious political event of the Regency era, he established his credentials as a patron of contemporary art.

A prime mover in the formation of a national gallery with his own collection of Dutch and Flemish painting, George Agar Ellis also featured in one of the oil sketches called *Patrons and Lovers of Art* (NPG), by the Dutch artist Pieter Christoffel Wonder.[4] This sketch related to his larger composition *The Imaginary Picture Gallery* (1830; private collection), showing a group of British collectors.[5] In fact, Georgiana also appeared in this important assemblage of connoisseurs, represented vicariously by Thomas Lawrence's portrait of her with her infant son.[6] The central placement of her image in this composition is so prominent, seen as it is in company with Old Master paintings and masterpieces of the British school, that it seems almost certain that she appeared here for her own sake, not just as the wife of one of the sitters. In 1833 her brilliant husband (one of the founder Trustees of the National Gallery) died at the age of only thirty-six; she never remarried but continued to support the arts by lending works by Rembrandt, Rubens, Caravaggio and many others to exhibitions arranged by the British Institution.

When Watts drew this now plump, middle-aged woman, he characterised her kindly and objectively, with a fashionable swathe of clothing and lace cap upon her head. In common with the treatment of most of the other drawings, she turns her head to the side, indicating that the artist captured his sitters informally as they congregated after dinner at the Casa Feroni.

One senses, too, that Watts was careful to assimilate what he could; in this case one imagines he was particularly responsive to the conversation of Lady Dover who was then the custodian of a significant collection of art.[7]

1 Barbara Coffey [Bryant], *An Exhibition of Drawings by Sir George Hayter and John Hayter*, Morton Morris & Company, London, 1982, p. 8; Walker 1985, I, pp. 608ff., no. 999.
2 Georgiana's life up to the death of Lord Dover is chronicled in *Three Howard Sisters: Selections from the Writings of Lady Caroline Lascelles, Lady Dover and Countess Gover*, London, 1955. She and her sisters were close to their uncle, the Duke of Devonshire, a great collector himself.
3 Agar Ellis, a noted historian, also catalogued art as in his anonymous and privately printed *Catalogue of the Principal Pictures in Flanders and Holland* (1822).
4 Walker 1985, I, p. 617, no. 794.
5 General Sir John Murray gave him the commission; see Walker 1985, I, pp. 615–18; ill. in II, pl. 1595.
6 Walker (1985, p. 617) identified the painting, which is now in a private collection. Lawrence also painted her husband (Yale Center for British Art).
7 As well as owning Hayter's *Trial*, she also possessed Rembrandt's *Burgomaster Six* (now Buscot Park) and its pair, three works by Canaletto, and others by Carracci, Rosa, Bassano, Veronese, Reni and Murillo.

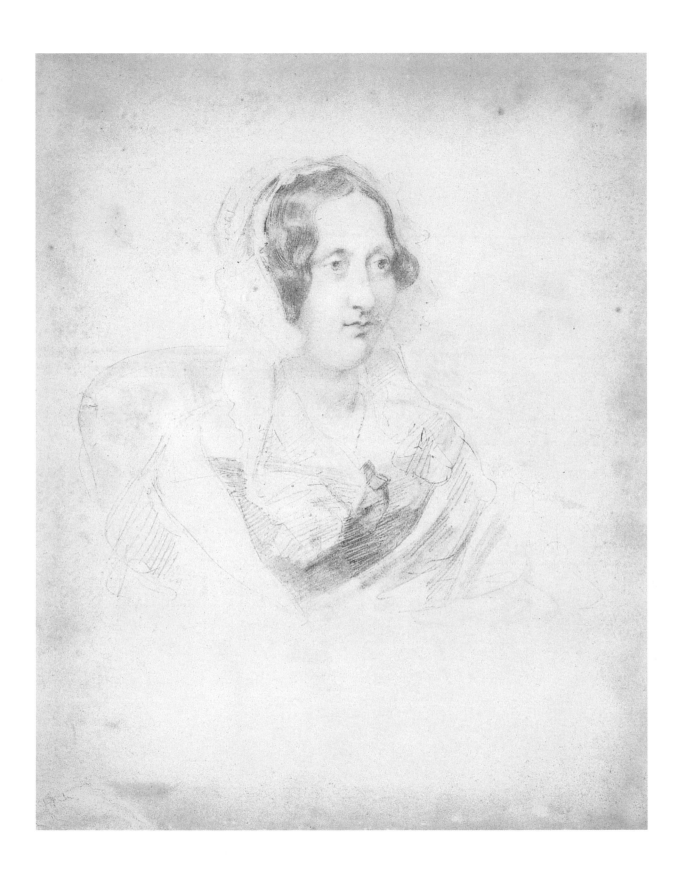

12 HORATIO WILLIAM, LORD WALPOLE

c.1844

Pencil on paper
279 x 210mm (11 x 8¼")
Private collection

Provenance Drawn for Lord and Lady Holland;
by family descent
Literature Liechtenstein 1874, II, p. 13; Erskine 1903,
p. 178; Macmillan 1903, p. 24; Ilchester Catalogue 1904,
p. 202, no. 321; Ilchester 1937, p. 339 (as 1848)[1]

Horatio William, Lord Walpole (1813–94),
was the eldest son of the 3rd Earl of Orford
(of the second creation); he succeeded
as 4th Earl of Orford in 1858. He shared
the passion of his sister Dorothy (no. 7)
for collecting, fully in keeping with the
traditions of the Walpole family.[2] In 1841
he married Harriet Pellew, the daughter
of Lord Holland's half-sister,[3] hence his
inclusion in the Hollands' circle. He and
his wife, however, parted company early
in their marriage, she living in Florence and
he in England.

In 1844 Watts visited Naples with the
Hollands. Lady Augusta, who lived with
her mother at the Villa Rochella before
marrying, had great affection for southern
Italy. On this occasion Lord Walpole joined
with them as they made a side trip to
Pompeii. Here Watts and Walpole alone of
the party managed to climb to the top of
Mount Vesuvius, peering into the opening
of crater.[4] Apart from a sense of adventure,
the two men had a keen interest in the art
of the past. For Watts the classical world
came vividly to life on this visit to Pompeii.
Walpole developed a historicist taste that
included the English past (at his seat,
Mannington in Norfolk, he used original
Tudor panelling and commissioned a portrait
of himself looking like a medieval monk).[5]
A contemporary once described him as 'very
learned, very cultured, and eccentric'.[6]

Like other portrait drawings by Watts,
the extreme precision of the face is paired
with looser treatment of the surrounding
elements of the design. Watts's drawing
reflects the unconventional spirit of
Walpole, who, like his sister, obviously
felt no shyness in donning picturesque
garb. The over-sized hat, perhaps protection
from the heat of the Italian sun, is as much
a feature of this portrait as Walpole's own
steady gaze.

1 There seems no reason to date this work to 1848;
it is not inscribed and it belongs to the group of portrait
drawings executed for the Hollands while the artist was
in Florence.
2 In 1895 he bequeathed a life-sized portrait by Nicolas
de Largillière (1656–1746) of Charles Stuart, the Old
Pretender, and his sister as children to the NPG (976).
3 Harriet was the daughter of Lady Holland from her first
marriage to Sir Godfrey Webster, Bt., which resulted in
a famous divorce; in 1816 Harriet married Fleetwood
Pellew; her daughter, also Harriet, married Lord Walpole.
4 Watts 1912, I, pp. 74–5.
5 A small oil on panel; for an illustration see the
Courtauld Institute Photographic Survey, private
collection XC, list I, no. 278a.
6 Lady Battersea's *Reminiscences* quoted in *Complete
Peerage*, X, p. 90.

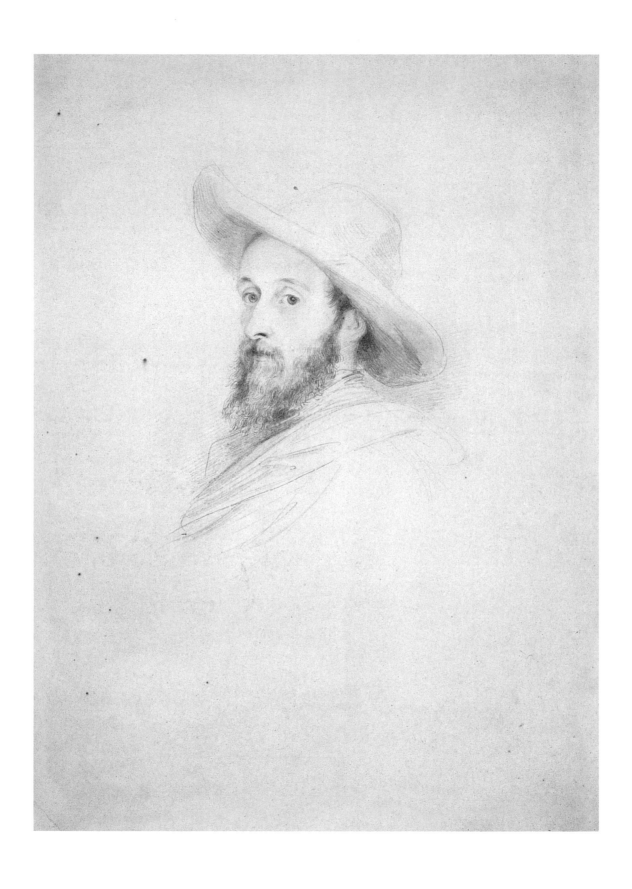

13 EDWARD MORRIS ERSKINE

c. 1843–4

Pencil on paper
205 x 148mm (8 x 6")
Inscribed (in another hand)
'Mr Edward Erskine by Watts'
Private collection

Provenance ?Collection of the Hollands; … Christie's,
6 March 1979, no. 43 (with two other drawings); The
Downstairs Gallery, London; acquired by the current
owner, *c.* 1999

Edward Erskine (1817–83), an exact
contemporary of Watts, had an entrée into
the diplomatic service, first as attaché to
his father the 2nd Lord Erskine in Munich
and later in a series of junior posts, which
included serving Henry Fox, 4th Lord
Holland, also as attaché. This young man,
known as 'Little Edward' or 'Little E.', was
a special favourite of the Hollands, 'living
with them for five years on terms of great
intimacy',[1] until his departure from Florence
around 1844.

This informal drawing is one of a
secondary group of works on paper drawn
by Watts during his time in Florence. These
more quickly executed studies also include
some outright caricatures (no. 14); they
served as more relaxed views of the *habitués*
of Casa Feroni, often individuals caught off-
guard, as Erskine is here, casually smoking a
cigar, rather than posing for a more finished
drawing. In several cases Watts portrayed
the same individual for the Hollands in both
a formal drawing and a quick sketch. He
drew such works directly onto writing paper,
further indicating that these are snatched
glimpses of guests and friends, executed as
the opportunity presented itself.

These works, probably not given to
the Hollands, were scattered in various
collections. Some are sketches of full-length
figures, such as the sculptor Hiram Powers[2]
or another young diplomat Andrew
Buchanan (Scottish National Portrait
Gallery). It might well be that these drawings
are more representative of Watts's own
personal circle of friends.

1 Ilchester 1937, p. 332. This author includes a more
formal drawing in the Addenda to his catalogue of 1904
(1939, p. 30).
2 For my discussion of this drawing of 1846, see
Victorian Art: Sacred & Secular, exh. cat., Julian Hartnoll
at the Burlington Fine Art Fair, Royal Academy, London,
1979, no. 3.

14 HENRY COTTRELL
('COUNT' COTTRELL)

c.1843–5

Pencil on paper
205 x 148mm (8 x 6")
Inscribed (in another hand) 'Mr Cottrell by Watts'
Private collection

Provenance ?Collection of the Hollands; … Christie's,
6 March 1979, no. 43 (with two other drawings); The
Downstairs Gallery, London; acquired by the current
owner, *c.*1999

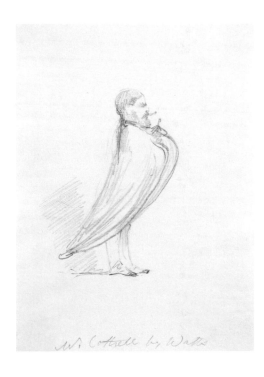

The intriguingly named Count Cottrell was
in fact Henry Cottrell (1811?–71),[1] who has
been repeatedly misidentified as Richard
Cottrell since (it seems) the catalogue of the
Ilchester collection of 1904.[2] Understand-
ably the first name of this little-known figure
became a matter of conjecture. It is now
possible to identify him as Henry Cottrell,
who later married Sophia,[3] the daughter
of Charles Augustus Tulk, and was a close
friend of Robert and Elizabeth Browning.

While in Florence, Cottrell carved out a
niche for himself in the service of the Grand
Duke of Lucca.[4] Given his semi-official
status, Cottrell knew the Hollands; he
arrived at the Casa Feroni within days of
Watts and they became fast friends. His art-
collecting interests undoubtedly appealed
to Watts,[5] who painted his portrait for the
Hollands (fig. 3) and also executed a drawing
and an oil sketch (unlocated) as well as this
caricature, all probably dating from the
earlier part of Watts's stay. This unusual
image of Cottrell is akin to other caricatures
by Watts of Piero Dimi and Tommaso
Corsini, in which the heads, sketched but
identifiable as portraits, sit atop strange
bird-like bodies. For Cottrell Watts has hit
upon a squat form, with an impressively
puffed-up chest, made all the more
incongruous by the cigar-smoking head
planted on top. The sides of the dinner
jacket angle backwards as wings enclosing
the figure. This is an example of how the
more informal of Watts's sketches turned
into caricatures. In this case the magnifi-
cently self-important pigeon-like figure
fits appropriately with what one writer
called the 'somewhat pretentious lifestyle'[6]
of Cottrell.

Cottrell arranged for Watts to visit
Parma where he studied the art collections
and painted the portrait of the grand duke.

Such was the success of this work that the
grand duke awarded him the decoration
of the Order of San Lodovico. Cottrell was
dismissed from the ducal court at the end
of 1845.[7] Returning to England, he married
in 1847, honeymooning at St Anne's Hill in
Sussex, an estate of the Hollands that was
formerly the residence of Charles James Fox
and was lent to him by Henry, 4th Lord
Holland, his friend of old.[8] The couple
returned to Italy where they struck up a
friendship with the Brownings. Cottrell's
experience as a helper to greater men
resulted in him readily lending his services.[9]
Thanks to his 'reverent care' he preserved
a great number of drawings Watts left in
Italy, as well as several large canvases[10] and
experimental frescoes that his wife, who
styled herself Contessa Cottrell, bequeathed
to the Victoria and Albert Museum in 1886.

1 Watts 1912, I, p.55, referred to him as Count Cottrell,
Chamberlain to the Grand Duke of Lucca.
2 Ilchester 1904, p. 46, in discussing Watts's oil portrait
(now unlocated), see also p. 200, no. 308, for a formal
portrait drawing.
3 Scott Lewis, 'Sophia Cottrell's Recollections', *Browning
Society Notes*, 24 (1997) – hereafter 'Lewis 1997' –
pp. 34, refers to Henry Cottrell, whose family lived at
Hadley Lodge, Barnet, near the Tulks. Henry married
Sophia Tulk in 1847. Cottrell is discussed, but his
connection with Watts is not noted.
4 Ilchester 1937, pp. 336–7. Ilchester's reference to him
as the 'second of the name' suggests that it was the
father who may have been Richard rather than the son.
Since some sources call Watts's friend the 2nd Count
Cottrell, he may have inherited the title from his father.
5 He acquired a work attributed to Giorgione, exhibited
at one of the RA's exhibitions of Old Masters in 1873.
6 Lewis 1997, p. 22.
7 Ilchester 1937, p. 337.
8 Lewis 1997, pp. 33–4.
9 Lewis 1997, p. 23; after 1862 he supervised the
building of Elizabeth Barrett Browning's tomb, designed
by Frederic Leighton (L. and R. Ormond 1975, pp. 76–7).
10 Watts 1912, I, p. 55.

15 ALICE DUFF GORDON
1846

Pencil on paper
225 x 160mm (9 x 6⅜")
Inscribed 'G F W. Careggi. 1846.'
Sir Andrew Duff Gordon, Bart.

Provenance Drawn for the sitter and given to her
by the artist; by family descent
Literature Gaja 1995, ill. opp. p. 90, where incorrectly
identified as Georgiana

This little gem of a drawing stands apart
from the series that Watts executed for the
Hollands (nos 9–12), in which he consciously
worked within a tradition of continental
portrait drawings. For his friends the Duff
Gordons Watts indulged his own particular
tastes at the time by hinting at the antique
in this work.

Alice (1822–1901), the younger sister
of Georgiana Duff Gordon (1817–1906),
along with their widowed mother, Caroline,
Lady Duff Gordon,[1] rented the villa at
Careggi when the Hollands left Florence.
During the summer of 1846 these well-bred,
well-travelled girls brightened up Watts's life
with singing and music making.[2] When they
departed, his letters to Georgy, who was
Watts's exact contemporary, remain as a
valuable record of his final months in Italy.[3]

Watts carried out many drawings at
this time, occasionally using the sisters. His
depictions, always in pencil, range from
casually observed studies to portrait
drawings. He was particularly interested in
their hair, even, as he reported to Georgy,
using Alice's 'dishevelled locks' for a figure
in his current composition, *Alfred Inciting
the Saxons* (Houses of Parliament). Two
other drawings of the sitter are in the same
collection, one showing her full face, and the
other with her famous wavy hair unbound.[4]
Even in old age her looks were considered
'in the classical manner' with her 'fair wavy
hair like the tendrils of a vine'.[5]

This drawing in strict profile suggests
an antique cameo image, and the idea of a
classical type reflected Watts's orientation
at this time. His letters are filled with
references to Phidias at this stage. The purity
of the outline and careful linear delineation
of the flowing waves of Alice's hair reveal
the artist's technical accomplishment as a
draughtsman. He honed his skills by drawing
in gold or lead point on metallic paper,[6] with
no erasing possible, as a way of making
every line count.

Unusually this drawing is dated, linking
it to a specific time and place. Given that
Watts drew this for Alice and then gave it to
her, there is a surprising lack of engagement
with the sitter. But that is partly due to his
absorption in the task at hand, as he turned
his pleasant friend's profile into a precise
study, a virtuoso display of his portrait-
making skills even on the smallest scale.
Close to several generations of Duff
Gordons, Watts portrayed them in Italy at
the very outset of his career and over fifty
years later in 1899 in the portrait of Lina
Duff Gordon (no. 62), great-niece of Georgy
and Alice.

1 Her husband Sir William Duff Gordon had died in
1823; for the family and its further reaches, see Frank
1994. Noted translator and traveller Lucie Duff Gordon
was married to their brother, Sir Alexander, 3rd Baronet.
My great thanks to Sir Andrew Duff Gordon for assistance
regarding his family history as it related to Watts.
2 Watts 1912, I, p. 76. His relaxed friendly manner with
Georgy in particular has suggested that there may have
been romantic interest on both sides but it seems they
were just friends; see Blunt 1975, pp. 42–4.
3 The letters exist in typescript as part of the Watts
Papers, and have been used by various authors. Extracts
here are from the typescripts, not from other published
sources.
4 The latter is illustrated in Gaja 1995, p. 91.
5 Noted by her great niece, see Waterfield, 1961, p. 10.
6 Watts 1912, I, p. 67.

GFW.
Caress. 1846.

16 LOUISA, MARCHIONESS OF WATERFORD

1847–8

Oil on canvas
565 x 520mm (22¼ x 20⅜")
Inscribed 'GF Watts'
Sir Andrew Duff Gordon, Bart.

Provenance Painted as a gift for Georgiana and Alice
Duff Gordon; by family descent
Exhibitions Watts Grosvenor 1881–2, no. 79; *The
Victorian Exhibition*, New Gallery, London, 1891–2,
no. 171; *Fair Women*, Grafton Gallery, London, 1894,
no. 135; Memorial Exh., London 1905, no. 11
Literature Spielmann 1886, p. 32; Watts 1912, I, p. 97;
Watts Catalogue, II, p. 166; Waterfield 1961, p. 80

Louisa Waterford (1818–91) was the
younger daughter of Lord Stuart de
Rothesay, a diplomat with Francophile tastes
whose postings on the continent meant the
family lived much abroad.[1] Her older sister
Charlotte married Charles Canning. As noted
beauties, they sat to a range of portrait
painters and were amateur artists them-
selves, with Louisa later receiving instruction
from Ruskin.[2]

Watts met Louisa in London in 1847
as a friend of Georgy and Alice Duff Gordon,
the sisters who had rented the villa at
Careggi from the Hollands. The portrait, a
present to them from Watts (mentioned in a
letter from the artist, 14 December 1847[3]),
was very much a personal image, not sent to
public exhibition and not at all in the mould
of a conventional portrait. Thinly painted
on a canvas with a pronounced texture, the
work bears the hallmarks of Watts's more
simplified style of painting after his return
from Italy. Such handling and the purity of
the near-profile view accorded with the
'classical' style of Lady Waterford herself. On
seeing her walking, Watts once exclaimed,
'It is Pallas Athene herself!',[4] such was her
natural grandeur. Other writers echoed

these sentiments almost exactly, specifically
mentioning the grand pose of her head. In
style Watts's painting reveals Francophile
tastes, particularly for the portraiture of
Ary Scheffer.[5]

Lady Waterford became a life-long
friend of Watts. She made a visual impact
on him, and he said: 'When she came into
the studio, it was like a glorious vision.'[6]
His admiration for her knew no bounds; her
humble nature and slightly hesitant manner
endeared her to him. On the subject of
her art he rhapsodised. He considered her
powers as a colourist unrivalled; and even
late in life, he had photographs after her
drawings and watercolours on his walls.
When she died, he designed a memorial
cross for her grave.

Louisa was related to other families
with whom Watts became connected
through friendship, the Somerses and the
Talbots. Her husband died in a riding
accident in 1859; she had no children. She
devoted the rest of her life to good causes
and art, her most significant achievement
as an artist being the murals she painted
for a school on one of her estates, at Ford
in Northumberland.

1 For her life see Michael Joicey, 'A Brief Memoir',
in *Lady Waterford Centenary Exhibition*, exh. cat.,
Lady Waterford Hall, Ford, Northumberland, 1983,
pp. 28–32.
2 In 1830 the sisters were painted with their mother
by George Hayter (Richard Green, London); *c.*1840 they
sat for the miniaturist Thorburn.
3 Transcriptions of letters from the Duff Gordons, Watts
Papers.
4 Augustus Hare, *The Story of My Life*, London, 1893,
p. 327; Watts 1912, I, p. 212, recounts the same
incident.
5 Scheffer was well known in London: Henry Wyndham
Phillips (no. 25) exhibited a portrait of him in 1850 and
some English collectors favoured his work (see the
portrait of Mrs Robert Hollond, *c.*1851, NG 1169).
6 Augustus Hare, *The Story of My Life*, London, 1893,
p. 327.

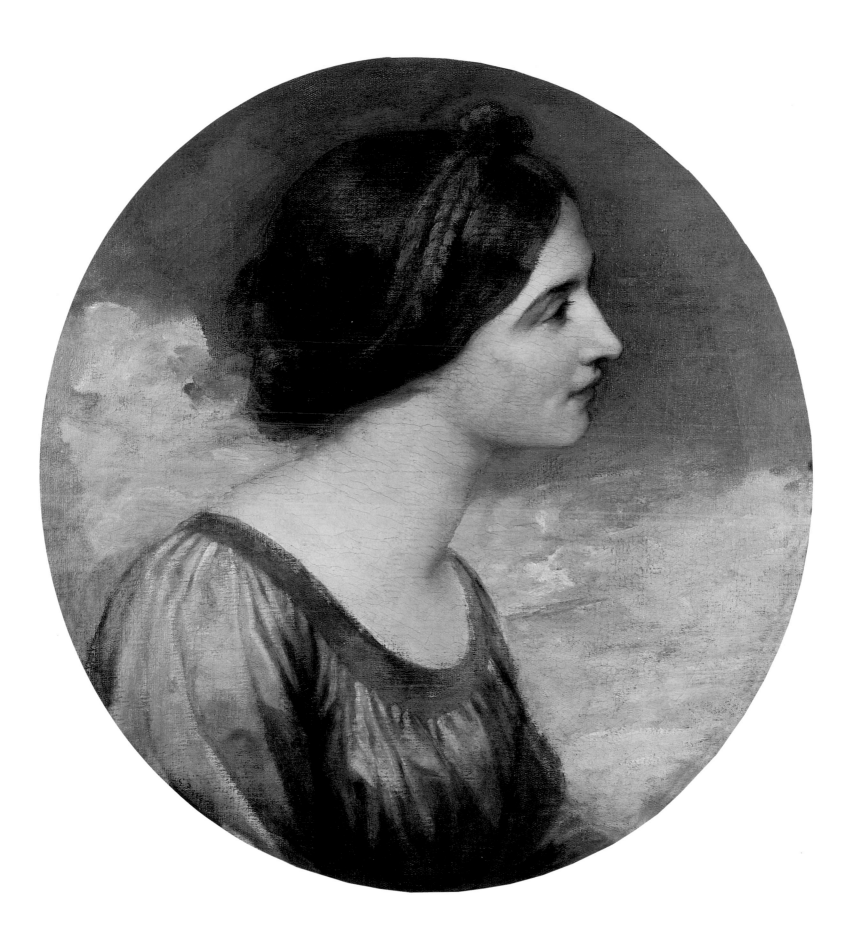

17 ANTHONY PANIZZI
1847

Oil on canvas
851 x 851mm (33 ½ x 33 ½")
Private collection

Provenance Painted for Lord and Lady Holland;
displayed at Holland House; by family descent
Exhibitions Watts London 1954, no. 12
Literature Liechtenstein 1874, I, p. 231; Louis Fagan,
The Life of Sir Anthony Panizzi, KCB, London, 1880, I,
p. 324; Spielmann 1886, p. 31 (NPG version); Erskine
1903, p. 181; Macmillan 1903, p. 85; Ilchester
Catalogue 1904, pp. 96–7, no. 131; Spielmann 1905,
pp. 40–41; Watts Catalogue, II, pp. 121–2 (incorrectly
dated to 1851); Watts 1912, I, pp. 66, 100–1, 189;
Ilchester 1937, pp. 373–4 (and ill. opp.); R. Ormond
1973, I, pp. 361–2; R. Ormond 1975, pp. 5, 19,
no. 1010 (NPG version)

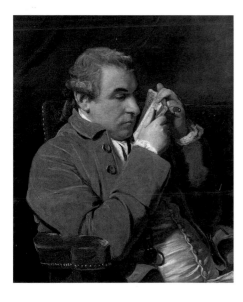

FIG. 30 *Giuseppe Baretti*, Joshua Reynolds, 1773–4,
oil on canvas, 737 x 822mm (29 x 32⅜").
Private collection

Watts's *Anthony Panizzi* is an unusual
portrait for it shows a man absorbed in
scholarly activity. The artist executed it
on commission for the Hollands and the
circumstances surrounding the painting of
the portrait explain its distinctive qualities.
Anthony Panizzi (1797–1879) was a political
exile from Italy who fled to England in 1823.
A noted scholar of Italian literature, he
attracted the support of William Roscoe and
Lord Brougham, with the latter obtaining for
him an academic post at University College
London in 1828. He went on to become
Assistant Librarian in the Department of
Printed Books at the British Museum in
1831, producing his noted translations and
editions of the Italian authors Matteomaria
Boiardo and Ludovico Ariosto (published
in nine volumes, 1830–34) and continuing
his passionate support of the cause of Italian
liberty. In 1843 Panizzi became part of the
Holland House circle of Dowager Lady
Holland,[1] a position of favouritism he con-
tinued to enjoy with the younger Hollands,
Augusta and Henry, who referred to him as
'good old Pan'.

Once the Hollands had left Italy, they
entertained at Holland House with Watts
frequently in attendance.[2] In October 1847
Panizzi, Watts and others were present at
a dinner party, with Panizzi reporting:

> There is at Holland House a famous portrait
> of Baretti by Sir Joshua Reynolds. Lord and
> Lady Holland and some of the guests, having
> prepared all this without my knowledge
> beforehand, surrounded me after dinner,
> made me look at Baretti's portrait, and then
> said that there should be a *pendant* to it, and
> that my portrait, taken by Watts, should be
> the thing. It was no use saying more than I
> did—which was not a little to decline the
> honour. The thing was a foregone conclusion;
> and so, before Watts goes to Italy, which
> he is going to do almost immediately, he is
> going to paint me.[3]

Watts's much hoped-for return to Italy did
not of course take place, but this account
provides fascinating evidence that the artist
was very much at the centre of a circle
where portraits functioned in an unusually
interesting way. At Holland House the
intellectuals and politicians, artists and
writers delved into the rich collection of
painted images as matter for stimulating
conversation, perceiving links between
portraits of the past and those of the
present. The artist had the encouragement
of his host and friend, Lord Holland, whose
sense of the past was acute; according to
one observer, 'he had not quite left the
eighteenth century behind him'.

Watts conceived his portrait of Panizzi
in the circumstances of forging an alliance
with Reynolds's *Giuseppe Baretti* (fig. 30),[4]
an image of a man also thoroughly absorbed
in the task at hand. As Nicholas Penny
observed, 'the vigorous characterization
would have been indecorous in the portrait
of a social superior and unlikely except in
the portrait of a friend';[5] a seemingly too
casual and informal approach would only
be possible in the depiction of a friend for
a friend.

The parallels between the actual
individuals depicted were striking and no
doubt suggested the planned pairing of the
painted portraits. Panizzi and Baretti, both
Italians, had settled in England as exiles,
pursuing literary careers. In the portraits
visual parallels are evident,[6] with both men
intent on their particular pursuit. Panizzi
writes with his quill pen, studying an
illuminated manuscript propped up on
books. He is however less the fashionable
man than the scholar at work, shaggy-haired
and rumpled. Reinforcing this sober image
is the palette of restrained tones, with the
russet of the background and dark red of
the books, perhaps suggested by similar
tones in Reynolds's portrait. Watts himself

had already essayed at least one portrait drawing inspiration from Reynolds, *Lady Holland* in a Riviera hat (no. 1), and he would continue to do so.

Interestingly, Watts might have added his own particular touch to the requirements of the commission, because he also seems to have been familiar with another portrait of Baretti by James Barry in the offices of the publishers John Murray.[7] The pose of the figure and the casual arrangement of books and papers is actually closer to Barry's portrait. But this reference can surely also be viewed as Watts's effort to present an art-historically rich mix in his portraits. In 1847 for him to paint a portrait intended to hang as a pendant to a work by Reynolds cannot fail to have aroused in him an utter determination to turn his forays in this genre into distinguished and thoughtful exercises.

Panizzi probably posed in the library at the British Museum,[8] with rows of books behind wire mesh doors. At the same time Watts was also painting Lady Augusta in the Gilt Room at Holland House, so characterizing locations as part of the presentation of the portrait was very much in his mind. Although Panizzi was a scholar of Italian literature, here he seems to be intent on the study of an illuminated manuscript.

Watts painted two versions of the portrait, worked on concurrently and quickly finished.[9] The second one,[10] slightly smaller, he retained, and it was exhibited widely by the artist before entering the National Portrait Gallery. Ormond considers that the portrait of this sitter in 1847 marked the beginning of Watts's collection of eminent individuals. Certainly, in painting two

versions, Watts seemed to be admitting to himself that he wanted to retain one, but not until two years later did he define to himself the idea of a gallery of worthies, and not until *c.*1860 did he actively paint such works to form a group. In 1868 Watts exhibited another portrait of Panizzi commissioned by the British Museum upon his retirement as Principal Librarian in 1866. Here Panizzi had enjoyed a remarkable career as the individual who masterminded the creation of the great dome of the Reading Room, completed in 1856.

1 Ilchester 1937, p. 362.
2 Immediately on his return he was still much under the wing of the Hollands, painting at this time the full-length portrait of Lady Holland (fig. 4, p. 14) and also participating in the new decorations at the great house.
3 Quoted in Louis Fagan, *The Life of Sir Anthony Panizzi, KCB*, London, 1880, I, p. 324, and Ilchester 1937, p. 374; the latter recognised that the letter must date from 1847 rather than 1850.
4 The portrait was a relatively recent addition to the collection at Holland House, having been acquired in 1843 in an exchange by Lord Holland's mother with the Marquess of Hertford.
5 Penny 1986, no. 85, p. 255.
6 Both canvases are almost exactly the same height, with Watts's slightly wider than the work by Reynolds (737 x 622 mm).
7 Illustrated in Penny 1986, p. 56, fig. 74. Watts was in contact with Murray's at this time or shortly after.
8 R. Ormond (1973, I, pp. 361–2) notes that official museum documents are visible in the version at the NPG.
9 He mentioned finishing the portrait in a letter to Georgy Duff Gordon less than a month later on 7 November 1847, Watts Papers.
10 Erskine made an attempt to detect the differences between the two versions, noting that the NPG version appeared to be closer in texture and darker and mellower in tone; Ormond notes that the NPG version is unfinished.

18 FRANÇOIS GUIZOT

1848

Oil on canvas
718 x 584mm (28¼ x 23")
Inscribed (in another hand)
'Monsieur Guizot by Watts'
Private collection

Provenance Painted for Lord and Lady Holland;
displayed at Holland House; by family descent
Exhibitions Royal Academy, London, 1848, no. 582,
as *Monsieur Guizot*; Watts London 1881, no. 150; Watts
London 1954, no. 13; *Victorian High Renaissance*,
Manchester City Art Gallery, Brooklyn Museum of Art,
Minneapolis Institute of Arts, 1978–9, no. 6
Literature Liechtenstein 1874, I, p. 235; Spielmann
1886, cat. p. 30; Erskine 1903, ill. opp. p. 177, pp.
181–3; Macmillan 1903, pp. 85–6; Ilchester Catalogue
1904, pp. 96–7, no. 131; Spielmann 1905, p. 27; Watts
Catalogue, II, p. 59; Watts 1912, I, p. 100; Ilchester 1937,
p. 372, ill. opp. p. 392; Staley 1978, pp. 60–61

Watts's return from Italy in June 1847 found him still under the wing of the Hollands, working for them in various capacities. The commission for this portrait followed upon that for Panizzi. Guizot, then aged sixty, had long since featured as a fixture in the sphere of the previous Hollands and had retained the allegiance of the current ones. His late-blooming romance with Princess Lieven (no. 27) further solidified his connection with the Holland circle.

In this sober portrait Watts sought an appropriate mode for the depiction of the great French politician, man of letters and former ambassador to London, François Guizot (1787–1874), then in exile in England.[1] Destined for Holland House as part of the collection of portraits there, the painting was a character study of the individual. From the dark background Guizot's head and face emerge with great clarity. The artist returned to the strict profile view to concentrate attention on the subtle geography of the face. Small stature may well be indicated by the high back of the deep red upholstered chair, which nearly dwarfs the sitter.

The severity of the profile view and the restrained handling of the thin paint suggest that Watts was attuning his style to his sitter by treating the image in a manner reminiscent of French neoclassicism and its heirs. The intense precision of the treatment suggests comparison with Ingres. As the foremost modern representative of the classical tradition, Ingres had a distinct appeal to Watts at just this time when he consciously sought a more classical orientation in his own work. Even in 1848 Watts no doubt knew of Ingres through the Francophile Hollands. This austere style suited Guizot's character and his famed reputation for unembellished oratorical brilliance.

Disruptions in the French government and the fall of the monarchy forced Guizot to flee France, arriving in London in early March 1848; it seems Watts painted the portrait almost immediately after this point. The sittings took place at Holland House with conversation ranging widely. From his personal knowledge of Napoleon Guizot related to the artist how 'he could never forget the steel-coldness of his eye'.[2] Again Watts gained knowledge through contact with such cosmopolitans.

Watts's *Guizot* hung in the Royal Academy exhibition in 1848, along with the equally French-inspired *Lady Holland* (fig. 4, p. 14). In much the same way that the displaced Frenchman and honoured intellectual dignified the salon of the Hollands, Watts's image of him played its role in gracing the portrait collection at Holland House. In the course of painting this portrait and others such as no. 17, Watts considered the function of such portraits beyond their value as commissions for clients. At this very time he began to formulate his own project of painting the great and good on his own initiative.[3]

After the oil Watts executed a pencil drawing of the sitter (unlocated), dated February 1849.[4] There is also an oil study (formerly Watts Gallery) showing a different pose with the sitter's arms folded in contemplation, which may represent a first idea for this work or a planned second portrait.

1 The translation of his *Histoire de la révolution d'Angleterre depuis Charles I à Charles II* came out in 1838; and that of his *Histoire de la civilisation en Europe* in 1846. In 1840 he briefly served as ambassador to London.
2 Watts 1912, I, p. 250.
3 See p. 15 and Watts 1912, I, pp. 113–14.
4 Ilchester 1937, p. 373, seen by Lady Ilchester in 1914, apparently owned by a descendant of the sitter. Allen Staley suggested this was a replica for Guizot to take back to France when he returned there. He also points out that a portrait of Adolphe Thiers (private collection) dating from 1856 was probably painted as a pendant to no. 17.

Monsieur Guizot. by Watts.

19 VIRGINIA PATTLE

1849

Silverpoint on paper
230 x 165mm (9 x 6½")
Trustees of the Watts Gallery

Provenance Collection of the artist
Exhibitions Memorial Exhs, London 1905, no. 119,
Edinburgh 1905, no. 6, Newcastle 1905, no. 210,
probably Dublin 1906, no. 84; Drawings and
Watercolours Fair, Park Lane Hotel, London, 2003
Literature Watts Catalogue, II, p. 121; Watts 1912, I,
ill. opp. p. 122, pp. 122–3, 158

This drawing, a work of considerable refinement, encapsulates Watts's first glimpse of Virginia Pattle (1826–1910) in 1849 when he encountered her walking in Mayfair near his studio in Charles Street. Her beauty, enhanced by unconventional garb, seized his attention. Their meeting shortly thereafter marked the beginning of Watts's lifelong alliance with various members of the Pattle and Prinsep families with whose lives his became inextricably entwined.

A mutual friend, who had sung the praises of the beauty of Virginia to Watts, arranged an introduction. She lived with her sister Sara and her husband Henry Thoby Prinsep on Chesterfield Street near Watts's Charles Street studio.[1] They had recently returned from Calcutta in India where their father James Pattle (1775–1845), a minor nabob from an Anglo-Indian family, had held a high position in the Bengal civil service. His fortune, such as it was, allowed for some comfort for his family after his death. An elder married sister, Julia Margaret Cameron (1815–79), who had also returned from the subcontinent in 1848, was well connected in London literary circles, counting among her friends Henry Taylor and Carlyle among others. There were four other sisters and their story, and the reign of 'Pattledom', has been told many times.[2] Thanks to their mixed French and Anglo-Indian ancestry, and formative years spent in India, these sisters assailed society in London with their unconventional manners and appearance. For Watts, on returning from Italy in 1847, London seemed grey and miserable, but when he met the Pattles, his life took on new meaning. He fell in love with Virginia and she briefly became his muse.

This drawing shows the full-length figure of Virginia much as she must have appeared when Watts first saw her. He was said to have been attracted by the long folds of her cloak. The upper figure is contained within a thick cape, turned slightly back on one side to reveal her clasped hands. The distinctive way Virginia wore her hair, enclosed in a net, without a hat, added to her almost classicised appearance. Drawn in silverpoint, a technique that allows for very precise lines, this work retains a slightly unfinished quality at the bottom edge. Here, as in the Italian portrait drawings, complete finish is resisted by allowing sketchy lines to trail off at the edge. This drawing probably preceded the major oil painting (no. 21).[3] As one of the first works inspired by Virginia, the drawing held a special place in Watts's thinking. For nearly half a century, according to Mrs Watts, it always hung above the studio dresser at Little Holland House.

1 Sara had already called on the services of one artist, Henry Tanworth Wells, whose miniature portraits of several members of the family including Virginia had appeared at the Royal Academy between 1846 and 1849.
2 Brian Hill, *Julia Margaret Cameron: A Victorian Family Portrait*, London, 1973; Elizabeth French Boyd, *Bloomsbury Heritage: Their Mothers and Their Aunts*, London, 1976.
3 Another similar drawing is in a private collection.

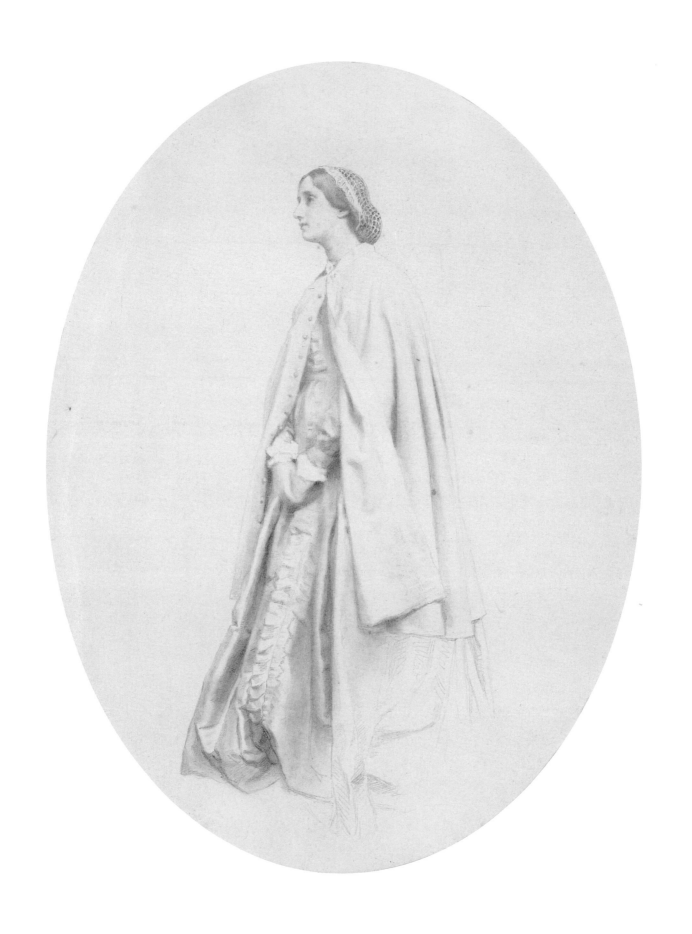

20 VIRGINIA PATTLE

1849

Pencil on paper
255 x 205mm (10 x 8")
Inscribed 'G F W 1849'
Hereford Museum and Art Gallery,
Herefordshire Heritage Services

Provenance Collection of the artist; R.E. Abbott;
bought from him by the Hereford Museum and Art
Gallery in 1953
Literature Watts 1912, I, p. 123 (? this drawing or
another similar one)

This newly rediscovered drawing of 1849,
published here for the first time, is the
earliest and most detailed record of Virginia
Pattle's face and as such it conveys more
about her exact appearance at the time
Watts first knew her than any other work.
It acts as a companion to the well-known
full-length drawing (no. 19), but it offers
much more about how she appeared
through Watts's eyes.

The face is striking with perfectly formed
features. The heavy-lidded eyes stare out
calmly, almost disturbingly so. The stillness
of her expression must have reminded Watts
of the classical sculptures he so ardently
aspired to equal. Indeed, Ruskin slightly later
declared that the Pattle sisters looked like
nothing so much as 'the Elgin Marbles with
dark eyes'.[1] For Watts Virginia personified
an antique ideal yet she herself had arrived
at this point from a different route.

Her style derived in part from her
French mother, Adeline de l'Etang,[2] and
grandmother who was maid of honour to
Marie Antoinette. As Virginia later noted
to her daughter: 'Did you ever see an
English-woman who knew how to enter a
room? … How they ruin themselves with
their clothes. An English-woman will put
anything, *anything*, on her head.'[3] In place
of exaggerated hairstyles and bizarre hats,
she wore her hair in a net, which simplified
her silhouette and must also have been a
way to keep cool in the Indian heat. She
wore unusual jewellery, such as turquoise
bracelets, brought back from India. She
carried off the Pattle style to an extreme
degree, confidently courting the gaze of
onlookers.

For this drawing Watts studied her
closely. In style it represents a departure
from the draughtsmanship of the Italian
works. Those drawings, largely showing
individuals he did not know well, were more
precise and sharply defined. This drawing
of Virginia possesses a melting softness,
as Watts seems to react to her gaze. It
remained in his collection but was never
exhibited or published, as he seems to have
regarded it as a wholly private image with
many memories of the past.

1 Letter from Ruskin to Margaret Bell of 3–4 April 1859,
quoted in Van Akin Burd, ed., *The Winnington Letters*,
London, 1967, p. 150.
2 She had died on the return sea voyage from India in
November 1845.
3 Lady Henry Somerset, *Eastnor Castle*, privately printed,
1889, p. 37.

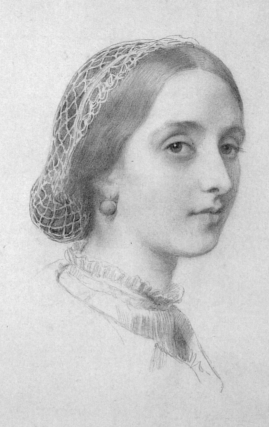

21 VIRGINIA PATTLE

1849–50

Oil on canvas
1780 x 1190mm (70 x 46⅛")
Inscribed 'G F W 1850'
Eastnor Castle Collection
(Photo: Photographic Survey, Courtauld Institute
of Art). Photographed before conservation

Provenance Bought from the artist by the sitter's
husband, Charles, Viscount Eastnor (later 3rd Earl
Somers); by family descent
Exhibitions Royal Academy, London, 1850, no. 257;
Watts Grosvenor 1881, no. 117; Worcester 1882,
no. 149
Literature Spielmann 1886, p. 31; Lady Henry Somerset,
Eastnor Castle, privately printed, 1889, p. 36; Watts
Catalogue, II, p. 122; Watts 1912, I, p. 125

When exhibited at the Royal Academy in
1850, this full-length portrait entitled *Miss
Virginia Pattle* – illustrated here before
conservation – struck audiences as entirely
out of the ordinary; it can still be seen as one
of the most remarkable portraits of its time
in its uncompromising and severe style.

Watts painted the portrait by choice,
not on commission, in his studio on Charles
Street, following his meeting with Virginia in
1849 (nos 20, 21). Attracted by the folds of
her cape, Watts regarded her as the epitome
of the classicizing style he sought, evoked by
the Elgin Marbles. His art had shifted from
a rich Italianate manner to an extremely
simplified and flatly painted style, composed
of broad masses with pale, fresco-like
colours, as seen here and in the other work
he exhibited that year, *The Good Samaritan*
(Manchester City Art Gallery).

In many ways Virginia's personal style
tallied with Watts's own stylistic objectives
and inspired the portrait. She was grandly
tall and wore robe-like dresses in fabrics
made interesting by thick folds rather than
fussy decoration. She contained her hair
in a net leaving the outline of her head
unencumbered. Her stillness and sense

of repose also set her apart. The artist
portrayed her standing in strict profile,
against a backdrop of pale blue sky, with
only a severe stone balustrade and black-
and-white tiled pavement for the setting,
which was almost certainly taken from the
grand surroundings of Holland House. Her
grey cloak, with broad folds, is unrelieved by
decoration. The only concession to detail is
a tendril of ivy cast down on the stone steps.

At the Academy in 1850 the Pre-
Raphaelites provided shock value with works
such as Millais's *Christ in the Carpenter's
Shop* (Tate); portraiture was represented by
tried and true masters such as Francis Grant
and James Sant, with Watts standing well
apart. A critic in *The Spectator* expressed
surprise at how he 'converts a charming
young lady, "Miss Virginia Pattle", into a
Titaness'.[1] This facetious comment is not
to be taken too seriously; it did however
indicate the unusual scale and appearance of
this portrait. In 1848 the rather continental
style of *Lady Holland* (fig. 4, p. 14) had not
found favour. The small portrait of Lady
Waterford (no. 16) hinted at the change to
a classicising style, which the artist whole-
heartedly adopted in *Virginia Pattle*.

Thanks to the exhibition of Watts's
portrait, Virginia attained fame with her
beauty becoming widely celebrated. She
became public property, with Thackeray
poeticizing her in *Punch*, 'On a Good-
Looking Young Lady', and great hostesses,
such as Lady Palmerston, seeking her for
their gatherings. One society watcher noted
that Virginia was the 'new lion' with 'people
getting on the benches at Devonshire
Houses to look at her'.[2] All this was to come
after the appearance of the portrait at the
Academy in May 1850.

Ironically for the artist, Virginia's future
husband fell in love with this portrait,
determining to marry the woman it
depicted. Charles Somers Cocks, Viscount
Eastnor (later 3rd Earl Somers, 1819–83),
may have seen the painting in Watts's

studio, since he knew Watts's close friends
Layard and Ruskin. But it seems he set
eyes on the painting at the Royal Academy
exhibition, saying 'That woman I must
know!' Less than two months later he and
Virginia were engaged. It came as a shock to
the artist who felt her loss more deeply than
her legion of admirers. His friend Phillips
(no. 25) observed that he 'worshipped her
in a way that Somers has never done'.[3] After
Virginia's wedding on 2 October 1850
Watts fell ill and her sister Sara tended to
him. That relationship flourished, prompting
Watts's move to Little Holland House with
Sara's family.

Eastnor, who inherited his title in 1852
and with it a great collection of art, shared
many of the interests Watts admired. He
travelled widely in Greece and the Near East
in search of better health, collected Italian
Renaissance art, painted watercolours and
became an early practitioner of photography
(an activity later pursued by his sister-in-law,
Julia Margaret Cameron). Watts painted him
in the guise of an artist, holding his portfolio
and drawing pen (Eastnor Castle).[4] As
enlightened patrons, Lord and Lady Somers
(as Virginia became) enabled Watts to
produce one of his key contributions to
the revival of classical subject matter in the
mid 1850s when he painted murals on the
walls of their townhouse on Carlton House
Terrace. He allowed them to purchase his
great work, *Time and Oblivion* (c.1849;
Eastnor Castle), and painted many portraits
of family members. As favoured friends,
they acquired 'the moonlight portrait' of
Tennyson (no. 34) and the double portrait
of Kate and Ellen Terry (no. 43).

1 'The Arts. The Royal Academy', *The Spectator*, 5 May
1850, p. 426.
2 A.M.W. Stirling, *The Letter-Bag of Lady Elizabeth
Spencer-Stanhope*, London, 1913, II, p. 253, letter of
16 June 1850.
3 Quoted in Hewett 1958, p. 47, from 8 May 1853.
4 From 1860 he was a trustee of the National Portrait
Gallery.

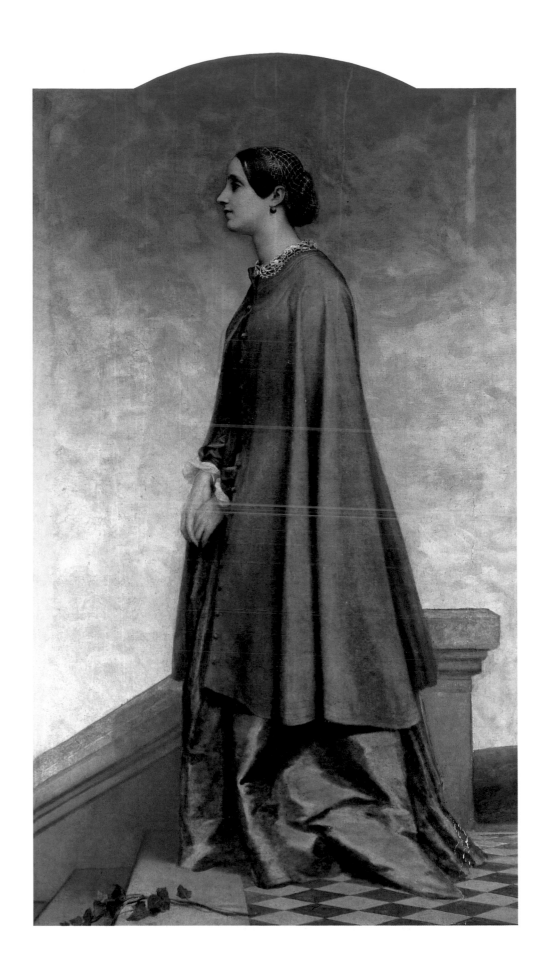

22 SOPHIA DALRYMPLE

*c.*1851–3

Oil on canvas
2050 x 780mm (80¾ x 30¾")
Inscribed 'G F Watts'
Trustees of the Watts Gallery
(Photo: © Bridgeman Art Library)

Provenance Collection of the artist; given by Watts
to Sophia's daughter Virginia, Lady Champneys, in the
1890s; by family descent until 1972 when presented by
Sir Weldon Dalrymple Champneys, Sophia's grandson,
to the Watts Gallery
Exhibitions *Japan British Exhibition*, London, 1910,
no. 72; *Artists at Home: The Holland Park Circle, 1850–
1900*, Leighton House Museum, London, 1999, no. 13
Literature Watts Catalogue, II, p. 44

One of Watts's most striking portraits,
this work depicts Sophia Dalrymple, the
youngest of the seven Pattle sisters and the
one most in sympathy with the artist during
the 1850s. Sophia dubbed Watts 'Signor',
a name that so suited his view of himself
that he retained it for permanent use. She
in turn became 'Sorella',[1] his informal sister.

Although born in India, Sophia
Dalrymple (1829–1911) was educated
in France, lived again in India and then
returned with her sister Virginia to England
in 1845; on the return voyage, their mother
died, hence Sophia remained under the care
of her elder sister, Sara Prinsep. Famously
beautiful, she married John Warrender
Dalrymple (1824–88), eventual heir to the
family baronetcy, in 1847 when she was
aged eighteen. His postings with the Bengal
civil service required him to serve in India,
so Sophia lived with the Prinseps, first in
Mayfair and later at Little Holland House.[2]
Her daughter Virginia was born around 1850
and a son Walter was born in 1854.

Sophia served as Watts's most willing
model as numerous small sketches of her
testify.[3] This painting, dating after the move
to Kensington in 1851, shows her in a starkly
simple composition, as also seen in the
portrait of Virginia (no. 21) and the double

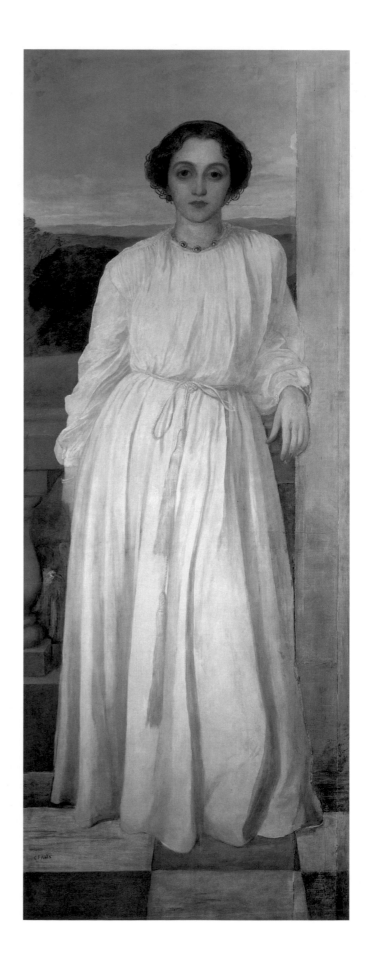

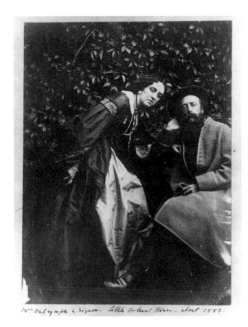

FIG. 31 *Sophia Dalrymple and G.F. Watts*, photographer unknown (possibly H.T. Prinsep), 1850s. Copy photograph from an Emery Walker negative. National Portrait Gallery (NPG EW 953/8)

portrait of Sara and Sophia (fig. 7).[4] Mrs Watts recorded that the artist painted the work rapidly, as the relative thinness of the medium confirms. It intentionally evokes fresco painting, a preoccupation of Watts's at this time, in its broad masses and flat colouring, but the work was a personal experiment, with an unfinished added section of canvas to the right side. In it Watts essayed a classicizing style. The thick folds of Sophia's dress corresponded to the drapery of antique sculpture, a touchstone for Watts. This work and the other related portraits of the sisters signal how the artist turned to full-length portraiture as a way of revitalising his art around 1850.

The grand balustrade behind the figure strongly suggests that Sophia is posed at Holland House itself, as views of the great house and its substantial terraces verify. The glimpse of the garden in the background contains rolling parkland seen from above, with an unexplained figure seen between

the balustrades. For at least two of his imposing full-length portraits of the sisters, Watts sought appropriate settings, leaving behind the informal rambling buildings of Little Holland House for the terraces and balconies of Holland House with all their associations of past grandeur.

The distinctive appearance of Sophia attracted Watts, especially her reddish-brown hair and down-turned eyes (the so-called 'Pattle eyes').[5] A photograph of them together from the 1850s (fig. 31), along with others dating from the same time,[6] shows the warm friendship the artist shared with the sisters and Sophia in particular. He even sketched her as she slept. Her distinctive style, like that of her sisters, consisted of simple dresses enlivened by Indian jewellery and accessories, such as the Hindu sacred thread, a *rakhi*,[7] symbolic of the love between siblings and tied around her wrist in the portrait. Her dark, mysterious eyes and Anglo-Indian background lent her an exotic appeal.

Unlike the portrait of Virginia (no. 21), this work did not go to public exhibition at the time Watts painted it; but it was on display at Little Holland House where it was widely seen.[8] Later in the 1850s younger artists also fell under Sophia's spell. Dante Gabriel Rossetti drew her (fig. 32),[9] focusing as had Watts on her hair and eyes. Burne-Jones created an album filled with drawings for Sophia,[10] whom he loved in seemingly unrequited fashion. As a depiction of a full-length figure in white garb, Watts's portrait was an important antecedent for Whistler's *White Girl* of 1860 (fig. 17, p. 31).

For Watts, who sought female company for inspiration and solace, the married and sympathetic Sophia contributed to his happiness. His later depiction of her with the poetic title *The Days That Are No More* (*c*.1856; private collection) summed up her special status in his life and art. Significantly it was Sophia, not Sara, who later witnessed Watts's marriage to Ellen Terry in 1864.

1 Watts 1912, I, p. 155.
2 She had already been portrayed by Henry Wells, who had depicted other members of the Pattle and Prinsep families before Watts, in what was probably a miniature portrait seen at the Royal Academy in 1848; in 1852 George Richmond, portrait draughtsman to the Establishment, drew her (private collection).
3 Watts 1912, I, pp. 157–8; some remain at the Watts Gallery in sketchbooks; others have appeared in the salerooms. Apparently Sophia owned many more which burned in a fire in the Pantechnicon in London (noted by Mrs Watts in Watts Catalogue, II, p. 44).
4 The bust-length portrait of Julia Margaret Cameron also shows the sitter in a very similar, simple white dress with full bodice gathered at the waist.
5 Sir Weldon Dalrymple-Champneys, *The Chevalier de L'Etang and his Descendants*, privately printed, 1972, p. 8.
6 See the photograph of Sara (or possibly Sophia) and Virginia, ill. in Dakers 1999, p. 29.
7 As discussed by William Dalrymple, her descendant, in *White Mughals: Love and Betrayal in Eighteenth-Century India*, London, 2002, p. xlv.
8 William Michael Rossetti (*Some Reminiscenses*, I London, 1906, p. 203) mentioned seeing some of the portraits of the sisters in the 1850s.
9 Virginia Surtees, *The Paintings and Drawings of Dante Gabriel Rossetti (1828–1882): A Catalogue Raisonné*, Oxford, 1971, I, no. 312, not ill.
10 Known as *The Little Holland House Album*, 1859, printed in facsimile, with an introduction and notes by John Christian, Dalrymple Press, Leuchie, North Berwick, 1981.

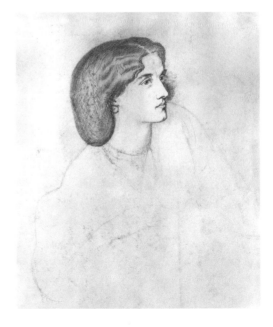

FIG. 32 *Sophia Dalrymple*, D.G. Rossetti, *c*.1856–60, pen and pencil, 410 x 333mm (16⅛ x 13⅛"). Rhode Island School of Design, Gift of Mrs Gustav Radeke

23 AUSTEN HENRY LAYARD

*c.*1852

Chalk on paper
597 x 495mm (23½ x 19½")
National Portrait Gallery, London
(NPG 1006)

Provenance Collection of the artist; given by him
to the NPG, 1895
Exhibitions *Layard and his Successors*, British Museum,
London, 1963, not numbered; Watts NPG 1975,
no. 1006
Literature Hon. William N. Bruce, ed., *Sir A. Henry
Layard, G.C.B., D.C.L.* London, 1903, ill. frontispiece
to vol. II; Spielmann 1905, p. 23; Hunt 1913, I, ill.
p. 253; R. Ormond 1975, p. 18; Egerton 1998, ill.
p. 426

FIG. 33 *Austen Henry Layard*, G.F. Watts, *c.*1852,
chalk on paper, 584 x 483 mm (23 x 19").
National Portrait Gallery, London (NPG 3787)

This large sheet is one of the two known chalk drawings that Watts executed of his great friend and exact contemporary, Austen Henry Layard (1817–94).[1] Layard had many careers, as an archaeologist, politician, diplomat, art collector and Trustee of the National Gallery, but at the time of Watts's drawings he had recently returned from his spectacular archaeological excavations at Nimrud, believed to be the site of the ancient Nineveh.

Like many of Watts's friends, Layard had enjoyed life on the continent.[2] By 1845 he began excavations at the Assyrian city of Nimrud under the auspices of the British Museum. After successfully unearthing many relief sculptures and other monuments, he returned to London during 1847–8, and by May 1848 Henry Wyndham Phillips had portrayed him in Eastern dress as *The Persian Traveller* in a portrait exhibited at the Royal Academy. In 1849 Layard returned to excavate a site related to Nineveh. A great popularizer, he wrote *Nineveh and its Remains* in 1849 and *Discoveries in the Ruins of Nineveh and Babylon* in 1853, both published by John Murray.

It seems likely that this drawing dates from the early 1850s, but rather than being executed several years after the other drawing (fig. 33, traditionally dated 1848), it seems to have been executed at about the same time. New research has revealed that Watts received a commission from the publisher John Murray in late 1852,[3] and that must be the date of the more formal drawing, completed by early 1853. The artist was known to prefer not to draw the shoulders in his head studies, but he readily agreed to do so for the finished drawing. In both portraits Layard's appearance is much the same, with no notable differences.

No. 23 stayed with Watts, and it may well be that this was his first attempt at catching Layard's distinctive expression.

Friends such as the Duke of Argyll (no. 35) found Layard singular in his physical appearance: 'he had a powerful head and a countenance expressive of great determination, and perhaps of just a little recklessness'.[4] Watts's attraction to the impetuous spirit and exhilarating lifestyle of the young archaeologist is evident. This portrait is clearly the depiction of a friend, with Layard's countenance vividly alive in the turn of the head, perfectly epitomising the comment of another acquaintance who noted that he 'must be in danger or he is not happy'.[5] As fellow founder members of the Cosmopolitan Club, along with Phillips, Watts and Layard spent many evenings together, and this drawing reflects such familiarity. Indeed the drawing almost certainly dates from just the time the Club was founded in late 1852.[6]

This portrait is a brilliant example of Watts's famed draughtsmanship in the early 1850s. Due to its less finished character, it displays the process he used to achieve his subtle effects of soft chalk shading. Technically varied, the drawing reveals a skilful contrast between areas of velvety shading and sharper lines to define the curling hair or the outline of the edge of the face. Although this work did not go to exhibition, other similar ones by Watts did, and one reviewer in 1851 described them as 'masterpieces of drawing – they have the mingled softness and strength of drawings by the old masters'.[7]

Watts and Layard continued to be fast friends, especially when Layard turned his attention from archaeology to art in the mid 1850s. He amassed an important collection of early Italian paintings (many of which he bequeathed to the National Gallery).[8] In articles on current art issues, including fresco painting, he highlighted Watts's efforts in this medium.

1 The more finished drawing (fig. 33) came to the NPG from the Murray family in 1951; see Malcolm Rogers, *From Elizabeth I to Elizabeth II: Master Drawings from the National Portrait Gallery*, London, 1993, no. 60, in which the traditional date of 1848 is given, based on a note by A.H. Hallam Murray that indicated that his father commissioned the drawing on Layard's return from Nineveh in June 1847. I believe this note, which was written many years after the event, is wrong. A confusion may have arisen since Layard went on two visits to Nineveh. In addition, neither of the drawings appeared in any of the publications by Murray in 1849 or 1853. Another portrait drawing of Layard existed, this one in pencil, exhibited at Leighton House in 1902, no. 37, belonging to a member of the Senior family.
2 Born in Paris, he grew up in a Florentine palazzo, returned to England to be apprenticed to a solicitor, passed his law exams, then travelled in the Near East from 1839 onwards, eventually ending up in 1842 in Constantinople as private secretary to Stratford Canning with various diplomatic assignments.
3 Letter from Watts to John Murray, 22 November 1852, and a further letter in March 1853, Murray Archives. A forthcoming article on Watts's commissions from the firm of John Murray is planned in which I will discuss this question in more detail.
4 *George Douglas, Eighth Duke of Argyll, KG, KT (1823–1900): Autobiography and Memoirs*, ed. Dowager Duchess of Argyll, London, 1906, I, p. 534.
5 Quoted in *Journals and Correspondence of Lady Eastlake*, ed. Charles Eastlake Smith, London, 1895, II, p. 15.
6 William Holman Hunt, also an original member of the Club, used this drawing as an illustration in his book (Hunt 1913) where he discusses the Club and Layard, whose Eastern travels fascinated Hunt on the eve of his own departure for the Middle East. By the time Hunt illustrated the drawing it was of course in the public domain as part of the NPG.
7 *The Times*, 7 May 1851, p. 8.
8 For a full discussion of Layard's life and interests, see Egerton 1998, pp. 426–30.

24 MARIE FOX WITH HER SPANISH POINTER, ELIA

*c.*1854

Oil on canvas
1080 x 826mm (42 ½ x 32 ½")
Inscribed (in another hand)
'Miss Mary Fox with Spanish Pointer'
Private collection

Provenance Painted for the Hollands; displayed at
Holland House; by family descent
Exhibitions Watts Grosvenor, 1881, no. 165; Watts New
Gallery, 1896–7, no. 17; Memorial Exhs, London 1905,
no. 42
Literature Liechtenstein 1874, I, p. 237, II, frontispiece;
Spielmann 1886, p. 31; Erskine 1903, pp. 179, 181;
Macmillan 1903, p. 24; Ilchester Catalogue 1904, p. 98,
no. 133; Spielmann 1905, p. 28 (as 'never completely
finished'); Ilchester 1937, pp. 390, 402–3, ill. opp.
p. 414; Watts Catalogue, II, p. 54

Marie (sometimes called Mary) Fox
(1851–78) was the adopted daughter of
Henry Edward and his wife Lady Augusta
Holland. Her parentage remains a mystery,
but it seems possible that she was the
natural daughter of Lord Holland.[1] Around
1850 he broached the subject of adoption,
since he and Augusta (who was then in her
late thirties) were still childless. He made
arrangements in Paris through a doctor
who found (or knew of) a baby born around
January 1851; the infant was sent off to a
nurse and then a nanny, until the age of
two and a half, when she arrived to live at
Holland House in June 1853. The portrait
dates from *c.*1854 when Mary was aged
three or four.

Some five or so years had passed since
Watts painted any portraits for the Hollands.
He lived at Little Holland House by this time,
associating more with the Prinseps and their
friends, as well as his own new circle of
acquaintances in London. This portrait thus
represented a renewal of his links with the
Hollands, and he painted it knowing it
would hang among the portraits at Holland
House. It sparked off his ambitions, as he

played on the idea of Van Dyck's *Children
of Charles I* (1637; Royal Collection), in
which the central, eldest child poses in
happy union with an enormous mastiff.
More specifically, there is a direct relation-
ship between his portrayal of a child and
her pet dog and Reynolds's portrait of the
*Hon. Caroline Fox and her King Charles
Spaniel* (*c.*1770; private collection) also in
the Hollands' own collection, almost as
though Watts was engaging in a dialogue
with the eighteenth-century master.

Watts, however, was a painter of the
mid nineteenth century and his portrait of
Marie Fox includes more specific references
than a comparable work by Reynolds. The
child's clothing is minutely characterized,
with much attention to detail, including
the tiny daisy she holds. The setting is
identifiable as the parkland surrounding
Holland House, with its famed ancient
cypresses on a hillside to the left. But it is
the affectionate relationship between the
child and the dog, as Marie puts her small
arm around Elia's massive neck and he in
turn inclines his head, that animates the
portrait in an immediate and irresistible
way. Marie herself later recalled him as her
'faithful friend and wise protector'.[2]

Watts was happy to paint both animals
and children from early in his career. While
in Italy, he painted the Hollands' greyhound.
The Spanish pointer (or Perdiguero de
Burgos) was a breed known in hunting.[3] The
literature on Holland House even includes
an anecdote about Elia showing her skills
when she aided in the capture of a partridge
wounded during hay-making near what is
now Kensington High Street.[4] Watts also
had an assured way with children from his
earliest years. The group portrait of the
Ionides family (oil study, *c.*1842; V&A), and
other child portraits, indicated his willing-
ness and flair for capturing the young. With
Marie, a relative newcomer to Holland
House, he seemed conscious of providing
her with a vivid and visible connection to

the family into which she had been adopted
by echoing Reynolds's portrait of an earlier
young member of the Fox dynasty.

Marie grew up not knowing her
background until close to her eighteenth
year, when Edward Cheney (no. 10), then
Lady Holland's legal adviser, urged her
to acquaint the girl with the facts of the
adoption, since Marie was approaching
marriageable age.[5] Lady Holland did so, as
far as she knew the truth, but there was bad
feeling about the lack of full information.
The Austrian, Prince Aloys (Louis)
Liechtenstein, married Marie in 1872; even
when she was living abroad,[6] rumours of
possible parents still circulated. Sadly, Marie,
who became estranged from Lady Holland,
died young in 1878, while only in her late
twenties. Her book on the history of Holland
House was published in 1874; at about the
same time Watts painted a portrait of her
(now in the collection of Peregrine Sabin) in
a decidedly French style, comparable to that
of Alfred Stevens or Edouard Manet.

1 Ilchester 1937, pp. 400–3, tells the story such as it
was known. Mary was allegedly the daughter of a French-
woman named Victoire Magny, but about her father the
records were blank. It seems significant that Lord Holland
'would never discuss the matter with her [Lady Holland],
and that he expressed a wish that she should not enquire'
(p. 401). There are two interpretations: either, because
she had not been keen on the adoption in the first place,
he chose not to renew the discussion of how it came
about or he avoided conversation on the topic because
he wished to spare her feelings at having an illegitimate
child raised at Holland House. Either way there seems
to be more to his role than that of merely an adoptive
father.
2 Liechtenstein 1874, I, p. 237.
3 Elia displays the characteristic 'ticking' (small speckles)
on her legs, but seems to have smaller ears than the
Spanish pointers of today.
4 Ilchester 1937, p. 390.
5 Ibid., pp. 429–30.
6 Ibid., pp. 436–7.

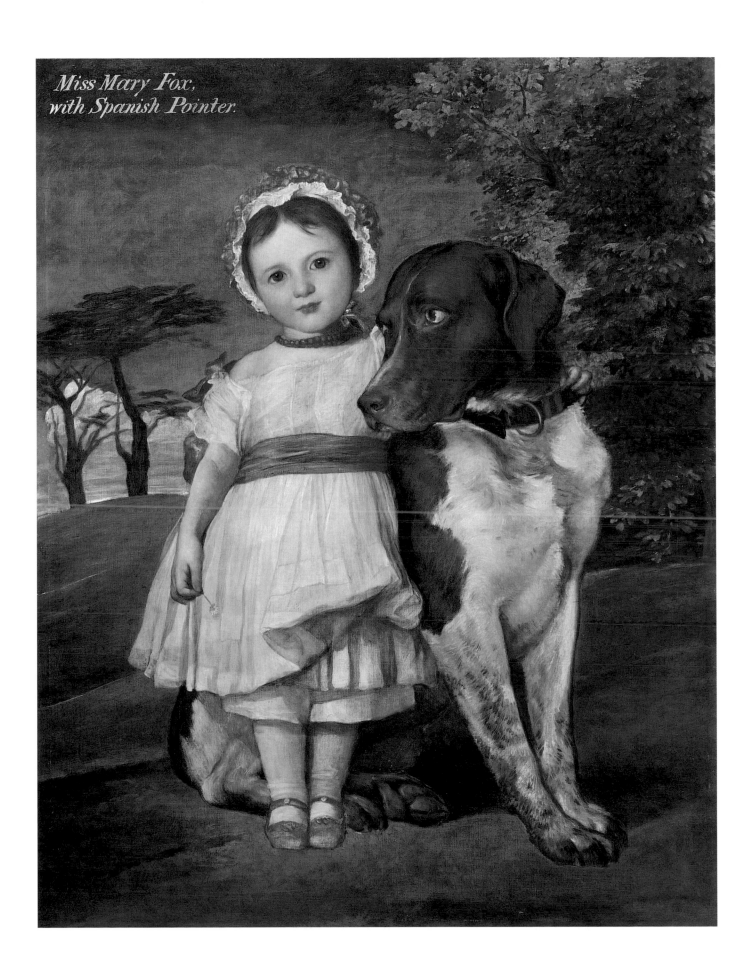

Miss Mary Fox,
with Spanish Pointer.

25 HENRY WYNDHAM PHILLIPS

*c.*1852–5[1]

Oil on canvas
1105 x 1003mm (43½ x 39½")
The Viscount Allendale

Provenance Probably painted for Phillips; his collection until the studio sale after his death, Christie's, 8 April 1869, no. 208; acquired by Wentworth Blackett Beaumont; by family descent
Exhibitions Watts New Gallery 1896, no. 47; Memorial Exhs, London 1905, no.163, and Manchester 1905, no. 18
Literature Watts Catalogue, II, p. 124; Watts 1912, I, 107, 139; Allendale Catalogue 1924, no. 15

Hardly known, this outstanding portrait of Watts's dear friend, the artist Henry Wyndham Phillips (1820–68), is one of his most fully realized and carefully wrought portrayals.

Henry was the son of Thomas Phillips (1770–1845), one of the major portrait painters of the first half of the nineteenth century and Professor of Painting at the Royal Academy. His father's extended career had encompassed the portrayal of the great and the good, as well as the artistic and literary. Definitive images of William Blake (NPG) and Byron (John Murray) are now known through Thomas Phillips's paintings. His son never reached the same level of note (he did not manage election to the Academy), but young Phillips had a distinctive career nonetheless, initially with impetus from his father with whom he studied.

Henry's middle name, Wyndham, must have been given to him in tribute to his father's greatest patron, George Wyndham, 3rd Earl of Egremont whose collection at Petworth contains many of Thomas Phillips's works. As a teenager, Henry produced a manuscript catalogue of the pictures at Petworth, allowing him the valuable lesson of studying these paintings at close quarters. Through his father, whose own collection included works by Reynolds, he had links to the traditions of portrait painting and men familiar with an earlier era of the British school.[2] Unlike Watts, Phillips was almost exclusively a portraitist. As a young man, he conducted his practice from his late father's well-located house on George Street, Hanover Square.[3]

Watts and Phillips may have known each other in Italy,[4] but they struck up a warmer friendship when Watts arrived back in London in 1847.[5] Phillips's visits to Paris in 1848 and the resulting portraits of French historian Lamartine (RA 1849; Louvre) and painter Ary Scheffer (RA 1850; unlocated)[6]

revealed him to be a painter working along similar lines to Watts, whose *Lady Holland* shown at the Academy in 1848 (fig. 4, p. 14) was in a distinctly French style.

The two men were already particularly close when Philips took over Watts's studio on Charles Street in mid 1852;[7] that year they were among the founder members of the Cosmopolitan Club, which slightly later based itself at the studio. Watts must have painted his friend in this era. A large chalk drawing from life showing Phillips's head[8] served as the basis for his face in the oil portrait. This work, characteristic of Watts's drawings in the early 1850s, shows a clean-shaven, youngish man.[9]

Everything about the painting proclaims Phillips as an artist, from the loose scarf casually tied around his neck to the prominent portfolios and artist's tools on the green baize table. A sculpture looms in the background, probably a plaster rather than a marble, but a distinct reference to the antique. Knowing Watts's avowed reverence for Phidias, so often asserted in his letters *c.*1850, this reference is understandable. But if we think of this panoply of art accessories enriching the characterization in the painting, then the youthful male nude, probably of an Antinous type,[10] is a further reference to Watts's and Phillips's ideals as artists, searching for the perfection of antiquity.

The sculpture also speaks of the erudite interests of the gentlemen connoisseurs and cultured individuals of the Cosmopolitan Club. It may even be possible that Watts set the portrait of his friend, who was the Honorary Secretary of the Club, in these rooms, where Watts had once painted and Philips currently did, so that the sculpture is associated with the practice of their art, as the sheets of drawing paper also suggest. Phillips's relaxed pose speaks of the comfortable relationship between the two men,[11] as well as suggesting the famously delightful

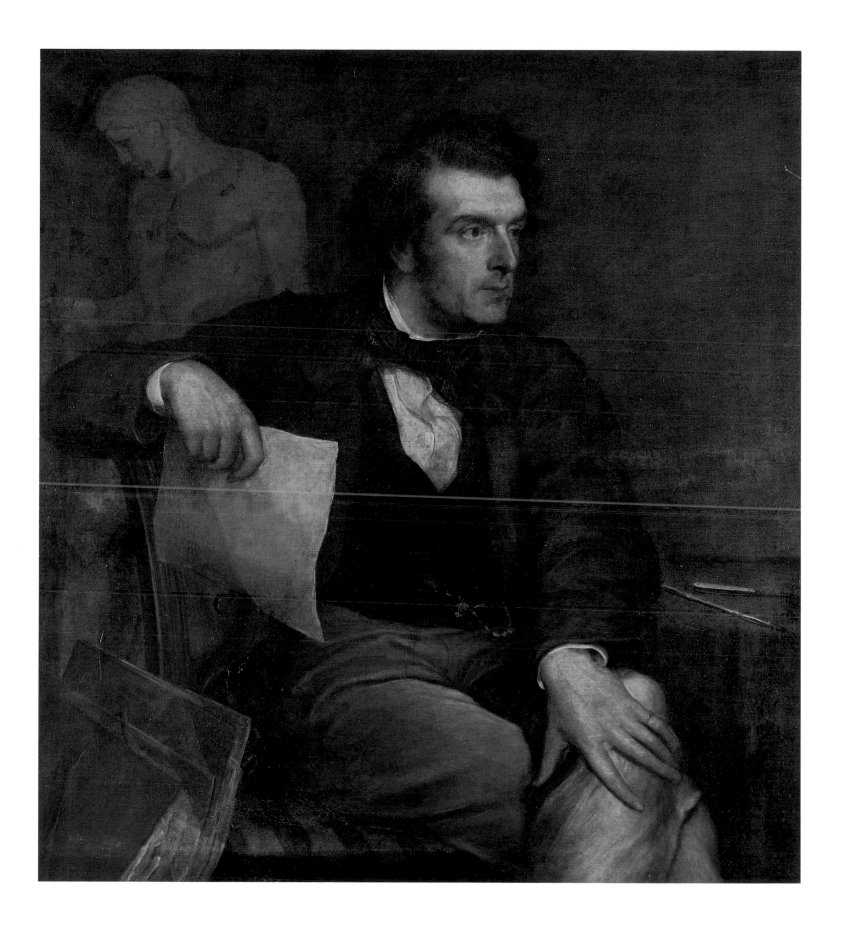

personality of the sitter. If Watts's portrayals of the Pattle sisters in their white dresses, in full-length splendour, seem impersonal, this sitter is by contrast entirely approachable.

The three-quarter-length format recalls contemporary works by Ingres. Watts's portraits of French sitters, painted in Paris in early 1856 (nos 26, 27), can be compared in their similar format and use of richly detailed setting to add to the characterization of the sitter. In handling, the combination of greens and reds is akin to *Marie Fox* (no. 24), as is the restrained, even flat brushwork, hence a date in the early to mid 1850s seems right.

Phillips's early death in 1868, aged forty-eight, came as a shock to all;[12] one common acquaintance wrote to Watts, 'our great, strong, cheery, handsome, active friend is really dead.'[13] This portrait remains an evocative record of the friendship between the two artists.

1 The date of 1865 traditionally given to this work is in my opinion incorrect; it must date from the first half of the 1850s, not later than 1856. The mistake derived from the New Gallery catalogue and although Watts was involved, he cannot have pronounced on every painting in that vast exhibition. Somehow this work, either because of an incorrect inscription on the frame, or a misremembered date from forty years previously, was dated 1865. For various reasons outlined in the entry, it should be clear that that date is far too late.
2 He painted the portrait of Samuel Rogers (collection of Timothy Clifford); and added to the gallery of portraits at the firm of publishers John Murray with a portrait of

George Borrow (RA 1844; NPG). Philips also actively participated in professional and charitable societies and was for thirteen years the Hon. Secretary of the Artists General Benevolent Institution, founded by his father, J.M.W. Turner and Francis Chantrey.
3 Later, when he had married and had a family, he resided at Sydenham.
4 Philips travelled in Italy, visiting Pompeii and Florence, but this may have been in the early 1850s.
5 They might have met in Italy since Phillips painted a portrait of William Blundell Spence, a friend of Watts in Florence, whose portrait he also painted. At the Academy of 1848 Phillips exhibited a portrait (unlocated) of Watts's great friend Layard in Eastern dress, the progress of which Watts could have followed. Mrs Watts mentions Phillips as a good friend (1912, I, p 107). Phillips was close to Lucie Duff Gordon and her family in the early 1850s; he painted her portrait in 1851 (NPG).
6 Phillips must have painted this work on speculation as he also exhibited it at the General Exhibition of Pictures in St James's Square in 1851; indeed it was still on his hands at his death and appeared in his studio sale.
7 Watts 1912, I, p. 139.
8 Sold at Phillips, London, 2 November 1987, no. 147.
9 Later depictions of Phillips, such as the dated photograph by Camille Silvy of 1862, and the still later portrait photograph by David Wilkie Wynfield, show a man who is distinctly older, and wearing a full beard.
10 Francis Haskell and Nicholas Penny, *Taste and the Antique*, New Haven and London, 1981, nos 4, 5. The image in the painting is not entirely clear but the torso is akin to the Capitoline and Belvedere Antinous.
11 The pose, in which the sitter adopts a position that calls attention to his knee, may well mean the painting post-dates January 1852 when Phillips fell at Waterloo Station and broke his kneecap (see Ross 1912, p. 30, and Frank 1994, p. 171).
12 See Ross 1912, p. 179. Tom Taylor undertook the arrangements for the sale of Phillips's collection.
13 Sir George Grove, quoted in Watts Catalogue, II, p. 124.

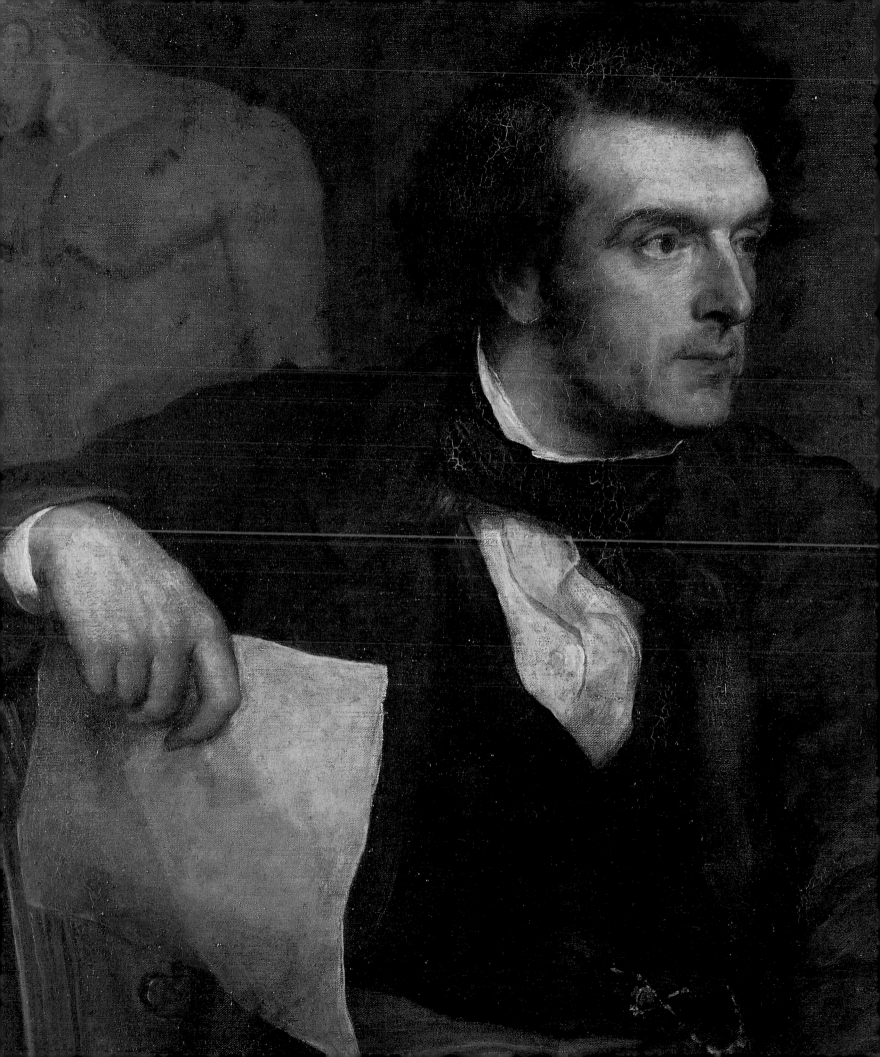

Oil on canvas
1143 x 876mm (45 x 34½")
Private collection

Provenance Painted for Lord and Lady Holland;
displayed in Paris and at Holland House; by family
descent
Exhibitions Watts Grosvenor 1881, no. 5
Literature Liechtenstein 1874, I, p. 235; Erskine 1903,
pp. 180, 183; Macmillan 1903, p. 85; Ilchester Catalogue
1904, pp. 46–47, no. 55; Spielmann 1905, p. 27; Watts
Catalogue, II, p. 23; Watts 1912, I, p. 162; Ilchester 1937,
pp. 325, 412

Watts's *Prince Jérôme Bonaparte* is, along
with *Princess Lieven* (no. 27), his most
sustained exercise in the French neoclassical
tradition of portraiture as practised by Ingres
and his followers. Painting the portrait of
the brother of Napoleon Bonaparte seems
an unusual feat for an English artist with a
modest reputation in 1856. Watts had in
fact already painted Jérôme while in Italy
but this work is lost.[1] His patrons the
Hollands arranged the opportunity for him
to paint three of their close friends during
a residential visit to Paris in the winter of
1855–6. The portraits, including *Princess
Lieven*, and one of Adolphe Thiers,[2] which
eventually went to Holland House, were
originally destined to grace the Hollands'
salon in Paris.

The youngest brother of Napoleon
Bonaparte, Prince Jérôme Bonaparte
(1784–1860) was in the twilight of his long
and eventful life. He had served in the
French navy, travelled to the United States,
married an American woman with whom he
had a child in 1805,[3] and had his marriage
annulled by the Emperor who as some sort
of compensation created him King of
Westphalia, a short-lived realm in western
Germany, in 1807. Jérôme retained this
title until 1813, later becoming Prince de
Montfort. He married again and had two

children, Princess Mathilde (1820–1904),
whom Watts had painted for her father
in 1844, and Prince Napoleon Joseph
(1822–91), nicknamed 'Plon-Plon'. Jérôme's
life became a fitful round of continental
travel until 1848 when his nephew Louis
Napoleon acceded to the Presidency of
France. He then gained official status, as
Governor of the Invalides, and later Marshall
of France and President of the Senate, with
the title 'Prince française'.

Prince Jérôme knew the 3rd Lord and
Lady Holland well. As an ardent Francophile,
Lady Holland owned one of François
Gérard's portraits of his brother Napoleon,
painted in 1825. Jérôme was also well
acquainted with the younger Hollands when
they lived on the continent during Henry's
diplomatic years in Florence and he 'claimed
Lady Augusta for an Italian solely'.[4] Marie
Fox (later Princess Liechtenstein) recalled
that the Prince bestowed sugar plums and
dolls on her when she was a child.

In the 1850s France became as
important as England to the Hollands, with
Augusta noting 'our *home* must be in Paris'.[5]
Jérôme frequented Augusta's salon at the
new residence in the Rue du Faubourg
Saint Honoré even though it included both
Orléanists and Bonapartists.[6] During Watts's
stay in early 1856 he lodged in a building
in the Rue des Saints Pères, painting several
portraits for the Hollands.

Watts must have counted it an honour
to portray such noted individuals as Jérôme
Bonaparte. The portrait suggests a familiarity
with Ingres, and the recent Exposition
Universelle had contained an exhibition
of his entire career, including a portrait of
Jérôme's son, Prince Napoleon Joseph.[7]
Ingres specialized in the three-quarter-length
format for both male and female portraits,[8]
with the figures set against precisely
delineated backgrounds. Watts has posed
the 'grave and silent' Jérôme against just
such a background. Like Ingres, Watts has
capitalized on the hands, placing them into

an elegantly telling arrangement. Watts's
young friend Frederic Leighton, who lived
in Paris at this time, had specifically visited
Ingres's studio,[9] and it is tempting to
speculate that such a visit may also have
been on Watts's itinerary during his visit in
the early months of 1856.

A distinctive feature of Watts's
composition is the marble sculpture group
in the background. While only partially
visible, it seems to be a figure group in
the neoclassical style. As in the near
contemporary portrait of Henry Wyndham
Phillips (no. 25), the sculpture acts as a
reference to the collecting preferences of
this cultured sitter, or indeed it may even
be a sculpture that was part of the collection
of the Hollands themselves. Both the
quotation of this work and the stylistic
inspiration of Ingres place this portrait
within a tradition of classicism that was
worlds away from contemporary English
practice. Watts's own continental
experience at this time provided him with
the inspiration to extend his portraiture
to new levels of accomplishment and
significance when he returned to London.

1 A related portrait of Jérôme Bonaparte is in a private
collection in South Africa. This work, a small repetition
of the head in an oval format, seems directly derived
from no. 26.
2 Illustrated in Ilchester 1937, opp. p. 392.
3 Also named Jérôme (1805–70), he grew up in
America, creating a dynasty of American Bonapartes.
4 Ilchester 1946, p. 182, as recorded by Lady Holland
in 1840.
5 Ilchester 1937, p. 357.
6 Ilchester 1937, p. 405.
7 Jérôme's son, Prince Napoleon, commissioned the
Maison Pompeienne in early 1856.
8 He used this format not just in the now well-known
female portraits such as *Madame Moitessier* (1856; NG),
but also in a series of male portraits set in interiors such
as *Amedée-David de Pastoret* (1826; Art Institute of
Chicago) and the *Comte Louis-Mathieu Mole* (1834,
private collection).
9 Mrs Russell (Emilie) Barrington, *The Life, Letters and
Works of Frederic Leighton*, London, 1906, I, p. 245.

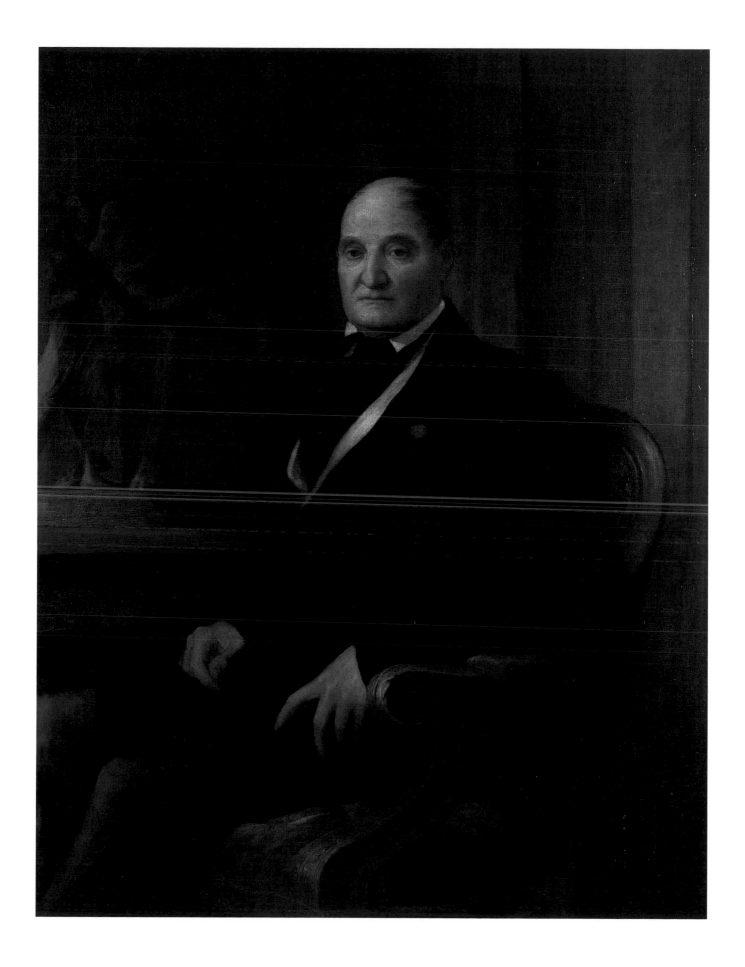

27 DOROTHEA, PRINCESS LIEVEN

1856

Oil on canvas
1130 x 851mm (44½ x 33½")
Private collection

Provenance Painted for Lord and Lady Holland; displayed in Paris and at Holland House; by family descent
Exhibitions Watts Grosvenor 1881, no. 5; *The Victorian Exhibition*, New Gallery, 1891–2, no. 42; Watts London 1954, no. 18
Literature Liechtenstein 1874, I, p. 279; Spielmann 1886, p. 31; Erskine 1903, p. 183; Ilchester Catalogue 1904, pp. 21–2, no. 24; Watts Catalogue, II, p. 93; Watts 1912, I, p.162; Ilchester 1937, ill. opp. p. 204, pp. 412–13, 448

Born Dorothea von Benkendorff, Princess Lieven (1784–1857) was a grand old lady with considerable political *savoir-faire*. Her husband, the Prince Lieven, served as Russian Ambassador to the Court of St James for twenty-two years from 1812, during which time they were *habitués* of the Holland House circle and close friends of the 3rd Earl and his wife. A dinner commemorating their departure from London was held at Holland House in July 1834. Her husband's death in 1839 left her somewhat rootless, but essentially she based herself in Paris, remaining friendly with the younger Hollands, especially Lady Augusta. In 1849, when there was a rift between Lord Holland and his wife, Augusta stayed in Paris in company with Princess Lieven.

Princess Lieven was very much a feature of Holland House in more ways than one. In the 1830s, when the conservatory was decorated with busts (some in plaster and some in marble) on pedestals, hers as a much younger woman appeared along with Charles James Fox, Count d'Orsay, Byron and George Washington among others.[1] By the mid 1850s, when she was in poor health, it may have occurred to Lord Holland and Augusta that they did not possess a handsome enough portrait of their great

friend. In her younger days, as the consort of a powerful ambassador, she had sat to Thomas Lawrence and Martin Archer Shee (1769–1850), but the Hollands did not possess a suitable depiction of her for display at Holland House.

With Watts's trip to Paris perhaps arranged just for this purpose, sittings took place in early 1856. How he reacted to the *grande dame* is not known, but in the portrait Princess Lieven appears to epitomise her renowned reputation as a scathing wit, who at this time wrote that she was 'going to Paris to postpone my death' yet promised to remain 'for the rest of my life as egotistical and self-centred' as she always had been.[2]

Watts adopted the three-quarter-length format in the manner of Ingres, which was appropriate for his French sitter. Ingres's recent portraits had also displayed similar handling of thin paint, which allows for the definition of decorative detailing within the space. This precise detailing also accorded with the individual herself. About Princess Lieven, one observer noted that 'beyond all people [she is] fastidious, and especially conscious of her own superiority and the inferiority of other people'.[3] This painted image conveys such traits; indeed, Lady Holland observed of Watts's portraits, 'I never know my friends until you have painted them'.[4]

The restrained colouring, a matt green and reddish brown, sets a subdued mood, as does her black garb. The image is, however, enlivened by a vigorously growing potted geranium, placed on a table adjacent to Princess Lieven, with the suggestion that, even within this dark enclosed Parisian salon with an ill old woman, a flowering plant lives, blooming profusely, as a recollection of the beauty of her youth. A year later the princess died.

The painting returned, with no. 26, to Holland House in Kensington to join other notable depictions of French men

and women,[5] several of which were by Watts (including one of Princess Lieven's former lovers, François Guizot [no. 18]), to maintain the longstanding ties of the family with France. The artist apparently considered it one of his best works.[6]

1 Ilchester 1937, pp. 495–6; it was still there in the 1930s.
2 Letter of November 1854 to Lady Palmerston, *The Lieven-Palmerston Correspondence 1828–56*, trans. and ed. Lord Sudley, London, 1943, p. 303.
3 Comment made by George Greville, as recorded in Georgiana Blakiston, *Lord William Russell and his Wife 1815–1846*, London, 1972, p. 34.
4 Ilchester 1937, p. 112.
5 These works hung in a small sitting room adjoining the ground-floor reception room; Ilchester 1937, p. 448.
6 Ibid., pp. 412–13.

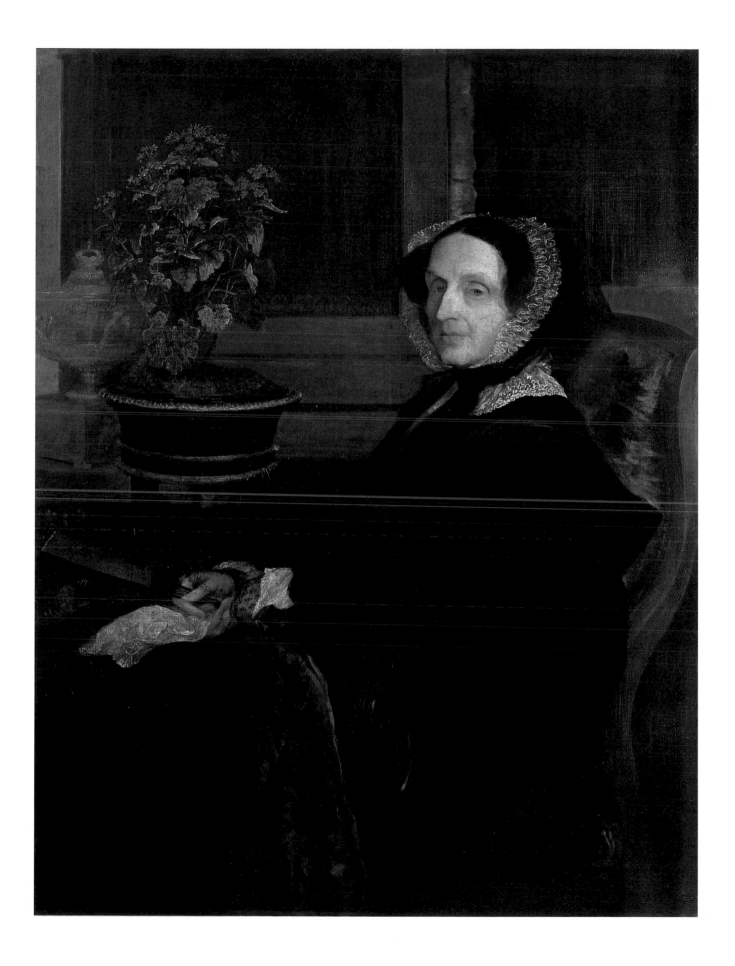

28 PRUDENCE PENELOPE CAVENDISH BENTINCK

c.1857–9

Oil on canvas
1473 x 1118mm (58 x 44")
Northampton Museums

Provenance Painted for the sitter and her husband;
by family descent; on loan to the Tate Gallery in 1946;[1]
given by W.G.F. Cavendish-Bentinck, grandson of the
sitter, to the Museum and Art Gallery, Northampton,
in 1948
Exhibitions Watts Grosvenor 1881, no. 174; *Exhibition
of Old Masters (National Gallery Fund)*, Grafton Gallery,
London, 1911, no.42; Watts London 1954, no. 26
Literature Spielmann 1886, p. 29; Watts Catalogue, II,
p. 13

This impressive work, one of Watts's most
truly dramatic portraits, vividly demonstrates
how the artist consciously went beyond the
boundaries of portraiture to create images
of great beauty and subtle meaning in the
later 1850s. In this case Watts's patrons,
Prudence (1830–96) and George Augustus
Frederick Cavendish Bentinck (1821–91),
had a key role in shaping his ambitions
about this work and others he painted for
them (no. 33).

The sitter's husband was related to the
Duke of Portland,[2] but he and his wife led
lives quite separate from the immediate
family of the duke, although no doubt the
notable Portland collections at Welbeck
Abbey provided an inspiring model for
the extensive art collection George
Cavendish Bentinck eventually acquired.[3]
In 1850 Prudence and George married in
Westminster Abbey with her cousin the
Duke of Wellington giving the bride away.
They were regular visitors to Holland House.
Prudence belonged to the Leslie family of
Ireland; her brother John Leslie was an
amateur painter, well known to artists in
London.[4] Watts knew George, a young Whig
MP, as a fellow member of the Cosmopolitan
Club and the Arts Club.[5]

Initially, around 1856, Watts received a
commission to paint George's mother, Lady
Frederick Cavendish Bentinck (Northampton
Museums).[6] This portrait followed soon
after Watts's *Princess Lieven* (no. 27) and
it is in much the same mode, showing an
older, cultivated woman. With the next
commission from Cavendish Bentinck, for
a portrait of his wife, Watts conveyed the
lessons of his recent conversion to creating
portraits that were 'valuable as works of
art'. He also termed such works 'elaborate
performances', a singularly apt description
for this particular portrait.

Watts shows Prudence rising from the
piano stool, turning emphatically outward
to her viewers. She grasps her music book,
as if about to select a piece thrilling enough
to match the moonlit sky visible beyond the
mullioned window. Vivid in colour, intense
warm reds mix with the burnt orange of her
silk skirt, and contrast with the blue of the
night sky. This extraordinary work is filled
with an almost Gothic spirit, as if the main
character has walked out of the pages of a
novel by Wilkie Collins or indeed a play by
their mutual friend, Tom Taylor. As a portrait
partaking of the spirit of the 'sensation'
novels and plays of the mid Victorian era,
this work displays originality almost
unmatched in any other portrait by Watts.

Indeed it is known that both Cavendish
Bentincks had a developed taste for the
theatre. George participated in amateur
theatricals performed at the Cosmopolitan
Club[7] and co-wrote a farce with Tom Taylor
in 1854. Prudence was a personal friend of
the great tragedienne, Adelaide Ristori, with
whom she visited Watts's studio in June
1856. Watts portrayed Ristori in a striking
drawing dating from just this time. One
eccentric detail in no. 28 is the sheet music,
which when examined (very) closely reveals
the name of Beethoven. The date 1795 may
well refer to this composer's Opus no. 1.
Such a stirring musical choice seems entirely
fitting in this unusual portrait. Why Watts
allowed this detail to emerge is intriguing.

One might well assume it was the wish of his
stimulating sitter although his own fondness
for Beethoven was well known to his friends
around 1860.[8] Watts's own affinity for
musical associations essayed here was
followed up in the portrait of Alice Prinsep
(no. 37) of 1860. With *Prudence Cavendish
Bentinck* dating from the late 1850s, Watts
mingled the idea of musical performance in
a painted portrait, anticipating advanced
ideas in English art of the 1860s.

1 Tate Gallery, *Report for the Year 1953–1954*, London,
1954, p. 80, along with three other portraits by Watts
including no. 36.
2 G.A.F. Cavendish Bentinck was the son of Lord
Frederick Cavendish Bentinck and grandson of the Duke
of Portland.
3 Bentinck's nascent collecting impulse seems to begin
with these commissioned portraits by Watts; by the
1870s he amassed a considerable collection of Old
Master and British paintings.
4 She was also a relation of the Irish poet Aubrey de
Vere, who Watts visited in 1850.
5 The Arts Club (see p. 28) a smaller and more
specifically defined group of connoisseurs, included at
the same time, Edward Cheney, Louis Huth and Robert
Holford.
6 Her husband had died in 1828 after only eight years
of marriage, leaving her to raise her only son George;
she died in 1862.
7 Algernon West, *One City and Many Men*, London,
1908, p. 156.
8 Watts 1912, I, p. 186.

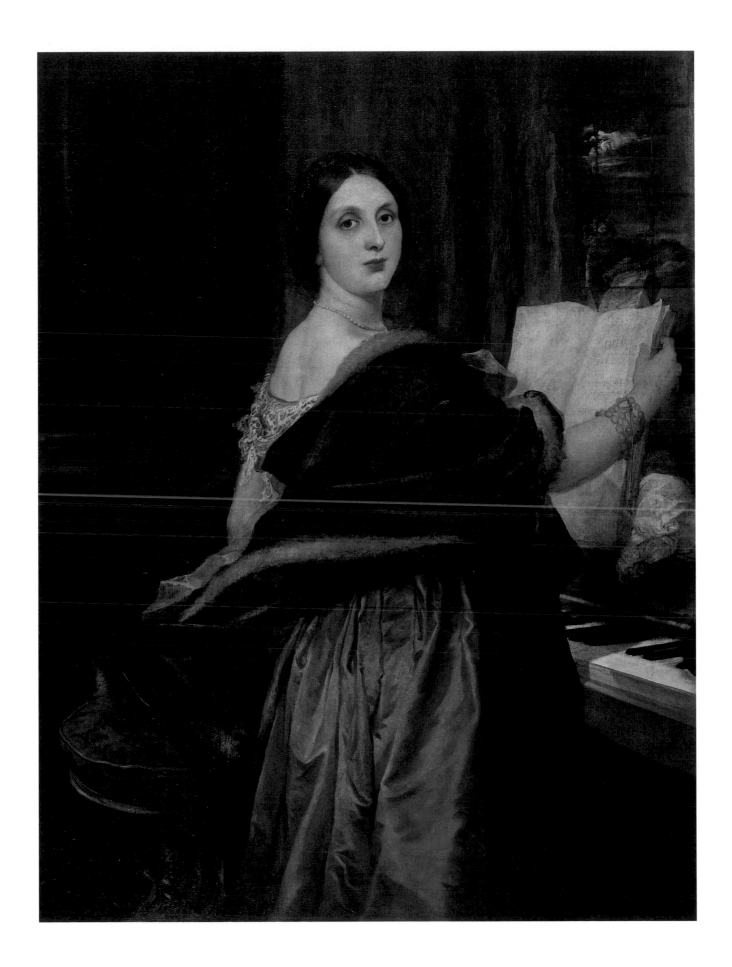

29 ISABELLA (ARABELLA PRESCOTT)
1857

Oil on panel
610 x 500mm (24 x 19¾")
Inscribed (lower right) 'G F W 1857'
Private collection

Provenance Sold by the artist to the family of the sitter for 80 guineas in 1857; by family descent; Phillips, London, 16 June 1998, no. 42
Exhibitions Royal Academy, London, 1859, no. 438, as *Isabella*
Literature John Ruskin, 'Notes on some of the Principal Pictures … Royal Academy, 1859' (Cook and Wedderburn 1903–12, XIV, pp. 239–40); Spielmann 1886, p. 30, as *Isabella*; Watts Catalogue, II, p. 125 (unillustrated); Hunt 1913, I, p. 140

Although in one sense this painting is a portrait of Arabella Prescott (1839–1902), the daughter of banker William George Prescott of Roehampton, it was not initially a commissioned work. Watts asked to paint Arabella, with whose family he shared some friends. Sir Henry Taylor, who knew the Prescotts, commented on the sitter, noting that 'she is not a person whom having once loved one can ever cease to love'.[1] Watts seems to have fallen under her spell and asked her parents if he might paint her.

Watts completed the painting by August 1857 when he alerted Arabella's mother that it was ready. He had made a false start on canvas,[2] necessitating extra labour, hence he seemed reluctant to name the price of eighty guineas. True to form, however, he indicated that he would 'very willingly keep it, to say the truth I am sorry I let it go'.[3]

Stylistically, the painting evokes the early Renaissance. Set against a limpid blue sky, the image is purified of all distractions. The face is framed by a simple coiffeur, reduced to a mere outline. The extreme delicacy of the thin paintwork is seen to good effect in the sheer lacy neckline, carefully worked gold embroidered border and elaborately knotted shawl. White roses adorn her hair. Painting on panel, as the artist did for some years around 1860, permitted such detail and high finish with relatively thin paint. Watts's visual inspiration, with its application of paint over a white ground, was fresco painting, both frescoes of the Renaissance and his own endeavours in this medium in the 1850s. The restrained technique underlines the distant look in the eyes of the sitter.

The image of Arabella became in Watts's thinking not the banker's daughter, but the study of an idealized head, with a poetic mood reflected in the artist's title, *Isabella*, suggestive of Keats's poem. In a letter of August 1857 Watts noted that it was hanging at Little Holland House; here it was on view to a range of visitors to Sara Prinsep's salon, including the young Pre-Raphaelites. *Isabella*, as a head study of a beautiful woman with flowers, set a precedent for Dante Gabriel Rossetti's *Bocca Baciata* of 1859 (fig. 14, p. 30), the first in his series of oils depicting sensual women embellished with decorative accessories. Watts's Italianate vision is more quattro-cento than Venetian, but a common impulse is evident.

Watts's own high opinion of this work encouraged him to send it as his sole contribution to the Royal Academy in 1859 under his own name (unlike the previous year), and it attracted the attention of discerning critics. The Pre-Raphaelite sympathiser F.G. Stephens writing in the *Athenaeum* considered it 'painted in the manner of Sir Charles Eastlake, turned, if it were possible, P.R.B. … it is the only good idealized portrait in the Exhibition'.[4] Ruskin in *Academy Notes* found it 'full of beauty and thoughtfulness'. In *The Times* Tom Taylor writing as a friend of Watts and also, it would seem, of the sitter, commented

> the most refined piece of portraiture in this room – indeed, we might say in the whole exhibition – is Mr. G.F. Watts's 'Isabella' a masterpiece of the tenderer harmonies of blond colouring, in combination with such drawing as is seldom called to the service of portraiture – drawing by which form is idealized without the sacrifice of truth, till we acknowledge perfect likeness, accompanied by something which we never saw in the face till the painter revealed its presence.[5]

This unusual portrait had been lost since its exhibition in 1859 until it resurfaced in 1998 on the art market. Important as Watts's only submission to the Royal Academy of 1859, it also vividly demonstrates the turning point in his portraiture in the second half of the 1850s. Here, as in *Jeanie Nassau Senior* (no. 32), he moved towards the idea of the portrait as subject painting with its own visual beauties and subtle meanings.

1 *Autobiography of Henry Taylor 1800–1875*, London, 1885, II, p. 140.
2 The unfinished oil study on canvas was formerly in the collection of Christopher Gibbs (Christie's, Manor House at Clifton Hampden, 25–6 September 2000, no. 184).
3 Watts to Mrs Prescott, 18 August 1857, private collection.
4 *Athenaeum*, 21 May 1859, p. 683.
5 *The Times*, 10 May 1859, p. 9.

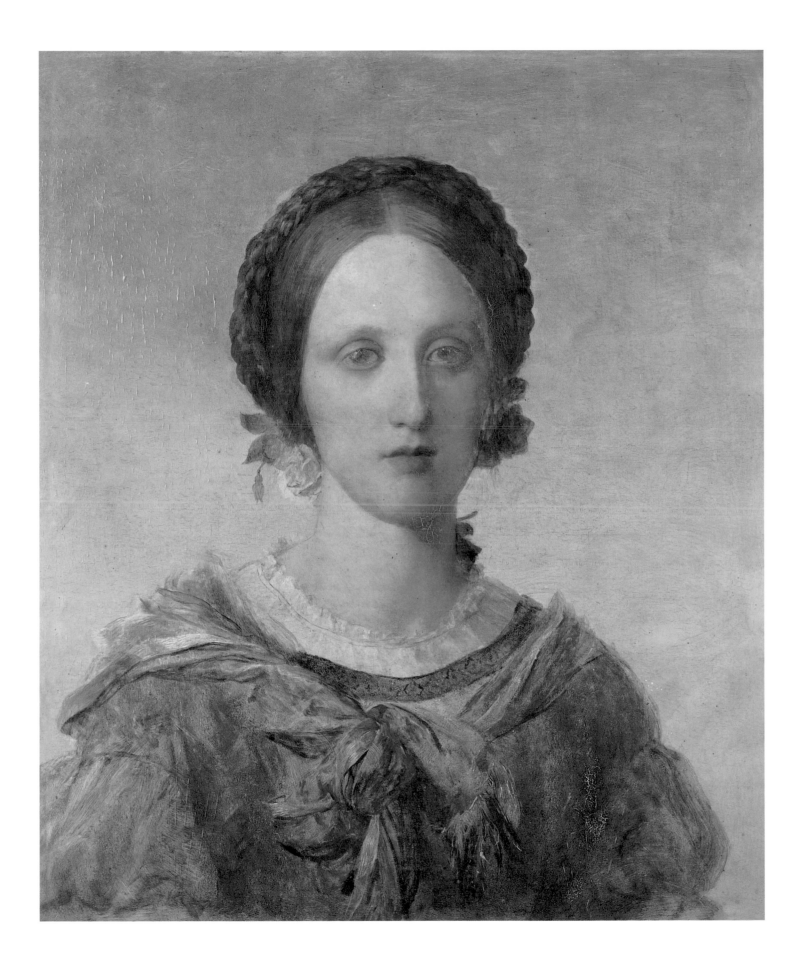

30 HELEN ROSE HUTH

*c.*1857–8

Oil on canvas
1950 x 1055mm (76¾ x 41½")
Dublin City Gallery, The Hugh Lane

Provenance Collection of the sitter and her husband (not
included in the sale of her deceased husband's collection
in 1905); sold privately by her to Sir Hugh Lane, by whom
given to the Municipal Gallery of Modern Art, Dublin, in
1908
Exhibitions Watts London 1954, no. 22
Literature 'The Dublin Gallery of Modern Art', *Burlington
Magazine* 12 (1908), p. 277; Watts Catalogue, II, p. 71

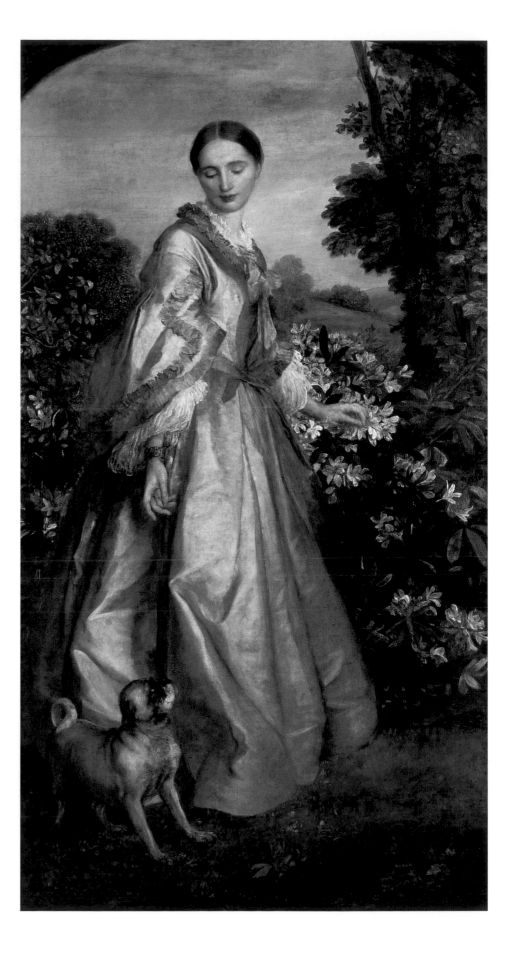

This relatively little-known work is one of Watts's greatest full-lengths, executed at just the time in the later 1850s when he redefined his objectives as a portrait painter. It enjoyed considerable status as part of the noted collection of modern art featuring the work of Watts and Whistler that the sitter and her husband formed after their marriage in 1855.

Helen Rose Huth (1837–1924), née Ogilvy, was the daughter of a Scottish merchant; she had recently married wealthy Louis Huth (1821–1905), whose day job as a company director for an insurance firm, disguised (and probably partly financed) a passion for art collecting.[1] In the 1850s Huth belonged to the Fine Arts Club, a breeding ground for educated connoisseurs. His older brothers had more conservative tastes, with Charles purchasing works by John Linnell and John Constable, and Henry concentrating on rare books.[2] Virtually a generation younger than his siblings, Louis turned to modern art, and prompted by his marriage, he commissioned the first of a series of oil portraits of his wife. Perhaps the conventional portrait of Helen by Charles Baxter (RA 1856; unlocated) resulted in his approach to Watts through other members of the Fine Arts Club. The artist first painted a simple portrait of Helen looking like a mere girl (formerly Ashmolean), followed by this full-length with an outdoor setting,[3] perhaps an allusion to the Huth family's taste for classic English landscapes by the likes of Constable and Linnell.

Watts's grand manner portrait possesses all the elements of an eighteenth-century portrait, but it is distinctly of its own time from the fashionable dress worn by the subject to the clipped Victorian garden filled with the equally fashionable blooming rhododendrons. The addition of a pug, no mere gesture to tradition, adds a highly personal, and piquant, note to the composition. If anything, this type of dog is reminiscent of Hogarth or Landseer, but

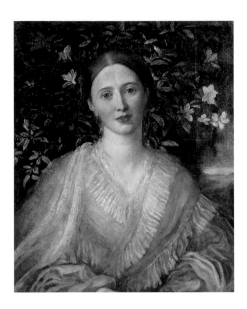

FIG. 34 Here identified as *Helen Rose Huth*, G.F. Watts, early 1860s, oil on canvas, 660 x 533mm (26 x 21"). Compton Verney. Purchased by the Peter Moores Foundation for display at Compton Verney, Warwickshire

looking at the interaction between Helen and the pug one must deduce he was her actual pet, for he is hardly a decorative accessory. The overall tonality of the painting, from the lavender silk to the clear blue spring sky, lights up the image, making this grand manner portrait a distinctly modern exercise for the young collectors.

Helen and Louis Huth formed an extraordinary collection of modern paintings and decorative arts. Huth's taste turned toward the Aesthetic preoccupations of his friend Rossetti with whom he vied for the pick of blue-and-white porcelain in the 1860s.[4] At about this time Watts painted Helen again (fig. 34) in a work that betrays the increasingly Aesthetic taste of the Huths, as the figure wears pale whitish grey, verging on blue, a colour scheme equally apparent in the first painting they bought from Whistler in 1865, *The Symphony in White, No. 3* (Barber Institute of Fine Arts, Birmingham).

By 1868 with the completion of their new country house, Possingworth in Sussex, with its grand picture gallery, the Huths further indulged their collecting, buying

several works from Watts including his full-length nude *Daphne* (RA 1872; unlocated). Huth patronised Whistler, commissioning another full-length portrait of his wife, eventually entitled *Arrangement in Black, No. 2: Portrait of Mrs. Louis Huth* (1872–3; private collection),[5] which in its study of black on black was seemingly conceived as a direct contrast to Watts's sunny, optimistic outdoor study, full of light and colour.[6] Whistler famously required numerous sittings from the delicate Helen, and when she complained that Watts never treated her that way, Whistler retorted: 'And still, you know, you come to me!'[7]

Her comment sheds a light on the interaction between sitter and portraitist. All told, Watts painted four portraits of Helen,[8] more than any other sitter except Lady Holland, the Pattle sisters, Ellen Terry and Violet Lindsay. This seems to indicate a real rapport between her and the artist, an interpretation born out by the fact that in about 1866 Watts also painted Helen's sister Eliza when she was due to marry and leave the country. Ever attuned to the emotional attachment between sisters, the artist believed that this portrait would serve as a comfort for Helen.[9]

1 The Centre for Whistler Studies lists him as the Director of The London Assurance for Fire, Life and Marine Assurance. His father, Frederick Huth, established a merchant house based in Moorgate.
2 MacLeod 1996, p. 432, lists Charles Frederick Huth (1806–95), who was a director of the Bank of England from 1866 onward.
3 A few studies survive: one is at the Ashmolean; another is in a small sketchbook at the Watts Gallery.
4 G.C. Williamson, *Murray Marks and his Friends*, London and New York, 1919, pp. 34–5.
5 Dorment and MacDonald 1995, no. 63.
6 It was of course also considered a homage to Velázquez, as noted in Aileen Ribeiro, 'Fashion and Whistler', in *Whistler, Women, & Fashion*, exh. cat., The Frick Collection, New York, 2003, p. 38.
7 E.R. and J. Pennell, *The Life of James McNeill Whistler*, Philadelphia and London, 1908, I, p. 179.
8 The fourth, now unlocated, showed her in profile.
9 Noted in Watts Catalogue, II, p. 119.

31 MARY ('MINNIE') SENIOR

1856–7

Oil on canvas
1981 x 1321mm (78 x 52")
Private collection

Provenance Probably painted for the sitter's father, Nassau William Senior; the sitter (Mrs Charles Simpson); by family descent to her daughter Amy (Mrs St Loe Strachey); John Strachey; Celia Strachey; and by descent
Exhibitions Royal Academy, London, 1858, no. 167 as *Miss Senior* as by F.W. George; Watts Grosvenor 1881, no. 8; Memorial Exhs, London 1905, no. 32
Literature William Michael Rossetti, *The Spectator*, 5 June 1858, p. 590; Spielmann 1886, p. 32; Barrington 1905, pp. 2–3; Watts Catalogue, II, p. 142; Watts 1912, I, p. 174; Hunt 1913, II, p. 139

Unlike the portrait of Jeanie Nassau Senior (no. 32), this one of her sister-in-law has remained out of the public eye. Conceived in sequence and with an obvious relation to each other, the two portraits debuted at the Royal Academy in 1858. They have not appeared together since the retrospective exhibition of Watts's work at the Grosvenor Gallery in 1881 and are here reunited for the first time in over one hundred years.

Watts knew the Seniors and the Hugheses, both families connected in 1848 by the marriage of Jeanie Hughes with Nassau John Senior (1822–91), the son of the famous economist, Nassau William Senior (1790–1864). Living at Hyde Park Gate, on the way to Kensington, the Seniors were part of the circle at Little Holland House. Henry Wyndham Phillips had painted the elder Senior in 1855 and Tom Hughes, Jeanie's brother, was a member of the Cosmopolitan Club and a friend of Tom Taylor.

Mary Charlotte Mair (1825–1909), known as Minnie, an only daughter, accompanied her parents on European travels to Italy and France, living in Paris at the Hotel Bristol, attending the salons, mixing with the intelligentsia and visiting the studios of artists such as Ary Scheffer. Close to her father, she assisted in his work

by translating French texts and edited several volumes of his writings after his death.[1] Her own book, *Many Memories of Many People* (1898), described their life in the 1850s.

Watts knew this cultured family in the 1850s,[2] at the time he was reformulating his attitude to portraiture, particularly after his travels in 1856. He arrived back in London and focused on portraiture with a renewed sense of commitment. This is one of the first full-lengths he painted after this decision to devote more attention and workmanship to his portraits. Largely completed by September 1857, he told Minnie's brother that he was 'working harder at it and more than he ever did at any picture before'.[3]

Fashionably dressed, Minnie walks along a path with her spaniel and then turns to gaze outwards with unusual directness. The setting is a contemporary garden. Beside the path is a mature laurel and within that grows a rambling rose with red blooms, climbing into the nearby trees. The artist's allusive mind may have intended the rampant red flowers invading the evergreens to suggest a combination of fresh modern beauty with old types, paralleling his depiction of his young sitter in the grand manner format.

Watts worked for several months on it, painting the dress separately. Once that was done, he still required two or three sittings from Minnie herself. In his usual fashion he offered to keep it if she did not approve, even offering to paint another,[4] partly due to his choice of a canvas too large for its ultimate destination.[5] Family members inspecting the portrait commented on the extraordinary likeness. Immediately after completing the work in October 1857, Watts started to paint Minnie's sister-in-law (no. 32) in a work not designed as an exact pair (the sizes differ) but as a companion image with a contrasting indoor setting.

With these two portraits Watts returned to the Royal Academy but he took the

strange precaution of submitting them under an assumed name, F.W. George. He wrote that he sent the pictures 'in accordance with the wishes of certain friends'.[6] But having avoided the Academy for his oil paintings for the past six years, he must have realised the time was right to re-enter the premier exhibition venue to progress professionally.

Advanced art critics identified a new type of portraiture exemplified by the two paintings. The critic in the *Athenaeum* wrote of 'the two best portraits ... really the works of Mr. Watts' as 'great and daring experiments of introducing Pre-Raphaelite finish of accessories into portraits, laurel bushes, box borders, gravel walks and flowers instead of the venerable and immemorial books, curtains, pillars and sloppy green distance'. The particularly modern aspect of the portrait struck the writer in another interesting way: 'Miss Senior, with a thoughtful fine face, walks like Miss Brontë's heroine down a garden.'[7] If Prudence Cavendish Bentinck (no. 28) seems a character out of Wilkie Collins, then Minnie Senior belongs to the world of the Brontës.

The question of Pre-Raphaelite influence arises, but such precise handling of details already featured in Watts's recent Ingresque portraits. What was new was the high key of the colour in a bright, almost floodlit setting, and the timing of this experiment might well show Watts responding to his younger contemporaries.

1 She later edited her father's *Journals Kept in France and Italy from 1848 to 1852* (London, 1871) under her married name, M.C.M. Simpson.
2 He later painted an unfinished portrait of her father, see Watts Catalogue, II, p. 142.
3 Extract from letter by Nassau John Senior to his father, 29 September 1857, Glasgow University Library.
4 Letter from Watts to 'Miss Senior', signed 'G.F. Watts detto Signor', Glasgow University Library.
5 Letter of 10 October 1857, Watts Papers.
6 Letter to Jeanie Nassau Senior, [May] 1858, Watts Papers.
7 *Athenaeum*, 15 May 1858, p. 629. The reviewer was Walter Thornbury, according to William Holman Hunt.

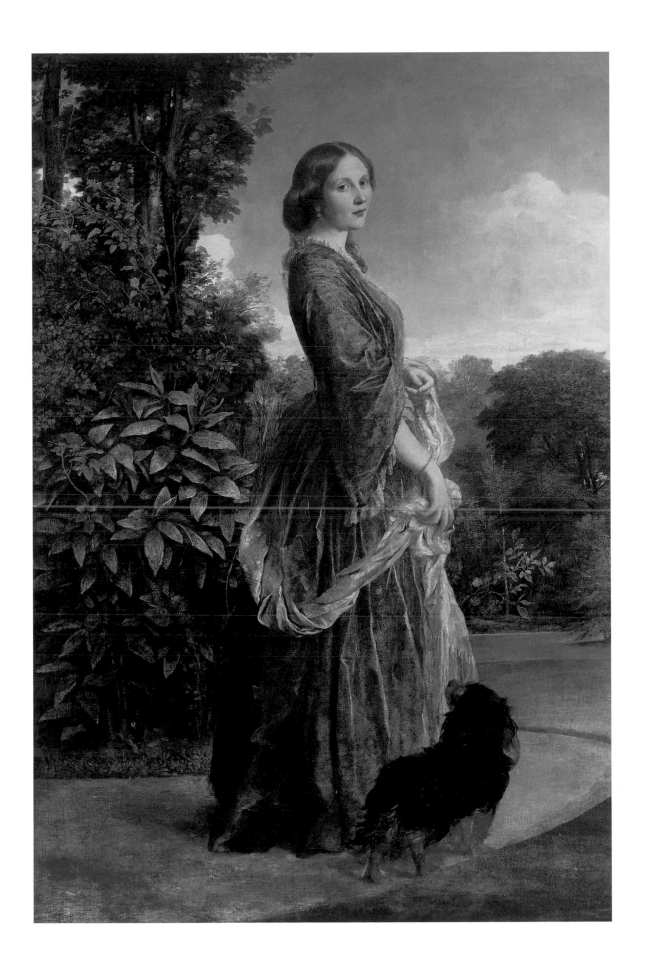

JANE ('JEANIE') ELIZABETH NASSAU SENIOR
1857–8

Oil on canvas
1765 x 1029mm (69½ x 40½")
Wightwick Manor, The National Trust
(Photo: National Trust Photographic Library/
John Hammond)

Provenance Painted for the sitter; by family descent to
Oliver Nassau Senior, by whom lent to Wightwick from
1947, and from whom bought by the National Trust with
the encouragement of Lady Mander in 1955
Exhibitions Royal Academy, London 1858, no. 142,
as by F.W. George; Watts Grosvenor 1881, no. 28; *The
Victorian Exhibition*, New Gallery, London, 1891, no. 87;
Watts New Gallery, 1896, no. 11; *Loan Collection of
Works: G.F. Watts, R.A.*, Leighton House, 1902/3, no. 29;
Watts London 1954, no. 21; *In Trust for the Nation:
Paintings from National Trust Houses*, National Gallery,
London, 1995–6, no. 14 (with provenance as above)
Literature *Athenaeum*, 15 May 1858, p. 625; Spielmann
1886, p. 32; M.C.M. Simpson, *Many Memories of Many
People*, London, 1898, p. 94; Barrington 1905, pp. 7,
202; Spielmann 1905, pp. 29–30; Watts Catalogue, II,
p. 142; Watts 1912, I, pp. 174–5; Hunt 1913, II, p. 139;
Spielmann 1913, p. 126; Laing 1995, pp. 44, 198–9

One of Watts's acknowledged masterpieces, this work is also a prime example of the artist's revived interest in portraiture in the second half of the 1850s. As a depiction of the artist's close friend, Jeanie Nassau Senior, this portrayal reveals layers of personal meanings as well as being a distinctly modern grand manner portrait.

Jeanie Nassau Senior (1828–77) was a member of the Hughes family, the sister of seven brothers, one of whom was Watts's friend Tom Hughes MP (1822–96),[1] member of the Cosmopolitan Club and author of the then just published *Tom Brown's Schooldays* (1857). The artist had already painted their mother in 1856.[2] Tom Taylor apparently knew the family as well. Jeanie had married Nassau Senior's son, Nassau John Senior in 1848. Watts befriended her in about 1851, some time before the portrait; while he travelled abroad in 1856, she served as his confidante, the recipient of a series of letters in which he revealed his depression and further worries: 'I pine dreadfully for some tender mind and hand; it is not good for man to be alone.'[3] Jeanie was another of the married women to whom Watts turned for solace and companionship. She possessed talents much valued by Watts, such as her mezzo-soprano voice, likened by her sister-in-law to a 'deep-toned silver bell'. In the 1850s she performed at her brother Tom's concerts for the poor, an indication of her innate social conscience.

Jeanie's warm personality endeared her to Watts,[4] but her beauty must have helped, especially her distinctively 'rippling golden hair',[5] featured in the portrait and also seen in Millais's *The Rescue* (RA 1855; National Gallery of Victoria, Melbourne). Jeanie met Millais through Tom Taylor when that artist wanted 'to get a beautiful face'[6] for his new painting, so she enjoyed some fame before Watts decided to paint her.

While finishing *Minnie Senior*, Watts must have decided to paint Jeanie in a companion picture. In December 1857 he wrote asking 'as soon as you feel up to sitting and find it will not interfere with your domestic duties, I hope you will give me an occasional hour for my picture. Its present state distresses me.'[7] Here, in contrast to the Victorian garden, Watts placed his sitter indoors. The season was, after all, approaching winter, but this setting also allowed the artist to play upon the idea of woman and nature. Jeanie did apparently have a fascination for the beauties of the natural world.[8] In the portrait she is seen leaning, somewhat awkwardly with her knee on a chair, to water a vase planted with lilies-of-the-valley. Cast upon the floor are various exotic cut flowers, including an orchid and arum lily, the products of the hothouse or conservatory, making clear her preference for the simple growing flowers she has nurtured. This activity was in Watts's mind the key to his painting, as he wrote when giving her a gift:

> I hope it will remind you of my picture,
> and the meaning I have in making you water
> (in the picture) a flowering root with so
> much solicitude. As I told you, I intended
> by the flowers to supply the better known
> sentiments aspirations and affections, which
> it is sometimes difficult to keep alive, or
> at least blooming in the crush of artificial
> society.[9]

The still-life elements of the portrait show a *tour de force* of the painter's technique. Yet this careful attention to the flowers, glass and porcelain,[10] as well as ornate furniture, enhanced the meaning as well as the appearance of the portrait in a manner reminiscent of Ingres's *Comtesse d'Haussonville* (fig. 5, p. 14), where there is also the detail of plants growing from a porcelain vase. In Watts's work this bohemian luxury was worlds away from the countryside lifestyles featured in Francis Grant's portraits.

Watts's picture is very obviously a modern woman in a modern setting, with the dark green wallpaper ornamented with tendrils of flowers and leaves recognisable as a feature at Little Holland House and seen in other works by the artist (no. 40). Perhaps he even intensified this green having seen the National Gallery's *Virgin and Child*, attributed to Giovanni Bellini (acquired 1855), featuring a similar colour in a fabric panel hanging behind the figures. Colour features elsewhere in Watts's portrait with Jeanie wearing a dress in the newly available deep purple made possible by aniline dyes. The medievalising sleeves were also a current fashion trend.[11] Watts has added his own paisley shawl along with other details to enrich the image and fulfil his wish to paint portraits that were 'elaborate performances'.

The precise detail and the unexpected

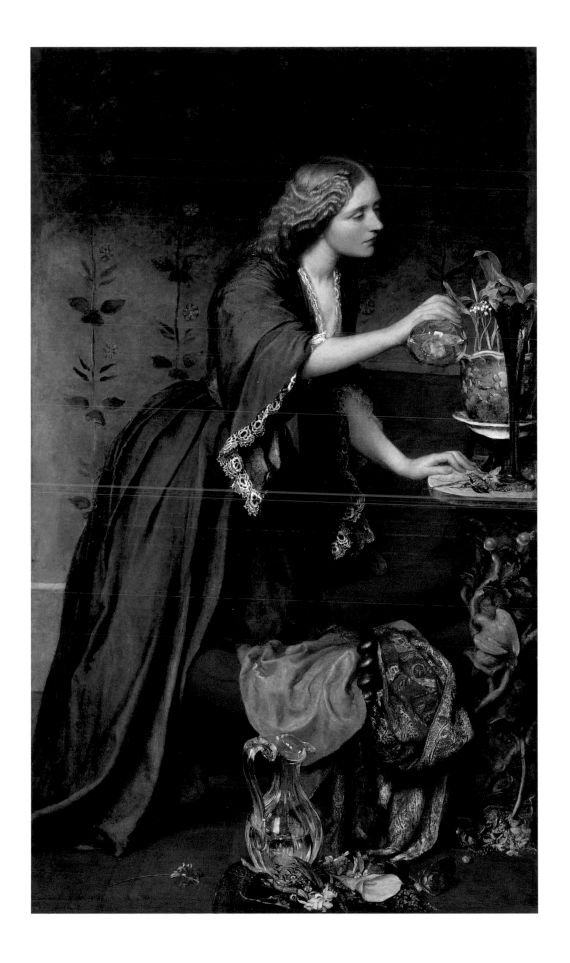

colour combinations of orange, purple, red and green evoked comparison with the Pre-Raphaelites who were much part of the Little Holland House circle in 1858. In 1906 William Michael Rossetti wrote that Watts was so 'impressed by the remarkable qualities imparted to Holman Hunt's paintings by high tints of colour and minute finish of details, he essayed a style of corresponding aim – *Mrs. Nassau Senior*'.[12] Holman Hunt's recently exhibited *Scapegoat* (RA 1856; Lady Lever Art Gallery, Liverpool) featured such 'high tints', including a particularly resonant purple. While it is certainly true that intense colour and detail are a feature of Watts's portrait, there are equally relevant thematic connections with the Pre-Raphaelite depictions of women within enclosed indoor settings, such as Millais's *Mariana* (RA 1851; Makins Collection) and Hunt's *Awakening Conscience* (RA 1854; Tate).

Although other associations can be made with Watts's *Jeanie Nassau Senior*, it is first and foremost a portrait and as such it had a considerable impact. In 1858, for William Michael Rossetti such portraits set a new standard; he wrote in *The Spectator* that Watts

> is among the few men of one's own time whom one can confidently rank with the leading men of *any* time for some special and surpassing gift. He belongs to the world's choice band of portrait painters … Exceeding beauty, blended with an ideal tone … is his special characteristic: he sets plain life, so to speak, to music.[13]

Watts's portraits provided an entirely new dimension to contemporary portrait painting in the late 1850s in the way he 'sets plain life … to music'. Inspired by the 'beneficent gracious nature'[14] of Jeanie Senior, Watts adapted the grand manner format into something both more personal and more modern.

At just the time Watts painted the portrait, perhaps on off-days or when the sittings concluded, Jeanie gathered up his drawings and organised them into albums.[15] This vital service preserved much of his work and even now provides reliable evidence of his activities in the 1850s. Later in life she had a career as a social reformer, appointed the first female Inspector of Workhouses and Pauper Schools in 1874.[16] Her death at the age of forty-nine was widely mourned, not least by Watts, her friend of twenty-six years.

1 Watts painted Tom (Watts Gallery), and later Julia Margaret Cameron photographed him.
2 This work used the formula of Leonardo's *Mona Lisa* (which he had recently seen in Paris) with the figure set against a steeply rising background, in this case the landscape around Malvern (illustrated in Barrington 1905, opp. p. 8).
3 Watts to Jeanie Nassau Senior, 31 October 1856, Watts Papers.
4 On their friendship, see Watts 1912, I, pp. 160–61, 322–3.
5 A trait noted by the mutual friend of Jeanie and Watts, Emilie Barrington (Barrington 1905, p. 2), who dedicated her book on Watts 'with grateful affection to the memory of Janie Senior'.
6 *The Pre-Raphaelites*, exh. cat., Tate Gallery, London, 1984, no. 67.
7 Watts to Jeanie Nassau Senior, 23 December 1857, Watts Papers. There are several drawings for the head of Jeanie; one in pencil is illustrated in Barrington 1905, opp. p. 4; another in chalks on blue paper was included in Watts London 1954, no. 125.
8 Barrington 1905, p. 59.
9 Ibid., p. 59.
10 She sent along her own lace and a glass vase for Watts to work from when she herself was not posing.
11 See Geoffrey Squire, *Simply Stunning: The Pre-Raphaelite Art of Dressing*, exh. cat., Cheltenham Museum, Cheltenham, 1996, pp. 20 and 42.
12 William Michael Rossetti, *Some Reminiscences*, London, 1906, I, pp. 204–5.
13 William Michael Rossetti, *The Spectator*, 22 May 1858, p. 555.
14 Barrington 1905, p. 7
15 Watts 1912, I, p. 161.
16 She also founded the Association for Befriending Young Servants.

33 PRUDENCE PENELOPE CAVENDISH BENTINCK AND HER CHILDREN

*c.*1857–60

Oil on canvas
1270 x 1016mm (50 x 40")
Tate. Presented by W.G.F. Cavendish-Bentinck 1948

Provenance Painted for the sitter and her husband; by family descent; on loan to the Tate Gallery in 1946;[1] and presented to the Tate Gallery by W.G.F. Cavendish-Bentinck on 19 February 1948
Exhibitions Royal Academy, London, 1860, no. 86; Watts Grosvenor 1881, no. 127; Watts New Gallery 1896, no. 49; *Exhibition of Old Masters*, Grafton Gallery, London, 1911, no. 42; *Exposition Retrospective de Peinture Anglaise (XVIII et XIX Siècles)*, Musée Moderne, Brussels, 1929, no. 192; *The First Hundred Years of the Royal Academy 1769–1868*, Royal Academy of Arts, London, 1951–2, no. 361
Literature Spielmann 1886, p. 29; Watts Catalogue II, p. 15; Watts 1912, I, p. 174

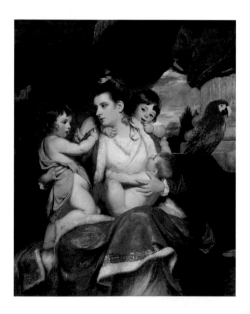

FIG. 35 *Lady Cockburn and her Children*, Joshua Reynolds, 1773, oil on canvas, 1416 x 1130mm (55¾ x 44½"). The National Gallery, London (NG 2077)

In George Cavendish Bentinck Watts found a patron and friend who combined both rising young politician and connoisseur of fine arts, particularly Venetian painting but also contemporary art. The Cavendish Bentincks knew other artists, with one friend relating in 1856 that 'the great judge, George, condescends to approve'[2] of Leighton's paintings. But Watts became portraitist to the family, portraying his mother and his wife (no. 28),[3] after which Cavendish Bentinck commissioned a group with his wife and their three children, Christina Anne Jessica, the eldest, and the younger boys, William and the red-haired baby, Frederick.[4]

This portrait is one of Watts's most stunning exercises in rich colour and compositional inventiveness. It invokes the example of Reynolds yet again, making a clear reference to *Lady Cockburn and her Children* (fig. 35), also an image of motherhood and itself modelled on various depictions of the personification of Charity as a fecund mother with naked infants, most notably by Van Dyck.[5] The overall composition from the turn of Prudence's head to the pose of the standing child, and even the view out to a landscape in the right background, are directly inspired by Reynolds's painting.[6] Watts might have recalled seeing Reynolds's privately owned portrait at the British Institution in 1843, but the work had been engraved and there was also a miniature dating from 1842.[7]

Watts made a distinct choice in situating his portrait in the tradition of Reynolds and the artistic lineage of the subject, demonstrating his own inflection on the notion of borrowed attitudes. This work perfectly exemplified his claims to paint portraits that would be 'valuable as works of art', as indeed he explained in letters exchanged with his friend George Cavendish Bentinck in the late 1850s (see pp. 19–20).

Family tradition held that Cavendish Bentinck, 'a passionate admirer of Italian art', influenced the way the portrait looked.

His grandson noted: 'I was told by my father [the baby] that the manner in which my grandmother and her children are placed in the picture and the Madonna effect was my grandfather's idea.'[8] Watts's first sketch (private collection, London) shows an oval-shaped composition, a Renaissance device, but the specific parallels with Reynolds's work are so compelling that it seems the artist took the brief that much further in accordance with his own interests.

Despite the art historical lineage of the painting, it contains personal references to the commissioning couple. Prudence's choice of unusual jewellery and paisley scarves identifies her artistic taste. The landscape seen to the right with its framed edge seems to be an actual painting, a darkly mysterious view in the manner of Gainsborough whose works featured in an exhibition at the British Institution in early 1859. This visual note also served as a reference to the growing collection of the Cavendish Bentincks who perhaps at this time (and certainly later) owned works by Gainsborough among their extensive collection.

In technique the glowing, intense colours resulted from the use of copal, a type of mixing agent, with layers of glazes adding depth, also seen in *Jeanie Nassau Senior*. Watts 'stoutly denied' this usage had anything to do with his younger contemporaries the Pre-Rapahelites, and for him the exploitation of deep colour seems more Venetian-inspired during this period of experimentation. When Ruskin saw the portrait he criticised it in typical fashion, telling Watts that in this 'group with the children' he 'depended too much on blending and too little on handling colour; that you were not simple enough, nor quick enough to do all you felt, nevertheless it was very beautiful'.[9]

Watts had refused to allow the earlier portrait of Prudence to go to exhibition, knowing 'that class of work is not hung on

the line and I cannot allow my hard work and care to be placed where these qualities would go for nothing'.[10] But he permitted the Cavendish Bentinck group to be sent in 1860, along with *Duke of Argyll* (no. 35). Commentators at the Royal Academy's exhibition noted his experiments with colour and glazes, yet some also perceived that the group was a 'learned performance', finding the face of the sitter 'quite old masterish'.[11] The *Art Journal*'s critic found an echo of Andrea del Sarto.[12] The art historical references from the Renaissance to Reynolds had enriched this work for both artist and patrons at a crucial juncture in Watts's thinking about portraiture.

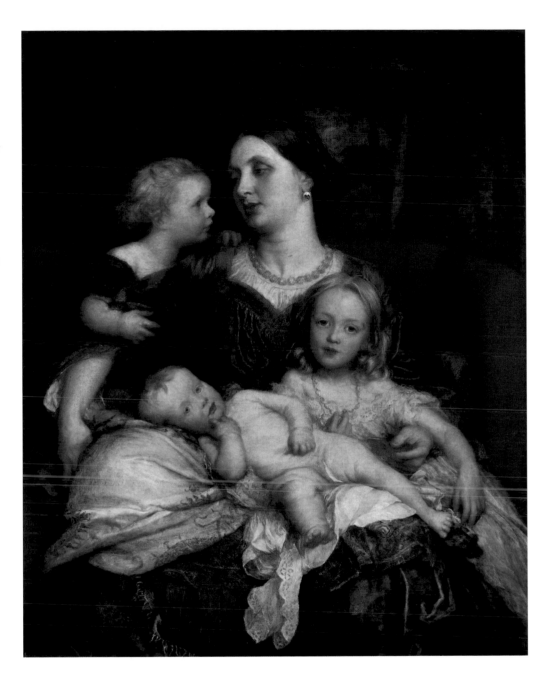

1 Tate Gallery, *Report for the Year 1953–1954*, London, 1954, p. 80, along with three other portraits by Watts including no. 28.

2 Letter from Henry Greville to Leighton, Mrs Russell Barrington, *The Life, Letters & Works of Frederic Leighton*, London, 1906, I, p. 255. Henry Greville, a Portland relation, mentioned the birth of Prudence's 'huge boy' in late August 1856.

3 Watts also painted the portrait of Cavendish Bentinck himself (Watts Catalogue, II, p. 14).

4 Judging by the ages of the children in the painting, he probably began the work in late 1857 or early 1858. Watts later painted the second daughter, Venetia, born after this painting was made, as a baby and later as a young woman in a striking half-length portrait now in a private collection.

5 For a complete discussion of Reynolds's work and its various sources, including the earlier literature, such as Edgar Wind's article of 1937, see Egerton 1998, pp. 210–17.

6 The infant's sprawling legs are however closer to Van Dyck's *Charity*.

7 By Henry Bone; Egerton 1998, p. 210. An example is in the Wallace Collection.

8 Letter from Victor Frederick William Cavendish Bentinck, 4 January 1952, Tate Archive.

9 Letter from Ruskin to Watts, 29 September 1860, Cook and Wedderburn 1903–10, XIV, p. 291.

10 Letter from Watts to Cavendish Bentinck, *c.*1857–60, Watts Papers.

11 Walter Thornbury, *The May Exhibition: A Guide to Pictures in the Royal Academy*, London, 1860, p. 65.

12 *Art Journal*, 1860, p. 163.

34 ALFRED TENNYSON:
'THE MOONLIGHT PORTRAIT'
1859

Oil on panel
695 x 470mm (27⅜ x 18½")
Inscribed 'G F W 1859'
Eastnor Castle Collection
(Photo: Photographic Survey,
Courtauld Institute of Art)

Provenance Collection of the artist; acquired by Charles, 3rd Earl Somers, and Virginia in the mid 1860s; Lady Henry Somerset at Reigate Priory, later at Eastnor Castle; by family descent
Exhibitions Colnaghi's, London, 1860 and probably 1862; Watts Grosvenor 1881, no. 95; Worcester 1882, no. 139; Watts New Gallery, 1896, no. 15; Memorial Exhs, London 1905, no. 189, and Dublin, 1907; *Tennyson Centenary Exhibition*, Fine Art Society, London, 1909, no. 96; International Fine Arts Exhibition, British Section, Rome, 1911; on loan to Tate Gallery, 1926; *Twee eeuwen Engelsche Kunst*, Amsterdam, 1936; Watts London 1954, no. 25; *British Portraits*, Museum of Western Art, Tokyo, 1972; *Treasure Houses of Britain*, National Gallery of Washington, Washington DC, 1985, no. 557 (entry by Francis Russell); *Whisper of the Muse: The World of Julia Margaret Cameron*, Colnaghi, London, 1990, no. 52 (entry by Jeremy Howard)
Literature Spielmann 1886, no. 25, p. 32; Cartwright 1896, p. 22; Charles Bateman, *G.F. Watts, R.A.*, London, 1901, p. 49; Chesterton 1904, pp. 73–4, 77, 81; Spielmann 1905, p. 30; Watts Catalogue, II, p. 157; Watts 1912, II, p. 167; R. Ormond 1973, I, pp. 447–8; Hoge 1974, pp. 132–3, 165–6, 174; L. Ormond 1983, pp. 49–53; Hutchings and Hinton, 1986, p. 81
Engraving James Stephenson, published by Colnaghi, 1862; mezzotint by Frank Short, 1903

Watts's portraits of Tennyson (1809–92) form a series that extend nearly fifty years from 1857 to almost the last year of the artist's life as he finally completed his great statue of the poet, allowing it to be cast in bronze. His constant engagement with portraying this particular friend indicated the deep connection between the two men whose views of life and death tallied in so many ways.

Watts met the Tennysons at Little Holland House in July 1857; Sara Prinsep had attracted the Poet Laureate and his wife to her salon through her sister Julia

Margaret Cameron. For Watts, meeting Tennyson occurred at just the time he had re-evaluated the genre of portraiture after a visit to Paris, taking on several full-length depictions of friends and endeavouring to make his portraits 'valuable as works of art'. The great poet provided a potential subject for study, and Watts painted him for his own collection, but the first portrayal (1857; National Gallery of Victoria, Melbourne) was not reckoned a success.

The next version, no. 34, differed only slightly, yet the shift in the angle of the head crucially changed the whole impact of the painting. A sideways gaze, rather non-committal, has become a thoughtful look downward, emphasising contemplation. Leonée Ormond has suggested the iconography of the image of Christ as the 'man of sorrows'.[1] The background changed from crimson red to a deep brown, promoting sombreness and introspection. This dark tonality accounted for the work being dubbed 'the moonlight portrait', although it might equally refer to the head of the poet appearing to be illuminated by moonlight. One writer later considered that the 'dreamy quality it possesses [is] suggestive of the poetic glamour of moonlight'.[2] The work was widely considered to be the best of Watts's portrayals of the poet. This focus on the head accorded with the grandeur of Tennyson's actual appearance. Observers always commented on his physical impact with his head even in this painting evoking Milton.[3]

Watts worked on this second portrait in 1859, the year Tennyson finished the *Idylls of the King*. The artist himself found the completed work better but qualified Emily's praise by writing: 'I dare not think I have done more than suggest what your poetic imagination has completed for you.'[4]

Watts painted the first two portraits of Tennyson for himself, neither as commissions nor as gifts. He exhibited the second at Colnaghi's gallery, and thus it was the first

exhibited portrait of the poet by Watts. The *Athenaeum* (probably F.G. Stephens) wrote of the thinness of execution, saying that 'as a study of colour, and what artists call texture, the picture is invaluable'. He continued:

> But the soul of the man, the grandeur of the countenance and vigorous repose that seem expressed by the set lines of the mouth – nervous as it is; the introspective eye, which is alone an epitome of the self-contemplative character of the master of modern verse – for he seems melancholy without debility, and sad because earnest; – these are the qualities of this remarkable portrait.[5]

The painting, widely seen at Little Holland House (Ruskin commented on it[6]), and then at Colnaghi's, promoted Watts as a portraitist at a critical juncture in his career. Its success prompted the publication of an engraving in 1862, exhibited at the Royal Academy the same year and the first after a portrait by Watts. 'The Moonlight portrait' marked the artist as the painter of poets, one who could capture the elusive 'introspective eye' and who by extension became a poet in paint himself.

Originally intended for Watts's 'series of the most remarkable men of our times', the portrait seems to have gone to the artist's friends, the Somersers, in the mid 1860s, probably around the time that he painted the two later portraits of Tennyson, best known by the version now in the National Portrait Gallery.

1 L. Ormond 1983, p. 49.
2 The painting acquired its informal title during Watts's lifetime, and it was certainly in common usage by the time the artist died; see R.E.D. Sketchley, *Watts*, London, 1904, p. 79, and *Masters in Art: G.F. Watts*, Boston, 1905, p. 40.
3 *Athenaum*, 12 May 1860, p. 655.
4 Quoted in L. Ormond 1983, p. 50.
5 *Athenaeum*, 12 May 1860, p. 655
6 Letter of 3–4 April 1859 to Margaret Bell, in *The Winnington Letters*, ed. Van Akin Burd, London, 1967, p. 149.

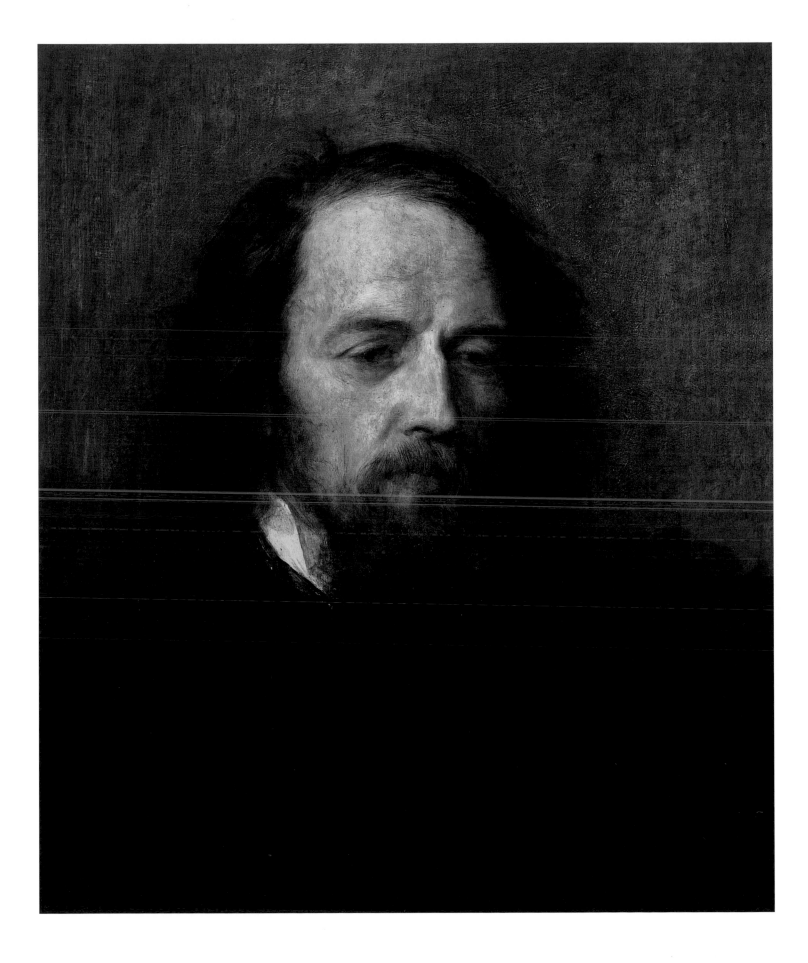

**GEORGE DOUGLAS CAMPBELL,
8TH DUKE OF ARGYLL**
1859–60

Oil on panel
597 x 495mm (23 ½ x 19 ½")
National Portrait Gallery, London
(NPG 1263)

Provenance Painted by the artist for his own collection;
on view at the Little Holland House Gallery, until May
1900; presented by Watts to the NPG
Exhibitions Royal Academy, London, 1860, no. 347;
'Winter Exhibition of Oil Paintings by British Artists',
Hanover Gallery, London, 1880, no. 136 (?); Watts
Grosvenor 1881, no. 108; Worcestershire Exhibition,
Fine Art Section, Worcester, 1882, no. 136; Watts
Birmingham 1885, no. 152; Watts New York, no. 130;
Watts Nottingham, 1886, no. 43; Royal Jubilee
Exhibition, Manchester, 1887, no. 538; Rugby, 1888;
'Second Exhibition', Society of Portrait Painters, Royal
Institute, London, 1892, no. 46; Chester, 1895; Watts
New Gallery 1896, no. 75; Watts London 1954, no. 27;
Watts NPG 1975 and 1980
Literature Spielmann 1886, pp. 20, 29; Macmillan
1903, p. 54; Sketchley 1904, p. 75; Spielmann 1905,
p. 31; Watts Catalogue, II, p. 4; R. Ormond 1975, pp. 10,
18, 19

George Douglas Campbell (1823–1900)
succeeded to the Dukedom of Argyll, and
its seat at Inverary Castle, in 1847. Although
much involved in Scottish affairs,[1] he made
his political career in England, attaining
high parliamentary office at the relatively
young age of twenty-nine when he joined
the Liberal cabinet of Lord Aberdeen in
1852 as Lord Privy Seal.[2] He lost, then
regained this post, holding it at the time
of Watts's portrait.

Watts knew Argyll, who acquired
Bedford (later Argyll) Lodge on Campden
Hill in 1853,[3] as a fellow resident of
Kensington. They had common links with
the Cosmopolitan Club and through mutual
friends, especially Tennyson. With his wide
interests in religion, science, philosophy,
legal and academic affairs, Argyll personified
the type of intellectual sitter Watts sought
for his portraits of worthy individuals.

Apart from Argyll's impressive
intellectual and political standing, his looks
also attracted notice, providing a vivid
subject for the portrait painter. A writer in
1857 noted that he was 'remarkable for an
extreme juvenility of appearance, and hair
which his enemies might call red'.[4] Another
writer commented on his hair 'as vividly
red as that of … Rob Roy, and … brushed
straight back and up from a truly intellectual
brow. His manner suggested a combination
of the Highland chief with the university
Professor.'[5] This intellectual capability comes
across directly in the painted portrait. The
red hair, which is such a prominent feature
of the portrait, calls to mind Pre-Raphaelite
portraits and subject paintings of the 1850s.[6]
Watts also put Argyll's 'Scottishness' very
much to the fore by portraying him with a
knotted tie of blue plaid, a consciously

contrasting colour to set against the orange
of the hair. The choice of neckwear signals
a bohemian aspect to this seemingly
establishment figure.

Watts's portrait of the Duke of Argyll
was an early inclusion in the artist's gallery
of prominent men of the day and the first he
sent to the Royal Academy. The appearance
of this painting occurred just before Watts
announced to friends (including those in
the press) that he planned to form a gallery
of prominent men. Shortly thereafter, he
actively sought other sitters. Watts clearly
considered this portrait a great success as
he regularly sent it to public exhibitions,
especially once his own reputation was
established after 1880.

1 In 1847 he and his wife, the daughter of the Duke
of Sutherland, entertained Queen Victoria and Prince
Albert at Inverary 'in the true Highland fashion'; see Ian
Gordon Lindsay and Mary Cosh, *Inverary and the Dukes
of Argyll*, Edinburgh, 1973, p. 322. Much attached to
Scotland, the Duke and Duchess of Argyll, and the nine
children they had by 1856, carried out improvements to
Inverary and its gardens from the 1840s onward.
2 See R. Ormond 1973, pp. 550–51, for Argyll's
inclusion in the group portrait of the *Coalition Ministry,
1854* (NPG 1125), in which he stands out noticeably as
the youngest member of the gathering.
3 Dakers 1999, p. 77, notes that Argyll Lodge, a lavish
house, attracted Argyll mainly on the strength of the
good bird watching it offered. His personal piper
patrolled the gardens playing Clan Campbell tunes to the
annoyance of his near neighbour and natural (Scottish)
enemy, the Earl of Airlie (no. 51).
4 From the *Gentleman's Magazine*, February 1857,
quoted in *Complete Peerage*, I, p. 212.
5 Quoted in Dakers 1999, p. 77.
6 In 1865 Watts painted another famous redhead, the
poet Algernon Swinburne (NPG). One contemporary
drew a comparison between these two men when he
noted that Swinburne 'looks like the Duke of Argyll
possessed of a devil' (Sir Algernon West, *One City Many
Men*, London, 1908, p. 167).

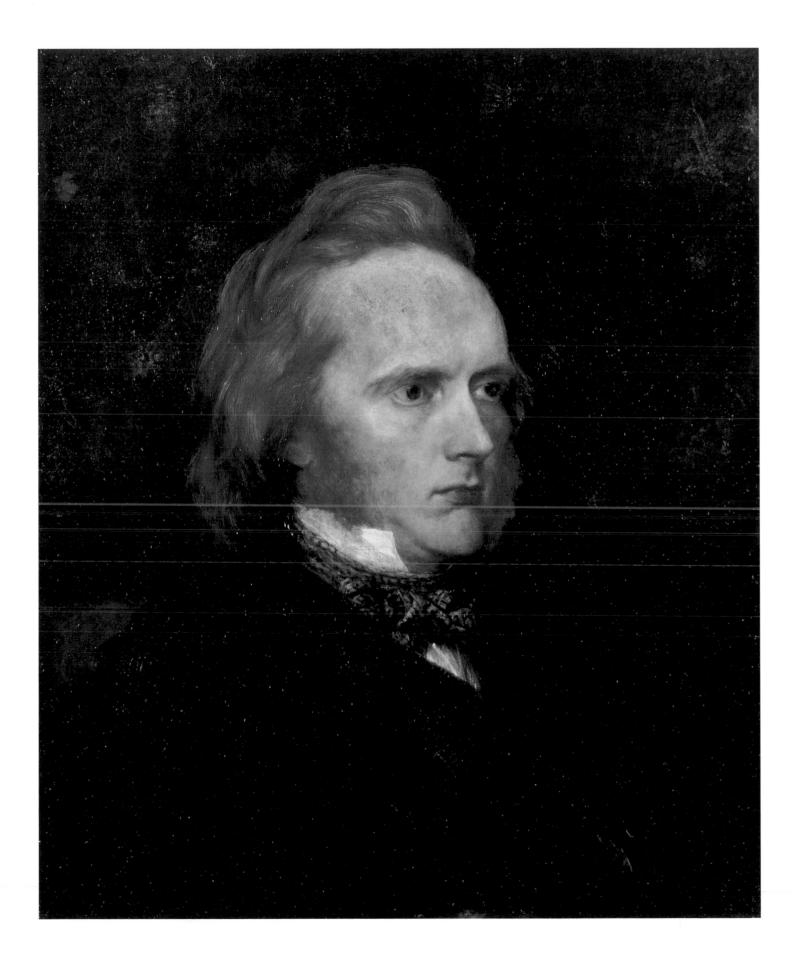

36 JOHN CAMPBELL, 1ST BARON CAMPBELL

1859–60

Oil on panel
2070 x 1155mm (81½ x 45½")
Lord Stratheden and Campbell

Provenance Collection of the artist until 1868; eventually passed to the family of Lord Campbell; by descent; placed on loan to the House of Lords by his grandson in 1955
Exhibitions *The Third and Concluding Exhibition of National Portraits commencing with the fortieth year of the Reign of George the Third and ending with the year MDCCCLXVII*, South Kensington Museum, London, 1868, no. 469; International Exhibition, London, 1871, no. 406 (possibly the small version); Watts Grosvenor 1881, no. 204 (possibly the small version); Watts London 1896, no. 94
Literature Spielmann 1886, p. 32; Spielmann 1905, pp. 32–3; Watts Catalogue, II, p. 28; R.J.B. Walker, *A Catalogue of Paintings, Drawings, Sculpture and Engravings in the Palace of Westminster*, Pt II, London, 1959–62, p. 13, no. 112

Watts painted this portrait of Baron Campbell as Lord Chancellor, one of his grandest and most fully realised works, at just the time he decided to raise his portraiture to a new higher level of accomplishment. This important, yet little-known, portrait should be seen in connection with Watts's collection of portraits of eminent men, the 'Hall of Fame', which grew during the later 1850s.

John Campbell (1779–1861), born in Scotland, had an outstanding career in English public life from the earliest years of the nineteenth century. His old *Dictionary of National Biography* entry runs to some seven pages of closely written text detailing his legal achievements. His career was not, however, without its ups and downs.[1] A Whig MP, Campbell had served as Attorney General, Lord Chancellor in Ireland, Chancellor of the Duchy of Lancaster and Lord Chief Justice. In 1859, in his eightieth year, he became Lord Chancellor and, as the DNB noted, 'no one, as he took pains to find out, had ever been appointed to, or had

even held, the office at so advanced an age'. But he is perhaps best known for his literary career, especially his landmark works, *The Lives of the Lord Chancellors … from the earliest times till the reign of George IV* (1846–7) and *Lives of the Chief Justices* (1849). These huge biographical compendia were noted for their entertaining style.

Since the 1830s Campbell had been portrayed in paintings by artists ranging from David Wilkie and George Hayter to Francis Grant,[2] images Watts would have known. Continually in the public eye during the 1850s as a judge, Campbell presided over several cases that were considered *causes célèbres* and his publications were reissued during these years. Watts probably came in contact with Campbell at Lincoln's Inn where the Lord Chancellor had trained and where Watts had just completed the mural, *Justice*. Campbell was also a distant relation of the Duke of Argyll, whom Watts also painted in 1860 (no. 35). Indeed these two works, along with the portrait of Gladstone (1858; NPG), revealed Watts stepping up his activity in finding worthy representatives in public life whom he could add to his collection. In an unpublished letter of December 1859 he wrote regarding the plan: 'I am most unwilling to give up Lord Campbell's picture, for one of my principal objects is to deserve well of posterity by making faithful & as far as may be in my power worthy records of the great men of the age, such portraits being the only true historical pictures.' He explained that in his studio was 'the commencement of a gallery that I am forming for myself, to bequeath to the National Portrait Gallery, an offering to posterity!'[3] Watts conceived the portrait of Campbell as taking its place within his 'gallery'.

In this rare male full-length the artist had a chance to depict an individual whose ideals had taken shape in the eighteenth century, thus forming a direct link with an era that many of Watts's portraits at this

time sought to evoke. The artist was particularly concerned to achieve accuracy in the depiction of the paraphernalia of office, writing in September 1860 to request access to the House of Lords in order to paint a study for this work.[4] Although it may seem unusual for Watts, the painter of many society beauties at this time, to seek specificity in the painting of the regalia of the ancient office of the Lord Chancellor, in fact such scrupulous concerns were very much part of his desire to be seen within a tradition. His careful delineation of the setting in the House of Lords, with the throne, mace and seal of the Lord Chancellor's office, helps to define the subject. Painting on an unusually large panel allowed the artist to treat the regalia and setting with the appropriate precision. Such a support was also familiar to him from the full-length Florentine portrait (fig. 8, p. 17) in his own collection and allowed him to capitalise on the elaborate setting as part of the overall presentation of his subject.

The sitter himself seems removed, even remote, less a great public figure than a man who after years in high office reflects upon his role in a time-honoured position, much as Campbell himself did in his *Lives of the Lord Chancellors*. In our day the portrait provides a useful reminder of such traditions. In art historical terms at any rate, the venerable John Campbell and his eminent status motivated Watts to match Reynolds who had portrayed another noted Lord Chancellor, Lord Mansfield, one of the heroes of Campbell's *Lives*.

1 When refused the post of Master of the Rolls, he had his wife raised to the peerage as Baroness Stratheden in further recognition of his own achievements.
2 R. Ormond 1973, pp. 83–4
3 Letter of 1859, Archive, The Getty Center. I will discuss this letter in a future article on Watts's portraits of eminent men.
4 This was probably the watercolour (Watts Gallery) later worked up as a small replica.

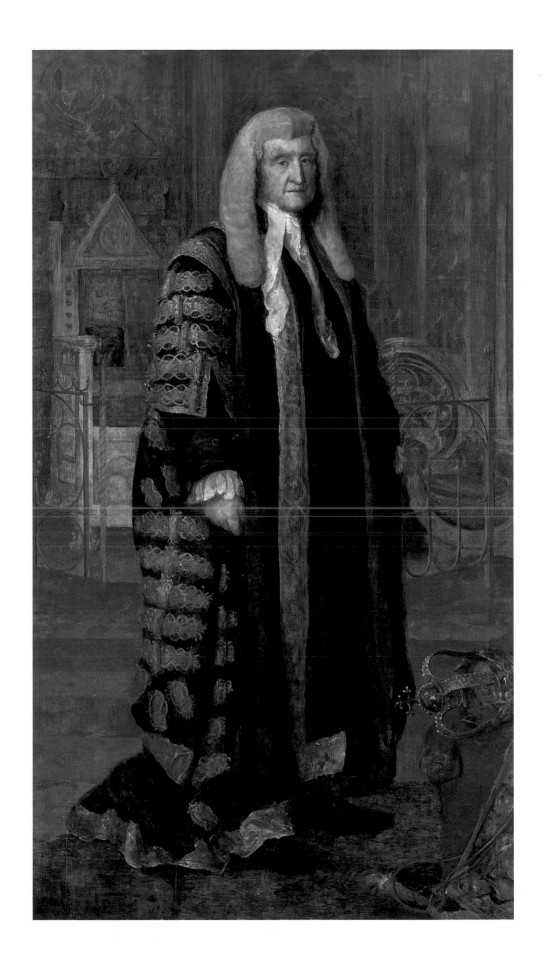

37 ALICE PRINSEP

1860

Oil on canvas
1289 x 921mm (50¾ x 36¼")
Inscribed 'G F W 1860'
Private collection

Provenance Painted by Watts at his own request; on display at the Little Holland House Gallery; eventually passed to the family; Alice's brother Sir Henry Thoby Prinsep by 1905; then to Alice's daughter, Mrs J.B. Strachey-Clitherow; by family descent
Exhibitions Royal Academy, London, 1861, no. 343; International Exhibition, London, 1871, no. 165; Watts Grosvenor 1881, no. 68 as *Lady Playing the Piano*; Centennial Exhibition, Melbourne, 1888–9, no. 36 as *Alice*; *Jahresausstellung von Kunstwerken aller Nationen*, Glaspalaste, Munich, 1893, no. 1654b as *Alice*; *Fair Women*, Grafton Gallery, London, 1894; Memorial Exhs, London 1905, no. 175
Literature Spielmann 1886, p. 31; Cartwright 1896, p. 26; Spielmann 1905, p. 32; Watts Catalogue, II, p. 127

This portrait of Alice Prinsep brilliantly demonstrates how Watts went beyond the boundaries of portraiture to create images of great beauty and subtle meaning. Seen at the Royal Academy in 1861, it yields a number of fascinating links with contemporary artist-friends of Watts at this time.

Watts knew Sara and Thoby Prinsep's daughter Alice (1846–1919) from a young age since she grew up at Little Holland House. In the painting she is aged fourteen. As with other portraits dating from the late 1850s, Watts constructed an elaborate presentation that may have less to do with the sitter herself and more to do with his own stated belief that his portraits were 'valuable as works of art'.

Alice has momentarily ceased playing the piano to gaze outwards. As in the portrait of Prudence Cavendish Bentinck (no. 28), the artist introduced the idea of an interrupted musical performance into the image to create a sense of ambiguity. The exotic tapestry or wall painting glimpsed behind the figure enhances the drama. Indulgence in still-life details, such as the

ornate carved candleholder on the piano and the clear glass vase with flowers behind the figure, reveals a sophisticated notion of the portrait as a beautiful object in itself. Alice is dressed in a Renaissance-inspired gown of midnight blue, with a boldly contrasting orange bodice and slashed sleeves, noted by one critic to be 'daring, but successfully daring'. This portrait of Alice, poised on the edge of adulthood, in its colour and ambiguous meaning might be seen as an updated version of Millais's early Pre-Raphaelite masterpiece, *Mariana* (RA 1851; Makins Collection).

The luminous colour and styling indicate Watts's study of older art both at home and abroad (see fig. 10, p. 18). During the immediately preceding years Charles Eastlake had expanded and enriched the National Gallery's holdings of later Italian painting (see p. 27), and the lessons of these portraits, especially those of women, with their lush costumes, had seeped into Watts's work. Yet the portrait remained distinctly modern, due primarily to the forthright gaze of the sitter. Equally, Watts had now fully absorbed the influence of French portraiture as best exemplified by Ingres, in which a calculated setting and beautifully displayed objects invoked the sitter's social milieu and position. Another contemporary point of comparison is Whistler's *At the Piano* (RA 1860; Taft Museum, Cincinnati) with its musical references, as well as a stylistically similar use of strong black.

At the Royal Academy this painting provoked rapturous reviews. Watts was only an occasional exhibitor, but it was an indication of his status in the art world as well as the singularity of his portraits compared to others in this genre. Tom Taylor considered that *Miss Alice Prinsep* stood out as 'the solitary example of a style of work in which Mr. Watts has no rival – that of idealized portraiture'.[1] The critic in the literary *Blackwood's Magazine* simply said it 'transcends every other portrait in the

exhibition'.[2] William Michael Rossetti referred to Watts's 'chaste and noble portrait art'.[3] F.G. Stephens found a work 'remarkable for vigour of tone and rich variety of colour', adding that the artist had solved the problem 'popularly reputed to have been only once overcome by Gainsborough in his "Blue Boy" of introducing without pervading coldness a large mass of blue in his picture'.[4] Yet again Watts's work brought about comparisons with the great tradition of English portraiture, as indeed it did with older art, when Tom Taylor suggested that after a visit to the National Gallery Watts's picture 'is the one that best stands this juxtaposition of old and new'.

Alice Prinsep's face, with her 'Pattle eyes', possessed what one reviewer called 'youthful dreamy beauty'. For Watts this proved a potent inspiration. Indeed in this work we see the first complete realisation of his distinct approach to the portrait, which one critic considered the most 'poetic rendering of female beauty this year'.[5] By using the portrait as the arena for virtuoso painterly skill and the infusion of a poetic mood, Watts in 1860 predicted and stimulated the Aesthetic values of the coming years. Poet George Meredith, who saw the painting at the Academy, seemed to recognise the primacy of the work of art beyond its value as a portrait when he wrote 'there is a *beautiful* portrait of Alice Prinsep by Watts. Idealized, of course – showing more *in* her than she possesses'.[6]

The painting occupied a prominent position in Watts's gallery at Little Holland House, as seen in the photograph of the artist by J.J.E. Mayall (fig. 11, p. 22), published in 1884.

1 *The Times*, 21 May 1861, p. 11.
2 *Blackwood's Magazine*, 1861, p. 215.
3 *Fraser's Magazine*, November 1861, p. 580.
4 *Athenaeum*, 4 May 1861, p. 601.
5 *The Spectator*, 25 May 1861, p. 557.
6 *The Letters of George Meredith*, ed. C.L. Cline, Oxford, 1970, p. 79.

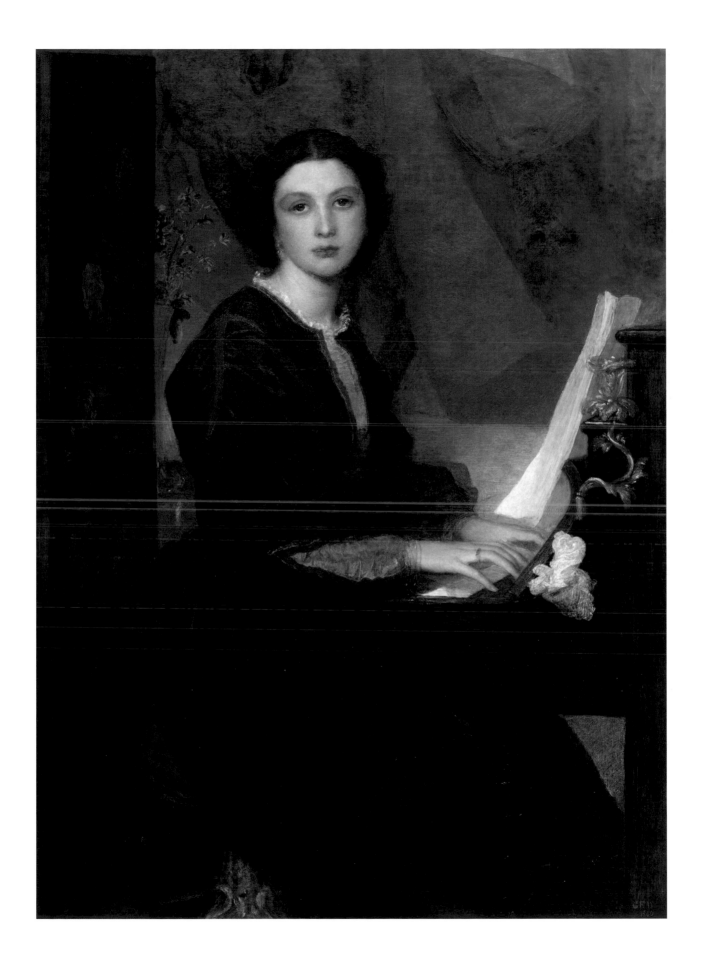

38 LADY MARGARET BEAUMONT
AND HER DAUGHTER

c.1860–62

Oil on panel
1920 x 1150mm (75⅝ x 45¼")
The Viscount Allendale

Provenance Painted for the family; by descent
Exhibitions Royal Academy, London, 1862, no. 124;
Watts Grosvenor 1881, no. 110; Memorial Exhs, London
1905, no. 176; *Exhibition of British Art c.1000–1860*,
Royal Academy of Arts, London, 1934, no. 496; Watts
London 1954, no. 32; *British Portraits*, Royal Academy
of Arts, London, 1956–7, no. 462; *Treasures of the North*,
Christie's, London, 2000, no. 67
Literature Spielmann 1886, p. 29; Watts Catalogue, II,
p. 12; Allendale Catalogue 1924, no. 11; Millar 1985,
pp. 36, 38–9

This portrait, one of Watts's grandest full-lengths, had a public dimension by virtue of its exhibition at the Royal Academy of 1862. It proved to be a key work in establishing the artist's reputation in contemporary English portrait painting.

In 1856 Lady Margaret de Burgh (*c.*1831–88) married Wentworth Blackett Beaumont (1829–1907);[1] she bore six children in rapid succession including three daughters by 1859. The child peering around her mother's skirts seems most likely to be the youngest, Amy.[2] A newly discovered portrait of Lady Margaret's sister Emily, Countess of Cork (*c.*1828–1912; fig. 36), painted at about the same time,[3] suggests that the commission for both works may have emanated from the girls' parents, Ulick, 1st Marquess of Clanricarde (1802–74), and his wife Harriet (formerly Canning), also painted by Watts (see no. 52).

Even if we assume the Clanricardes initiated the commissions, the portrait of Lady Margaret was destined to belong to her and her husband Wentworth Beaumont. His great wealth derived from lead mines in Northumberland, but this young MP had also inherited a truly great art collection from his father, which contained masterpieces of world class, including Giorgione's *Adoration of the Shepherds* (*c.*1510; National Gallery of Art, Washington DC). He regularly lent these works to exhibitions in London beginning in 1861.[4] Watts responded best to this type of collector. They may have owned great dynastic collections (or been in the process of amassing new ones) but they had their own keen involvement with the arts, usually coupled with an intelligent and informed outlook.

The commission for this ambitious portrait followed on Watts's successes at the Royal Academy with the sisters-in-law from the Senior family (nos 31, 32) in 1858 and the Cavendish Bentinck group of mother and children (no. 33) in 1860, works that showed the artist to be a painter of thought-ful portraits with art historical references and unusual qualities of mood. Watts reinforced his client's sophistication in the arts, evident in other small details in the portrait such as Lady Margaret's jewellery and her desire to be portrayed in a gown evocative of the previous century. This portrait comes closest to the works of Gainsborough in its sense of movement and in the handling of the pale layers of fabric and lace in the dress. It captures a moment, as the main figure is seen just stepping downward. Watts always favoured Reynolds over Gainsborough, as he himself wrote (see pp. 28–9), but in this case the momentary action, link between mother and child, and most of all the shimmering layers of silk and lace in the dress, all suggest an inspiration from the other eighteenth-century master.[5]

The gracefulness of Lady Margaret is achieved with a series of subtle devices, such as the touch of the hand on the door frame, and the clasping of her handkerchief. These actions and even the use of a plant within a container indicate that Watts had paid some attention to the similar devices in portraits by Van Dyck and the court beauties by Peter Lely. The setting is as much a part of the portrait as the figures, with Lady Margaret moving through a doorway into what seems to be a conservatory with patterned tiled floor. The flowering azalea sets up a comparison between the beautiful, elaborately gowned inhabitant of the house and nature, contained here in full bloom in one small clay pot. Such ideas had permeated Watts's work already, as in the portrait of his friend Jeanie Nassau Senior, and here filtered through to his commissioned portraiture.

The portrait of Lady Margaret's slightly older sister Emily, Countess of Cork (fig. 36), also painted on panel, sets up a contrast. Here the subject is out of doors, on a grand terrace with the spacious open lawns of an estate seen in the background. It is almost certainly Holland House with its distinctive quatrefoil-patterned balustrade, on which

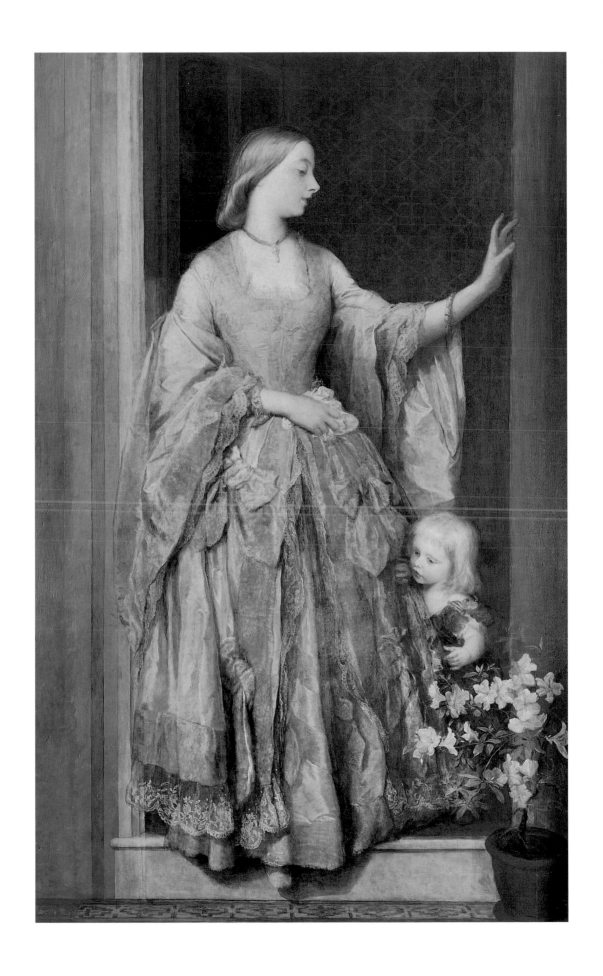

perches a peacock (a bird that still features in Holland Park today). The image of Lady Cork, wearing outdoor velvet garb and set against a landscape background, contrasts with her sister, who is confined within a doorway, with just a hint of nature in a potted plant. In the former the emblematic peacock could conjure up associations of India or ancient Rome, immortality or evil, but its striking colour and purely decorative function (especially relevant in other contemporary paintings)[6] may hint at an assessment of the role of his beautiful sitter.

Watts knew the Beaumonts as friends in London, and due to their wide-ranging interest in the arts, the portrait of Lady Margaret went to exhibition at the Royal Academy.[7] Critics paid particular attention to the handling, the 'exquisite refinement, both of drawing and colour'.[8] F.G. Stephens noted the 'delicate colour and beautiful textures'.[9] The critic for the *Art Journal* deduced that 'the portrait group is treated as a picture … the head of the lady is something in character like some of Reynolds's heads'.[10] This work encapsulates how Watts's portraits were viewed in their own day as fusing the great traditions with a modern approach, both in the presentation of the sitter and in the painterly handling. This interplay between past and present was perfectly clear to informed observers in the 1860s, as indeed it was to Watts's connoisseur friends when they commissioned him. The full-length portrait of Lady Margaret in her pale-coloured gown and flowering azalea perfectly embodied the new spirit of aestheticism and indeed might be seen as a precursor of Albert Moore's portrayals of women and flowers dating from later in the decade.[11]

Around 1860 Watts used panels rather than canvases for most of his portraits. For smaller works this choice made sense, but it introduced great difficulties in the case of full-length portraits; he even added a section to the left side of this panel. Based on his own sixteenth-century Florentine painting (fig. 8, p. 17), he seems to have considered that this support made more precise workmanship and more elaborate detail possible, thus contributing to his mission to paint portraits that were 'valuable as works of art'.

1 He was created Viscount Allendale in 1906.
2 Watts began the work by early 1860 carrying on throughout 1861, and Margaret (b.1856; identified as the child in the recent Christie's exhibition catalogue) was by then four; a second daughter, Violet (b.1858), was two. The most likely child is Amy (b.1859), who would have been a toddler by 1860/61. The child in the portrait is much younger than four years, and is not much more than eighteen months old, if that.
3 A letter from Lady Cork to Watts indicates that the portrait was in progress in July 1860; Watts Catalogue, II, p. 39.
4 The main family seat at Bretton Hall (now part of Leeds University) in the West Riding of Yorkshire contained generations of family portraits, yet Watts's portrait probably remained at their London town house on Piccadilly.
5 A close point of reference, especially in the way the child moves forwards from the side of the mother's gown, is Gainsborough's *Mrs Moody and her Two Sons* at Dulwich Picture Gallery; open to the public and potentially easily known by Watts. Another master, Van Dyck, to whose work Watts remained attuned, provided a comparable image of a mother and child in *A Genoese Noblewoman with her Child* (Cleveland Museum of Art), from the collection of the Earl of Caledon, exhibited in 1854 at the British Institution (see *Van Dyck*, exh. cat., National Gallery of Art, Washington DC, 1991, no. 37).
6 Frederic Leighton's *Pavonia* (RA 1859; private collection) shows a peacock fan as a decorative accessory; in 1862 he painted a full-length of a girl feeding peacocks (RA 1863; private collection). Watts's *Study with the Peacock's Feather* (1862–5; private collection) also showed this newly fashionable accessory which became such a potent symbol for the later Aesthetic movement.
7 Watts also sent *Bianca* (fig. 15, p. 31) and the full-length *Sir Galahad* (1860–62; Fogg Art Museum).
8 *The Times*, 3 May 1862, p. 140.
9 *Athenaeum*, 3 May 1862, p. 602.
10 *Art Journal*, 1862, p. 136.
11 *Azaleas* (RA 1868; Dublin City Gallery, The Hugh Lane) can be seen as an extension of the ideas of the beautiful found in Watts's portrait of Lady Margaret Beaumont.

FIG. 36 *Emily Charlotte de Burgh, Countess of Cork and Orrery*, G.F. Watts, 1859–60, oil on panel, 1930 x 965mm (76 x 38"). Private collection

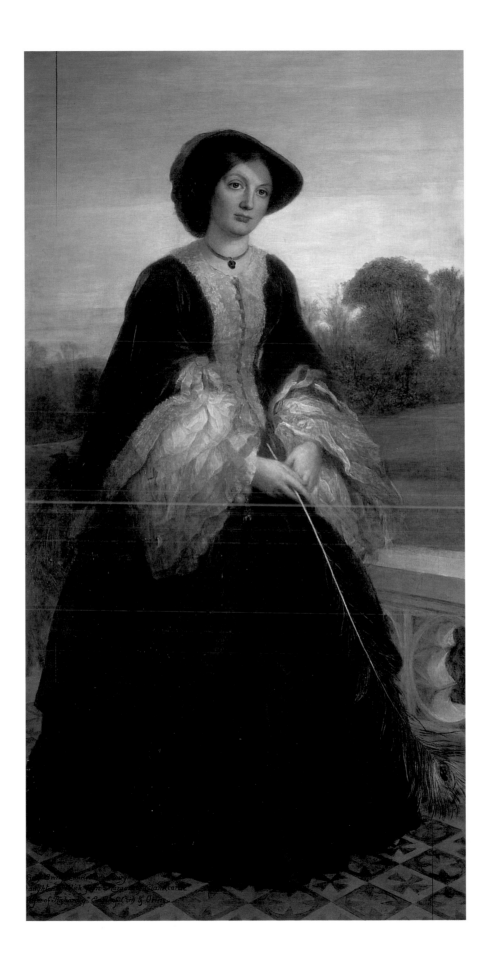

39 FRANCES, MARCHIONESS OF BATH

*c.*1861–5

Oil on canvas
2057 x 1115mm (81 x 44")
The Marquess of Bath, Longleat House
(Photo: Reproduced by permission of
the Marquess of Bath, Longleat House,
Warminster, Wiltshire)

Provenance Painted for the 4th Marquess and
Marchioness of Bath; by family descent
Literature Canon J.E. Jackson, *Catalogue of Paintings at
Longleat*, privately printed, 1866, no. 215; Mary Louisa
Boyle, *Biographical Catalogue of the Portraits at Longleat*,
London, 1881, p. 58, no. 18; Watts Catalogue, II, p. 10;
Watts 1912, I, p. 236

This portrait of Lady Bath is a highly
orchestrated full-length in the grand manner
tradition, comparable to *Lady Margaret
Beaumont* (no. 38). At Longleat since its
completion, the portrait is only known in
the context of the collections there, yet it
is an important example of Watts's most
ambitious portraiture.

In August 1861 Frances Isabella
Catherine (1840–1915), daughter of the
Viscount de Vesci of Ireland, married John
Alexander Thynne, 4th Marquess of Bath
(1831–96). Inheriting the title as a child, he
travelled abroad when aged twenty-one on
a grand tour, which awakened a passion for
Italy. This interest dictated lifelong collecting
and later substantial redecorating of
Longleat, his country seat, in the style of
an Italian Renaissance palazzo. He cultivated
an informed interest in Italian art, buying
widely from the1850s onwards. In London
he served Queen Victoria in various
capacities, including diplomatic tasks, so he
and his wife resided at the Stable Yard, St
James's Palace and later in Berkeley Square.

Lord and Lady Bath commissioned this
portrait shortly after their marriage in 1861
as a formal image of the new marchioness.
This convention in aristocratic families had
the rationale of depicting the new wife at

the outset of married life, before the arrival
of children. A near-contemporary portrait
of Lord Bath by James Swinton and one of
1870 by George Richmond (both Longleat)
emphasise country values in contrast to the
sophisticated image of Frances.[1] Tall and
elegant, with a love of high fashion, she
once wrote 'one can never have enough
gowns'.[2] Due to her penchant for clothes,
she put aside one or two favourite dresses
each year, forming a collection still in
existence today at Longleat, including the
gown in this portrait.

Watts worked on the portrait for some
years with 'the subtle quality of resemblance
eluding him'.[3] During this time he became
a great friend of Frances, also painting two
bust-length portraits,[4] related to the full-
length, obviously in an effort to capture her
face accurately. Later Frances reminisced
about the sittings: 'Well, I know these
began soon after my marriage and now I
have six children.'[5] The painting was at
Longleat by 1866, by which time she had
three children.[6]

The patrons commissioned the work
to form part of the extensive collection of
portraits at Longleat. With this knowledge
Watts portrayed his sitter in an image with
distinct historical reverberations. Frances's
ornate gown of the palest grey silk clearly
evokes the late eighteenth century. Although
the dress incorporates some current fashion
trends, such as the pagoda sleeves, it is
essentially a confection that avoids a
contemporary look, eschewing the vogue
for the crinoline, for example, in order to
provide a timeless image of elegance in the
spirit of eighteenth-century portraiture. The
virtuoso display in the painting of the gown
reminds the observer of Gainsborough.
Other details make specific references to
the particularly rich representation of early
and late seventeenth-century portraits at
Longleat. The elegant styling of the whole
image, and sense of movement in the figure,
are akin to works by or attributed to

Van Dyck, especially *Lady Isabella Rich*
(*c.*1635). The patterned carpet running
exactly parallel to the bottom edge of the
canvas is directly comparable to those in
Lady Arabella Stuart (*c.*1600) by Paul van
Somer and *Lady Thynne* (*c.*1610) by William
Larkin, one of the rarities at Longleat.

The collection of Lord and Lady Bath
was certainly very much part of the thinking
behind the commission to Watts in 1861.
The inherited collection of dynastic
portraits grew to include an outstanding
accumulation of Italian Renaissance works.
Watts would have found Lord Bath's
intellectual credentials, such as membership
in the Philobiblon Society and from 1874
Trusteeship of the National Portrait Gallery,
sympathetic to his own. Like Watts, Lord
Bath lent some of his portrait treasures to
the National Portrait Exhibition in 1866.

When Watts tackled such an aristocratic
portrait, he re-created the type while pre-
serving certain qualities to evoke different
eras. The references to the eighteenth
century in the dress, and to the seventeenth
century in the pose and the detail, were
apparent to his patrons, but Watts also
introduced a modern sensibility. The back-
ground space is strangely devoid of a sense
of place, and this emptiness and lack of
character lend an enigmatic, indeed timeless
quality to the portrayal.

1 Swinton's full-length portrait shows Lord Bath
outdoors with a landscape view; Richmond's later
portrait shows him in shooting dress (both Longleat).
2 Quoted in David Burnett, *Longleat: The Story of an
English Country House*, new rev. edn, Wimborne, 1996,
p. 143.
3 Watts 1912, I, p. 236, with the incorrect date of 1873.
4 One of these enjoyed an independent existence when
purchased by Charles Rickards, the other descended
in the Baring family, and there is an oil study at the
Watts Gallery.
5 Mrs Watts relates this anecdote in two different
versions and seems to take it literally, assuming that
the painting did not reach completion until 1873.
6 Later Watts painted the daughter of Lord and Lady
Bath, Lady Katherine Thynne (RA 1891; Longleat).

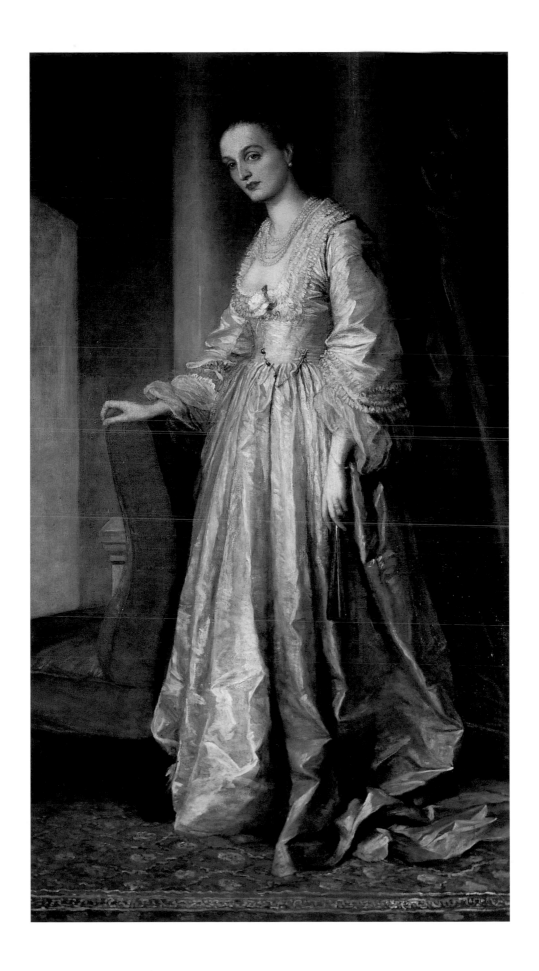

40 EDITH VILLIERS
1861–2

Oil on canvas
762 x 444mm (30 x 17½")
Inscribed (lower right) 'G F Watts 1862'
Private collection

Provenance Painted by the artist for his own collection; sold to Charles Rickards by 1876; his sale, Christie's, London, 2 April 1887, no. 16 (as *The Countess of Lytton*), bought Agnew; Charles W. Carver; Mrs R.H. Anderson; until purchased by Mary Lutyens (Mrs J.G. Links), the granddaughter of Emily; by family descent
Exhibitions Watts Manchester 1880, no. 46 (as *Edith*); Memorial Exhs, London 1905, no. 19, Edinburgh 1905, no. 125, Manchester 1905, no. 31, Newcastle 1905, no. 162, Dublin 1906, no. 34; International Fine Arts Exhibition, British Section, Rome, 1911, no. 105; *Lutyens: The Work of the English Architect Sir Edwin Lutyens (1869–1944)*, exh. cat., Arts Council of Great Britain, Hayward Gallery, 1981, London, no. 91
Literature 'Notes and News', *The Academy*, 21 October 1876, p. 417; Macmillan 1903, p. 87; Watts Catalogue, II, p.165; Emily, Lady Lytton, *The Birth of Rowland: An Exchange of Letters in 1865 between Robert Lytton and his Wife*, edited by their daughter, London, 1956, p. 116; Loshak 1963, p. 485; Mary Lutyens, *Edward and Elizabeth*, privately printed, 1996

Watts's *Edith Villiers* is one of his studies of young women, painted around 1860, that merged portraiture with a poetic interpretation. The ravishing colour and implicit mood link it with contemporary works such as *Alice Prinsep* (no. 37) and *Emily Tennyson* (no. 41) in which the artist, created a gallery of modern beauties to parallel his eminent 'worthies'.

Edith Villiers (1841–1936) is best known as the wife of Robert, 1st Earl of Lytton, whom she married in 1864.[1] Lytton, a diplomat who became Viceroy of India in 1876, was painted by Watts in 1884 (NPG). But long before, the artist was acquainted with Edith's family through Henry Taylor and the Little Holland House circle. He first encountered Edith, and her twin Elizabeth, as children and drew them with their heads together in profile in a fine pencil study (unlocated).[2] Their mother, who had been left a widow by the early death of her husband the Hon. Edward Villiers in 1843, relied upon the support of her brother-in-law, the Earl of Clarendon. The two girls 'came out' in 1860, with Elizabeth marrying first. As a result Edith was 'feeling very lonely and miserable'. In May 1861 her mother arranged a visit to Watts at Little Holland House for her portrait, probably at the artist's request. She wrote that 'she was made to sit for about an hour and a half' in a hot studio; further sittings took place in June when 'they pulled down my hair and then made me sit to Mr. Watts. It was such a *bore*'.[3] On 10 June she posed for three hours; on 5 August for two more.

Overall, counting just the time Edith noted, Watts spent at least eight hours on the painting. None of this evident labour, nor indeed the boredom of the young woman herself, emerges in the portrait. The profile view lends simplicity to the image, much as Watts achieved in *Emily Tennyson*. In common with that work, this portrait is also painted on an unusually roughly textured canvas, which must have offered the artist a way to even out his brushstrokes, for the medium itself is quite thin. Watts painted the work in a narrow upright format, an unusual choice and perhaps an experiment in varying the shape of his portraits, in this case, to suit his famously tall sitter.

Watts set the figure against the distinctive emerald green wallpaper with the flowering vine motif, a feature of the décor at Little Holland House, which also appears in the background of *Jeanie Nassau Senior* (no. 32) and later portraits. In *Edith Villiers* the long tendrils of the pattern echo the flowing golden hair of the girl herself. The appeal of unbound hair recurred the following year in Watts's portraits of Ellen Terry – in these personal works painted without commission, he seemed to be seeking out a type of sitter to represent the idea of youthful modern beauty.

Although it is said that Edith's mother could not afford the painting, it is just the sort of work Watts painted on his own behalf, so it remained on view at Little Holland House throughout the 1860s. Later he sold it to Charles Rickards who formed a specialist collection of Watts's work. In 1876 an account in the *Academy* commented on the painting of 'Miss Villiers of noble severity in design and the most delicate refinement of colour'.[4] Such comments further fostered the idea of Watts as an exponent of the poetic portrait.

1 Her eventful later life and that of her daughter (who married Edwin Lutyens) have come under scrutiny in several modern studies including Marian Fowler, *Below the Peacock Fan: First Ladies of the Raj*, London, 1987, and Jane Ridley, *The Architect and His Wife: A Life of Edwin Lutyens*, London, 2002.
2 According to a letter of March 1859 (Watts Papers), Watts had originally planned to paint the two sisters in a full-length life-size portrait, an ambitious proposition that did not come to fruition. By 1861 he had channelled his aspirations for portraiture in new directions.
3 Quotes from her diary in Mary Lutyens, *Edward and Elizabeth*, privately printed, 1996, not paginated.
4 *Academy*, 21 October 1876, p. 417.

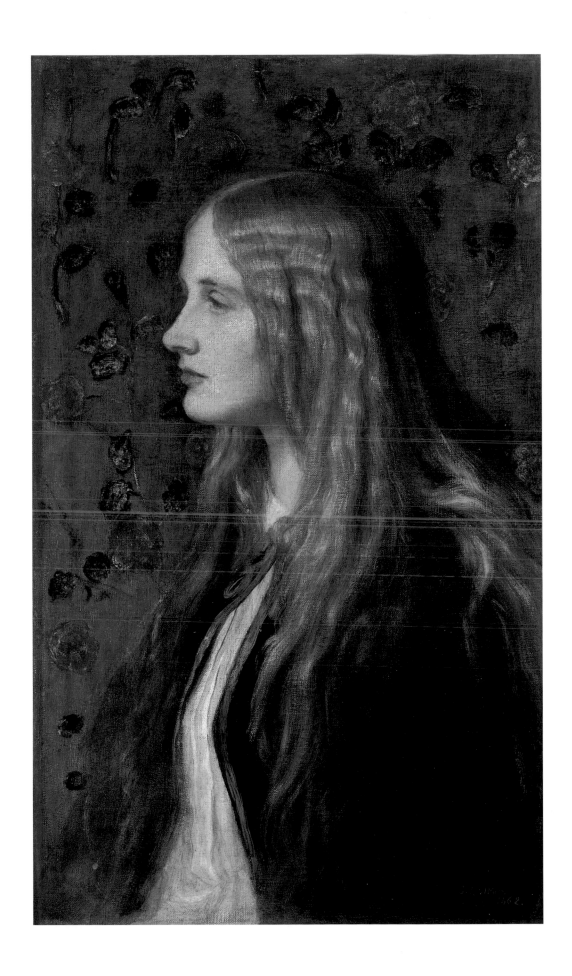

41 EMILY TENNYSON
1862–3

Oil on canvas
613 x 553 (24 x 21¾")
Tennyson Research Centre, Lincolnshire County Council

Provenance Painted for the sitter; displayed at Farringford, Isle of Wight, and later at Aldworth; by family descent; placed on permanent loan to the Tennyson Research Centre, 1962; bought by Lincolnshire County Council, 1980 (on deposit at the Usher Art Gallery, Lincoln)
Literature Watts Catalogue, II, p. 159 (where incorrectly dated 1865); Nancie Campbell, *Tennyson in Lincoln: A Catalogue of the Collections in the Research Centre*, Lincoln, 1973, II, no. 6207; Hoge 1974, ill. frontispiece and p. 174; L. Ormond 1983, p. 54; Hutchings and Hinton 1986, ill. opp. p. 42, pp. 111 (21, 22, 29 November 1862), 119 (25 June 1863)

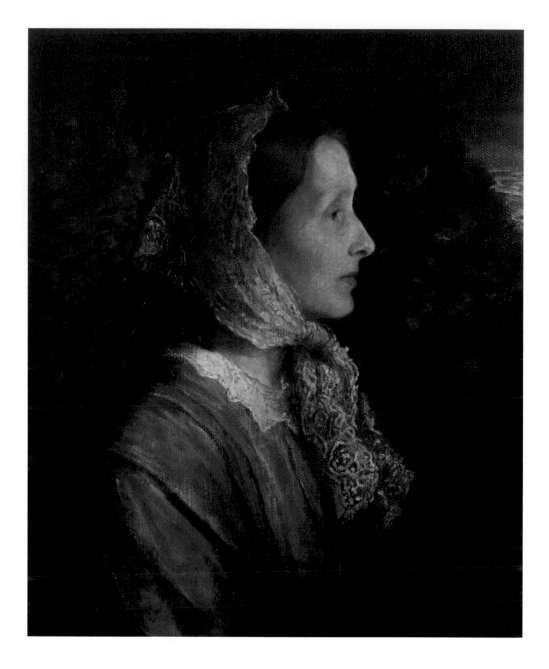

After an extended engagement Emily Sellwood (1813–96) married Alfred Tennyson in 1850, the same year he was appointed Poet Laureate. They met Watts in the summer of 1857 at Little Holland House where Tennyson, like the artist, adorned the salon of Sara Prinsep. Further contact followed at the Tennyson's residence, Farringford, near Freshwater on the Isle of Wight.

Watts portrayed Emily several times. The earliest picture is a characteristic large-scale chalk drawing,[1] showing her face in close-up, with her eyes gazing upwards as if to suggest her devotion to her poet. The next portrait of Emily is a smaller, more intense drawing (fig. 37),[2] dated July 1858, executed at Little Holland House; the signature, 'Signor', indicates that Watts was already on close terms with the Tennysons. Indeed, he must have known Emily well by this time for this portrait delves beneath the surface, a quality echoed in the treatment of the drawing as the merest outline with the minimum of shading. The haunting quality of this image suggests the deep reserves Watts discerned in Emily.

At this time Watts had just begun the first portrait of the poet (National Gallery of Victoria, Melbourne) while the Tennysons stayed at Little Holland House; in 1859 he painted him again (no. 34). Several years later Watts painted Emily, beginning in November 1862 at Farringford, 'to surprise A', as she noted in her journal.[3] The portrait was to be a gift to seal the friendship between Watts and the Tennysons. A drawing showing Emily in profile (Witt Collection, Courtauld Institute of Art) is clearly a preliminary idea for it. Again the artist has focused on the head in profile, barely suggested, with her eyes gazing as if into a void.

The canvas is an extraordinarily rough material.[4] Although it might have been all that was available in Freshwater, away from the studio in London, in fact Watts favoured

FIG. 37 *Emily Tennyson*, G.F. Watts, 1858, graphite drawing on white paper, 352 x 254 mm (13⅞ x 10"). The Fogg Art Museum, Harvard University Art Museums, Gift for Special Uses Fund

such loose-textured canvases. On this material it is all the more remarkable that the artist managed such delicate effects in handling the creamy pink complexion of his sitter. The texture worked to advantage in the distinctly autumnal wooded landscape that surrounds Emily, where the roughness emerges through the paint. A strong ultra-marine blue sky is glimpsed above the horizon. The final painting, with its overall blue tonality, is suggestive and sad. Emily's journal noted that as soon as Watts finished with her sittings, he began a new portrait of Tennyson (NPG), on a very similar rough canvas, with the background filled with foliage. It can now be seen that Watts first attempted this type in Emily's portrait. The two portraits also share a moody quality fostered by the wooded setting the figures inhabit and, although never officially a pair, they were conceived in sequence.

Emily modelled for the face for only three or so days with Watts working on the painting while staying with Julia Margaret

Cameron at nearby Dimbola. He borrowed the lace veil to paint separately while the area of the face was drying. He kept the work until June 1863, when he sent it to Emily.[5] When revealed to a group of friends including the Duke (no. 35) and Duchess of Argyll, they pronounced it to be like Gainsborough.[6] One cannot help thinking the distinctive blue tonality must have called to mind the *Blue Boy*, which Gainsborough was said to have painted on a dare, proving that blue could dominate a composition. The remark also signalled Watt's status in the early 1860s as a portraitist who embraced the traditions of the British school.

Within his own *oeuvre* Watts's painting was contemporary with a group of private images depicting beautiful women in poetic reverie. For Watts Emily Tennyson's character and appearance coincided with these more poetic portraits. Indeed, with each of his portrayals of her, Watts seemed to get closer to the inner person, as he peeled away layers of propriety, focusing more and more on the intangible aspects of his friend's personality. She herself likened Watt's achievement to that of a 'subtle alchemist' (see p. 27), such were the mysterious means by which he conjured up elusive beauty.

1 Ill. in Ann Thwaite, *Emily Tennyson: The Poet's Wife*, London, 1996, between pp. 236 and 237.
2 *Romantic Art in Britain: Paintings and Drawings 1780–1860*, exh. cat., Detroit Institute of Arts and Philadelphia Museum of Art, Philadelphia, 1968, no. 205 (entry by Allen Staley).
3 Quoted in Hutchings and Hinton 1986, p. 111.
4 The actual canvas can still be seen at the back, turned over the stretcher.
5 There seems to be a reference to one friend suggesting that the work was to be exhibited at the Royal Academy (letter from Reginald Cholmondeley to Emily Tennyson, Watts Papers) but that came to nothing, perhaps due to the private nature of the work.
6 Quoted in L. Ormond 1983, p. 50, and Hutchings and Hinton 1986, p. 119.

42 LADY CONSTANCE LOTHIAN AND HER SISTERS, LADY GERTRUDE AND LADY ADELAIDE TALBOT

1862

Oil on canvas
1492 x 1181mm (58¾ x 46½")
Earl of Ancram

Provenance Collection of the artist (on view at the Little Holland House gallery); Watts Gallery, 1904–78, although allocated to Mrs Watts and from her to Mrs Michael Chapman (legal descendant of the artist), and later her son, until sold at Sotheby's, Belgravia, 19 March 1979, no.29; bought by a descendant of one of the sitters
Exhibitions Memorial Exhs, Edinburgh 1905, no. 75, Manchester 1905, no. 21, Newcastle 1905, no. 8, Dublin 1906, no. 68; on loan to the Tate Gallery, 1921; Watts London 1954, no. 31
Literature Barrington 1905, p. 92; Watts Catalogue, II, p. 156; Watts 1912, I, p. 211; Hare 1893, III, pp. 231–2; Rowland Alston, *Catalogue of the Watts Gallery*, Compton, 1951, p. 15; Ford 1998, II, p. 106

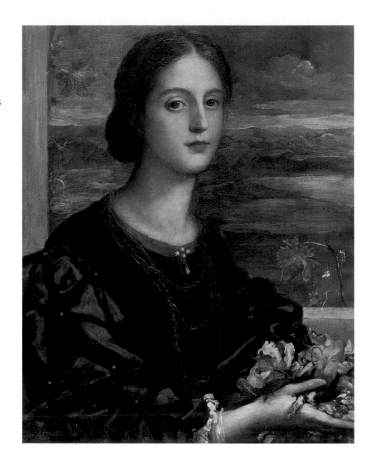

FIG. 38 *Constance, Marchioness of Lothian*, G.F. Watts, 1865, oil on canvas, 673 x 533mm (26½ x 21"). Kiplin Hall, North Yorkshire

Sometimes called 'The Ladies Talbot', this painting shows Lady Constance Lothian (1836–1901), Lady Gertrude (1840–1906, later Countess of Pembroke) and Lady Adelaide Talbot (1844–1917, later Countess Brownlow). They were the daughters of Henry John Chetwynd-Talbot, 18th Earl of Shrewsbury (1803–68), who by 1854 was Rear-Admiral in the Royal Navy. He succeeded indirectly to the peerage in 1856, and his right to the title was allowed in June 1858.[1] Watts knew the family through his friend Lady Waterford (no. 16), who was sister-in-law to the wife of Lord Shrewsbury and aunt by marriage to Lady Constance Lothian. Constance (fig. 38) became a special friend of Watts, one of many close personal friendships with sympathetic women he relied upon throughout his life.

Watts also befriended the man she married in 1857, her first cousin, William Schomberg Kerr, 8th Marquess of Lothian (1832–70).[2] This young man, part of the group of Christ Church, Oxford, graduates whom Watts knew in London, shared the same intellectual and collecting interests.[3] Lothian also enjoyed the company of artists, as he belonged to the Hogarth Club. He possessed a truly great ancestral collection of paintings and had a specialist interest in Italian art, which he and his wife collected during travels after their marriage.[4]

In September 1862, on a long visit to one of their seats, Blickling in Norfolk,[5] Watts conceived this group portrait 'for his

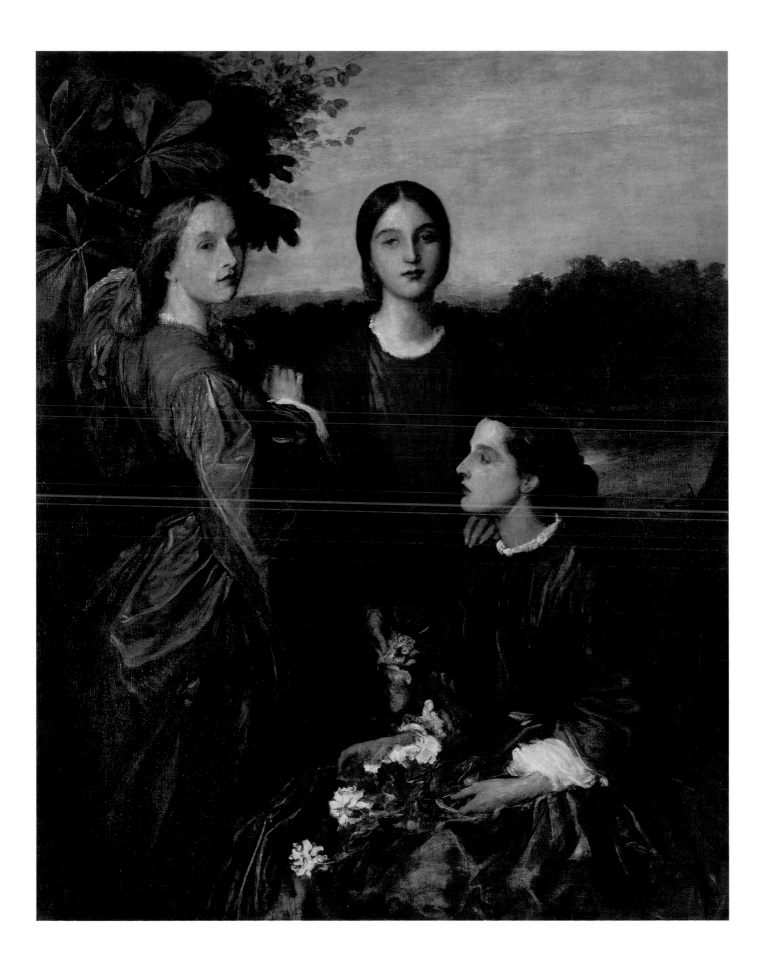

FIG. 39 *Autumn Leaves*, John Everett Millais, *c*.1855–6, oil on canvas, 1041 x 736mm (41 x 29"). Manchester City Art Gallery

own pleasure',[6] carrying it out to a near complete state, but with some areas suggestively unfinished. Watts had a special fondness for depicting sisters; he frequently sought to paint such female siblings together (fig. 7, p. 16; no. 43) or separately (fig. 36, p. 121; no. 38) whenever the opportunity arose. In this work Constance sits, while Gertrude, in more dramatic pose and striking blue dress, turns and Adelaide, the youngest, stands in the middle. The image embodied a visual manifestation of his interest in female beauty and poetic meaning in much the same way as in *Alice Prinsep* (no. 37). He was also sensitive to differences in personality. When he painted Constance in a single portrait (fig. 38), he elaborated the image with a mysterious landscape background in the manner of the *Mona Lisa* but his sitter appears reticent.[7]

Watts's group of the sisters went even further in extending the range of portraiture

by likening it to subject painting. Although there is no specific activity taking place, other than the passing of flowers from Adelaide to Constance, there is a distinct mood to the piece. Rather than grasp the blooms, Constance sits impassively as they fall away, cascading downwards. The painting has a lyrical quality that can be compared to Millais's *Autumn Leaves* (fig. 39) exhibited at the Royal Academy in 1856, in which a similar gathering of young women, in a very similar composition, conveys a sense of the transience of life. In Watts's work, set in early autumn, the Norfolk landscape and horse chestnut in full leaf enhance this sombre mood. He may well have had a particular reason for thinking in such elegiac terms. Another sister, Victoria, had died as a young woman in 1856. The spectre of the missing sister seems to pervade the image.

Yet another reason for the mood of melancholy was the health of Constance's husband. Lothian had contracted a debilitating illness. Confined to a wheelchair, he is seen in a photograph with his thin frame contained within a heavy suit, a sensitive handsome face gazing off to the side.[8] Doctors were unable to help as he gradually declined. Watts channelled this painful experience into the conception of his great design, *Love and Death* (as discussed on pp. 32–3). In portraying Lothian himself (fig. 22), in a work dating from the mid 1860s, 'he knew he was painting a doomed man'.[9] This portrait, one of Watts's most sensitive studies, along with the group of the Talbot sisters, reveals just how far he was prepared to allow associations of love and death to pervade his portraiture. Aged only thirty-eight years, Lord Lothian died in July 1870. At the behest of Constance, Watts produced a magnificent tomb monument in alabaster complete with a dramatically carved portrait head.

1 Along with the title, he gained Alton Towers, Pugin's Gothic masterpiece in Staffordshire, but much of the collections there had already been sold.
2 For details on Lothian, see *Blickling Hall*, *National Trust*, London, 1987, pp. 43ff.
3 For a fuller account of his life, see *Cecil Marchioness of Lothian: A Memoir*, ed. Cecil Kerr, London, 1922. His double first in classics and history promised a great career. A bibliophile, he was a member of the Roxburghe Club; he also published a fragmentary treatise entitled *A Parallel between the History, Literature and Art of Italy in the Middle Ages* (1863), which was privately printed.
4 In 1861 while in Rome Lothian bought two works which indicated his wide-ranging taste: Lucas Cranach's *Venus and Cupid* and a work considered to be by Titian (now Polidoro da Lanciano), both now in the National Gallery of Scotland.
5 Louisa Waterford wrote on 6 September 1862, 'I am going next week to see my niece, Lady Lothian, at Blickling, in Norfolk. Watts the painter is there, making studies for a portrait of Conzy (Lothian) and her two sisters, Gertrude and Adelaide Talbot' (quoted in Hare, 1893, pp. 231–2).
6 Watts 1912, I, p. 211. There are several slight compositional drawings, including one exhibited in Watts London 1954, no. 130 (see Ford 1998, II, nos RBF494–97). On the same visit Watts also painted a head study of their father, of which there are two versions: one at the Watts Gallery and the other more highly finished at the National Maritime Museum. He also planned a magnificently unrealisable, life-sized equestrian portrait of Lord Shrewsbury with his son as standard-bearer.
7 For his portrait of Gertrude see fig. 20 on p. 33; at Kiplin Hall, Richmond, North Yorkshire, there is also a portrait of Adelaide, *c*.1865. She is best known through Frederic Leighton's grand full-length, at Belton House, Lincolnshire, exhibited at the Royal Academy in 1879.
8 *Blickling Hall*, *National Trust*, London, 1987, p. 43.
9 Watts 1912, I, pp. 210–11. The poet George Meredith praised this portrait for 'the living intelligence in the eyes, a point rarely achieved'. Apparently the portrait was dubbed 'the Titian Schoolmaster'.

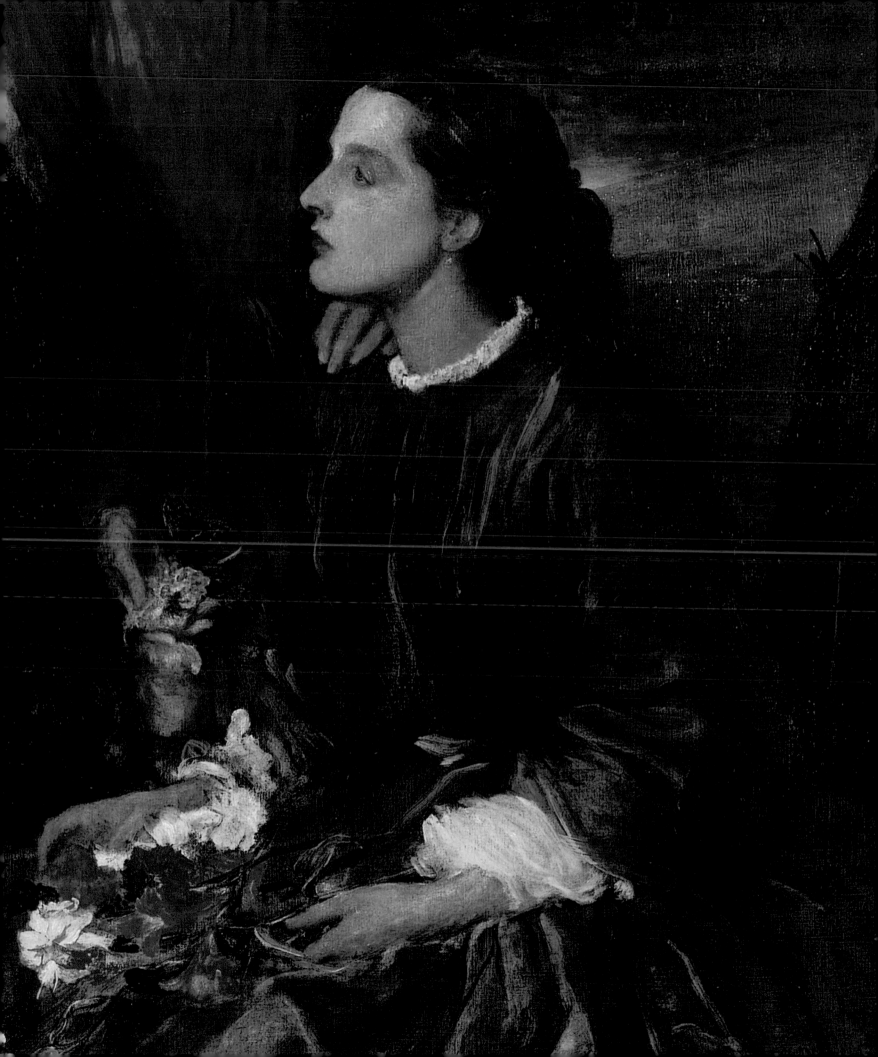

43 THE SISTERS
(KATE AND ELLEN TERRY)
1862–3

Oil on canvas
685 x 890mm (27 x 35")
Eastnor Castle Collection
(Photo: Photographic Survey,
Courtauld Institute of Art)

Provenance Collection of the artist until sold or given
to Virginia, Lady Somers, and Lord Somers, who
displayed it at Reigate Priory; later Eastnor Castle;
by family descent
Exhibitions ?Little Holland House Gallery[1]
Literature Watts Catalogue II, p. 152; Claude Phillips,
'"The Sisters" by G.F. Watts', *Burlington Magazine*, IX
(1906), pp. 6–7; Terry 1908, p. 48, ill. opp. p. 54;
Dudley Harbron, *The Conscious Stone: The Life of Edward
William Godwin*, London, 1949, pp. 45–7; Robertson
1953, p. 323; Loshak 1963, p. 476 and fig. 9; Staley
1978, p. 70

A remarkable example of the poetic impulse
in Watts's work in the early 1860s, this
painting has attained a certain renown as the
first depiction of Ellen Terry, whom the artist
married shortly after.

The portrait shows Kate Terry (1844–
1924)[2] and her younger sister Alice Ellen
(1847–1928), usually called Nell. The two
girls, the eldest two of a large family of
actors, had toured and performed from an
early age.[3] In 1862 Kate enjoyed a stunning
success in London as the leading lady in
Friends and Foes at the St James's Theatre.
Tom Taylor, who combined drama with art
criticism, among much else, promoted Kate
as an up-and-coming actress. He also sensed
that her physical appearance, with long
auburn hair, and her theatrical flair would
suit Watts's art in much the same way that
he had earlier introduced the actress Ruth
Herbert to him. So, with Ellen enlisted as a
chaperone for Kate, the two sisters went to
Little Holland House with the artist
intending to paint Kate.

Watts's encounter with Kate and Ellen
led not to a single portrait of the elder sister
but a combined depiction of both girls in
which the mood of the piece prevailed. The
two sisters, loosely embracing, with Ellen
resting her head on Kate's shoulder, are both
lost in their own thoughts. Kate, wearing a
modern frock, is the less finished figure, her
hands quite loosely sketched in. Ellen, by
contrast, so obviously the focus of Watts's
attention, wears the showier, Renaissance-
inspired dress in vibrant turquoise and white
with dramatically slashed sleeves. Ellen's

pose accentuates her golden hair and the
expanse of pale white skin on her neck.
A distant blue landscape with a stretch of
woods provides a mysterious backdrop to
the image, subtly underlining the poetic
mood – a device that Watts would have
known from Leonardo's *Mona Lisa* (Louvre).[4]
Rich colour is also introduced with the
paisley shawl, a favourite studio accessory.
The carefully contrived portrayal and its
artistic treatment promote a sense of the
beautiful and as such fit in with Aesthetic
trends of the 1860s.

Such an approach could also be found
in Watts's contemporary portrait of Edith
Villiers (no. 40) and in the portrayal of Lady
Lothian and her sisters (no. 42), both works
in which the dreamy gazes of the sitters lent
them an entirely new poetic spirit. And here,
as in the Lothian portrait, the artist never
completely finished the painting. However,
this incompleteness only serves to enhance
the lyrical expressiveness of the work.

1 Artist William Rothenstein (*Men and Memories*, I,
London, 1931, p. 33) recalled seeing it at the gallery.
2 In 1867 Kate married Arthur Lewis, a well-to-do silk
merchant who lived in Moray Lodge on Campden Hill,
Kensington. She retired from the stage, yet the theatrical
impulse continued in the family with her grandson,
Sir John Gielgud.
3 Ellen appeared with Charles John Kean in *The Winter's
Tale* in 1856 aged nine; see the photograph in the NPG
(RN15280).
4 Watts would have known about other portrayals of
sisters in British art, such as Gainsborough's *Linley Sisters*
(1772), then on view at the Dulwich Picture Gallery.

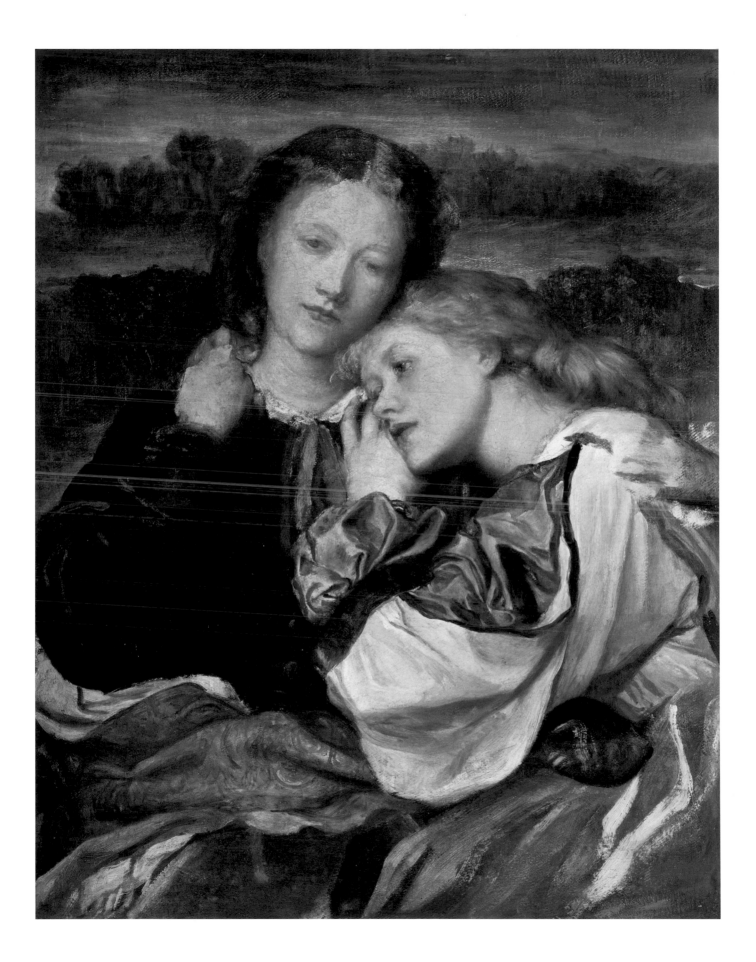

44 CHOOSING
(ELLEN TERRY)
1864

Oil on strawboard
472 x 354mm (18⅝ x 14")
National Portrait Gallery, London
(NPG 5048)

Provenance Bought from the artist by Eustace Smith, MP, 52 Prince's Gate; bought privately *c.*1884/7 by Sir Alexander Henderson, Bt., MP (later Lord Faringdon); his sale, Sotheby's, 13 June 1934, no. 135; bought by Barbizon House, London; and immediately acquired by Kerrison Preston; accepted by HM Treasury in lieu of death duties from his estate and allocated to the NPG, 1975

Exhibitions Royal Academy, London, 1864, no. 395; Memorial Exhs, London, 1905, no. 74; Burlington Fine Arts Club, 1912, no. 23; *Theatrical Exhibition*, Lady Lever Art Gallery, 1949, no. 235; *The First Hundred Years of the Royal Academy 1769–1868*, Royal Academy of Arts, London, 1951–2, no. 348; Watts London 1954, no. 37; *Victorian Painting 1837–87*, Agnew's, London, 1961, no. 108; *Bicentenary Exhibition*, Royal Academy of Arts, London, 1969, no. 366; *Masque of Beauty*, NPG, 1972, no. 43; Watts London 1974, no. 18; *Whisper of the Muse: The World of Julia Margaret Cameron*, Colnaghi, London, 1990, no. 79; *Treasures from the National Portrait Gallery*, touring exhibition, Japan 1995–6, no. 26; *The Victorians: British Painting in the Reign of Queen Victoria, 1837–1901*, National Gallery of Art, Washington DC, 1997, no. 31; *Artists at Home: The Holland Park Circle, 1850–1900*, Leighton House Museum, London, 1999, no. 14

Literature Spielmann 1886, p. 30; Barrington 1905, pp. 3, 31, 33, 198; Terry 1908, repr. p. 150; Watts Catalogue, I, p. 27; Gordon Bottomley in *Barbizon House: An Illustrated Record*, London, 1934, p. 14; W. Graham Robertson, 'A Note on Watts's Picture "Choosing"', *Apollo*, XXVII (1938), p. 318; Robertson 1953, pp. 313, 316, 323, 398, 403; Loshak 1963, p. 483 and fig. 9; Blunt 1975, pp. 110–11; Staley 1978, pp. 70, 73

As one of Watts's best-known works since its acquisition by the National Portrait Gallery in 1975, *Choosing* has attained such an iconic status that one needs to rediscover the image and its meanings.

While Watts worked on the painting of the Terry sisters (no. 43), he grew more interested in Ellen whose stage career progressed. She performed in Bristol, but by spring 1863 she was back in London with a part in Tom Taylor's *Our American Cousin*, then in repertory at the Haymarket Theatre. By this time life at Little Holland House attracted her more than her acting, as she later noted in her memoirs, 'the stage seemed a poor place when compared with the wonderful studio'.

Watts's own attraction to Ellen suggested to him that he could protect her from a life in the theatre, then considered a dubious occupation for a woman. As his friend Roddam Spencer Stanhope recalled, Ellen's 'beauty and her somewhat unprotected position much troubled his chivalrous nature'.[1] Watts sounded out friends with his plans to adopt her; then, abandoning that notion, he thought of marriage. The legal document later produced at the time of their divorce in 1877 recorded that 'although considerably older than his intended wife he admired her very much and hoped to influence, guide and cultivate a very artistic and peculiar nature and to remove an impulsive young girl from the dangers and temptations of the stage'.[2] To his friend Lady Constance Leslie he wrote that he was 'determined to remove the youngest [Ellen] from the temptation and abominations of the stage, give her an education and, if she continues to have the affection she now feels for me, marry her'.[3]

Their marriage occurred on 20 February 1864, timed to take place immediately before both of their birthdays, with Watts about to turn forty-seven and Ellen thinking she was about to turn sixteen, but in fact, nearly seventeen.[4] They were married at St Barnabas Church on the Holland Estate with Tom Taylor, Kate Terry, Val Prinsep and Sophia Dalrymple acting as witnesses. Sara Prinsep was noticeable by her absence.

Ellen wore a Renaissance-inspired dress of brown silk, with sleeves decorated with bands of black velvet, designed (according to Ellen) by the artist Holman Hunt, a friend and Kensington neighbour,[5] who lived on the corner of Melbury Road, near Little Holland House, in a substantial house named Tor Villa. Of all the Pre-Raphaelites, Hunt was closest to Watts, noting that the elder artist shared 'many private and appreciative confidences' with him.[6] Hunt turned to decorative figure paintings in the early 1860s as in the portrait of model Annie Miller, eventually named *Il Dolce far Niente* (1860–65; formerly Forbes collection).[7] Here an Italianate dress with full sleeves drew inspiration from Giulio Romano's portrait of *Isabella d'Este* at Hampton Court Palace. It is not known if Hunt designed this dress himself, but it indicates that a model in one of his own paintings wore a similar Renaissance-style dress.

Since Watts and Ellen married in February, and she is shown in *Choosing* wearing her wedding dress,[8] it seems likely that Watts conceived the work as a marriage portrait, a traditional type with a long lineage. Completed for the Royal Academy by April 1864, the painting represents the early and optimistic phase of Watts's relationship with Ellen. He must have begun it almost immediately after their wedding.

In the painting a dense camellia bush fills the space behind the figure, almost entwining Ellen within its lush flowering tendrils. Camellias are among the first flowers of the year, opening as early as February. A noted favourite of Victorian gardens, this shrub, found throughout the Holland estate, must have burst into bloom at just the time of the wedding.

Watts painted *Choosing* as a small work on a type of hardboard (unlike the larger canvas he had used for no. 43). He favoured such denser supports around 1860 since they permitted the most precise touches. Critical reception of the Academy exhibition focused on the beauties of the artistic treatment. William Michael Rossetti discussed it with other portraits, noting that it showed a 'very fair and very youthful lady with camellias'.[9] F.G. Stephens admired the 'tone and richness of the flesh painting'.[10]

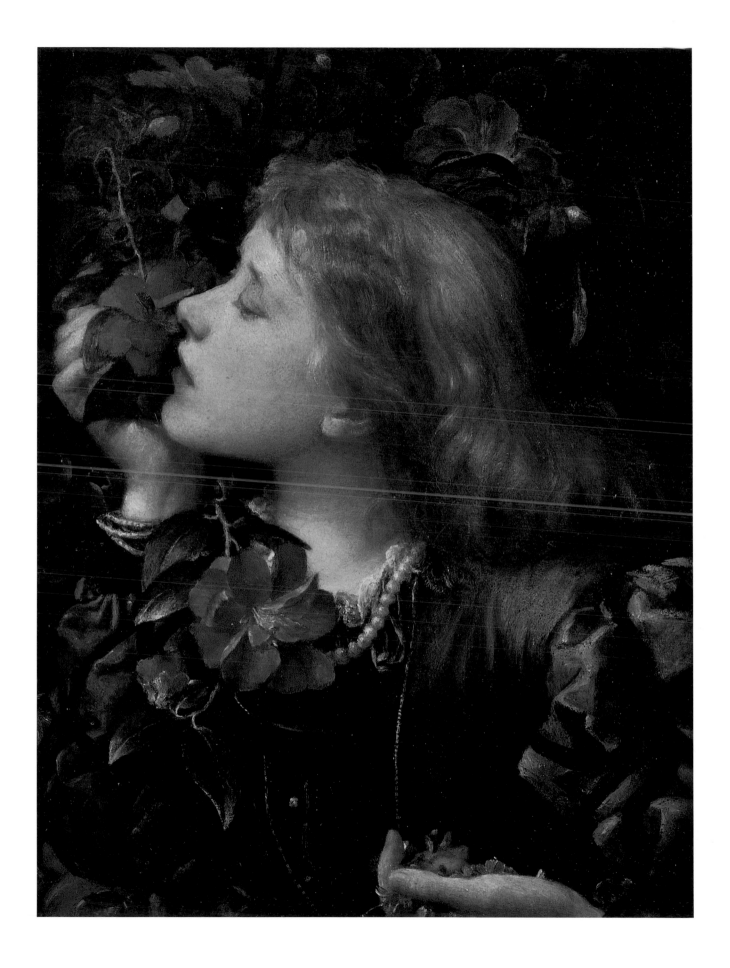

The critic for the *Art Journal* commended Watts's 'usual subtle sense of the harmony of colour'.[11] His technique was much admired at this time; later he 'sorely deplored the loss of the power of completer finish which he possessed when he painted "Choosing"'.[12] Tom Taylor, who knew both artist and sitter well, gave the most attention in his review of the Academy in *The Times* to

> Mr. Watts's lovely blonde, who hesitates in her choice … the loveliest example of colour and the most delicate piece of fancy in the exhibition. It is an almost solitary example here of the poetry of painting and its harmony of hue and tender suavity of line transform the trivial yet not ungraceful little incident into an idyll which delights the eye and stamps itself on the memory.[13]

Watts occupied a distinct niche for 'the poetry of painting'; with *Choosing*, he confirmed his inclinations in a public exhibition. Parallels with Rossetti's paintings of women with flowers (fig. 14, p. 30) might be cited, but this was a type that Watts had already refined in his own work, as in *Bianca* (fig. 15, p. 31) of 1862. These works reveal a kinship among artists in the 1860s, as ideas of the beautiful in painting developed into the major preoccupations of Aestheticism.

Choosing began as a portrait, with Watts naming it for the Academy exhibition. Famously entitled to point up Ellen's choice between the opulent but scentless camellias and the humble violets she turns away from, it also depicts her choices on another level, for she personally had chosen marriage over the stage. But the depiction of such a contrast is also the focus of traditional allegorical representations. In the National Gallery an acquisition of 1847, Godfried Schalcken's *Allegory of Virtue and Riches* (*c.*1667), shows a beautiful girl balancing on a miniature scale the weight of a small bird, symbolic of virtue, with a collection of jewels.[14] The action in this painting subtly parallels Ellen's

in *Choosing*. Watts's knowledge of and response to older art animated his distinctly modern treatment of his young wife.

Acquired soon after the Academy exhibition by Eustace Smith,[15] a noted collector with a taste for modern art, the portrait remained in private collections until the memorial exhibition of 1905, when Ellen must have seen it afresh. Graham Robertson, who knew Ellen Terry well, asserted that *Choosing* was the 'favourite of all the portraits painted of her'.[16]

1 A.M.W. Stirling, *Life's Little Day: Some Tales and other Reminiscences*, London, 1924, p. 219.
2 Quoted in Loshak 1963 from the Divorce Proceedings, 13 March 1877, High Court of Justice, Probate, Divorce and Admiralty Division.
3 Quoted in Blunt 1975, p. 105.
4 Ellen cited the year of her birth as 1848, but in fact it was 1847, as noted in the old *Dictionary of National Biography*. Seventeen was not particularly young for marriage, with many women taking that step before they were twenty.
5 Terry 1908, p. 53; she described it as brown silk although the colour is now closer to green.
6 Hunt 1913, II, pp. 324–6.
7 On Hunt's painting see Allen Staley, 'Pre-Raphaelites in the 1860s: II', *British Art Journal*, V, no. 1 (2004), pp. 6–8.
8 Robertson 1931, p. 55.
9 *Fraser's Magazine*, July 1864, p. 69.
10 *Athenaeum*, May 1864, p. 651.
11 *Art Journal*, 1864, p. 166.
12 Barrington 1905, p. 198.
13 *The Times*, 30 April 1864, p. 13.
14 NG 199, bequeathed by Richard Simmons in 1847; this work is also on a small scale, painted on copper and with the figure inclining in the same direction as the figure in Watts's work.
15 Watts painted Smith's portrait (Tate) in 1872; Smith also owned *Sir Galahad* (Fogg Art Museum). Blunt (1975, p. 111) gives an account from Smith's granddaughter of how the painting was nearly destroyed with others of Ellen once she and Watts separated. But Smith refused to forfeit it, swiftly removing it from the artist's studio. See also Timothy Wilcox, 'The Aesthete Expunged: The career and collection of T. Eustace Smith, MP', *Journal of the History of Collections*, 5, no. 1 (1993), pp. 49–50.
16 Robertson 1953, p. 316.

45 ELLEN TERRY
1864

Pencil on paper
165 x 184mm (6½ x 7¼")
Inscribed (not by the artist) 'Ellen Terry'
Private collection

Provenance Retained by Watts; to Watts's adopted
daughter, Lilian Chapman; by family descent; Sotheby's,
London, 1 July 2004, no. 301
Exhibitions Watts London 1954, no. 136

This small but fascinating studio survival
shows Ellen Terry having fallen asleep,
probably in the course of posing for *Choosing*
(no. 44). Watts was noted for taking many
hours for his sittings at this time, as for
Edith Villiers (no. 40). One of the reasons he
married Ellen may well have been to secure
her as a permanent model, the perfect
choice for his new paintings which focused
on the beauties of the sitters chosen as well
as the technique used. During her relatively
short time living at Little Holland House in
1864, Ellen found herself posing for many
drawings and a wide variety of paintings
including no. 46, *Ophelia* (Watts Gallery)
and *'Watchman, What of the Night?'* (private
collection). While modelling for the last,
she fainted from the weight of the armour.
But despite such rigours, she was happy
because, as she wrote later, 'my face was
the type which the great artist who married
me loved to paint'.[1]

The long hours required, even for a
relatively small work such as *Choosing*, are
seen in this drawing to have taken their toll
on Ellen. She wears a dress very much like
her wedding dress with gathered sleeves. In
a similar, though reversed position from that
in the painting she has lost the actual pose
of leaning forwards, and instead slumped
back upon a chair and fallen asleep. Watts,
as if unable or unwilling to wake her,
carries on with a pencil drawing of great
tenderness, which seems to open a hitherto
closed window on their relationship. It

portrays a moment in their private life at
Little Holland House, and seems to strip
away all the words, gossip and opinions
about their ill-fated marriage over the past
150 years. Her youthful beauty was for him
an inspiration, even if she herself was an
imperfect muse.

Life at Little Holland House meant that
Ellen was subject to the requirements of the
head of the household, Sara Prinsep, who
according to all accounts treated her as
a 'naughty child', berating her on one
occasion for unbinding her golden tresses.
Watts of course always painted Ellen with
her hair long and loose. But he, too, became
impatient with her 'restless and impetuous
nature', as can be gathered from the
evidence for their divorce some thirteen

years later. Here he accused Ellen of 'an
insane excitability indulging in the wildest
suspicions, accusations and denunciations
driving him to the verge of desperation'.[2]
Even in this drawing something of Ellen's
exuberant personality is hinted at, as she
has spent all her energy and dropped off
to sleep. Watts must have worked on the
drawing for some time, as it is fairly detailed
and gives a particularly good idea of Ellen's
full lips and strong chin, along with the wavy
hair that so fascinated him.

1 Terry 1908, p. 53.
2 Loshak (1963) published excerpts from this important
document; see above no. 44, note 2.

137

46 ELLEN TERRY

*c.*1864

Oil on canvas
597 x 597mm (23½ x 23½")
National Portrait Gallery, London
(NPG 2274)

Provenance Collection of the artist; given to
Ellen Terry *c.*1882; her sale, Christie's, London,
17 December 1928, no. 16; bought Sampson;
presented by subscribers to the NPG
Exhibitions New Gallery, London, 1909, no. 148;
Shakespeare Exhibition, Whitechapel Art Gallery,
London, 1910, no. 122a; Watts NPG 1975;
Victorian High Renaissance, Manchester, 1978, no. 14;
Watts NPG 1980
Literature Terry 1908, p. 60; Loshak 1963, p. 480;
Ormond 1975, p. 19

FIG. 41 *The South West Wind from Life*, Julia
Margaret Cameron, 1864, albumen silver print
from glass negative, 254 x 216 mm (10 x 8½").
The Metropolitan Museum of Art/Harris Brisbane
Dick Fund, 1941. (41.21.19) Photograph © 2004
The Metropolitan Museum of Art

FIG. 40 *Ellen Terry*, G.F. Watts, 1864, pencil on
paper, 110mm (4⅜") (circular). Sotheby's, London

This work has a special connection with
artist and sitter, as it was one of the few
paintings of Ellen to survive in Watts's
collection,[1] and when they became re-
acquainted in the 1880s, he presented it to
her as a gift.[2] It shows Ellen from the same
angle as in *Choosing*, but this work is on
canvas and on a larger scale. The treatment
is broader and richer, more inspired by
Venetian painting, especially in the fascin-
ation with the white skin of her neck and

cheek contrasted with the deep, glowing
colours of the fabrics surrounding her. The
first idea for the composition is a small
drawing (fig. 40) showing just her head
inclining forward with her eyes gazing up-
wards, a drawing Watts retained. The
forward movement of the figure suggests
Ellen's own impetuous nature. Equally,
as she leans towards the red curtain, one
might almost imagine her craving a return
to the stage.

Watts's images of Ellen often suggest
her own input into realising the artist's
vision. Emilie Barrington, who knew her
well, considered that Ellen's 'dramatic
genius' had considerable impact on com-
positions as different as *Joan of Arc* (various
versions) and the sculpture *Clytie* (marble,
Guildhall Art Gallery).[3] As an actress, she
had a way of moving and presenting herself
in a naturally energetic fashion, since on
the stage her actions would be read from a
distance. This quality is also apparent in the
several photographs of Ellen taken by Julia

Margaret Cameron in 1864 and 1865, such
as *The South West Wind from Life* (fig. 41).
Here, with a mere turn of her head, Ellen
animates the idea with her physical presence
and expressive face.

Cameron, who lived and worked on
the Isle of Wight, captured Ellen in other
photographs during visits in 1864. But by
this time the marriage of Ellen and Watts
was foundering. One can detect a sadness
coming over her face in such photos at this
time, even in the well-known image of her
wearing a white dress and fingering a coral
necklace.[4] On a visit to see the Tennysons at
Farringford in October 1864, another guest,
Edward Lear, wrote: 'Pattledom has taken
entire possession of the place – Camerons
and Prinseps building everywhere: Watts in
a cottage (not Mrs. W.).'[5] By January 1865
a legal separation had been drawn up.
Dispatched back to her parents on Stanhope
Street in London,[6] Ellen later confessed,
'I was thunderstruck; and refused at first
to consent to the separation, which was
arranged for me in much the same way as
my marriage had been'.[7] She continued to
sign herself 'Ellen Watts' for several years,
but with her return to the stage in 1867,
she reverted to Ellen Terry and began a new
chapter in her life.

1 He apparently destroyed many of the paintings of her;
see Robertson 1931, p. 55.
2 Ellen noted (Terry 1908, p. 60) that Watts 'did not
touch it except to mend the edges'.
3 Barrington 1905, p. 35.
4 This photo, which is in fact entitled *Sadness*,
is illustrated in Sylvia Wolf, *Julia Margaret Cameron's
Women*, Art Institute of Chicago, New Haven and
London, 1998, p. 71.
5 *Later Letters of Edward Lear to Chichester Fortescue*, ed.
Lady Strachey, London, 1911, p. 47, letter of 19 October
1864.
6 She is seen with her family in a series of photographs
by Charles Dodgson (Lewis Carroll) on the balcony of
their house on 14 July 1865.
7 Terry 1908, p. 59.

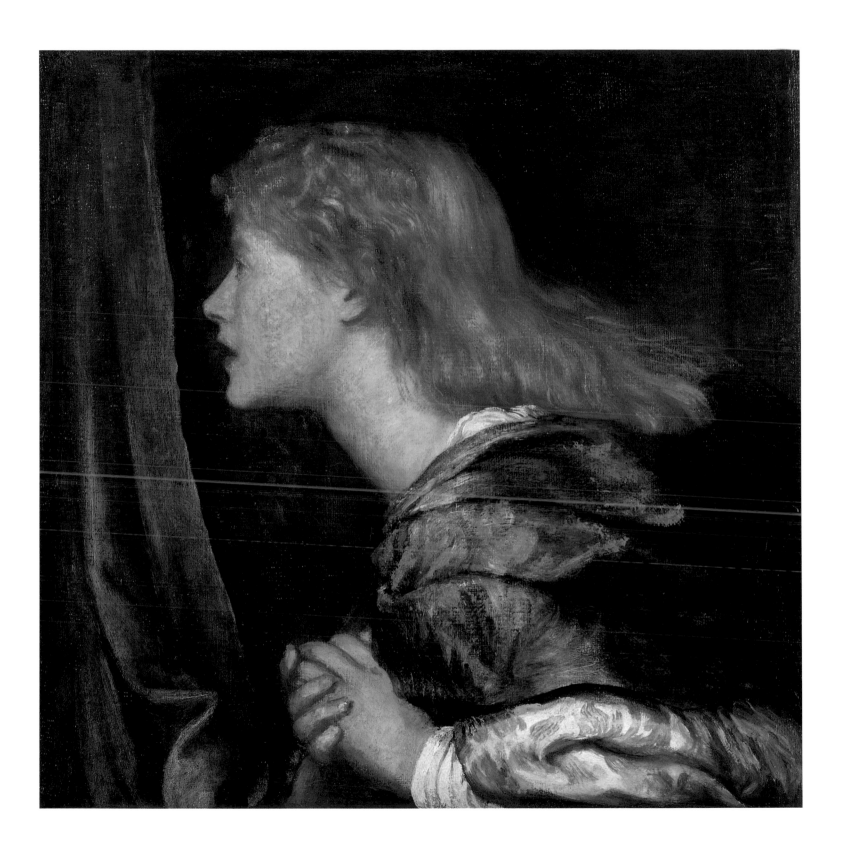

47 SARA PRINSEP

1864

Oil on panel
229 x 229mm (9 x 9")
Inscribed 'Signor 1864'
Private collection

Provenance Presumably given to the sitter by the artist;
by family descent; Mrs John Palmer, her sale, Christie's,
16 March 1973, no. 168; bought by the mother of the
present owner
Exhibitions *Exhibition of English Drawings, Watercolours
and Paintings*, Colnaghi's, London, November–December
1973, no. 177
Literature *Apollo*, XCVIII (1973), ill. p. 391; Blunt 1975,
ill. opp. p. 172

This small portrait of Watts's closest and
dearest friend Sara Prinsep is a rarity in
bearing the signature 'Signor'. A palpable
sense of their closeness emerges from its
intimate size and delicate handling.

A year older than Watts, Sara Prinsep
(1816–87), one of the Pattle sisters, was
born in India and educated partly in France.
She had the same exotic appeal and
unconventional style as her sisters Virginia
and Sophia. Like her other sister Julia
Margaret Cameron (her elder by one year),
Sara married a man much older than herself
in India in 1835. Henry Thoby Prinsep
(1792–1878), who had been highly placed
in the Bengal Civil Service, returned to
England in 1843 to serve as a Director of
the East India Company and later member of
the Council of India. The Prinseps had four
children: her son Valentine (1838–1904)
became an artist and friend of Watts; her
daughter Alice is the subject of no. 37.

As the chatelaine of Little Holland
House from 1851 to 1874, Sara played a key
role in Watts's life over a longer period of
time than any of the other sisters. From the
time he met her in Mayfair in 1849 to her
death in 1887 they were in regular contact,
with Watts initially living as a member of the
family as she nursed him through a serious
illness in 1850 and then throughout the
1850s and 1860s. She created the 'earthly
paradise' at Little Holland House, presiding
over a salon of luminaries such as Tennyson
and the young Pre-Raphaelites.

Watts portrayed her regularly in oils and
drawings in the early stages of their friend-
ship.[1] She first posed with Sophia for the
grand double-portrait of c.1850–51 (fig. 7,
p. 16) and another full-length (unlocated);[2]
a drawing in profile dates from about the
same time, with several oils following in the
1850s, including one later entitled *In the
Time of Giorgione*. Although one observer
commented that she was filled with restless
energy – there was 'no such thing as quiet
where she was'[3] – it is interesting that in all
of Watts's depictions of her she seems to be
a remarkably calm presence.

This work dates from 1864 during a
crucial phase in Watts's personal life in the
year of his marriage to and separation from
young Ellen Terry. Among all the second-
and third-hand accounts of Watts's
marriage, Sara's name is prominent. What
is certain is that she did not attend his
wedding, which suggests some disapproval,
and that once Ellen was installed at Little
Holland House, Sara treated her as a
'naughty child'. One observer considered
that she 'wrecked the marriage';[4] she may
well have encouraged their separation.

None of this emotional tumult is
suggested in Watts's portrait of Sara. Like
Choosing, painted the same year, the work
is small and precisely painted with great
delicacy. Layers of glazes build up the
surface, lending a sonorous depth to the
blues of the background. The artist devoted
much attention to the creamy tones of the
face, adding a bloom of pink. The blue
background, suggestive of the sky, and the
sensitive expression of Sara herself lend a
sadness to the image that seems to reflect
the artist's own sense of regret at the time.
This entirely private portrait stayed with Sara
and her family, a token of Watts's affection
for her, despite all that had happened.

1 Watts 1912, III, p. 78.
2 Watts Catalogue, II, p. 126.
3 Laura Troubridge, *Memories and Reflections*, London,
1925, p. 20.
4 A.M.W. Stirling, *Life's Little Day: Some Tales and other
Reminiscences*, London, 1924, p. 219.

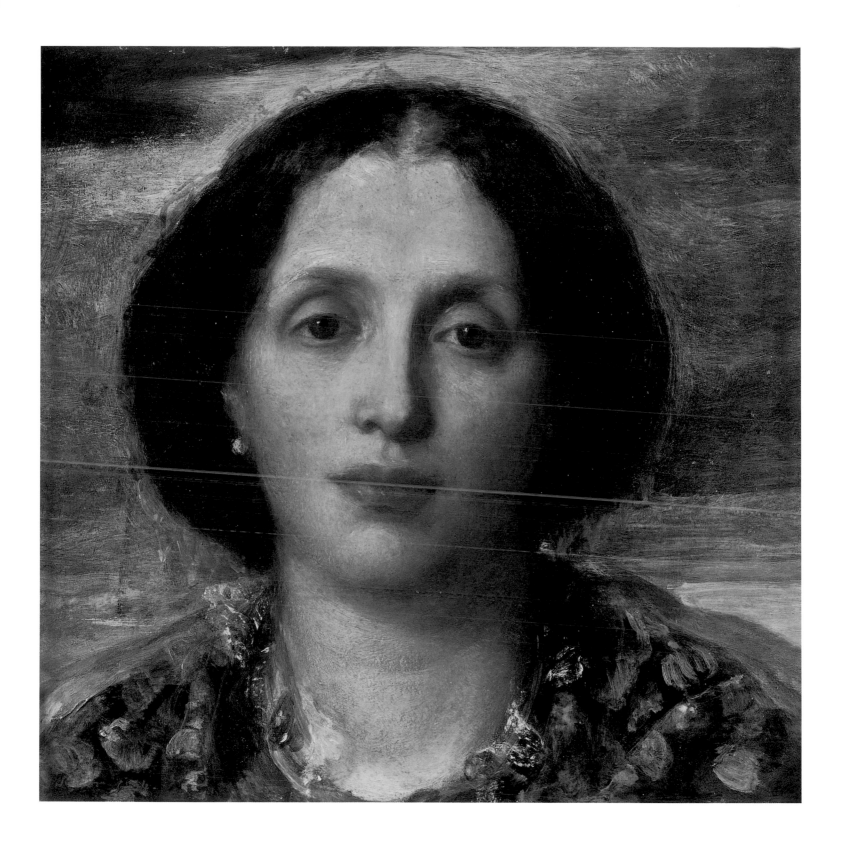

48 SELF-PORTRAIT

c.1862–4

Oil on canvas
648 x 521mm (25½ x 20½")
Inscribed (possibly later) 'G F W 1864'
Tate. Bequeathed by Sir William Bowman, Bart.
1898

Provenance Acquired by William Bowman in 1864; with his family, until presented at his request to the National Gallery of British Art in 1897
Exhibitions Watts Grosvenor 1881, no. 56; Royal Jubilee Exhibition, Manchester, 1887, no. 258; Watts New Gallery 1896, no. 83; Stockholm 1897
Literature Spielmann 1886, p. 32; Spielmann 1905, pp. 36–37; Watts Catalogue, II, p. 167; Watts 1912, I, pp. 217–18, II, pp. 195–6, 264; Bryant 1987, pp. 57–8

This work, often entitled the 'Bowman Self-Portrait', is the best known of Watts's self-portraits. It shows him wearing a dark velvet coat and black slouch hat. Replete with echoes of earlier artists' self-portraits, it is nonetheless a startlingly direct view of Watts completed in the year of his ill-fated marriage to Ellen Terry. It conjures up a face that one observer at this time described as 'a serious countenance suggesting a latent weariness and melancholy hidden under a crust of reserve'.[1]

During the early 1860s Watts became well acquainted with prominent ophthalmologist William Bowman.[2] The doctor, a frequent visitor to the studio, had spotted the painter's self-portrait, begun some years before. Watts noted that it was 'knocking about for some time in the studio, and at last Bowman much wished to have it'.[3] In November 1863 Bowman wrote to Watts, with a payment of one hundred guineas, mentioning the artist's proposal 'soon to finish for me the head of the great poet', referring to a portrait of Tennyson.[4] He added that he wished that 'the head of the great artist [i.e. the self-portrait]' matched the other, 'for I would fain have painter and painted, a pair of nobles answering one to the other on my walls'.[5] Bowman's

imaginative engagement with these images hints at the wider function of portraits among Watts's circle in the 1860s.

For Watts self-portraiture formed an essential part of his art. On a practical level he painted a self-portrait 'whenever I want to make an experiment in method or colour and am not in the humour to make a design'. Yet such images had considerable resonance. He knew the Uffizi's collection of artists' self-portraits from his time in Florence, once calling it the 'most interesting gallery I know'.[6]

At this stage in his career, with mature, well-informed tastes, Watts approached self-portraiture with a sense of past and present. From Poussin's *Self-Portrait* of 1650 in the Louvre (with which Watts re-acquainted himself in Paris in early 1856) he gained the idea of the pose, with head turning outward and hands placed upon a portfolio. As a great classicist in style, Poussin painted a self-portrait that for Watts suggested the formal, even abstract treatment of the mathematically precise lines of the grey panelling in the background. But for the image of the artist himself Watts was irresistibly drawn to Rubens's dramatic self-portrait of 1623 in the Royal Collection as a bearded gentleman swathed in a dark cloak, his head topped with a wide-brimmed black hat.[7] The idea that Watts felt he could reconcile the portraits of these two very different artists in his own self-image reveals the depth of his thinking about portraiture, placing in context his involvement in the National Portrait exhibitions a few years later.

When Bowman expressed interest in Watts's portrait, the artist finished and signed it.[8] The painting took its place in the doctor's collection with the portrait of Tennyson and eventually Bowman's own portrait (no. 49). In the late 1880s Bowman asked Watts about his planned bequest to the nation, since he wished to follow through with an 'old intention' that the

self-portrait be included with the rest of the bequest. In 1897 the portrait went into the 'Watts Room' at the new Tate Gallery at Millbank, with an inscription on the frame: 'Bequeathed by Sir William Bowman, Bart., in testimony of the love he bore the painter'.

1 Barrington 1905, p. 2, describing her first sight of Watts at Rossetti's studio in 1865.
2 He was often referred to as an 'oculist'; see no. 49 for his biographical details.
3 Watts 1912, I, p. 217.
4 The 'Bowman Tennyson', signed and dated 1864, is closely related to the NPG's *Tennyson* and was sold at Christie's, London, 25 March 1994.
5 Watts 1912, I, p. 218.
6 Letter to Charles Rickards, 10 February 1869, Watts Papers; quoted in Watts 1912, I, pp. 244–5.
7 Queen Victoria lent this portrait to the Manchester Art Treasures exhibition in 1857, so it was known outside the Royal Collection.
8 In 1867 the artist completed another version of this portrait (private collection), exhibited Watts London 1974, no. 19. There is yet another less finished, related work in the National Gallery of Ireland. The 'Bowman Self-Portrait' became well known through engravings, most notably appearing in the *Magazine of Art* in 1878 and in the catalogue for the exhibition of Watts's work in New York in 1885. For an unfinished version of the latter engraving, a mezzotint by Charles William Campbell, *c.*1885, see *The Artist as Portrait*, exh. cat., Roy Davids at the Fine Art Society, April 2000.

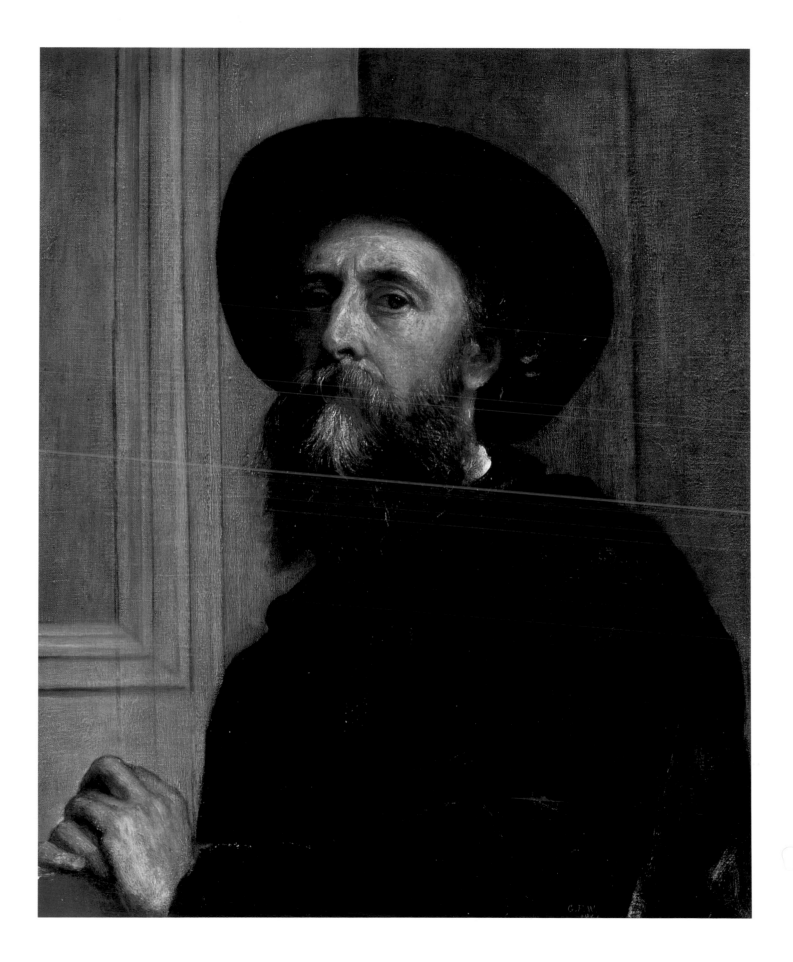

49 WILLIAM BOWMAN
1864–5

Oil on canvas
648 x 521mm (25½ x 20½")
Private collection

Provenance Painted for the sitter; by family descent
Exhibitions Royal Academy, London, 1865, no. 251;
Exposition Universelle, Paris, 1867, no. 119a; Watts
Grosvenor 1881, no. 159; Royal Jubilee Exhibition,
Manchester, 1887, no. 266; Watts New Gallery 1896,
no. 71; Memorial Exhs, London 1905, no. 58, Edinburgh
1905, no. 42, Manchester 1905, no. 15, Newcastle 1905,
no. 13; Watts London 1954, no. 39
Literature Spielmann 1886, p. 29; frontispiece to *The
Collected Papers of Sir William Bowman, Bart. F.R.S.*,
London, 1892, I; Spielmann 1905, p. 37; Watts
Catalogue, II, p. 18; Bryant 1987, pp. 57–8

Watts painted this portrait after William
Bowman commissioned his portrait of
Tennyson and the artist's own self-portrait
(no. 48). It is one of his most sympathetic
portraits of men at a time when he focused
on other such unusual and innovative
images of this type (see fig. 19, p.33).

William Bowman (1816–92), the son
of an eminent doctor, had early success in
medicine with a speciality in treating eyes.
Appointed a full surgeon at the Royal
London Ophthalmic Hospital at Moorfields,
Bowman reached the top of his profession
by the early 1850s. His speciality led him
into contact with artists, including Watts,
who sought treatment for eye problems.[1]
He lived in North End, Hampstead, and had
a taste for the arts.

In November 1863 Bowman sent Watts
one hundred guineas, which was either
advance payment for his own portrait or
for the artist's self-portrait. The letter also
confirmed the commission for the artist
'to finish for me the head of the great poet',
which Bowman seems to have considered
a desirable pair to the head of the painter.
In fact, Bowman's own portrait is an equally
relevant pair, which the artist seems to have
conceived in relation to his self-portrait.

Watts and Bowman were near
contemporaries, yet very different men.
Watts gazes out seriously, even guardedly,
whereas Bowman is the epitome of relaxed
confidence. In an unusual view, studiedly
casual, Bowman leans over the back of
a chair, hands folded, seeming to listen
intently to the artist's own conversation.
Watts tended to avoid painting hands but
here they serve as an essential key to the
informality of the image. The oblique view
of the figure within the composition displays
originality, compared to the general run of
English portraits in the 1860s.

Far from being an entirely private image,
the portrait appeared at the Royal Academy
in 1865 where it was universally approved.

The writer in the *Examiner* thought it
'unquestionably the finest portrait of the
year'.[2] Some critics noted a kinship with
the art of Titian, one considering it 'the only
canvas that Titian … would have cared to
look at'.[3] The *Art Journal* discerned that
the 'style has a breadth which seems to
comprehend more than is positively put on
the surface. Such a picture proves how noble
the art of portraiture may become.'[4] Tom
Taylor wrote in *The Times* that 'Mr. Watts's
portrait of Mr. Bowman, the oculist, best
satisfies the true requirements of a portrait.
It interests without one's knowing the
person painted.'[5] This sensitive depiction of
the sitter speaks of the true friendship that
existed between artist and patron, but it also
showed a new direction for male portraiture
in suggesting mood and meaning beyond
mere likeness.

As a collector of modern art, Bowman
chose imaginatively, particularly works in
watercolour by J.F. Lewis, George Price
Boyce, Frederic William Burton and Dante
Gabriel Rossetti, acquisitions that probably
dated from later in the 1860s.[6] He also
acquired other paintings by Watts,[7]
including the early 'symbolical' design also
seen at the Academy in 1865.[8]

1 Watts 1912, I, p. 217.
2 *Examiner*, May 1865, p. 363.
3 'The London Art Season', *Blackwood's Magazine*, 1865,
p. 240.
4 *Art Journal*, 1865, p. 168.
5 *The Times*, 6 June 1865, p. 6.
6 He seems to have inherited some Old Master paintings
from his father.
7 He commissioned a further portrait of his close friend,
the noted Dutch ophthalmologist and physiologist,
Franciscus Cornelis Donders (1818–89), also known to
Darwin (Watts Catalogue, II, p. 46).
8 I identified and discussed this painting, *Design for
a Larger Picture*, later called *Youth in the Toils of Love*
(Memorial Art Gallery, University of Rochester), in Bryant
1987. Watts gave it to Bowman in 1867 in recognition
of Bowman's 'generosity, kindness and genius'.

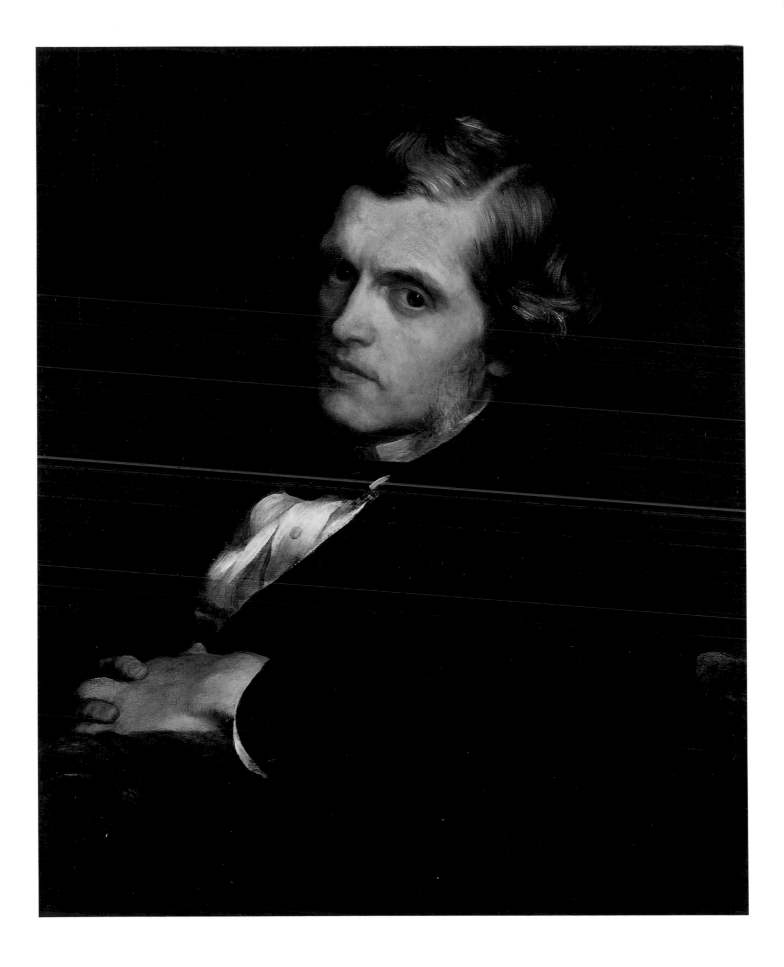

50 BLANCHE, COUNTESS OF AIRLIE
1865–6

Oil on canvas
762 x 635mm (30 x 25")
Private collection

Provenance Painted as a commission for the Earl and
Countess of Airlie; by family descent
Exhibitions Watts Grosvenor 1881, no. 87; Watts New
Gallery 1896, no. 34; Memorial Exhs, London 1905,
no. 84, Manchester 1905, no. 157; Watts London 1954,
no. 42; *Society Portraits 1850–1939*, Colnaghi and the
Clarendon Gallery, London, 1985, no. 7
Literature Spielmann 1886, p. 29; Watts Catalogue, II,
p. 1; Caroline Dakers, *Clouds: The Portrait of a Country
House*, New Haven and London, 1993, p. 26; Dakers
1999, pp. 80–82

Watts's portraits of the Earl and Countess of
Airlie represent his privately commissioned
portraiture at its best. In the mid 1860s his
growing success with his work in general
and portraiture in particular attracted
the type of patron who suited him best.
Artistically inclined, aristocratic sitters with
an appreciation of his aspirations, as indeed
Blanche Airlie proved to be, provided the
perfect subject and audience for his work.

Born the Hon. Henrietta Blanche Stanley
(1830–1921), daughter of Lord Stanley of
Alderney, she had been fond of artist and
illustrator Richard ('Dicky') Doyle but in
1851 married David Ogilvy, 10th Earl of
Airlie (no. 51), whose seat in Scotland was
Cortachy Castle.[1] In London they were
based at Airlie Lodge on Campden Hill in
Kensington. Like Sara Prinsep, and perhaps
slightly in rivalry with her, Blanche also
cultivated a salon of writers and artists. She
approached Watts initially for a portrait of
her husband, to which he acquiesced in
1863,[2] although the actual work on it and
her portrait seems to date from slightly later.

Watts's portrayal of Blanche shows her
in Italianate dress, with billowing sleeves,
trimmed with velvet ribbons, a style of
clothing that referred to sixteenth-century
Venetian art. The artist certainly knew

the splendid portrait by Paris Bordone
(fig. 42), acquired by the National Gallery in
1861, which shows a similar type of gown
with full sleeves on a frontally posed figure.
The comparable colouring of the red gown
makes this a very close precedent for Watts's
portrait. Equally he knew the Renaissance
device of positioning the figure behind a
parapet from another recent acquisition at
the National Gallery.[3] Watts's use of Old
Master precedents for aristocratic portraits
allowed his works to harmonise with the
great ancestral collections they entered.

A more modern comparison for this
portrait can be found in the work of Dante
Gabriel Rossetti, whose studies of women
and flowers in increasingly splendid
compositions also drew upon Venetian
inspiration. Watts, who esteemed Rossetti's
work very highly, may well have cast an
eye on his recent paintings such as *Woman
Combing her Hair* (private collection)[4]
of 1864 or *The Blue Bower* (Barber Art
Institute) of 1865, which themselves had
been a response to Watts's portrayals
of women from the late 1850s. Watts's
distinctive approach was to adapt for

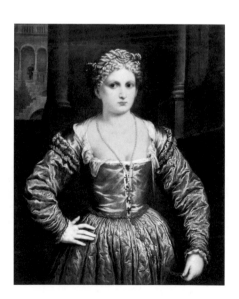

FIG. 42 *Portrait of a Young Lady*, Paris Bordone,
*c.*1550, oil on canvas, 1067 x 857mm (42 x 33¾").
The National Gallery, London (NG 674)

portraiture certain precedents in older
and modern art, particularly regarding
decorative elements, to enrich the image.
For Blanche Airlie this was singularly
appropriate, since she featured in the artists'
community in Kensington as a personal
friend of Leighton, Rossetti and others.
Watts may have discerned that Blanche
possessed an ability to appreciate both older
and more modern art historical references.

Watts initially painted the work with-
out the hands, a feature he always found
difficult, but he wrote to Blanche in May
1866: 'I put in the hands for the benefit
of the picture & consequently for my own
advantage, so that an additional charge for
them is out of the question.'[5] He refused to
charge more than 150 guineas, the original
price agreed upon (going so far as to say
that even if he had decided to transform
it into a full-length he would not have
charged more).

The portrait found great favour when it
was delivered to Airlie Lodge. William Ewart
Gladstone, fond of artistic society himself
and a great fan of Watts, proclaimed 'it was
the finest woman's portrait in this century'.[6]

1 The Airlies and their patronage of art and artists
including Watts are discussed by Dakers (1999, pp. 77ff.)
in the chapter 'Art and Society on Campden Hill'. I am
indebted to this source for citations from letters.
2 Dakers 1999, p. 79.
3 The early sixteenth-century Venetian *Portrait of
a Lady*, once attributed to Palma Vecchio (NG 595,
acquired in 1858).
4 See Bryant 1997, no. 33.
5 Letter of 4 August 1866, quoted in Dakers 1999,
pp. 81–2.
6 Ibid., p. 82.

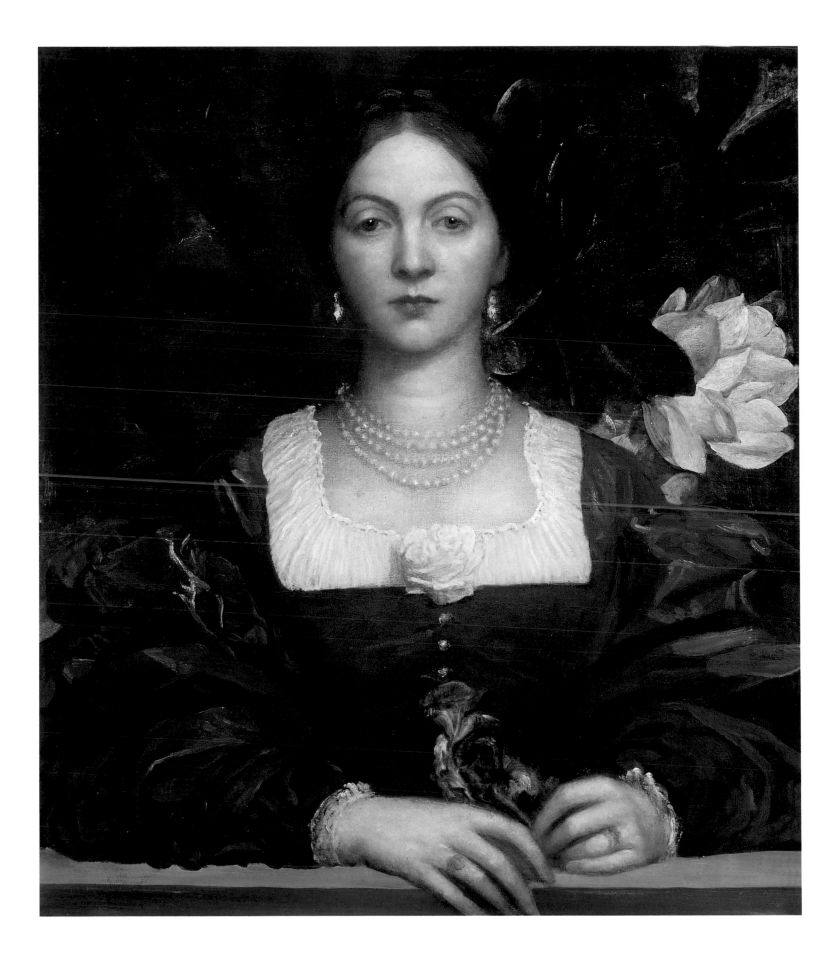

51 **DAVID GRAHAM DRUMMOND OGILVY, 10TH EARL OF AIRLIE**
1865–6

Oil on canvas
660 x 533mm (26 x 21")
Private collection

Provenance Painted as a commission for the Earl and Countess of Airlie; by family descent
Exhibitions Watts Grosvenor 1881, no. 88; Watts New Gallery 1896, no. 108; Watts 1954, no. 41; *British Portraits*, Royal Academy of Arts, 1956–7, no. 450
Literature Spielmann 1886, p. 29; Watts Catalogue, II, p. 1; Dakers 1999, pp. 80–82

Watts's *Earl of Airlie*, like the companion portrait of his wife, and indeed other depictions of aristocratic sitters from the 1860s (fig. 38, p. 128; no. 52), brilliantly represent this particularly fertile and inventive phase in his portraiture. Again the key for Watts seemed to be his personal affinity with certain sitters, which enabled him to produce images full of beauty and layers of associations, all well beyond the remit of commissioned portraits.

David Graham Drummond Ogilvy (1826–81), 10th Earl of Airlie, a Kensington neighbour, had friends in common with Watts. The artist painted the portrait at the request of Airlie's wife Blanche, who as early as 1863 suggested the idea and was more attuned to the arts than her husband. Both had travelled abroad in Italy in the 1850s, perhaps due to Airlie's poor health.

Watts responded to the commission with a portrait full of the imagery of Romanticism. The Scottish peer is swathed in the Ogilvy of Airlie tartan over his black coat. A wild and windswept landscape, with a suggestion of mountain peaks, further accentuates the drama of the image, yet the calm face of the sitter, painted with the utmost care, stares out in unusually sympathetic fashion. The contrast between the smooth lines and precise painting of the face and the more agitated brushstrokes of the background gives the sitter an almost vulnerable quality, perhaps intended by the artist since Airlie's health was weak.

Blanche Airlie conveyed her feelings about the portrait

> No one knows what a wonderful work of art it is, who has not lived with it. It is so noble & grand & pure & deep all these things so much mystery besides in the wild background. It is like a knight as you say, not a gentleman of the 19th century[1]

For Watts the work reflects his own attempt to cast his sitters in a particular role: here the Earl is seen as part of a tradition of romantic Scottishness, which can be traced back in the novels of Walter Scott and the art of David Wilkie. The associations made in these portraits – Old Master art for the portrait of Blanche – put them into a new category.

In fact the realities of his sitter's life did not necessarily coincide with Watts's visualisation. Airlie, although in poor health (which Watts could genuinely respond to, due to his own chronic complaints), was an avid gambler who later turned to cattle breeding,[2] hence his travel to the west of America the year this portrait was completed. Airlie eventually died in early middle age, long before his wife, while he was in Denver, Colorado.

1 Letter from Blanche to her mother, 27 September 1866, quoted in Dakers 1999, p. 81.
2 According to Dakers 1999, p. 85.

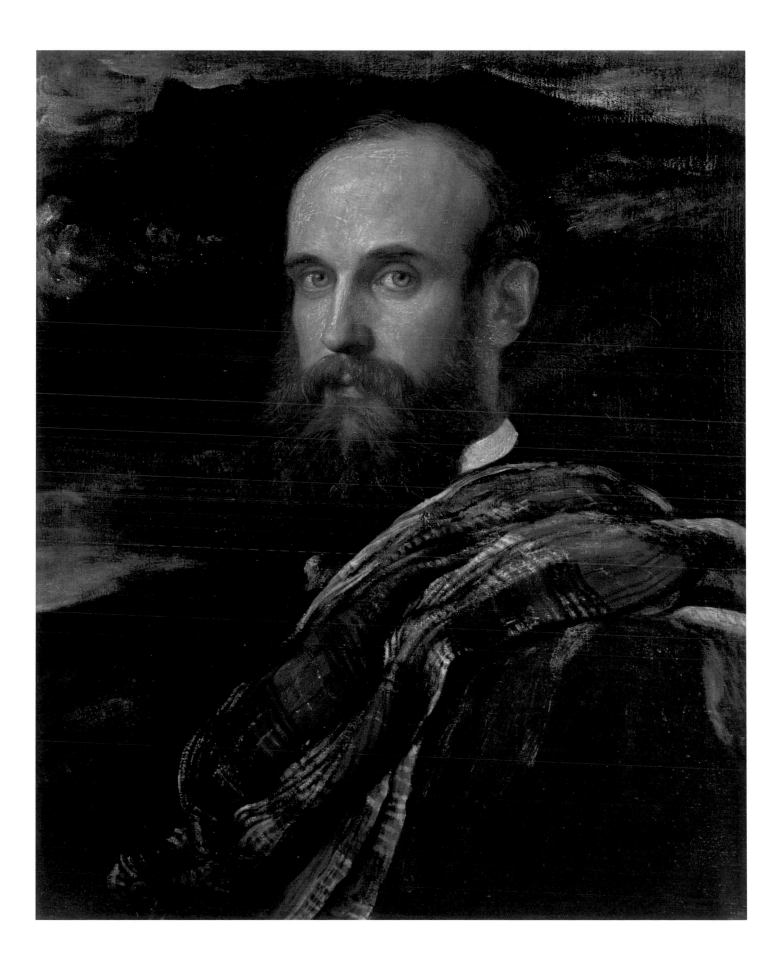

52 HARRIET, MARCHIONESS OF CLANRICARDE

c.1865

Oil on canvas
760 x 640mm (30 x 25¼")
The Viscount Allendale

Provenance Painted for the family; by descent
Literature Allendale Catalogue 1924, no. 14

This seated half-length portrait of the formidable Lady Clanricarde portrays a member of the cultured and elite circles that Watts moved in during the 1860s. Around 1865 he painted a series of portraits (hitherto unpublished) for the Beaumonts continuing his connection with that family, including this one depicting the mother of the sisters in the two full-lengths of *c.*1860, *Lady Margaret Beaumont* (no. 38) and *Emily, Countess of Cork* (fig. 36, p. 121).

Harriet Canning (1804–76) was the only daughter of the great political figure and one time prime minister, George Canning. As a young woman she enjoyed life at the very centre of London society and had a reputation for her looks and her intelligence. Considered 'very beautiful, and very like her father, with eyes full of fire and great expression in all her features', she did, however, according to one observer in 1831, display 'a little more of political animosity than is quite becoming in a pretty woman'.[1] The first love of Henry Fox, later 4th Lord Holland,[2] she instead married Ulick de Burgh (1802–74) in 1825, the same year he was created Marquess of Clanricarde. A career politician and diplomat, he was Ambassador to St Petersburg from 1838 to 1841 and later in government. With these interests, both he and his wife were frequently at Holland House around 1850. At his London residence in Carlton House Terrace Clanricarde demonstrated advanced taste in the arts by commissioning fresco paintings around 1850. Soon after, his near neighbours Lord and Lady Somers commissioned Watts to do the same. Although Watts knew the Marquess of Clanricarde and his wife in London, the impetus for this portrait came from their daughter and her husband and the work remained in their collection along with others by Watts.

This portrait, directly inspired by Venetian painting, exemplifies Watts's broader style of the mid 1860s. Painted on canvas, rather than panel, the brushwork shows a confident and virtuoso display. The daringly bold colour, a highly keyed blue, contrasts with the brash red, rose-patterned upholstered chair. A landscape to the left, as in other portraits by the artist, might easily be read as a view outdoors or a reference to another painting, since the Beaumonts did indeed possess landscape paintings by Dutch and Italian artists such as Salvator Rosa.

Harriet wears a black velvet hat with a white feather, such as one might find in a portrait by Rubens. The sitter herself has the almost brazen sideways look of Restoration beauties. The attention to details such as the fan and gesture of the hands links it with portrait traditions and further animates the portrayal. The bold visual treatment underscores the forthright nature of this worldly-wise woman. The portrait, an entirely private one, remained with the Beaumonts, hanging amid their renowned collection.

1 Quoted in *Complete Peerage*, 3, p. 238.
2 Ilchester 1937, p. 29.

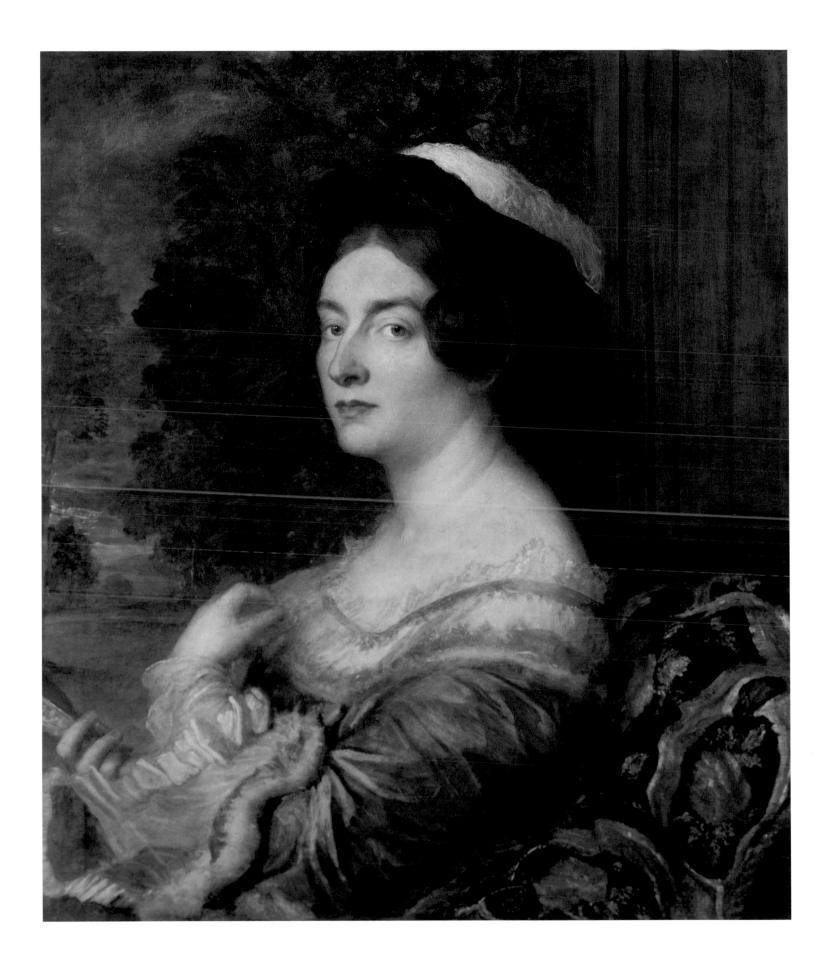

53 JOHN WILLIAM SPENCER, 2ND EARL BROWNLOW

c.1865

Oil on canvas
920 x 600mm (33 ¼ x 23 ⅝")
*Belton House, The Brownlow Collection
(The National Trust)*

Provenance Painted for the family of the sitter; by family descent at Belton, to the Cust Barons (and, for a period, Earls) Brownlow, until 1984, when included in the gift of the 7th Baron Brownlow to the National Trust
Literature Watts Catalogue, II, p. 20; Adrian Tinniswood, *Belton House, Lincolnshire*, The National Trust, rev. edn., 2002, p. 77, no. 76

John William Spencer Egerton-Cust (1842–67) was the son of Viscount Alford (who had died in 1851 before inheriting the family title) and his remarkable wife, Lady Marian Alford (1817–88). In 1849 the family had acquired some of the vast Bridgewater fortune, which included Ashridge House in Hertfordshire and a great art collection; after legal complications, the entire fortune came to John William in 1853.[1]

The family had enjoyed the choice art collection of Abraham Hume, which came to them through Sophia Hume (d.1814), first wife of the 1st Earl.[2] Canova's monument to her is in the church at Belton. Such a legacy predisposed John to the arts. His mother, Lady Marian Alford, an artist herself, encouraged her sons in such matters from an early age and for her sensitive firstborn, John, these lessons had an impact.[3] His artistic inclinations led him to photography, which he practised in the early 1860s.[4] He also acted as benefactor to the impoverished poet Gerald Massey (1828–1907). Consumption rendered Brownlow an invalid much under the care of his mother, unlike his robust younger brother Adelbert, whom Watts also later painted.

Watts painted Lord Brownlow in 1865–6 at a time when he was also working on the single portraits of the Talbot sisters (see no. 42). The families were friendly; one of the sisters, Adelaide, married Brownlow's brother Adelbert in 1868. According to Mrs Watts, the portrait was painted when it became known that the life of the young earl was threatened. With his illness worsening, Brownlow went to Menton in the south of France where he died in February 1867 aged twenty-four. His friend Massey composed a poetic eulogy, *In Memory of… Earl Brownlow*, privately printed in 1869. A portrait photograph as frontispiece confirms the accuracy of Watts's portrayal. Making reference to a painting of Brownlow, perhaps even Watts's own, Massey wrote,

The fine pale face, pathetically sweet,
So thin with suffering that it seemed all soul.

For Watts the circumstances of Brownlow's decline resonated with the similar illness of Lord Lothian, as he found himself painting promising young men 'doomed to die'. This placed pressure on the artist whose role became to capture a life about to be cut off. In this image Watts adopted an unusual format of a narrow half-length figure. Brownlow stands resting on a stone pedestal, a variation on a pose often used by Van Dyck. The work more immediately suggests Mannerist portraiture, especially in the attenuated figure and features as well as the almost unnaturally extended fingers. The sense of death slowly extinguishing life comes across in the painted image, which seems to be almost drained of colour. The melancholy air of the consumptive young man is almost painful to behold.

Yet the image took on a life of its own, with several related depictions of Brownlow: a head study in profile (formerly Ashridge), probably from life; and a bust-length version of no. 53 at Belton with its replica, once in the collection of Charles Rickards. Some of these versions went to family members, but that any should go to an outside buyer testifies to how Watts's portraits went beyond the confines of genre; indeed, in this case the painting visually typified the notion of a doomed aristocratic youth, replete with melancholy.

1 On the family history see Adrian Tinniswood, *Belton House*, London, 1992, pp. 24ff.
2 For a popular account of the story, see Bernard Falk, *The Bridgewater Millions: A Candid Family History*, London, 1942.
3 She initiated improvements at Ashridge in Hertfordshire and in 1859 commissioned the maverick Gothic revivalist, E.B. Lamb, to build Berkhamsted Town Hall.
4 See the Compton Family Album, sold Bloomsbury Book Auctions (catalogue no. 477), 4 December 2003, no. 5, which contained works labelled 'Photographed by Brownlow 1863'.

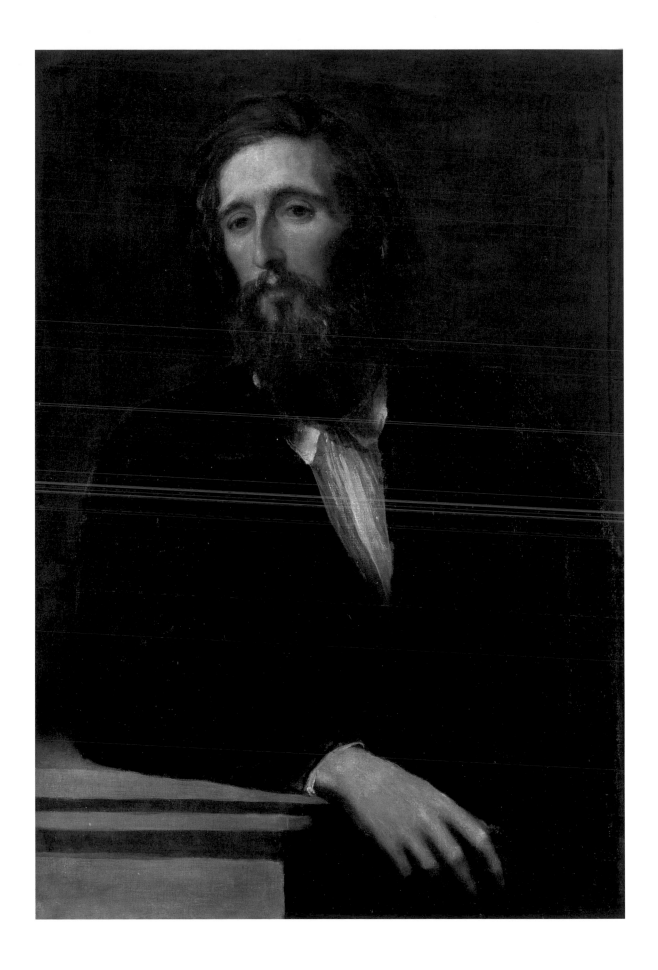

54 MADELINE WYNDHAM

c.1867–73

Oil on canvas
2159 x 1041mm (85 x 41")
Private collection

Provenance Painted for Madeline and the Hon. Percy
Wyndham; by family descent
Exhibitions Grosvenor Gallery, London, 1877, no. 22;
Exposition Universelle, Paris, 1878, no 266; Watts
Grosvenor 1881, no. 52; *Fourth Exhibition of the Society
of Portrait Painters*, New Gallery, London, 1894, no. 7;
Memorial Exhs, London 1905, no. 184; New Gallery,
London, 1908, no. 278; on loan to the Tate Gallery,
1933–5 and 1955
Literature Spielmann 1886, p. 32; Macmillan 1903,
p. 87; Spielmann 1905, pp. 46–47; Watts Catalogue,
II, p. 173; Watts 1912, I, pp. 239–40, 325–6; Caroline
Dakers, *Clouds: The Portrait of a Country House*, New
Haven and London, 1993, pp. 25–6, 34, 77; Bryant
1996, pp. 114–18; Dakers 1999, pp. 124–5, 227

Traditionally known as *The Hon. Mrs. Percy
Wyndham*, this grand portrayal of Madeline
Wyndham was Watts's last successfully
completed full-length portrait. When seen
at the first exhibition of the Grosvenor
Gallery in 1877 and in Paris a year later,
it had a huge impact on a wide range of
observers including Henry James.

Madeline (1835–1920), the daughter
of an Irish baronet, married the Hon. Percy
Wyndham (1835–1911) in 1860. As the
second son of the recently created first
Baron Leconfield, Percy had grown up at
Petworth House and Watts would have
been aware of the dynastic collections
there. But unlike several of his earlier large
portraits (nos 38, 39), where the eighteenth
century is evoked, here a more modern
presentation prevails to suit the young
couple then at the outset of their family life
and, as it turned out, great collecting careers.
In the mid 1860s Madeline involved herself
with the Egremont collections, painting
several watercolours showing the décor
and placement of works of art in the rooms
at Petworth.[1]

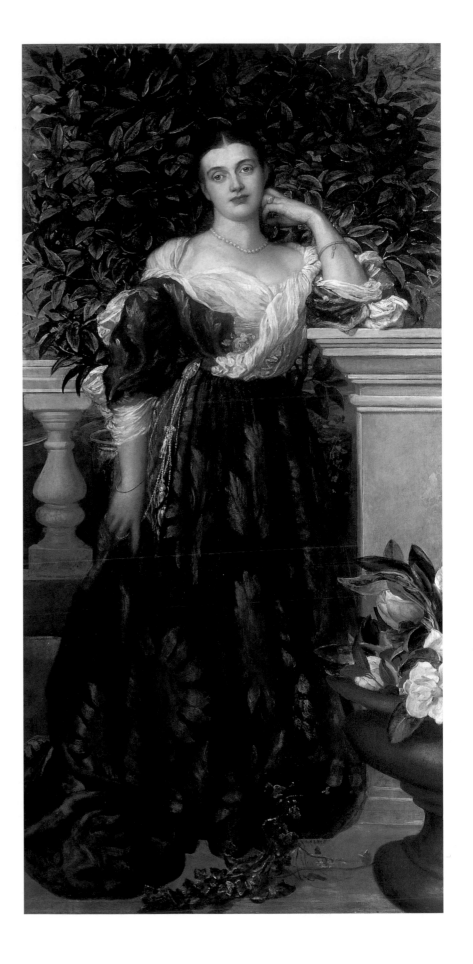

By 1865, when the Wyndhams contacted Watts, he had weathered the storm of his failed marriage and found new patrons for his subject paintings. He hoped to reduce his portrait practice, but he could not resist the commission to paint Madeline, even though it seems Leighton had already turned it down.[2] Watts's work on his portraits of the Airlies (nos 50, 51), friends of the Wyndhams, had led him into a circle of aristocratic patrons. There was also the promise of the Wyndhams' further patronage. In 1868, while the portrait was in progress, Madeline negotiated for the purchase of Watts's *Orpheus and Eurydice* (RA 1868; formerly Forbes Collection). Later she and Percy acquired modern art by Whistler, Leighton, Rossetti and others, displaying it in their newly decorated town house in Belgrave Square. The Wyndhams paid Watts handsomely for the portrait; initially commissioned for £600, he eventually received £1000,[3] probably the highest amount he had ever had for any picture up to that time. Watts counted Madeline, who had a warm personality and considerable style, in his group of favoured female confidantes, telling her that her 'friendship is very precious'.

Watts painted two oil studies (Watts Gallery).[4] The plan for the portrait was clear from the outset, with the overall light tonality darkened and the sunflower-patterned dress appearing more subdued in the final painting.

Although some of the elements of a grand manner portrait are present, this work exudes modernity thanks to Madeline's forthright gaze and the contemporary decorative references. A full laurel frames the upper part of the figure, as a kind of natural corona around her head. The blooming magnolia set in a massive pot bears opulent flowers that match the character of Madeline's beauty. She possessed striking looks, 'a tall strong woman', according to one observer; her

own husband called her 'Cobra' because of her eyes.[5] The strongly sculptural rendition of the figure coincided with Watts's new interest in this medium in the later 1860s.

Watts planned to send the portrait to the Royal Academy in 1870, but it remained in his studio until about 1873. Coutts Lindsay chose it for the opening exhibition of the Grosvenor Gallery in 1877 (see also no. 55), where informed critics such as Sidney Colvin considered it the equal of Watts's *Love and Death* for its 'high and commanding qualities'.[6] Henry James, captivated by its eye-catching splendour, quoted his companion who noted: 'It is what they call a "sumptuous" picture … That is, the lady looks as if she had thirty thousand a year.' James himself considered that there was 'something admirably large and generous in the whole design of the work' from 'the first portrait painter in England'.[7]

For an English audience the portrait epitomised an informed aristocracy and art elite, but in Paris at the Exposition Universelle the portrait of Madeline Wyndham appeared without such associations. For Edmund Duranty the work was very much part of Watts's 'symbolical' orientation; this critic simply wrote that she 'rassemble à une sibylle',[8] affirming a link with both a Michelangelesque tradition of powerful female figures and the prophetic sibyls of antiquity. For some English critics the work bore comparison with that of the noted French society portraitist Charles Carolus-Duran due to the confidence and magnificence of the image.

A generation later, when the Wyndhams commissioned a full-length group portrait of their daughters by John Singer Sargent (fig. 43), he painted the three women in the grand drawing room at Belgrave Square, where they lounged on a white sofa adjacent to a vase of blooming magnolias. But Sargent also included a portrait within a portrait. Glowing out of the shadows,

Watts's *Madeline Wyndham* appeared directly in the centre of the composition. Sargent's homage, seen at the Royal Academy in 1900, while Watts was still very much alive, only served to reinforce his distinguished position at the opening of the new century as one of the great portraitists of the last one.

1 Ill. in *Petworth House West Sussex*, The National Trust, 1997, pp.36, 91.
2 Dakers 1993, p. 25.
3 Ibid., p. 26.
4 Watts London 1954, no. 142 and Ford 1998, I, pl. 106, II, no. RBF73.
5 Dakers 1993, p. 17.
6 *Fortnightly Review*, June 1877, p. 823.
7 His review originally published in *The Galaxy*, August 1877, reprinted in *The Painter's Eye: Notes and Essays on the Pictorial Arts* by Henry James, ed. John L. Sweeney, London, 1956, pp. 142–3.
8 'Exposition Universelle, Les Ecoles Etrangères de Peinture', *Gazette des Beaux Arts*, 18* (1878), p. 310.

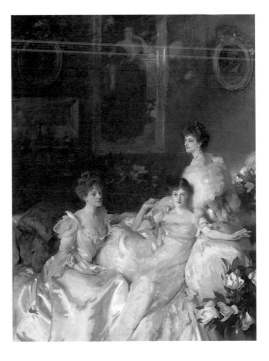

FIG. 43 *The Wyndham Sisters*, John Singer Sargent, 1899, oil on canvas, 2921 x 2137mm (115 x 85⅛"). The Metropolitan Museum of Art, New York, Wolfe Fund, Catherine Lorillard, Wolfe Collection, 1927. (27.67) Photograph © 1994 The Metropolitan Museum of Art

55 BLANCHE, LADY LINDSAY
1876–7

Oil on canvas
1105 x 851mm (43 ½ x 33 ½")
Private collection

Provenance Painted by the artist for his own collection;
on view at the Little Holland House Gallery until *c.*1890
when given to the sitter; her collection until her death
in 1912; to the sitter's daughter, Euphemia (later Mrs
Henrey), who loaned it to the Tate Gallery 1912/13 until
1947; eventually loaned to the John Rylands Library,
Manchester, from the family, to whom it returned in
1996

Exhibitions Grosvenor Gallery, London, 1877, no. 34,
as *Lady Lindsay (of Balcarres)*; *Works by Modern Artists*,
Royal Institute of the Fine Arts, Glasgow, 1878/9, no.
158; Watts Grosvenor 1881, no. 183; Watts New York
1884, no. 117; Watts Birmingham 1885, no. 134; Watts
Nottingham 1886, no. 44; Memorial Exhs, London 1905,
no. 211; *The Grosvenor Gallery: A Palace of Art in Victorian
England*, Yale Center for British Art, 1996, no. 64; *The
Pleasures of Collecting: Renaissance to Impressionist
Masterpieces*, Bruce Museum of Arts and Sciences,
Greenwich, CT, 2002–3, no. 93

Literature Joseph Comyns Carr, 'La Grosvenor Gallery',
L'Art, 10 (1877), p. 265 (translated in the same author's
Examples of Contemporary Art, London, 1878, p. 4);
Spielmann 1886, p. 31; Watts Catalogue, II, p. 95;
Watts 1912, I, p. 325; Henrey 1937, p. 201; Virginia
Surtees, *Coutts Lindsay 1824–1913*, Norwich, 1993,
p. 133; Bryant 1996, pp. 114–16, 118

Engraving Etching by Louis Monzies, 1877

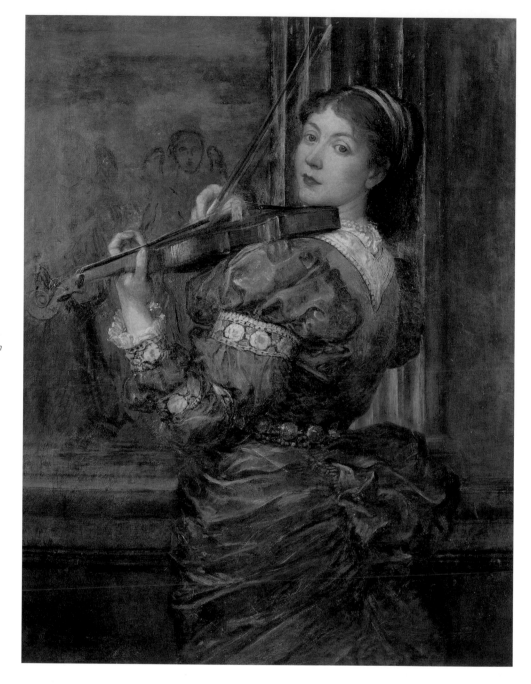

Watts's *Lady Lindsay* is one of the most
splendid and richly worked of the artist's
later portraits. His close connection with
the sitter, who was co-founder of the
Grosvenor Gallery, prompted this theatrical
exercise for the opening of the gallery.
At the same event Watts also showed
Madeline Wyndham (no. 54) and his great
painting *Love and Death* (Whitworth
Art Gallery, Manchester). Thanks to this
exhibition, Watts's reputation enjoyed a
complete renewal.

Caroline Blanche Elizabeth (1844–
1912), née FitzRoy, married Sir Coutts
Lindsay, Bt. (1824–1915) in 1864 when
she was twenty years old. He was a serious
amateur artist who left the military to pursue

his artistic calling, studying briefly in Ary
Scheffer's studio in Paris. Blanche was also
a gifted amateur watercolourist. It is said
that the two met at Little Holland House.
Watts knew Coutts Lindsay as a friend from
around 1849,[1] and they both shared a great
friendship with Lord and Lady Somers.[2]
Coutts was aged forty by the time he

married Blanche, some twenty years his
junior; they lived in South Kensington in a
studio house and soon had two daughters.[3]
Due to problems with her eyes, Blanche
turned from art to music, devoting herself
to the violin.

Once married, their lives revolved
around the fine arts, music and literary

pursuits. As heiress to the Rothschild fortune, Blanche, along with her husband, collected earlier Italian art on their travels.[4] Coutts exhibited at the Royal Academy but realised that this crowded venue proved unsatisfactory for a wide range of artists who eschewed popular narrative art. Into this category came his friends Watts and Burne-Jones, among many others. The Lindsays decided to build a gallery on New Bond Street that would be an alternative to the Royal Academy and would be receptive to younger artists and alternative painters. Blanche supervised the decorations, sparing no expense to import the most luxurious embellishments. An Italian doorway from a church in Venice provided the entrance, green marble from Genoa enriched the interior; areas of deep crimson damask, divided by gilt pilasters, covered the exhibition rooms, creating an opulent environment for the select group of artists Coutts invited to show there.

Watts's contact with Coutts and Blanche, and his knowledge of their forthcoming venture, must have prompted the painting of this uncommissioned portrait. According to her grandson, Watts called one morning and, on finding her, exclaimed: 'There is the very picture I've been waiting for. It shall be a half-length portrait of Lady Lindsay playing the violin.'[5] It may even show her Stradivarius violin,[6] which also featured in Coutts's portrait of her sent to the same opening exhibition of the Grosvenor Gallery.[7] Her complicity in the creation of these 'performance' portraits seems certain.

For Watts this linking of music with painted portraits had already proved a rich vein in reinvigorating the genre of portraiture throughout the 1860s, as in the portrayal of Joachim playing his violin (fig. 19, p. 33). For Blanche the musical context perfectly reflected her aesthetic preferences. She appears as a fashionable individual, with a deep olive green silk dress

and jewelled belt around her waist, her up-to-the-minute stylishness very much part of her appeal. Blanche's sudden turn, as if momentarily interrupted in her playing, lends an unusual directness to the portrait. In the background one can see what seems to be a tapestry or large painting of angels playing lutes, perhaps an evocation of one of the Italian Renaissance works owned by the Lindsays, several of which featured music-making,[8] or even a modern work.[9] This visual connection between a depiction of music in older art with Blanche's own practice casts her in the role of a modern music-making angel. Joseph Comyns Carr, a critic closely connected with the Grosvenor and a writer for the French periodical L'Art, illustrated his article on the gallery with the stunning engraving by Monzies after Watts's painting. He discussed the portrait for its qualities of 'style', commenting that it is 'marked by a suavity of line and sumptuous amplitude of form that accord very happily with the suggestion of music'.[10]

The opening in May 1877 of the Grosvenor Gallery proved to be a great social as well as artistic event. For Oscar Wilde the exhibition was 'materially aiding that revival of culture and love of beauty'.[11] The Lindsays, especially Blanche, a great hostess, created an atmosphere of exclusivity and culture. Her portrait played its role, positioned in the place of honour and an example of Watts's work in which his style was deployed with great verve and virtuosity, seen especially in the slashing strokes of her dress. Critical comment centred on how the work was 'delightfully harmonious in colour'[12] and 'radiant with life and energy, very rich in colour'.[13] This unconventional portrait, seen for the first time in 1877, presents Blanche as a woman of style who turns to welcome the artistic elite to the Grosvenor Gallery.

Watts and Blanche remained great friends; she would play her violin while he painted, offering comments on his work.

Her portrait occupied a central position in his gallery at Little Holland House (fig. 11, p. 22) and he sent it to numerous exhibitions. But, sometime after Coutts and Blanche separated,[14] he decided to present it to her, perhaps as a consolation and memento of that flamboyant earlier chapter in her life.

1 On returning from Italy, Watts painted at Dorchester House, owned by his friend Robert Holford. Here he met Lindsay, whose sister was married to Holford.
2 Somers was a cousin of Coutts. The Somerses and Lindsay travelled in the Mediterranean on several tours in the 1850s. Surtees suggests that Coutts Lindsay had an affair with Virginia. It seems that Virginia had a hand in arranging the marriage of Coutts and Blanche, in much the same way that her sister Sara may have had a role in the arrangements of Watts's marriage the very same year.
3 Coutts had already had several affairs resulting in at least one illegitimate child; later there were others.
4 They amassed a considerable collection, now found in a number of public institutions including the National Gallery in London and the Museum and Art Gallery in Northampton.
5 Henrey 1837, p. 201.
6 Ibid., p. 230.
7 The portrayal of individuals with musical instruments, while not unknown in earlier British art, had after the 1860s gained renewed relevance. Even Francis Grant, President of the Royal Academy, exhibited at the first Grosvenor exhibition showing a portrait of Sir James Hope Grant and a Violoncello (c.1861; NPG).
8 For example, A Concert, then attributed to Palma Vecchio, a large work with three music-making women bequeathed by Lady Lindsay to the National Gallery in 1912 (NG 2903).
9 Possibly a design by Morris & Co., as stylistically it suggests Burne-Jones's decorative work.
10 Quoted in Bryant 1996, p. 118; see pp. 117–21 for the role played by Carr in disseminating ideas about advanced English painting to a French audience.
11 Oscar Wilde, 'The Grosvenor Gallery', Dublin University Magazine, 90 (1877), p. 126.
12 The Times, 1 May 1877, p. 10.
13 'Grosvenor Gallery', Builder, 5 May 1877, p. 440.
14 They separated in 1882; the great art collection remained with Blanche, indicating that her money had funded it and probably that her taste had guided its formation.

56 DOROTHY TENNANT

1876–7

Oil on wood
635 x 533mm (25 x 21")
*Tate. Presented by Henry Curtis in memory
of Dorothy Tennant, Lady Stanley 1926*

Provenance Painted for the mother of Dorothy Tennant;
in the collection of Dorothy while she was married to
Henry Morton Stanley and later in the collection of her
second husband, Henry Curtis; by whom given to the
Tate Gallery in 1926
Exhibitions Royal Academy, London, 1877, no. 267;
Watts Grosvenor 1881, no. 93 (lent by Mrs Tennant)
Literature Spielmann 1886, ill. p. 25, pp. 24, 32; Watts
Catalogue, II, p. 156; Watts 1912, I, p. 313; Bryant 1997,
p.74

Dorothy Tennant (1855–1926) is known for
marrying the famed explorer Henry Morton
Stanley in 1890, but she gained a reputation
as an artist long before. As a young painter,
she met Watts on the Isle of Wight in 1876.
'Dolly' remained a close and important
friend to him for some years, encouraging
him to publish his ideas on art.

Dorothy, along with her sister Eveleen
(1857–1937) and their mother, holidayed
near Freshwater in the summer of 1876.
They frequented Watts's home, The Briary,
where he began this portrait and another
of Eveleen (Tate), both later completed
in London. The recently widowed Mrs
Tennant, somewhat ambitious as an artist
herself, inherited money from the Tennant
family's mining interests in Wales,[1] as well
as a splendid residence in Richmond Terrace,
Whitehall, from where she conducted a
salon that attracted Gladstone and Ruskin
among others. Her much older husband
Charles,[2] who died in 1873, had been an
MP from 1830 onwards and a considerable
landowner and industrialist with an estate
in Neath, Glamorganshire.

When she met Watts, Dorothy had
already spent several winters studying art
in Paris under Jean-Jacques Henner and was
enrolled at the Slade School under Edward

Poynter and Alphonse Legros. She had her
studio at Richmond Terrace and was much
involved in the art world, which included
posing for her friend John Everett Millais's
painting *No!* (RA 1875; private collection).
While on the Isle of Wight, making daily
visits to The Briary, Dorothy had an
opportunity to learn from Watts, noting that
seeing him made her work 'doubly hard'.[3]
For him the beauty of the two sisters proved
irresistible. Dorothy was tall with auburn
hair; Eveleen much darker with more
'southern' colouring.[4] Of each he created
apt images with various art historical
references for his friend Dolly.

The portrait shows her in historicist
dress suggesting seventeenth-century Van
Dyckian costume in the lace trim of the
neckline. Watts was as ever fascinated with
the treatment of hairstyle, here an elaborate
French twist, which allows focus on her
neck. The fine handling of the creamy pink
complexion displays a level of workmanship
facilitated by the use of the panel support,
a rare choice by the 1870s. But there are
some unusual features to the work, as the
artist has made an odd division of the
background, perhaps due to an addition
to the right side.

Watts seems to have extended the
composition in order to add an important
detail, Dorothy's hand holding a red squirrel.
This unusual feature suggests some
knowledge of *Lady with the Squirrel and
Starling* by Holbein (c.1526–8; National
Gallery), then in the collection at Houghton
Hall in Norfolk.[5] As an emblematic creature,
the squirrel connoted industry; in addition,
its fine hairs were used to make paint
brushes, a suitable reference for an artist.[6]
But apart from such associations, it seems
that Dorothy herself had an interest in
natural history. According to one visitor,
her studio contained 'a most fascinating
assemblage of birds and reptiles'.[7]

Exhibited in the same year as the newly
opened Grosvenor Gallery, this painting

instead appeared at the Royal Academy
with a particularly long title accentuating
the sitter's pedigree (*Miss Dorothy
Tennant, second daughter of the late Charles
Tennant, Esq. of Cadoxton Lodge, Neath,
Glamorganshire*) and which at the very least
presented her in public as a marriageable
young woman. Dorothy, however, preferred
to wait for marriage; she began to exhibit
her paintings of young street urchins,[8]
a choice of subject matter directly at odds
with her privileged background. A close
personal friend of the writer Henry James,
Dorothy also mixed with an interesting circle
of French actors and artists. In 1880 Watts
introduced her to the French painter Jules
Bastien-Lepage (1848–84), who dedicated
his self-portrait to her, inscribing it 'à mon
amie …'. She convinced Watts to write 'On
the Present Conditions of Art', published in
1880.[9] Only in 1890 at the age of thirty-five
did she marry Stanley.

1 On the family see Keith Tucker, *Chronicle of Cadoxton*,
Neath, 1994. The Tennant family had industrial interests
in Wales, building a famous canal, in addition to mines
for coal and copper in the area of Cadoxton-juxta-Neath.
2 He is not to be confused with Sir Charles Tennant of
Grosvenor Square and The Glen, Innerleithen, a later
Victorian collector.
3 Watts 1912, I, p. 313.
4 Eveleen's portrait is also darker in mood; set out of
doors, she poses with an umbrella which surrounds her
head, adding an ominous note to the depiction. The
condition of the work prevented its inclusion in this
exhibition. Eveleen later married poet and essayist
Frederick Myers, the founder of the Psychical Society
(see Bryant 1997, pp. 69 with ill., 74), and she became
an accomplished photographer.
5 Interestingly, in slightly later correspondence Dorothy
mentions Holbein when she and Watts have been
discussing the impact of technique versus subject matter
in great art of the past.
6 A squirrel also features in John Singleton Copley's
portrait of a boy, known to Watts from the Lyndhurst
collection and exhibited at the International Exhibition
of 1862.
7 J.G. Millais, *The Life and Letters of Sir John Everett
Millais*, London, 1899, II, p. 69.
8 She found her subjects in the streets of north Lambeth.
9 Watts 1912, I, pp. 313–16.

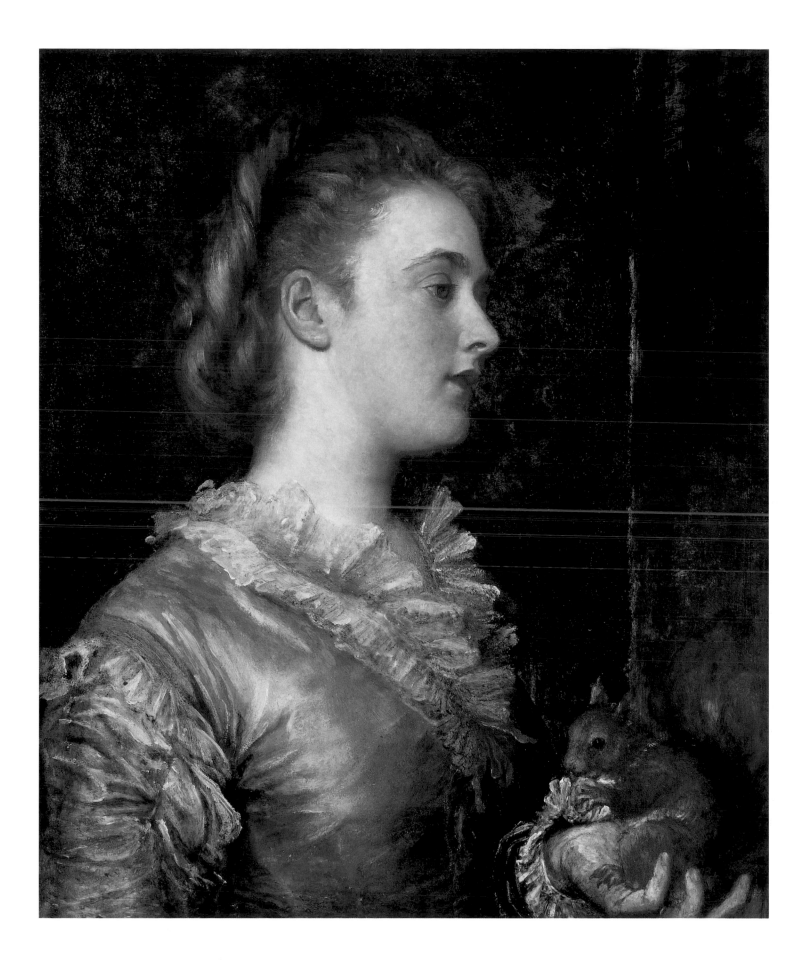

57 VIOLET LINDSAY

*c.*1879

Oil on canvas
300 x 220mm (11¾ x 8⅝")
Private collection

Provenance Painted by Watts for his own collection;
retained until 1901 when sold to Baron Wantage
(the sitter's cousin); his collection at Lockinge House,
Berkshire; by family descent until 1945 when given by
C.L. Loyd to Lady Violet Benson (the sitter's daughter);
by family descent
Exhibitions Watts Birmingham 1885, no. 146; Watts
New York 1884, no. 113; Watts Nottingham 1886,
no. 38; Royal Jubilee Exhibition, Manchester, 1887,
no. 246; Guildhall, London, 1890, no. 15;
Jahresausstellung von Kunstwerken aller Nationen,
Glaspalaste, Munich, 1893, no. 1637; Watts New
Gallery 1896, no. 63; La Libre Esthétique, Brussels,
1894; Stockholm, 1897; St Petersburg, 1897 (the last
two according to Mrs Watts); *The Souls*, Bury Street
Gallery, London, 1982, no. 4
Literature Spielmann 1886, p. 31; A.G. Temple,
*Catalogue of Pictures forming the Collection of Lord
and Lady Wantage*, London, 1902, Watts Catalogue,
II, p. 97; Fogg 1946, p. 109, no. 100; Jane Abdy and
Charlotte Gere, *The Souls*, London, 1984, pp. 46–7;
Bryant 1997, p. 80

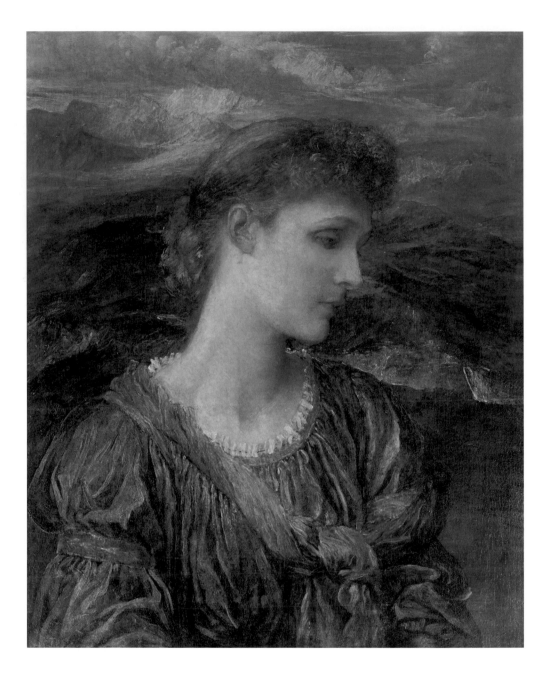

Watts's *Violet Lindsay* is an evocative late
work that reaches beyond the limits of
genre, for it is less a portrait than a study
of mood and colour, replete with poetic
meaning. The unusual quality of the work
is due in no small part to the sitter herself,
the striking Violet Lindsay, an artist as
well as a central figure in the artistic life
of London in the later Victorian era and
one of the avant-garde aesthetes known
as 'The Souls'.

Watts had long known members of
the family of Marion Margaret Violet
Lindsay (1856–1937) such as her great-
uncle Coutts Lindsay, but it was probably
in 1879, while he painted a portrait of her
father the Hon. Charles Lindsay (RA 1879;
private collection), that he came into
contact with her. In 1882 she married Henry
Manners (1852–1925), who inherited the
title Marquess of Granby in 1888 (later

becoming Duke of Rutland) and served
in government under the Prime Minister
Lord Salisbury.

Domestic life notwithstanding, Violet
pursued her life as an artist, executing
sensitive, freely worked portrait drawings.
Her own self-portrait, in which tendrils of
loose hair frame her face, has a compelling
quality thanks in part to its sketchy

directness. She exhibited regularly at the
Grosvenor Gallery, New Gallery and Grafton
Gallery, the Symbolist venue par excellence.[1]
Her distinctive looks, which had attracted
many artists, had become well known,
appearing on public display at the Royal
Academy in 1876 in a portrait by George
Dunlop Leslie.[2] In 1886 she posed for the
nun in Millais's *Mercy: St Bartholomew's*

Day, 1572 (RA 1887; Tate). In later portraits by artists as various as James Jebusa Shannon and Jacques-Emile Blanche one also senses her natural ability to perform as she posed.

Violet was an artist, but it was her unusual, almost otherworldly beauty that fascinated Watts over a period of years, resulting in several portraits and oil studies.[3] Her personal style consisted of wearing diaphanous gowns in faded and subdued colours, with floating veils and trailing scarves and ribbons.[4] Watts responded to this highly individualised self-presentation when he first portrayed her in 1879 (private collection). This painting, purchased by his patron Charles Rickards,[5] went to Watts's retrospective at the Grosvenor Gallery in 1881 with the title *Reverie*, which allowed a focus on its ambiguous meaning. Descriptions of this work tally with no. 57 indicating that the two versions were almost identical.

In 1881 the critic for *The Times* noted how Watts 'plays, for instance, upon his canvas with different harmonies of blue (as in the portrait of Miss Violet Lindsay, called *A Reverie*), as a musician upon an instrument, and so throughout the whole range of the chromatic scale'.[6] The alliance of colour and music had by 1881 a full lineage in Aesthetic thinking, especially in Whistler's work but also, as is less appreciated today, in Watts's work. His experiments in technique around 1880 resulted in a greater attention to colour and texture, as can be seen in this work, with the overall harmony in blue relieved by the reddish hair and golden-coloured scarf. In testing the impact of different colour combinations, he painted another version (fig. 44), varying the colour, lessening the pervasive blue and making the scarf red rather than gold.

In no. 57, the prime version, she sits against a weird landscape of blue-toned mountains rising steeply with their high tops disappearing amid the misty clouds that roll across the view. Devoid of vegetation, this rocky landscape holds no sense of reassurance or delight in nature. Watts's first point of reference is again Leonardo's *Mona Lisa*, in which the curious rising landscape also contributes to the enigmatic mood.[7] This art historical reference has thoroughly meshed with the portrayal. The predominantly cool colouring and tones of blue suffuse the image, imparting an unmistakable sadness, much as Watts achieved with colour in *Hope* (GG 1885; private collection) several years later. The almost withdrawn quality of the sitter has a psychological dimension that reveals how Violet served as a Symbolist muse in this portrait.

The afterlife of the image bears out its unique status. Watts exhibited it regularly throughout the 1880s in England and in 1893 in Munich. In 1894, when the young Belgian avant-garde group, La Libre Esthétique, staged its first exhibition in 1894, they requested a submission from Watts who by this time had a considerable international reputation. He sent only this painting, and it appeared in the exhibition isolated on an easel. Its Symbolist character elicited the comments of Fernand Khnopff, artist and art critic, in the *Studio* magazine:

> The portrait of the Marchioness of Granby, by G.F. Watts R.A., is the work which dominates the entire exhibition. Placed upon an easel before a bronze-green background, it appears, in its frame of gold, as a superb jewel. The blues of the robe and the blues of the mountains against which is posed the pale head with blond hair form a harmonious ensemble, of a richness without parallel.[8]

Watts's portrait of Violet shifted into a new context. An ambiguity of mood, subtle colouring, intense focus on the rocky desolate landscape all combine to give the work of art the suggestive qualities of a poem or piece of music. In this work the Symbolist muse became a Symbolist icon.

FIG. 44 *Violet Lindsay*, G.F. Watts, *c.*1879, oil on canvas, 657 x 524mm (25⅞ x 20⅝"). The Fogg Art Museum, Harvard University Art Museums: Gift for Special Uses Fund

1 A collected exhibition of her drawings appeared at the New Gallery in 1902 when the Musée de Luxembourg purchased three.

2 This work was in the Wantage collection, no. 132 in Temple's catalogue.

3 There is some confusion over these various versions, not helped by Mrs Watts's catalogue. One oil study is at the Watts Gallery; another was sold from the Chapman collection. Watts first depicted Violet facing forwards in an oil where her shadowy dark eyes lend a haunted quality to the face.

4 As recounted by her daughter Lady Diana Cooper; see Jane Abdy and Charlotte Gere, *The Souls*, London, 1984, p. 48.

5 The work remained in Rickards's collection until his sale at Christie's in 1887.

6 *The Times*, 6 January 1882, p. 6.

7 Walter Pater's study on Leonardo, first published as an essay in the *Fortnightly Review*, I, 1869, later appeared in *The Renaissance*, 1873. Watts drew on the *Mona Lisa* as a portrait type as early as 1856.

8 Fernand Khnopff, 'Some English Art Works at the "Libre Esthetique" at Brussels', *Studio*, III (1894), p. 32; for a fuller discussion, see Bryant 1997, pp. 78–81.

58 THE DEAN'S DAUGHTER (LILLIE LANGTRY)

1879–80

Oil on canvas
648 x 521mm (25½ x 20½")
Trustees of the Watts Gallery
(Photo: © Bridgeman Art Library)

Provenance Painted for the artist; on display at the
Little Holland House Gallery; the Watts Gallery
Exhibitions Royal Academy, London, 1880, no. 4; Watts
Grosvenor 1881, no. 193; Watts Birmingham 1885, no.
148; Watts Nottingham 1886, no. 2; *Second Exhibition of
the Society of Portrait Painters*, Royal Institute, Piccadilly,
London, 1892, no. 194; *Fair Women*, Grafton Gallery,
London, 1894, no. 139; *Exhibition of Dramatic and
Musical Art*, Grafton Gallery, London, 1897, no. 182;
Memorial Exhs, London 1905, no. 61, Edinburgh 1905,
no. 79, Manchester 1905, no. 109, Newcastle 1905,
no. 89, Dublin 1906, no. 52
Literature Spielmann 1886, p. 31; Macmillan 1903,
p. 87; *Catalogue of Pictures by G.F. Watts, O.M., R.A.*, The
Picture Gallery, Compton, 1904, no. 37; Barrington 1905,
p. 86; Spielmann 1905, pp. 47–8; Watts Catalogue I,
p. 35, and II, p. 88; Langtry 1925, pp. 57–9; Alston 1929,
p. 25, no. 42

Watts's portrait of Lillie Langtry, noted 'professional beauty' of the later Victorian era, shows him responding to a current celebrity in a work that is surprisingly simple in its presentation.

Emilie Le Breton (1853–1929), daughter of the Dean of Jersey, grew up in a family of boys and acquired the name Lillie due to the whiteness of her skin. She married Edward Langtry at an early opportunity in order to seek adventure in London. Soon after her arrival in 1876, the young artist Graham Robertson declared it was 'the first and only time in my life I beheld perfect beauty. The face was that of the lost Venus of Praxiteles.'[1] She gained an entrée into society through an invitation to a soirée where her beauty caused a sensation. The other guests included the artists Millais, Frank Miles and Whistler. Through Miles she met Oscar Wilde, and the lush language of his poem 'The New Helen',[2] published in

July 1879, publicly personified her as a reincarnation of the Greek temptress.

An intriguing character, new to everyone, Lillie stood out a mile from the aristocratic ladies of London society with her unusual sense of style. She always wore black, at least at the outset of her career when money was tight,[3] and fixed her hair in a distinctive chignon in a figure-eight shape set low on the back of her head, a style that became known as the 'Langtry knot'. Shrewdly, she befriended artists who immediately painted her or used her as a model (as in Burne-Jones's *Golden Stairs*, 1872–80; GG 1880, Tate), and through these paintings her famous beauty became a matter of public display.

Millais, who hailed from Jersey as well, painted her as *A Jersey Lily* (RA 1878; Jersey Museums Service) wearing her signature black garb.[4] Her seeming virtue had already been compromised by a public affair with the Prince of Wales, but this only added to her attraction. Edward Poynter and Val Prinsep, Watts's neighbour, had already portrayed her when Watts invited her to sit in the autumn of 1879. The small, close-fitting poke bonnet was her own and characteristic of the early simplicity in her dress. Unusually Watts chose to paint her wearing it, although he did confiscate the opulent ostrich feather such was his sympathy towards birds, firmly believing that they should not be used to ornament women's clothing.

In his portrait Watts decided to show Lillie's beauty more obliquely. The title he eventually chose when he sent the portrait to the Royal Academy in 1880, *The Dean's Daughter*, refers to her earlier (more innocent) life. The plain outdoor clothing, rather than high-fashion gowns, sets off her beauty without exaggerating it. Quiet containment is underlined by the careful technique in the painting of the face with a bloom of pink upon the cheek. The artist told Spielmann that he set the figure against

a strong green 'to suggest roses and leaves'. Freer strokes and various surface effects can be seen in the background, but precision is saved for the face and its famous profile.

Watts and Lillie enjoyed each other's company in the course of many sittings at New Little Holland House (see no. 59). He began another depiction of her as 'Summer',[5] seen full face holding a basket of roses against a background of blue sky and intended perhaps as a counterpart to the more wintry depiction of her in outdoor dress. She enjoyed posing for Watts:

> one always felt at rest with him. I spent hours and hours posing without experiencing strain or fatigue. Sometimes scarcely a stroke of work was done in the studio. Watts would ring for tea, ignore the sitting and, instead entertain me with lengthy dissertations on art.[6]

He appreciated her complete freedom from vanity even though she personified a current cult of beauty.

When Blanche Lindsay (no. 55) visited the studio and saw the painting of Lillie, she approved. After Watts related to her an elaborate dream in which Titian and Reynolds had instructed him, he commented on Lillie Langtry's portrait: '"I have been working at it all day", he said smiling, "You like it, that is because Titian has been teaching me in my dream".'[7]

1 Quoted in Laura Beatty, *Lillie Langtry: Manners, Masks and Morals*, London, 1999, p. 36.
2 Ibid., p. 141.
3 She was also in mourning for her brother Reggie who had recently died.
4 See Kate Flint in Funnell and Warner 1999, pp. 197–200, and Warner in no. 52.
5 After forty or more sittings it fell into abeyance and later he painted out Lillie's face, replacing it with another sitter in 1902; Watts Catalogue, II, p. 88. Mrs Barrington made a copy of no. 58; see Barrington 1905, p. 86.
6 Langtry 1925, p. 58.
7 Quoted in Henrey 1937, p. 216.

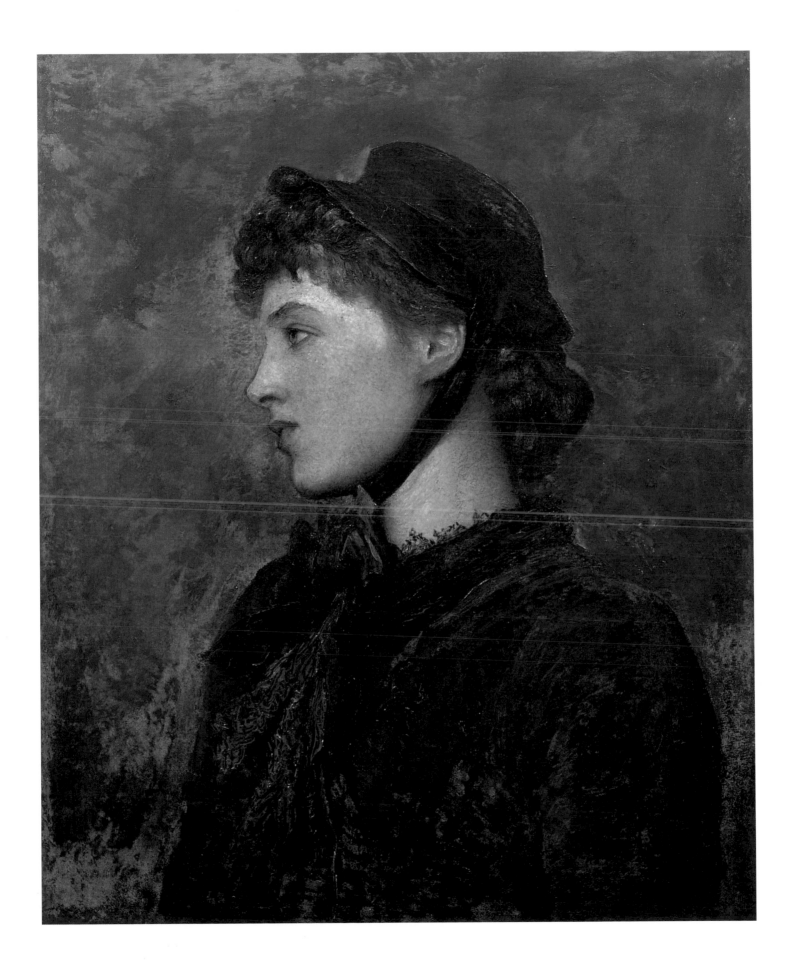

59 SELF-PORTRAIT
1879–80

Oil on canvas
765 x 645mm (30⅛ x 25⅜")
Inscribed 'G F Watts 1880'
*Galleria degli Uffizi, Collezione degli Autoritratti,
Florence, 1880*

Provenance Painted by request for the Gallery of Artists'
Self-Portraits at the Uffizi, Florence
Exhibitions Royal Academy, London, 1880, no. 212;
Firenze e L'Inghilterra, Palazzo Pitti, Florence, 1971, no. 93
Literature Spielmann 1886, p. 32; Barrington 1905,
p. 86; Watts Catalogue, II, p. 168

Although relatively modest in size, this self-portrait has a sense of monumentality in its formality. It also embodies some grand notions about the role of the artist that were fully in keeping with Watts's view of himself at this stage in his career as he stands, palette in hand, before his own painting of *Time, Death and Judgement.*

In late 1878 Watts celebrated, along with the rest of the artistic community, the election of his close friend and neighbour, Frederic Leighton, as President of the Royal Academy. Leighton's masterful personality and social accomplishment made him the perfect choice, as did his familiarity with the international art world. In 1879, for their famed gallery of artists' self-portraits, the Uffizi Gallery in Florence asked Leighton to contribute and to recommend other British artists.[1] Leighton proposed only two artists, Millais and Watts.

For Watts this request came after his recent successes at the Grosvenor Gallery, which had revitalised his career. He had commissioned the building of a residence on Melbury Road, named New Little Holland House in 1876; in 1879 he decided to build a picture gallery addition to display his own works (it opened in 1881). By this time, at just over sixty years old, Watts had attained a high position among his peers and was beginning to be known internationally.[2]

Self-portraiture had always fascinated him. In 1869 Watts cited 'the most interesting gallery I know is the collection of Artists' Portraits painted by their own hands'.[3] The destination of the Uffizi in Florence, a city he had lived in, for his newly commissioned self-portrait sparked off his own dialogue with Titian, the Italian artist he admired most and who was much in his thinking at just this time (see no. 58). He had adopted Titian's method of painting based on the account of Marco Boschini,[4] which his friend Emilie Barrington had translated for an article earlier the same year. As a regular visitor to Watts's studio, she observed that the first picture he painted after reading this account was the present portrait.[5] He 'smothered his canvasses [*sic*] with a mass of colour that made … a bed or base for the touches which he painted over it' in order to preserve the freshness of the colour. Fingers were used to apply the finishing touches, a tactile connection with the painting that would have appealed to Watts's tendency to experiment with his materials.

Such experiments paid dividends. Watts told friends that artists thought the self-portrait 'the best thing I have done, in painter-like qualities, I believe it is so'. In November 1879 he wrote telling his patron Charles Rickards: 'I have been asked to send my own portrait to be hung in a room of the Uffizi Palace at Florence'; he added that, if instead he put the self-portrait into the Grosvenor Gallery, it would sell for £1000. This characteristic concern with prices (so often eliminated in Mrs Watts's hagiographical biography) was to Watts a measure of his reputation vis-à-vis his contemporaries.

Watts had an equal concern for the past. For his earlier self-portrait of the mid 1860s (no. 48) Watts evoked Rubens and Poussin; in this later portrait his model is Titian, not just for the technique but also for the image of the artist, as comparisons with that artist's late self-portraits demonstrate. As Watts aged, his Italian sobriquet 'Signor' became more and more apt, as he cast himself in the role of a modern old master. One contemporary noted that 'in his ruby coloured skullcap, Watts's resemblance to Titian is more marked than ever'.[6]

For the background Watts chose his own recently exhibited *Time and Death* (later to be named *Time, Death and Judgement*),[7] one of his highly regarded 'symbolical' designs. Time appears to one side, and Watts turns his head towards the pale draped figure of Death. By setting his own somewhat subdued figure, wearing a brown jacket, against the glowing colours of *Time, Death and Judgment*, Watts allowed this work to take a subtle but telling role. Due to the large scale of the composition, there is no sense that he is in fact in front of an easel painting. Such is the power of this looming composition that the artist becomes a virtual participant in its gloomy drama.

1 On Leighton's self-portrait, finished the year after Watts's, see Leonée Ormond in Jones *et al.* 1996, no. 84.
2 Bryant 1996, pp. 116ff.
3 Letter to Charles Rickards, 10 February 1869, Watts Papers; Watts 1912, I, pp. 244–5.
4 In several seventeenth-century treatises Boschini (1605–81) argued in favour of the sensuous delights of Venetian brushwork.
5 Barrington 1905, p. 86. The closely related version in the NPG (fig. 25, p. 37) represented another stage in the working process.
6 Lord Ronald Sutherland Gower, *Old Diaries 1881–1901*, London, 1902, p. 303.
7 Bryant 1997, no. 123, for a discussion of the main version in the National Gallery of Canada.

60 ALFRED TENNYSON

1890

Oil on canvas
635 x 508mm (25 x 20")
Inscribed 'G F Watts 1890'
Masters, Fellows and Scholars, Trinity College, Cambridge

Provenance Painted for the Great Hall, Trinity College, Cambridge
Exhibitions Watts New Gallery 1896, no. 19; Memorial Exhs, London 1905, no. 200, Manchester 1905, no. 85; *Cambridge Portraits*, Fitzwilliam Museum, Cambridge, 1978, no. 22
Literature *Athenaeum*, 11 October 1890, p. 490; Spielmann 1905, pp. 52–3; Watts Catalogue, II, p. 158; Watts 1912, II, pp. 158–65, 167, 192, 232; R. Ormond 1973, I, pp. 447–8; L. Ormond 1983

Watts's portrait of Lord Tennyson is one of his late, great works, following on from a series of earlier portrayals of his close friend in the 1850s (no. 34) and 1860s. In 1890, when Dr H. Montagu Butler, Master of Trinity College, Cambridge, requested that Tennyson sit for a portrait for his old college, the poet was reluctant, but came around to the idea when Watts's name was proposed as the painter. Hallam Tennyson, son of the poet, approached Watts who would not accept a commission but agreed to paint the portrait based on his long-standing friendship with the poet.

From the same sittings at Farringford in May 1890 Watts painted two portraits, one showing Tennyson in the scarlet robes of a Doctor of Civil Letters, the other in a peer's ermine.[1] Hallam announced to Dr Butler that the work was underway, referring to it as 'the finest portrait ever done of my Father'.[2] He added that since Tennyson had never managed to reach Cambridge to collect his honorary doctorate, 'he is in consequence of their red tape painted as an Oxford man for Cambridge'. The texture of the canvas gave cause for concern, but the artist finished the first version he had begun and that was given to Trinity. Pleasant sittings, with Hallam reading aloud, allowed the two elder statesmen to converse genially about poetry and art. An illustration, which appeared in a contemporary periodical, recorded the proceedings, with Tennyson sitting in front of a huge shrub of laurel.

The composition harks back to the earlier portraits of the poet with foliage backgrounds (as in the version of *c*.1863; NPG). But, unlike the Bowman Tennyson (see nos 48, 49), where a glimpse of shore-line opens out the depiction, here the lushly green foliage fills most of the space, almost claustrophobically. This device, however, allows total focus on the massive craggy head of the poet surmounting the huge bulk of his robed torso. The face is powerfully modelled, with strong highlights shining on the cranium and nose. The sculptural qualities here in evidence may well have suggested the potential of Tennyson as the model for an actual work of sculpture, which in fact Watts carried out beginning in 1898. The application of the paint is equally bold, with broad strokes suggesting rather than defining the mass of the figure. But it is the colour, with two different shades of red, unblended and loosely dragged, that demonstrates the power of Watts's late style.

Although he refused to send the painting to the New Gallery exhibition, its completion attracted press interest since Watts was by this time of such stature in the wake of international exhibitions that a major completed work was immediately newsworthy. Although the portrait was much praised in its day,[3] later commentators have perhaps not warmed to it. But examining this work in the original allows its full impact to come across, amply demonstrating Watts's own comments about this very painting: 'That is what a portrait should do; it is not by accentuating but rather by keeping in mind, and dwelling upon those lines which are noblest. It is the half unconscious insistence upon the nobilities of the subject.'[4] The glory of the deep crimson colour and the elegiac quality of the depiction represent a summation of Watts's portraiture.

1 The second painting is at the National Gallery of South Australia. Watts offered it to Hallam when he was Governor of South Australia in 1901 as a gift to commemorate 'our debt to the Colony', letter of Watts to Hallam Tennyson, 14 August 1901, Beinecke Library, Yale University. There is also a drawing in red chalk derived from no. 60 that Watts carried out in August 1890 (Tennyson Research Centre, Lincoln) at the request of Hallam Tennyson for the frontispiece of Macmillan's edition of his father's poems. My thanks to Jonathan Smith, College Archivist, and Joanna Ball, Sub-Librarian, at Trinity College.
2 Letter from Hallam Tennyson to Dr Butler, 25 May 1890, Trinity College Library, Cambridge. At this stage the writer had apparently asked Watts to paint two versions, so the second could go to the nation.
3 Charles Villiers Stanford, *Studies and Memories*, London, 1908, p. 97.
4 Quoted in Watts Catalogue, II, p. 158. The wording differs somewhat in Watts 1912, II, p. 164.

61 ROUNDELL PALMER, 1ST EARL OF SELBORNE
1892–3

Oil on canvas
890 x 692mm (35 x 27¼")
Inscribed 'G F Watts 1893'
Honourable Society of Lincoln's Inn

Provenance Initially commissioned from the Benchers of Lincoln's Inn in late 1891, but later presented by the sitter's daughter, Lady Sophia Palmer, to Lincoln's Inn in 1896

Literature Roundell Palmer, *Memorials*, Part II, *Personal and Political*, ed. Lady Sophia Palmer, vol. II, London, 1898, p. 391; Watts Catalogue, II, p. 141; Watts 1912, II, p. 238; Spielmann 1913, p. 129; *The Records of the Honourable Society of Lincoln's Inn: The Black Books*, Vol. V (1845–1914), Book XXXVII, ed. Sir Ronald Roxburgh, Lincoln's Inn, London, 1968; Thomas B. Brumbaugh, 'G.F. Watts: Two Lords Chancellor and a Brief Correspondence', *The Pre-Raphaelite Review*, III, no. 2 (1979–80), pp. 114–16

Painted in the last decade of the artist's working life, this portrait is an outstanding example of Watts's continued engagement with the question of how to depict an eminent sitter, an issue that had preoccupied him for nearly fifty years.

After a distinguished parliamentary and legal career, Roundell Palmer (1812–95) had served twice as Lord Chancellor, most recently under Gladstone from 1880 to 1885; he was created Baron Selborne in 1872 and raised to an earldom in 1882. A friend of Watts, F.W. Gibbs of Lincoln's Inn, acted as intermediary to see if the artist would accept a commission of £500 from the Benchers to paint 'a head as fine as

Mannings', a reference to Watts's master-piece *Cardinal Manning* (GG 1882; NPG). Watts accepted on his usual conditions, which he explained later to Spielmann, that 'he could keep it or part with it as he pleased', adding 'hardly professional practice!'[1] But the lack of clarity in the matter had repercussions. Impressed with Selborne's appearance, he decided to paint the portrait at a larger size, more comparable to *Cardinal Manning* and larger than his usual head-and-shoulders format. When he then asked for an additional £100, the Benchers demurred.[2]

Correspondence with the sitter's daughter gives an insight into how Watts tackled the portrait, as he warned that

> my work in that direction is very unequal and not having the eyesight of earlier times (I am in my 76th year) I have for some time absolutely declined to paint portraits professionally! … I have in this case great difficulty in refusing and perhaps might find time to paint Lord Selborne for my own gallery of representative men.[3]

The letters of 1892 also reveal Watts's preliminary preparations, as he asked for 'any photographs you may have of Lord Selborne that I might get the characteristics into my head before beginning. The more various the better, with or without the wig.' But he was noticeably annoyed with her when she sent a photograph of another painted, rather than photographic, portrait of her father; Watts retorted: 'I do not want another man's impression.'

Watts's attraction to this commission stemmed partly from his own past experience. He had painted Baron Campbell as Lord Chancellor in 1860 (no. 36), and although that portrait had gone to the sitter's family, he retained a small version. Such eminent individuals were a potential addition to his own gallery but Selborne's appearance also appealed to the artist who

'was struck with the effect of the fine forehead'. The approach to the portrait changed as Watts worked. Initially the sitter posed with the full-bottomed wig of his profession which Watts 'generally considered a great advantage pictorially', but 'in this instance [it] entails a loss too great to submit to', for it obscured the 'fine forehead' of the man himself. This notion of the head as the focal point of intellectual activity enters into any analysis of Watts's usual series of distinguished contemporaries. But with Selborne the artist also saw the potential to increase the universal appeal of the work by avoiding the wig. Moreover, in his quest for a timeless quality he considered that 'the fur coat will enable me to get rid of the ordinary abominations',[4] by which he meant modern-day clothing.

Watts thus reconfigured the portrait on a larger scale allowing for a more substantial composition. He portrayed Selborne not as a lawyer, but as an intellectually powerful individual of any or all time. Clear light illuminates the prominent forehead, but equally sensitive is the handling of the aged skin of the face, as an alert nervousness pervades the features. Clad in a magnificent robe trimmed with a wide expanse of pale grey fur, Selborne is swathed so that his body disappears, allowing focus on the head, with only his hand emerging from the boldly painted sleeve. The colouring is subdued but there is a textural richness in the varied effect of broad handling contrasting with the finer, softer area of the fur.

The fur-trimmed robe inevitably recalls similar ones worn by Rembrandt in his self-portraits, such as the late work Watts would have known well from the collection of Lord Lansdowne (now Iveagh Bequest, Kenwood).[5] Such portraits had long fascinated him and much earlier he had made a small copy after another late *Self-Portrait* by Rembrandt in the Louvre (fig. 10, p. 18). In the portrait of Lord Selborne Watts drew on his knowledge of older art as a fully

integrated method in his repertoire to create a compelling image of great age and dignity. By this time the allusion to Rembrandt is an almost subliminal association, rather than a direct quotation, which allows the audience to perceive greater depths within the portrait.

The depiction of Lord Selborne, like a prophet pondering the future, confirms Watts's continued ability to treat both the man and his mind in portraiture.

1 Spielmann recounts this as a correction of Mrs Watts's published reference to this portrait being a commission (1912, p. 129). The phrase 'hardly professional practice!' is Watts's own. Mrs Watts seemed at pains to downplay this commission in her catalogue saying that 'the subject did not appeal … and there was not much exchange of thought during the sittings'. But it seems clear her motive was to skirt over the fact that the commission was not accepted outright by the Benchers because Watts demanded extra money. In fact, the two men greatly admired each other with Selborne commenting that 'the beauty and value of Mr Watts's creations was incalculably enhanced by the noble spirit which inspires and lives in all his works'.
2 The Black Books of Lincoln's Inn note that the artist requested the extra money after he had been paid, admitting his own mistake, saying he 'forgot' the figure of £500 and then painted a larger work, hence he was now asking for another £100. The outcome is not recorded but we have to assume that Selborne's family took over the commission, since they eventually presented the work to Lincoln's Inn the year after Selborne's death.
3 Letter from Watts to Lady Sophia Palmer, 7 May 1892, quoted in Thomas B. Brumbaugh, 'G.F. Watts: Two Lords Chancellor and a Brief Correspondence', *The Pre-Raphaelite Review*, III, no. 2 (1979–80), p. 114.
4 Quotations from Watts's letters to Lady Sophia Palmer, 10 May, 17 May and June 1892, quoted in Brumbaugh 1979, p. 116. Further letters about this commission (Huntington Library) reveal Watts requesting the Benchers to 'get me something like a definite wish to have Lord Selborne bare-headed' so that he could convince Lady Sophia on this point.
5 Lord Lansdowne, who was an important patron of Watts in the 1850s, displayed Rembrandt's portrait (now at Kenwood) in Lansdowne House in London, where it was seen by Waagen in 1854, as noted by Julius Bryant, *Kenwood: Paintings in the Iveagh Bequest*, New Haven and London, 2003, pp. 73, 76.

62 LINA DUFF GORDON
1899–1900

Oil on canvas
1280 x 720mm (50⅜ x 28⅜")
A.J.C. Beevor

Provenance Painted at the request of the artist; retained
by him until after 1904 when given by Mrs Watts to the
sitter; by family descent
Exhibitions Summer Exhibition, New Gallery, London,
1900, no. 145; Autumn Exhibition, Royal Society of
Artists, Birmingham, 1900, no. 272
Literature *Catalogue of Pictures by G.F. Watts, O.M., R.A.,*
The Picture Gallery, Compton, 1904, no. 80; Watts
Catalogue, II, p. 48; Ross 1912, ill. opp. p. 12; Waterfield
1961, pp. 81–2; Frank 1994, pp. 356–7

This portrait of Lina Duff Gordon is one of
Watts's most impressive late works, note-
worthy for its glowing warm colours and
rich handling.

Watts's longstanding links with the Duff
Gordon family extended back fifty years to
Italy, where he had befriended Georgy and
Alice (no. 15), and to London, where he
knew their sister-in-law Lucie (1821–69),
the noted Egyptian traveller.[1] Caroline Lucie
(known as Lina) (1874–1964), daughter of
Sir Maurice Duff Gordon, Bart., and Fanny
Waterton, and great-granddaughter of Lady
Duff Gordon, was also the great niece of
Georgy and Alice who were living on into
their eighties by this time. After the
separation of her parents, Lina had lived
in Italy with her aunt Janet Ross at Poggio
Gherado near Florence. When she returned
to London, she resided with her great-aunt
Georgy, who brought her to New Little
Holland House in Melbury Road in order
to ask Watts to sign the portrait of Lady
Waterford (no. 16). In 1902 Lina married the
artist Aubrey Waterfield amid some family
opposition, although not that of her aged
aunt, who supported her decision.[2]

In the mid 1890s, when Watts met
Lina, she recounted that he 'looked at me
searchingly', murmuring, 'Yes, something
of your grandmother, Lucie'.[3] This renewed

contact allowed her 'to take an inherited
place in his affections', as Mrs Watts noted,[4]
in many visits to Limnerslease, the artist's
home in Surrey. Lina's pale beauty prompted
Watts to paint this three-quarter length and
begin another one in 1899. In discussions
about the forthcoming portrait it emerged
that she possessed a gown of opulent Indian
material that fifty years before an Indian
prince from Cawnpore had presented to
Lucie Duff Gordon.[5] Known as kincob cloth,
woven from rose silk and real gold threads, it
had been fashioned into a gown for a fancy-
dress ball in Italy, the style modelled on one
worn by a figure in a painting by Leonardo.
After many hours of posing in this striking
but heavy garment, Lina removed it and
promptly fell on her bed exhausted.

Watts painted this work on a larger
scale than most of his late portraits. On his
preferred roughly textured canvas, brush-
work is evened out, creating loose overall
surface effects. There is very little detail
or smoothness, except in the area of the
face where the complexion of the figure is
meticulously built up. Otherwise, as in much
of Watts's late work, there is the desire for
loose texture, which allows the colour of the
paint itself to shine forth, seen to especially
brilliant effect here in the golden highlights
of the dress.

Many of the elements of Watts's earlier
portraits are here, in the pose of the figure
and the delicate movement of her hands,
along with the familiar accessories of a
potted plant and the view out beyond a
terrace. But the style marks it as a late work.
There is also an unmistakable quality of
nostalgia, as this portrait seems less about
the sitter and more about the great artist at
the end of his career. Youthful beauty and
the exotic, positively glowing attire combine
to create an image filled with sensual colour
and rich textures, as the eighty-year-old
Watts recaptured the warmth and colour
of Italy in an evocative portrait of his own
youthful memories.

1 Watts's friend Henry Wyndham Phillips painted a
portrait of Lucie Duff Gordon in 1852 (NPG); her book
Letters from Egpyt was published in 1866. Her daughter
Janet Ross edited later editions of her mother's letters,
as well as publishing widely.
2 Lina and her husband posed for the artist Charles Furse
for the large dramatic painting *The Return from the Ride*
(RA 1903; Tate); in 1917 they founded the British
Institute in Florence. For further details about the family
see Kinta Beevor, *A Tuscan Childhood*, London, 1993.
3 Waterfield 1961, p. 80.
4 Watts 1912, II, p. 253.
5 On the background to Nana Sahib, the Indian prince,
see Frank 1994, pp. 7, 178–81; along with the cloth he
also sent a necklace, *c*.1855, on the eve of the Indian
Mutiny. My thanks to A.J.C. Beevor for kind assistance
regarding his family's history.

SELECT BIBLIOGRAPHY

Allendale Catalogue 1924
A Portion of the Collection of Oil Paintings at 144, Piccadilly, London, and Bretton Park, Yorkshire, Anderson and Garland, Valuers, Newcastle-upon-Tyne, privately printed, 1924

Alston 1929
Rowland Alston, *The Mind and Work of G.F. Watts, O.M., R.A., with a Catalogue of the Pictures … at the Picture Gallery* [at] *Compton in Surrey*, London, 1929

Barrington 1905
Mrs Russell (Emilie) Barrington, *G.F. Watts: Reminiscences*, London, 1905

Blunt 1975
Wilfrid Blunt, *'England's Michelangelo': A Biography of George Frederic Watts, O.M., R.A.*, London, 1975

Bryant 1987
Barbara Bryant, 'The Origins of G.F. Watts's "Symbolical" Paintings: A Lost Study Identified', *Porticus: Journal of the Memorial Art Gallery of the University of Rochester*, vols. 10–11 (1987–8), pp. 53–9

Bryant 1996
Barbara Bryant, 'G.F. Watts at the Grosvenor Gallery: "Poems Painted on Canvas" and the New Internationalism', in Susan Casteras and Colleen Denney (eds), *The Grosvenor Gallery: A Palace of Art in Victorian England*, New Haven and London, 1996, pp. 109–28, 176–9

Bryant 1997
Barbara Bryant, 'G.F. Watts and the Symbolist Vision' and all entries on G.F. Watts, in Andrew Wilton and Robert Upstone (eds), *The Age of Rossetti, Burne-Jones & Watts: Symbolism in Britain 1860–1910*, exh. cat., Tate Gallery, London, 1997

Cartwright 1896
Julia Cartwright, 'George Frederic Watts, R.A.', *Art Journal: Easter Annual*, 1896

Chesterton 1904
G.K. Chesterton, *G.F. Watts*, London, 1901 (and later editions)

Complete Peerage
G.E.C. / G.E. Cokayne (ed.), *The Complete Peerage of England, Scotland and Ireland, Great Britain and the United Kingdom, Extant, Extinct or Dormant* (new edn, ed. V. Gibbs *et al.*, London, 1910–40

Cook and Wedderburn 1903–12
E.T. Cook and Alexander Wedderburn (eds), *The Works of John Ruskin*, 39 vols, London, 1903–12

Dakers 1999
Caroline Dakers, *The Holland Park Circle: Artists and Victorian Society*, New Haven and London, 1999

Dorment and MacDonald 1995
Richard Dorment and Margaret F. MacDonald, *James McNeill Whistler*, exh. cat., Tate Gallery, London, 1995

Egerton 1998
Judy Egerton, *National Gallery Catalogues: The British School*, London, 1998

Erskine 1903
Mrs Steuart [Beatrice] Erskine, 'Mr. G.F. Watts' Portraits at Holland House', *The International Studio*, XX (1903), pp. 176–87

Fogg 1946
Paintings and Drawings of the Pre-Raphaelites and their Circle, exh. cat., Fogg Art Museum, Harvard University, Cambridge, Mass., 1946

Ford 1998
'The Ford Collection – I, II,' *The Sixtieth Volume of the Walpole Society*, London, 1998

Frank 1994
Katherine Frank, *Lucie Duff Gordon: A Passage to Egypt*, London, 1994

Friederichs 1895
Hilda Friederichs, 'An Interview with Mr. G.F. Watts, R.A.', *The Young Woman: A Monthly Journal and Review*, IV (1895), pp. 73–82

Funnell and Warner 1999
Peter Funnell and Malcolm Warner, *Millais: Portraits*, exh. cat., National Portrait Gallery, London, 1999

Gaja 1995
Katherine Gaja, *G.F. Watts in Italy: A Portrait of the Artist as a Young Man*, Pocket Library of Studies in Art, XXIX, Leo S. Olschki Editore [Florence], 1995

Hare 1893
Augustus Hare, *The Story of Two Noble Lives*, vol. III, London, 1893

Haskell 1976
Francis Haskell, *Rediscoveries in Art: Some Aspects of Taste, Fashion and Collecting in England and France*, Oxford, (2nd edn, 1980)

Henrey 1937
Robert Henrey, *A Century Between*, London and Toronto, 1937

Hewett 1958
Osbert Wyndham Hewett (ed.), *'… and Mr. Fortescue': A Selection from the Diaries from 1851 to 1862 of Chichester Fortescue, Lord Carlingford*, London, 1958

Hoge 1974
James O. Hoge (ed.), *The Letters of Emily Lady Tennyson*, Pennsylvania and London, 1974

Hunt 1913
William Holman Hunt, *Pre-Raphaelitism and the Pre-Raphaelite Brotherhood*, 2 vols, London, 1913 (2nd edn)

Hutchings and Hinton 1986
Richard J. Hutchings and Brian Hinton (eds), *The Farringford Journal of Emily Tennyson 1853–1864*, Newport, 1986

Ilchester Catalogue 1904
The Earl of Ilchester, *Catalogue of Pictures Belonging to the Earl of Ilchester at Holland House*, privately printed, 1904 (addenda, 1939)

Ilchester 1937
The Earl of Ilchester, *Chronicles of Holland House, 1820–1900*, London, 1937

Jones *et al.* 1996
Stephen Jones *et al.*, *Frederic Leighton 1830–1896*, exh. cat., Royal Academy of Arts, London, 1996

Laing 1995
Alastair Laing, *In Trust for the Nation: Paintings from National Trust Houses*, exh. cat., National Gallery, London, 1995

Langtry 1925
Lillie Langtry (Lady de Bathe), *The Days I Knew*, London, 1925

Liechtenstein 1874
Princess Marie Liechtenstein [Marie Fox], *Holland House*, 2 vols, London, 1874

Loshak 1963
David Loshak, 'G.F. Watts and Ellen Terry', *Burlington Magazine*, 105 (1963), pp. 476–85

MacLeod 1996
Dianne Sachko MacLeod, *Art and the Victorian Middle Class: Money and the Making of Cultural Identity*, Cambridge, 1996

Macmillan 1903
Hugh Macmillan, *The Life-Work of George Frederic Watts, R.A.*, London, 1903

Millar 1985
Oliver Millar, 'Portraiture and the Country House', in Gervase Jackson-Stops (ed.), *The Treasure Houses of Britain: Five Hundred Years of Private Patronage and Art Collecting*, exh. cat., National Gallery of Art, Washington DC, 1985, pp. 28–39

Monkhouse 1882
Cosmo Monkhouse, 'The Watts Exhibition', *Magazine of Art*, 1882, pp. 177–82

Munhall 1998
Edgar Munhall, *Ingres and the Comtesse d'Haussonville*, The Frick Collection, New York, 1998 (2nd, rev. edn)

L. Ormond 1983
Leonée Ormond, 'George Frederic Watts: The Portraits of Tennyson', *The Tennyson Research Bulletin*, 4 (1983), pp. 47–58

L. and R. Ormond 1975
Leonée and Richard Ormond, *Lord Leighton*, New Haven and London, 1975

R. Ormond 1973
Richard Ormond, *Early Victorian Portraits*, 2 vols, National Portrait Gallery, London, 1973

R. Ormond 1975
Richard Ormond, *G.F. Watts: The Hall of Fame: Portraits of his Famous Contemporaries*, London, 1975

Penny 1986
Nicholas Penny (ed.), *Reynolds*, exh. cat., Royal Academy of Arts, London, 1986

Robertson 1953
Letters from Graham Robertson (1866–1948), Kerrison Preston (ed.), London, 1953

Robertson 1978
David Robertson, *Sir Charles Eastlake and the Victorian Art World*, Princeton, 1978

Ross 1912
Janet Ross, *The Fourth Generation*, London, 1912

Sketchley 1904
R.E.D. Sketchley, *Watts*, London, 1904

Spielmann 1886
M[arion] H[arry] Spielmann, 'The Works of Mr. George F. Watts, R.A., with a complete catalogue of his Pictures', *Pall Mall Gazette*, Extra Number, 22 (1886), pp. 1–32

Spielmann 1897
M.H. Spielmann, 'Mr. George Frederick Watts, R.A.', *Magazine of Art*, 1897, pp. 200–210

Spielmann 1905
M.H. Spielmann, *G.F. Watts, R.A., O.M., as a Great Painter of Portraits: A Lecture with Additions and Emendations* (delivered at the Memorial Hall, Manchester, 7 June 1905), London and Manchester, 1905

Spielmann 1913
M.H. Spielmann, 'The Portraiture of George Frederic Watts', *The Nineteenth Century*, 1913, pp. 118–32

Staley 1978
Allen Staley, 'Introduction' and 'Post-Pre-Raphaelitism', in *Victorian High Renaissance*, exh. cat., The Minneapolis Institute of Arts; City Art Gallery, Manchester; The Brooklyn Museum, 1978, pp.13–19, 21–31, cat. nos 1–34

Stephens 1887
F.G. Stephens, 'George Frederick Watts, Esq., R.A., LL.D.', *The Portfolio*, 1887, pp. 13–19

Terry 1908
Ellen Terry, *The Story of My Life: Recollections and Reflections*, London, 1908 (2nd edn, 1922)

Waagen 1838
Gustav Waagen, *Works of Art and Artists in England*, 3 vols, London, 1838

Waagen 1854
Gustav Waagen, *Treasures of Art in Great Britain*, 3 vols, London, 1854

Waagen 1857
Gustav Waagen, *Galleries and Cabinets of Art in Great Britain*, London, 1857 (supplement to Waagen 1854)

Walker 1985
Richard Walker, *Regency Portraits*, 2 vols, National Portrait Gallery, London, 1985

Waterfield 1961
Lina Waterfield, *Castle in Italy*, London, 1961

Watts 1880
G.F. Watts, 'The Present Conditions of Art', *The Nineteenth Century*, 1880, pp. 235–51

Watts 1888
G.F. Watts, 'Thoughts on our Art of Today', *Magazine of Art*, 1888, pp. 90–92

Watts 1889
G.F. Watts, 'More Thoughts on our Art of Today', *Magazine of Art*, 1888–9, pp. 244–56

Watts 1912
M[ary]. S. Watts, *George Frederic Watts: The Annals of an Artist's Life*, 3 vols, London, 1912

Watts Catalogue
'Catalogue of the Works of G.F. Watts, compiled by his widow', 3 unpublished MS vols by M.S. Watts, c.1910, Watts Gallery, Compton, Surrey. The first volume of this catalogue contains the Subject Paintings; the second two contain the Portraits. Since the latter two have continuous pagination, these volumes are here referred to as volume II.

Watts Papers
Watts Papers (formerly Watts Gallery), unpublished, sold Sotheby's, 14 March 1979, microfiche copies at the National Portrait Gallery (and some originals), the Watts Gallery and Tate

EXHIBITIONS

Watts Manchester 1880
A Collection of Pictures and Sculpture: The Works of G.F. Watts, Esq., R.A., Royal Institution, Manchester, 1880

Watts Grosvenor 1881
Winter Exhibition: Collection of the Works of G.F. Watts., R.A., Grosvenor Gallery, London, 1881–2

Watts New York 1884
Paintings by G.F. Watts., R.A. (with catalogue notes compiled in part by Mrs Barrington; reprinted in Barrington 1905, pp. 118–38), Metropolitan Museum of Art, New York, 1884–5

Watts Birmingham 1885
Collection of Paintings by G.F. Watts, R.A. and Edward Burne-Jones, A.R.A., Museums and Art Gallery, Birmingham, 1885

Watts Nottingham 1886
Collection of Pictures by G.F. Watts, R.A., Museum and Art Gallery, Nottingham, 1886

Watts New Gallery 1896
Winter Exhibition: The Works of G.F. Watts, New Gallery, London, 1896–7

Memorial Exhs
London 1905
Winter Exhibition: Works by the Late George Frederick [sic] Watts, R.A., O.M. and the late Frederick Sandys, Royal Academy of Arts, London, 1905
Manchester 1905
G.F. Watts Memorial Exhibition, City Art Gallery, Manchester, 1905
Newcastle 1905
Special Loan Collection of Works by the Late G.F. Watts, R.A., O.M., Laing Art Gallery, Newcastle, 1905
Edinburgh 1905
Memorial Exhibition of Works by the Late G.F. Watts, R.A., Royal Scottish Academy, Edinburgh, 1905
Dublin 1906
Watts Memorial Exhibition, Royal Hiberian Academy, Dublin, 1906

Watts London 1954
George Frederic Watts, O.M., R.A., 1817–1904 (exhibition organised by the Arts Council of Great Britain; exh. cat. by David Loshak), Tate Gallery, London, 1954

Watts London 1974
G.F. Watts: A Nineteenth-Century Phenomenon (exh. cat. by John Gage and Chris Mullen), Whitechapel Art Gallery, London, 1974

Watts NPG 1975
G.F. Watts: The Hall of Fame, touring exhibition (no exh. cat.), National Portrait Gallery, London, and Laing Art Gallery, Newcastle, 1975

Watts NPG 1980
G.F. Watts: The Hall of Fame, touring exhibition (no exh. cat.), National Portrait Gallery, London, 1980–81

INDEX

Figures in **bold** refer to catalogue entries; those in *italics* refer to figure captions. All pictures are by Watts unless otherwise stated.